DUBAI
ARCHITECTURE & DESIGN

daab

Arkiteknik International & Consulting Engineers | Grand Hyatt Dubai 8

Atkins, KCA International Designers | Burj Al Arab 16

Atkins | Al Mas 24

Atkins | Bright Start Tower 30

Atkins | Chelsea Tower 34

Chapman Taylor, Dewan Architects & Engineers | Pearl Dubai 38

Creative Kingdom, Wilson & Associates | Park Hyatt Dubai 42

Creative Kingdom, KCA International Designers | Madinat Jumeirah 48

Folli Follie | Folli Follie 62

Keith Gavin, Godwin Austen Johnson, Karen Wilhelmm, Mirage Mille | Jumeirah Bab Al Shams 66

Gensler | DIFC Gate Building 80

gmp– von Gerkan, Marg und Partner Architects | Dubai Sports City 84

Joachim Hauser, 3deluxe system modern GmbH | Hydropolis Underwater Resort Hotel 96

Ho+k Hellmuth, Obata + Kassabaum | Dubai Autodrome 102

Jung Brannen Associates, Dewan Architects & Engineers | Media-1 104

KCA International Designers | Al Mahara 110

KCA International Designers | Arboretum 112

KCA International Designers | Pierchic Restaurant 120

KCA International Designers | Segreto 126

KCA International Designers | Six Senses Spa 136

KCA International Designers | The Wharf 144

Louis Vuitton Malletier Architecture Department | Louis Vuitton 148

Mel McNally Design International | Lotus One 154

Nakheel | Dubai Waterfront 162

NORR Group, Carlos Ott | National Bank of Dubai headquarters 164

NORR Group, Hazel W.S. Wong | Emirates Towers 166

RMJM | Al Gurg Tower 174

RMJM | Capital Towers 178

RMJM | Dubai International Convention Centre 180

RMJM | Marina Heights 184

RMJM | The Jewels 186

Skidmore, Owings & Merrill LLP | Burj Dubai 190

Skidmore, Owings & Merrill LLP | Sun Tower 194

Wilson & Associates | Givenchy Spa 200

Wilson & Associates | Nina 208

Wilson & Associates | One&Only Royal Mirage 214

Wilson & Associates | Rooftop 224

Wilson & Associates | Traiteur 232

Noch vor wenigen Jahrzehnten war Dubai kaum mehr als eine beschauliche Beduinenstadt. Heute erhebt sich aus der Wüste die Skyline einer Boomtown. Darüber mag sich mancher verwundert die Augen reiben und meinen, einer Fata Morgana aufzusitzen. Doch es ist Fakt: Die Stadt am Persischen Golf pulsiert und wächst in ungekannter Weise. Superlative bestimmen die News darüber. Es sind vor allem diese Berichte von immer neuen Bauten, die alles bisher Errichtete in den hier kaum vorhandenen Schatten stellen. Burj Al Arab, das derzeit größte Luxushotel der Welt, mit seiner auch technisch einzigartigen Fassade ist nur ein Beispiel. Palm Projekt oder Hydropolis, beides visionäre, künstlich angelegte Inseln, gehören in die gleiche Kategorie. Oder sei es der Bau des weltweit höchsten Wohnturms. Dubai wartet mit einer Art Preview der Supermoderne auf – ein Trend, der sich auch im Design diverser Restaurants, Hotels und Labelstores niederschlägt. Denn diese Stadt als wichtigstes Tor zum mittleren Osten ist vor allem eines: durch und durch international und von ungeheurer Vehemenz beim Aufbruch in eine neue Zukunft. Davon gibt dieses Buch eine Anschauung, mit exemplarisch ausgewählten Objekten und pointierten Informationen dazu.

Only a few decades ago, Dubai was merely a tranquil Bedouin city. Today, the skyline of a boomtown rises from the desert. Some may rub their eyes and wonder whether they are being fooled by a mirage. But it is a fact: the city near the Persian Gulf is throbbing and growing in an unprecedented way. Reports about it are distinguished by superlatives. In particular, reports regarding new buildings in this country of little shadow overshadow anything that has been constructed before. Burj Al Arab, currently the world's largest luxury hotel, with its also technically unique façade is just one example of these buildings. Palm Project or Hydropolis, both visionary, artificially created islands belong to the same category. As does the construction of the world's highest apartment tower. Dubai presents a kind of preview of the ultramodern—a trend that is also reflected in the design of various restaurants, hotels and label stores. Representing the most important gate to the Middle East, this city is primarily one thing: thoroughly international and with incredible power on its way to a new future. This is the theme of this book, with chosen objects and crucial information concerning them.

Lo que hasta hace unas pocas décadas no era más que una tranquila ciudad beduina se levanta hoy en el desierto en una explosión arquitectónica, como si de un espejismo se tratase. Pero Dubai es real: la ciudad del Golfo Pérsico crece y palpita a pasos agigantados. Sólo se habla de superlativos; las constantes noticias de nuevas construcciones hacen sombra, una sombra aquí costosa, a todo lo construido hasta el momento. Burj Al Arab, actualmente el mayor hotel de lujo del mundo, con su fachada sin igual desde el punto de vista técnico es tan sólo un ejemplo de ello. Palm Projekt o Hydropolis, dos islas artificiales visionarias, así como la torre de viviendas más grande del mundo corresponden también a esta categoría. Dubai ofrece un avance de lo súper moderno, una moda que se hace presente en el diseño de diversos restaurantes, hoteles y tiendas de marca. Y es que esta ciudad emisaria de Oriente Medio es por encima de todo más y más internacional, y vehemente en su intento de abrir brecha hacia el futuro. Esta obra muestra su visión con una selección de objetos e informaciones acertadas.

Il y a seulement quelques années, Dubaï n'était à peine plus qu'une tranquille ville de Bédouins. Aujourd'hui c'est la silhouette d'une ville en plein boom qui s'élève dans le désert. Il y a de quoi se frotter les yeux avec étonnement et se demander s'il ne s'agit pas d'un mirage. C'est un fait : une vie trépidante règne dans la ville au bord du Golfe Persique et elle se développe d'une manière incroyable. Dans les informations sur le sujet les superlatifs fusent. Il s'agit surtout de reportages sur encore et toujours de nouvelles constructions, qui relèguent dans l'ombre, pourtant ici quasi inexistante, ce qui a été construit jusqu'alors. Burj Al Arab, actuellement le plus grand hôtel de luxe du monde, n'en est, avec sa façade également unique du point de vue technique, qu'un exemple. Palm Projekt ou Hydropolis, deux îles artificielles visionnaires, appartiennent à la même catégorie. Ou encore la construction du plus haut immeuble d'habitation du monde. Dubaï offre une avant-première artistique du super moderne, une tendance qui s'exprime aussi dans le design des divers restaurants, hôtels et boutiques labelisées. En effet les caractéristiques de cette ville, qui est la porte la plus importante sur le Moyen-orient, sont son coté complètement international et l'incroyable véhémence avec laquelle elle s'élance vers un nouvel avenir. C'est un regard sur ce phénomène que ce livre donne à voir avec des exemples choisis avec soin et accompagnés d'informations pertinentes.

Ancora fino a pochi decenni fa, Dubai era poco più di una tranquilla città di beduini. Oggi lungo l'orizzonte desertico si staglia lo skyline di una „boom town". A questa visione forse qualcuno può stentare a credere ai propri occhi e temere di essere vittima di un miraggio. Invece è un dato di fatto: affacciata sul Golfo Persico, Dubai pulsa di vita e cresce ad un ritmo mai visto prima. Delle novità non si può che parlare per iperboli, visto che solo i superlativi assoluti sembrano potersi avvicinare alla grandiosità dei nuovi progetti che sembrano del tutto intenzionati a voler mettere in ombra (impresa difficile da queste parti) quanto costruito finora. Burj Al Arab, con la sua facciata avanguardistica da un punto di vista tanto tecnico quanto estetico, l'albergo che tuttora detiene il primato di essere il più lussuoso del mondo, ne è solo un esempio. Palm Island o Hydropolis, entrambe isole artificiali avveniristiche, appartengono alla medesima categoria. E ancora il progetto di costruzione del grattacielo residenziale più alto del mondo. Dubai è di per sé un'anteprima dell'era ultramoderna, un trend che si va affermando anche nel design di svariati ristoranti, hotel e label store. Infatti nella sua veste di principale porta sul Medio Oriente, questa città incarna soprattutto due qualità: l'essere totalmente internazionale e la voglia dirompente di proiettarsi nel futuro. È di tutto ciò che questo libro vuole anticipare la visione, offrendo una selezione mirata di progetti architettonici corredati delle relative informazioni più rilevanti.

Arkiteknik International & Consulting Engineers
Grand Hyatt Dubai | 2003
Al Qataiyat Road
Photos: © Courtesy Grand Hyatt Dubai

Schon die Grundfigur beeindruckt: Aus der Warte eines Vogels betrachtet ergibt das Gebäude den arabischen Schriftzug von Dubai. Das derzeit größte Hotel vor Ort ist bekannt als vornehmer Rahmen für Tagungen. Kein Wunder, bei dem Ambiente, das sich vom Feinsten zeigt und gern auf historische Bezüge verweist. Sehens- wie erlebenswert ist auch die Wasserlandschaft der Spa.

The basic shape of the building is already impressive: Seen from the sky, the building spells Dubai in Arabic letters. The currently largest hotel of the city is famous as an elegant setting for conferences. This is not surprising, given the hotel's exclusive atmosphere with frequent historic references. The spa's waterscape is also worth a visit.

Ya la planta de esta figura impacta. A vista de pájaro el edificio constituye el sello árabe personal de Dubai. Actualmente, el hotel más grande de la ciudad se ha ganado la fama de ser el marco ideal para convenciones; lo cual no es de extrañar dado su ambiente exquisito y los detalles de vinculación histórica. A ello se suma un universo de agua en el spa digno de ser visto y disfrutado.

Le plan-masse déjà est remarquable : vu du ciel le bâtiment dessine le mot Dubaï en arabe. L'hôtel, le plus grand de l'endroit pour le moment est prisé pour les congrès grâce à son cadre distingué. Rien d'étonnant car l'ambiance, qui s'appuie volontiers sur des références historiques, se montre pleine de finesse. Le spa avec son paysage aquatique mérite d'être admiré et essayé.

Già la figura di base colpisce per la sua imponenza. Visto da una prospettiva aerea, il complesso riprende la dicitura Dubai in caratteri arabi. Attualmente il più grande hotel in loco, il Grand Hyatt offre un'ambientazione prestigiosa per convegni. Non c'è da meravigliarsi, trattandosi di un contesto d'eccezione nel quale non mancano i rimandi alla tradizione storica. La zona umida della SPA è una vera oasi per i cinque sensi.

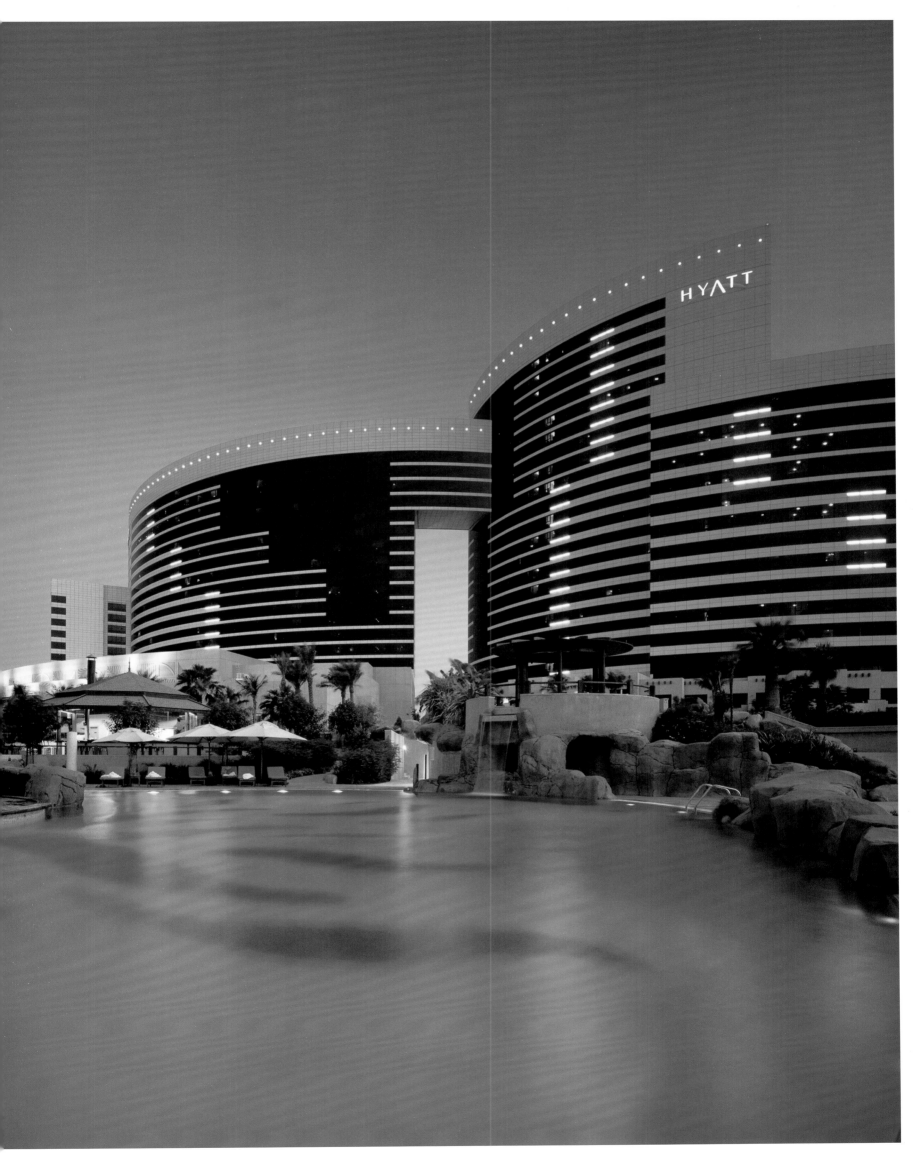

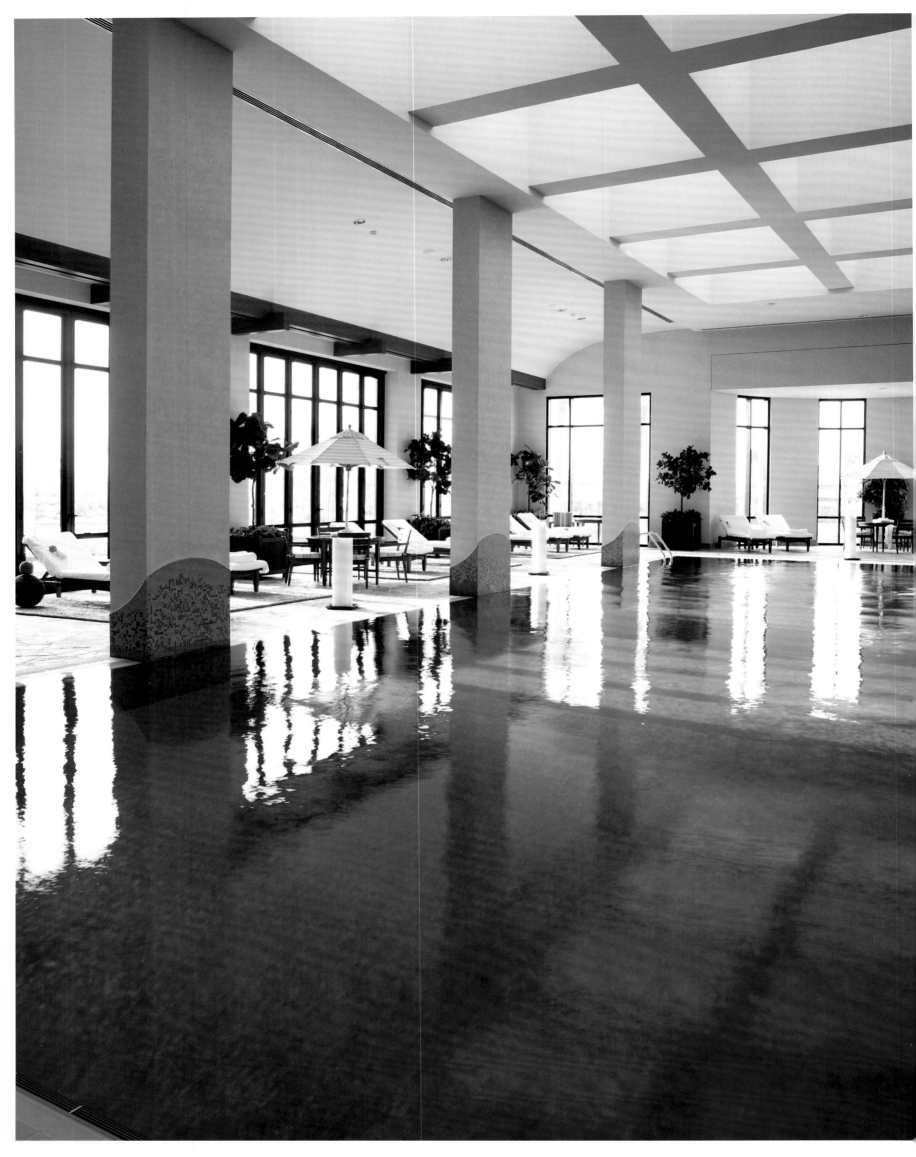

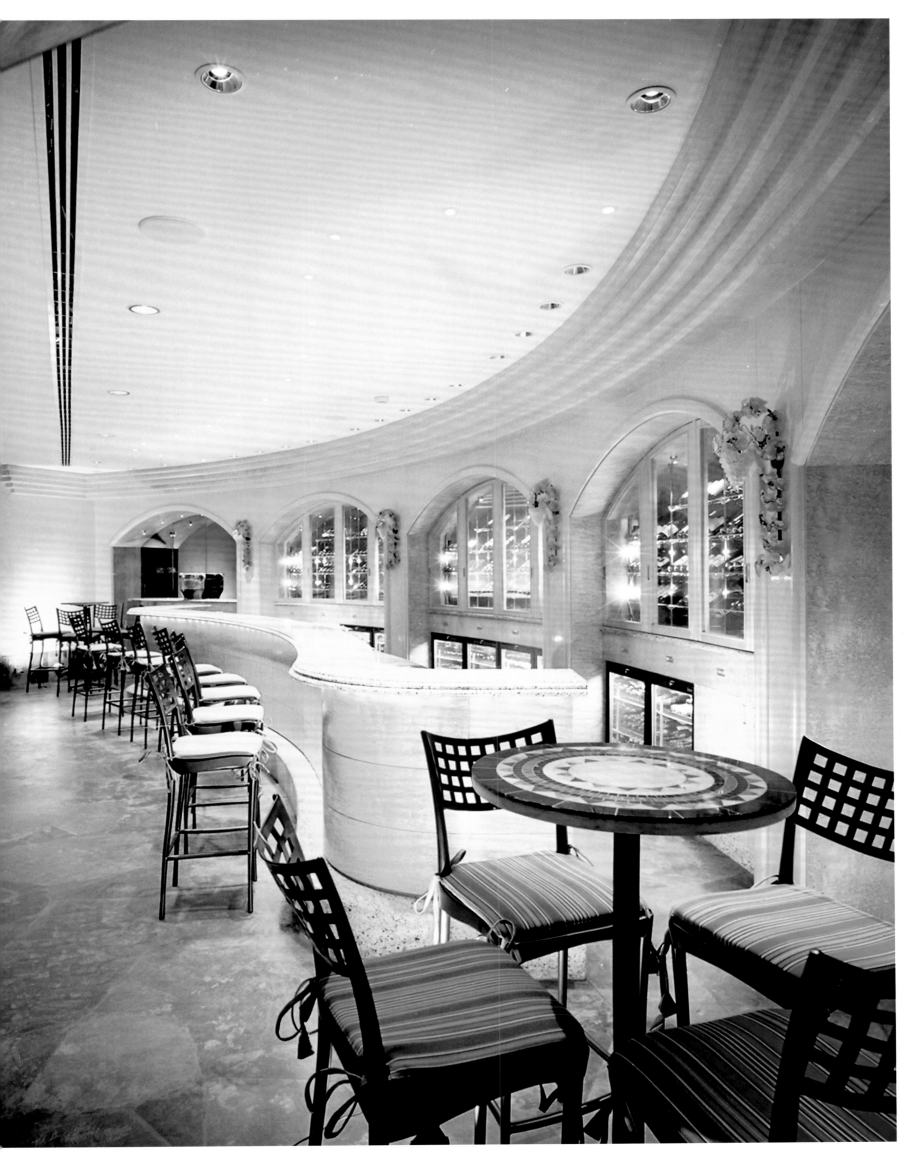

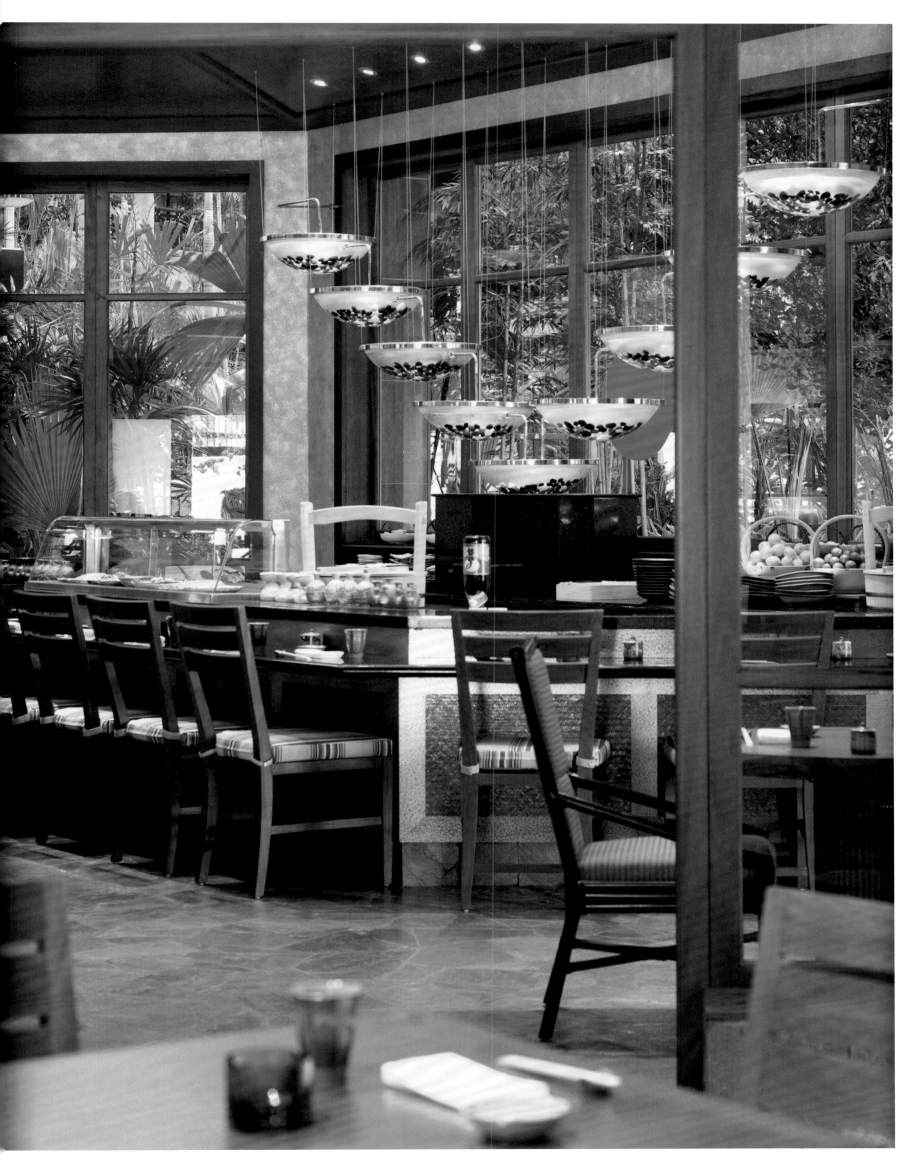

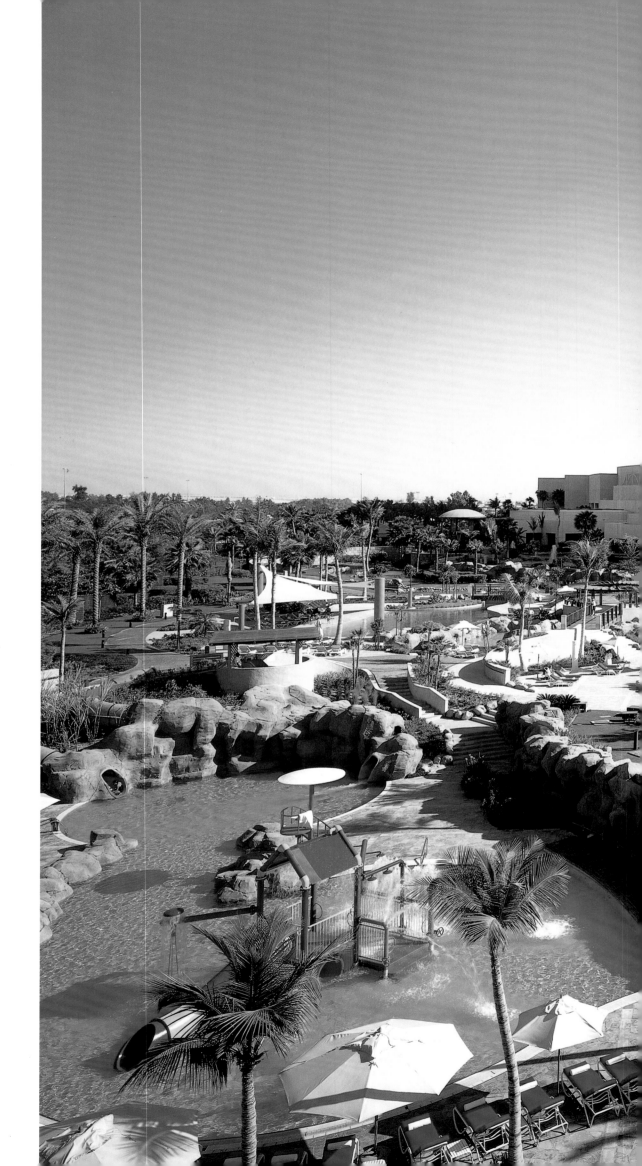

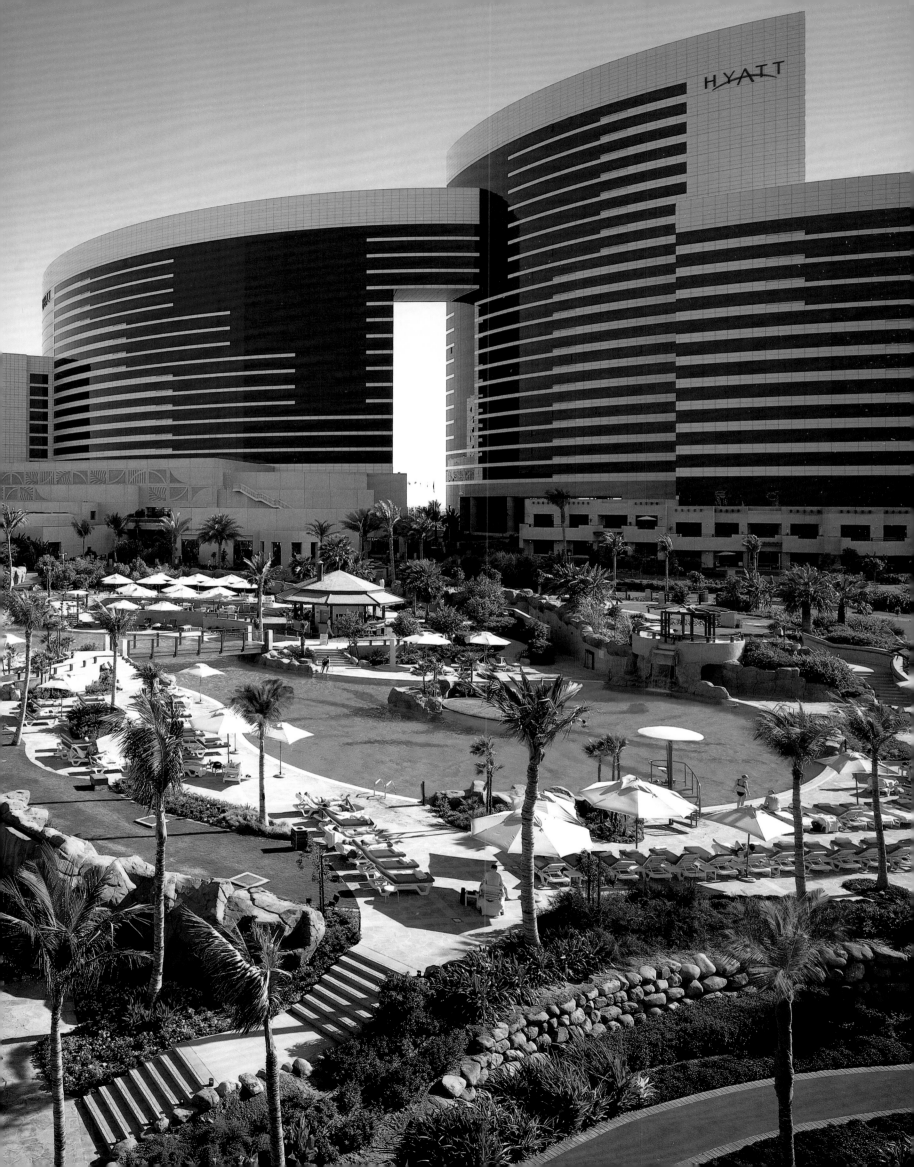

Atkins, Interior Design by KCA International Designers
Burj Al Arab | 1999
Jumeirah Beach Road
Photos: © Courtesy Jumeirah

Ein riesig gespanntes Spinnaker als Fassade auf einer Insel von Menschenhand – vielen gilt das höchste Luxushotel der Welt schon jetzt als eine Ikone der Supermoderne. Im Inneren öffnet sich ein Sesam voller Exklusivität: ein wabenartiges Atrium, Böden pur aus Marmor, dazu luxuriöse Suiten und Angebote. Das ist modern im Stil und doch von orientalischer Originalität.

A huge taut spinnaker as a façade, on a man made island—the tallest luxury hotel in the world is already considered by many as the icon of the ultramodern. Open sesame, and the interior is full of exclusivity, a honeycomb-shaped lobby, marble floors, as well as luxurious suites and offerings. The style is modern coupled with Middle Eastern originality.

Como fachada un imponente spinnaker desplegado sobre una isla artificial. El hotel más alto del mundo se ha convertido para muchos en icono de la súper modernidad. En su interior se abre un tesoro de exclusividad. Un atrio en forma de panal, suelos de puro mármol y suites y propuestas de auténtico lujo. Todo en un estilo moderno, pero embebido en la originalidad oriental.

Avec un énorme spinnaker tendu en façade sur une île construite par les hommes, cet hôtel de luxe, pour beaucoup le plus grand, est déjà considéré comme l'icône du super moderne. L'intérieur s'ouvre sur une véritable caverne d'Ali Baba d'un design raffiné : un atrium en nid d'abeilles, des sols entièrement en marbre ainsi que des somptueuses suites et des offres diverses. Le style est moderne mais garde cependant une originalité arabe.

La facciata, a forma di un enorme spinnaker dispiegato, spicca su un'isola artificiale: già oggi l'hotel di lusso più alto del mondo è considerato da molti l'icona dell'era ultramoderna. All'interno, come in risposta alla formula magica „apriti sesamo", ecco dischiudersi l'apoteosi dell'esclusività: atrio poliedrico, pavimenti esclusivamente in marmo, suite di lusso ed altre offerte prestigiose. All'insegna della sintesi perfetta fra stile moderno ed originalità orientale.

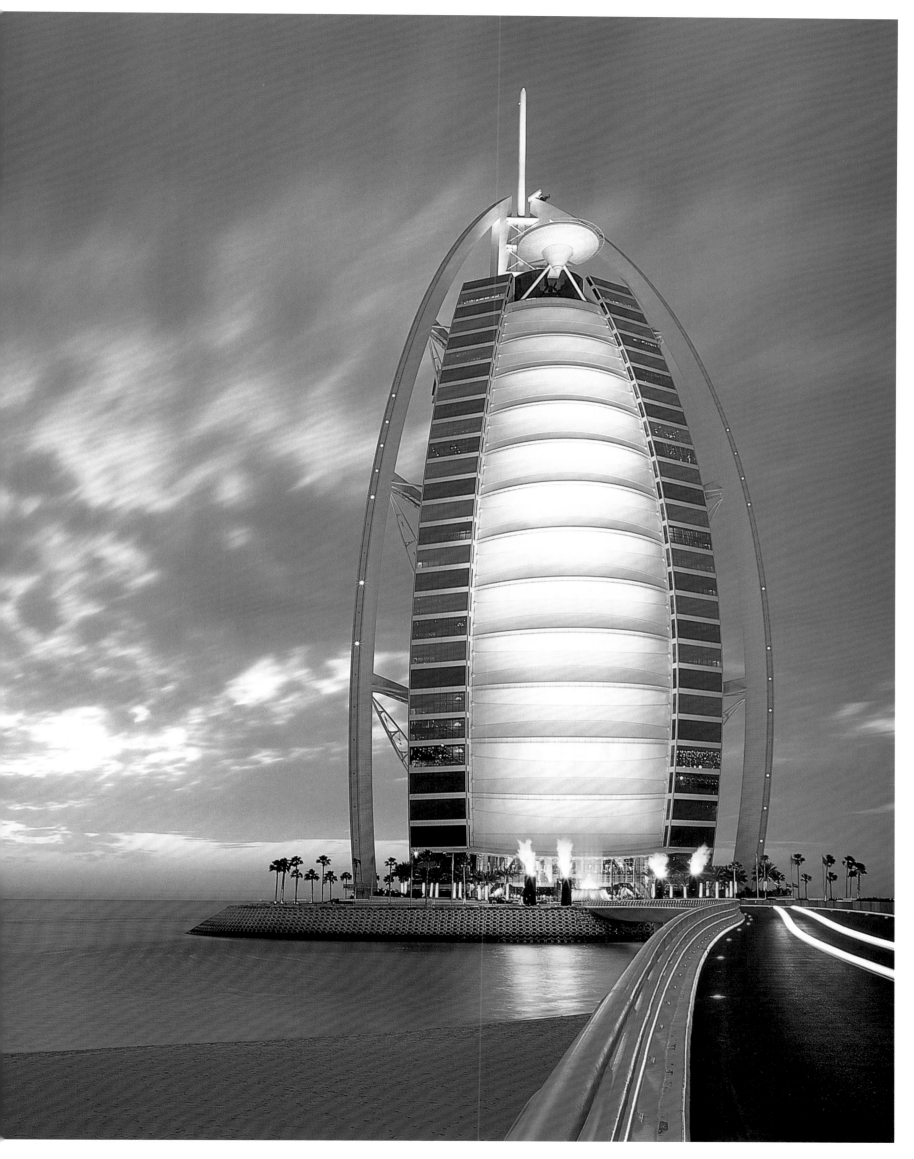

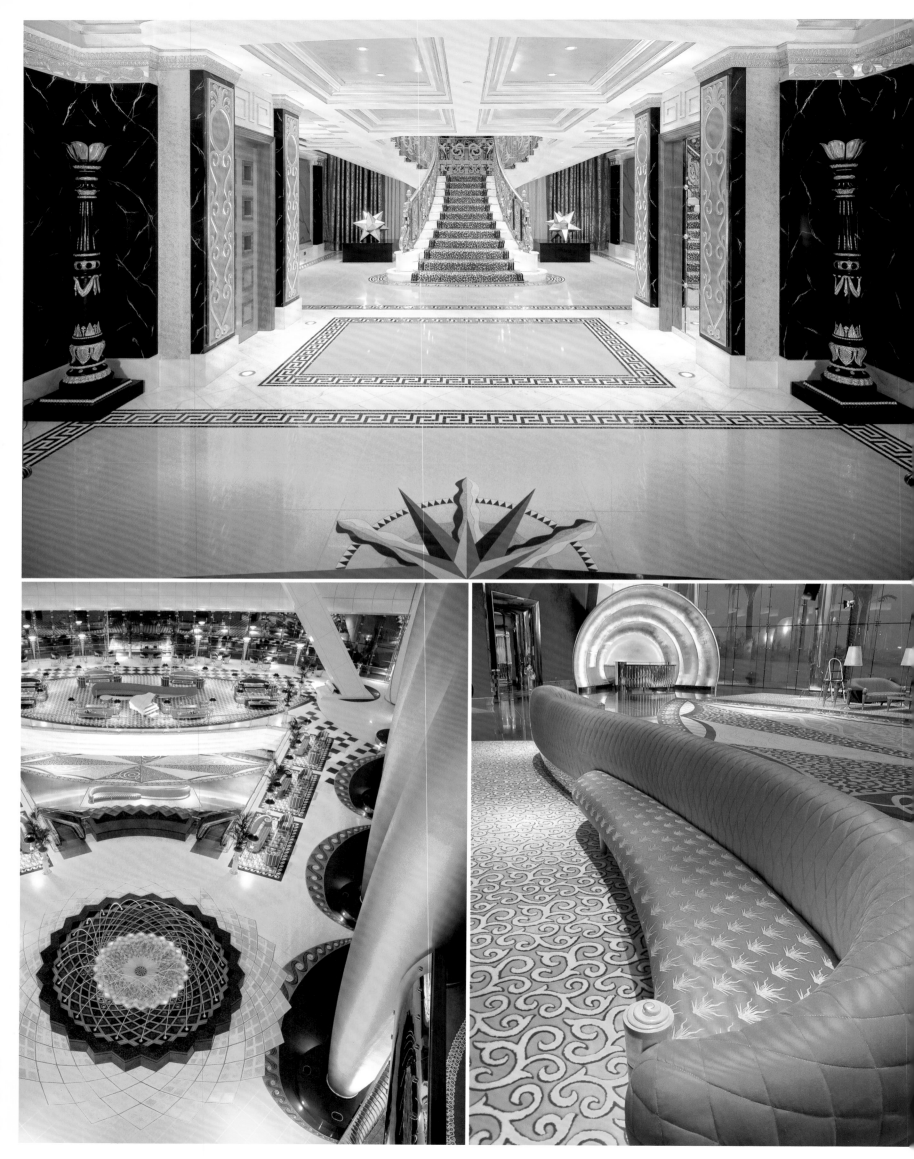

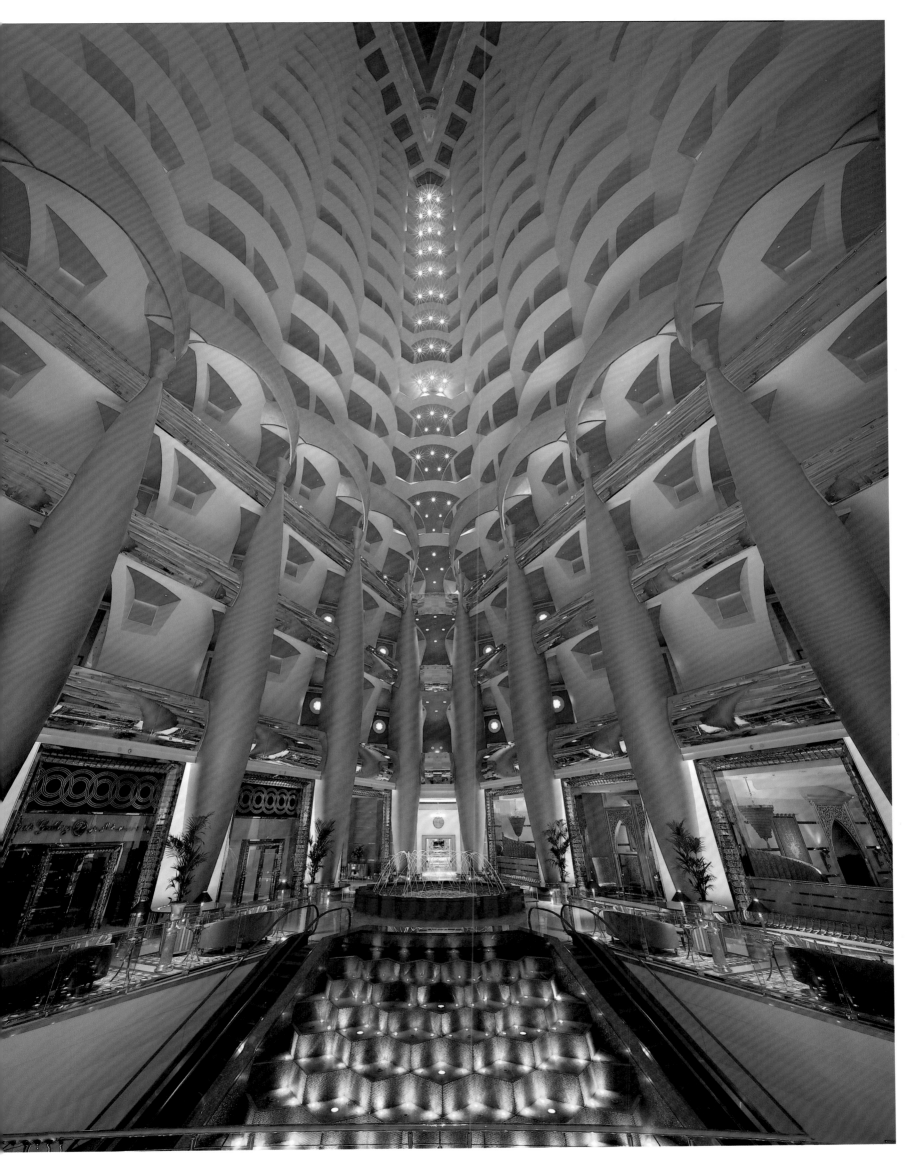

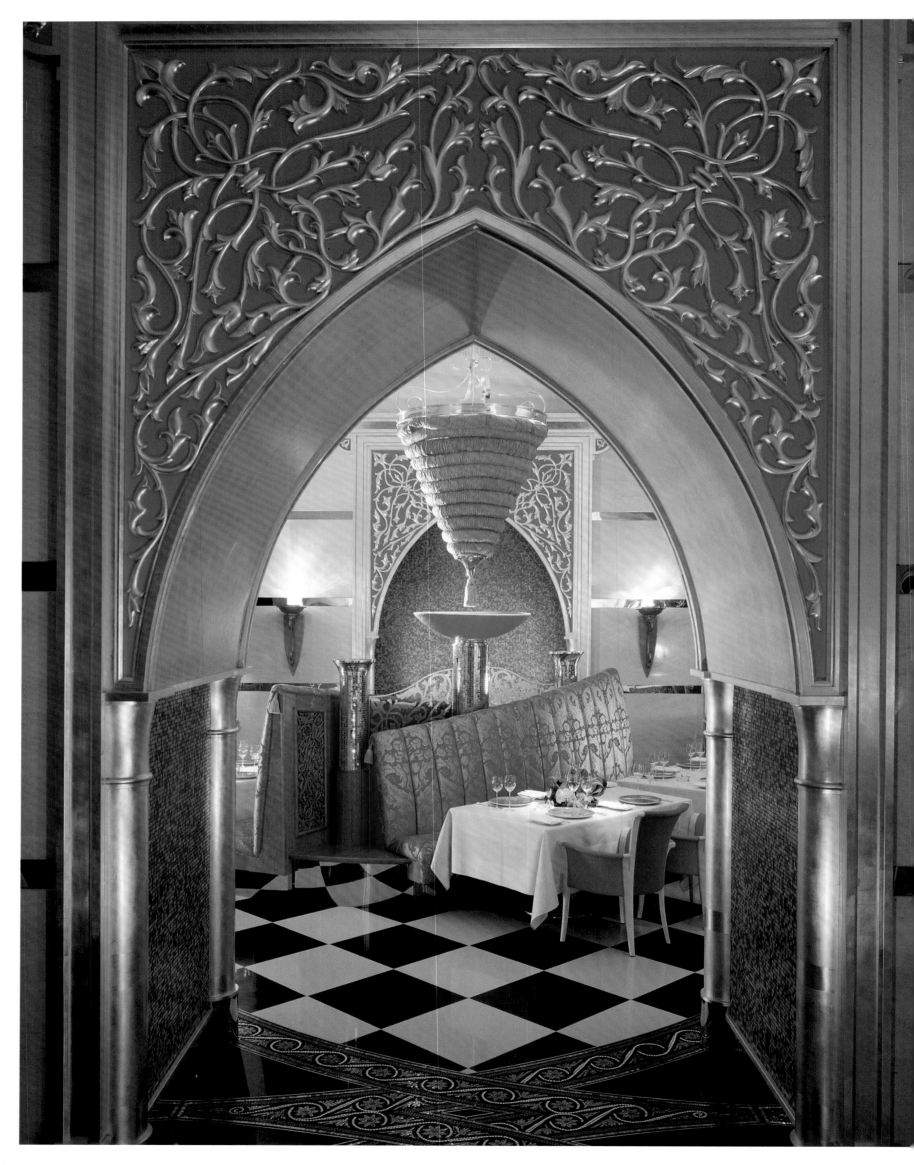

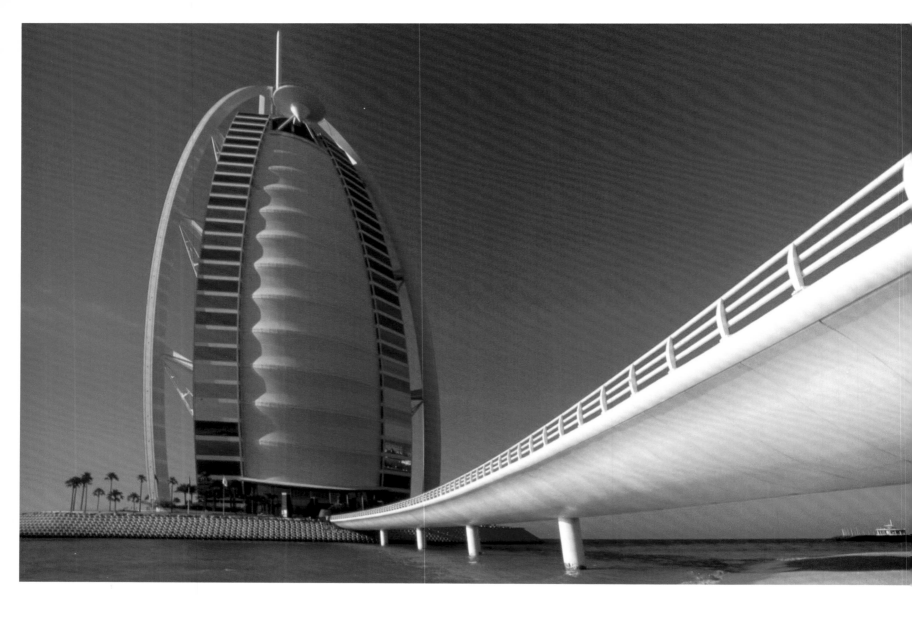

Atkins
Al Mas | 2006
Jumeirah Lakes Development
Photos: © Courtesy W S Atkins

Zwei ovale, sich überlappende Glastürme bestimmen die Silhouette dieses im Bau befindlichen Hochhauses. Als Hauptgebäude eines geplanten Zentrums am Jumeirah See wird es die Diamantenbörse beherbergen. Folglich dominieren edelsteinartige Elemente die Formgebung, beginnend beim Sockel und fortgesetzt in der Präzision und Eleganz der beiden Türme.

Two overlapping oval-shaped glass towers characterize the silhouette of this skyscraper that is still under construction. As the main building of a planned center near the Jumeirah Lake, it will house the Diamond Exchange. Consequently, the shape is dominated by gem-like elements from its the base to the precision and elegance of both towers.

Dos torres de vidrio ovales imbricadas definen la silueta de este rascacielos en construcción. Será el edificio principal de un centro destinado a albergar la bolsa de diamantes, junto al lago de Jumeirah. De ahí que la forma esté dominada por elementos a modo de joyas, comenzando por el zócalo y culminando con la precisión y elegancia de las torres.

Deux tours ovales qui se chevauchent définissent la silhouette de ce bâtiment en construction. En tant que bâtiment principal d'un centre prévu au bord du lac Jameirah, il abritera la bourse aux diamants. Le ton de l'ensemble architectural est donc donné par des éléments qui rappellent des pierres précieuses, comme le socle ainsi que la précision et l'élégance des deux tours.

La silhouette di questo grattacielo tuttora in costruzione è definita dall'intersecazione di due torri ovali in vetro. Edificio principale di un nuovo centro che nascerà sul lago Jumeirah, esso è destinato ad ospitare la Borsa dei diamanti. Questa funzione si rispecchia nella predominanza di elementi che ricordano gemme preziose e che sottolineano le forme estetiche dell'edificio, a partire dalla base per confluire nella precisione e nell'eleganza delle due torri.

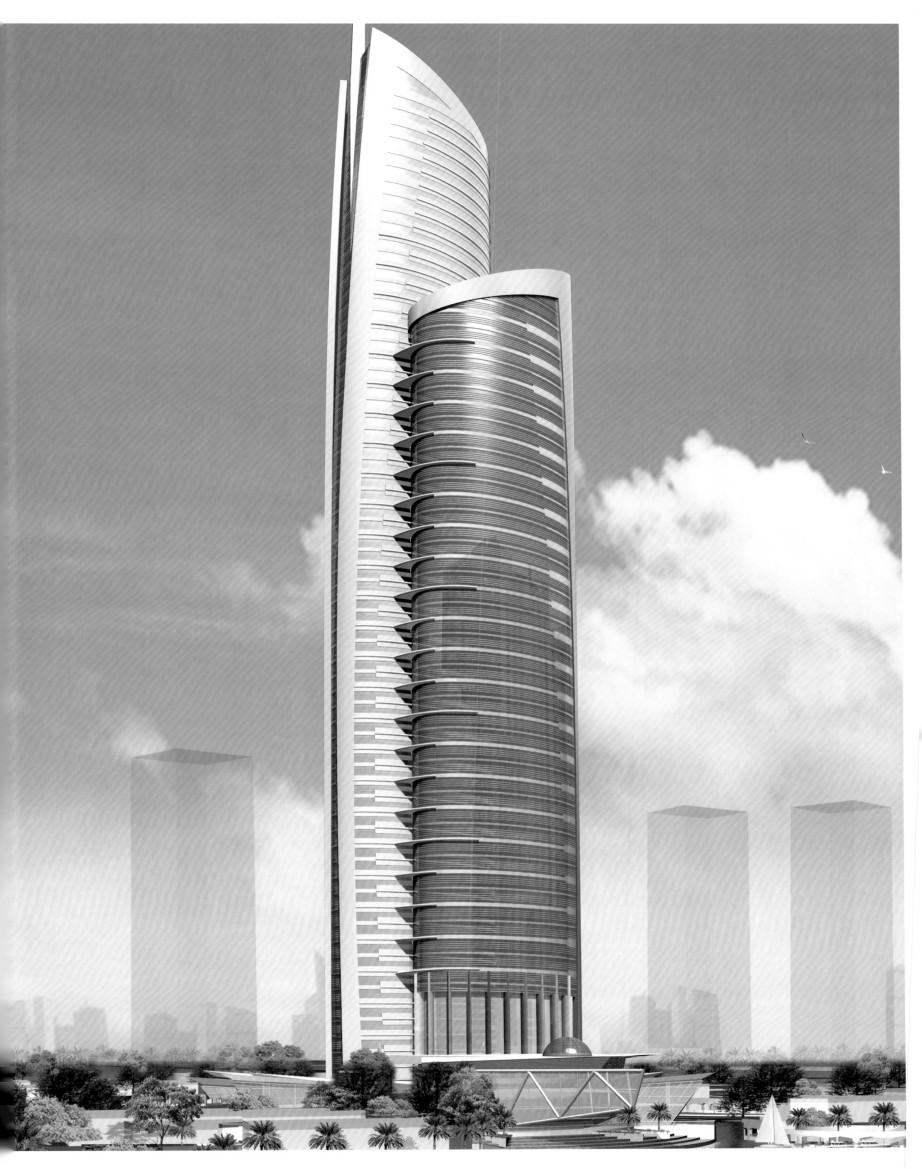

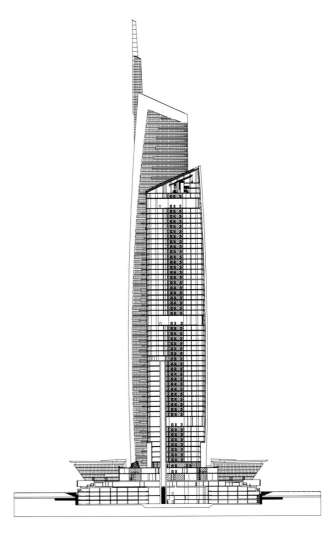

27

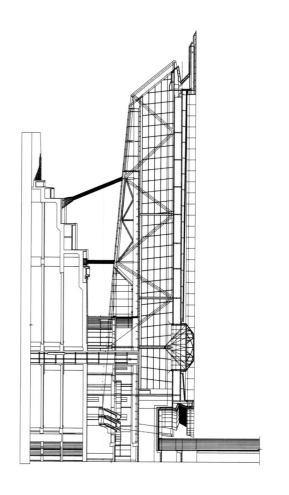

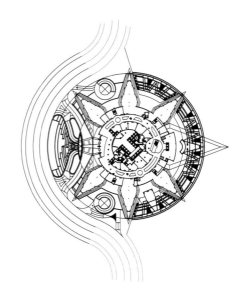

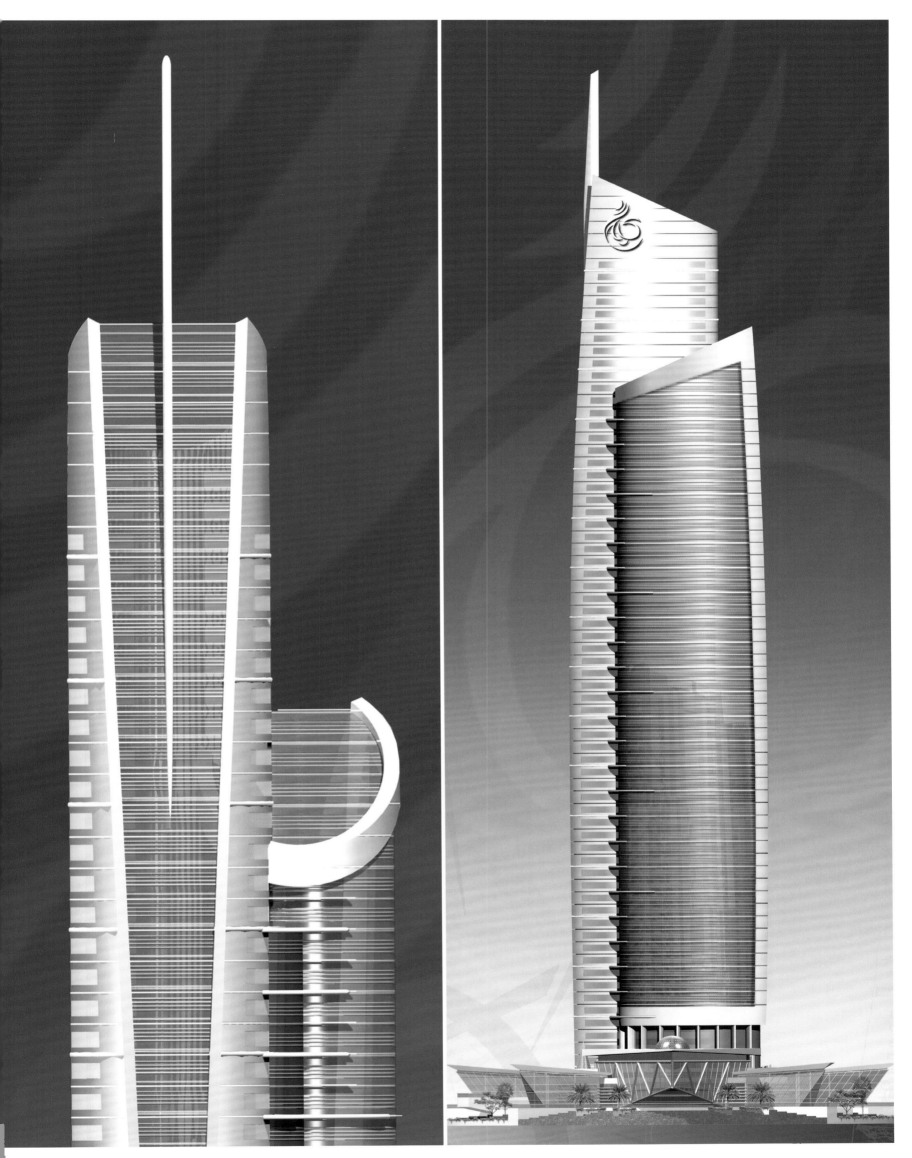

Atkins
Bright Start Tower | 2006
Sheikh Zayed Road
Photos: © Courtesy W S Atkins

Als ein „leuchtendes" Wahrzeichen der Stadt entsteht mit 59 Stockwerken der (vorerst) höchste Wohnturm der Welt. Seine Grundform: zwei schlanke, nahezu eins werdende Quader, die sich umklammern. Der markante Abschluss der Spitze betont dazu die symmetrische Komposition. Dank der leichten Materialien erscheint der Gigant aber wie eine schwerelose Hülle für komfortables Wohnen.

The world's currently highest apartment tower of 59 floors is being built as an "illuminated" landmark of the city. Its basic shape is of two clasped stone blocks nearly merging into one. The unique top part of the tip emphasizes the symmetrical composition. Because of the light materials used, the tower looks like a weightless wrap enclosing comfortable living space.

Como un emblema "resplandeciente" de la ciudad se levanta este edificio de 59 plantas, hasta el momento el mayor rascacielos de viviendas del mundo. Su estructura básica está constituida por dos bloques estrechos entrelazados que parecen fundirse en un sólo paralelepípedo; a ello se une una marcada cúspide que realza la simétrica composición. Los materiales ligeros con los que ha sido construido este gigante le dotan de una apariencia de cubierta ingrávida envolviendo confortables viviendas.

Le plus haut (pour le moment) immeuble d'habitations du monde qui s'élève avec ses 59 mètres est comme un véritable emblème « lumineux » de la ville. Sa forme de base est constituée par deux volumes élancés presque parallélépipédiques qui s'imbriquent l'un dans l'autre. La forme remarquable de la pointe accentue la composition symétrique. Le géant apparaît pourtant, grâce à la légèreté des matériaux, comme une enveloppe flottante qui abrite de confortables appartements.

Vero emblema "splendente" della città, il Bright Start Tower, con i suoi 59 piani, è (per il momento) il più grande grattacielo residenziale del mondo. La sua forma di base: due snelli parallelepipedi, avvinghiati quasi a formare un'unica struttura. La parte slanciata dell'estremità finale sottolinea la composizione simmetrica. I materiali leggeri conferiscono a questo gigante le sembianze di un involucro privo di gravità all'insegna dell'abitare confortevole.

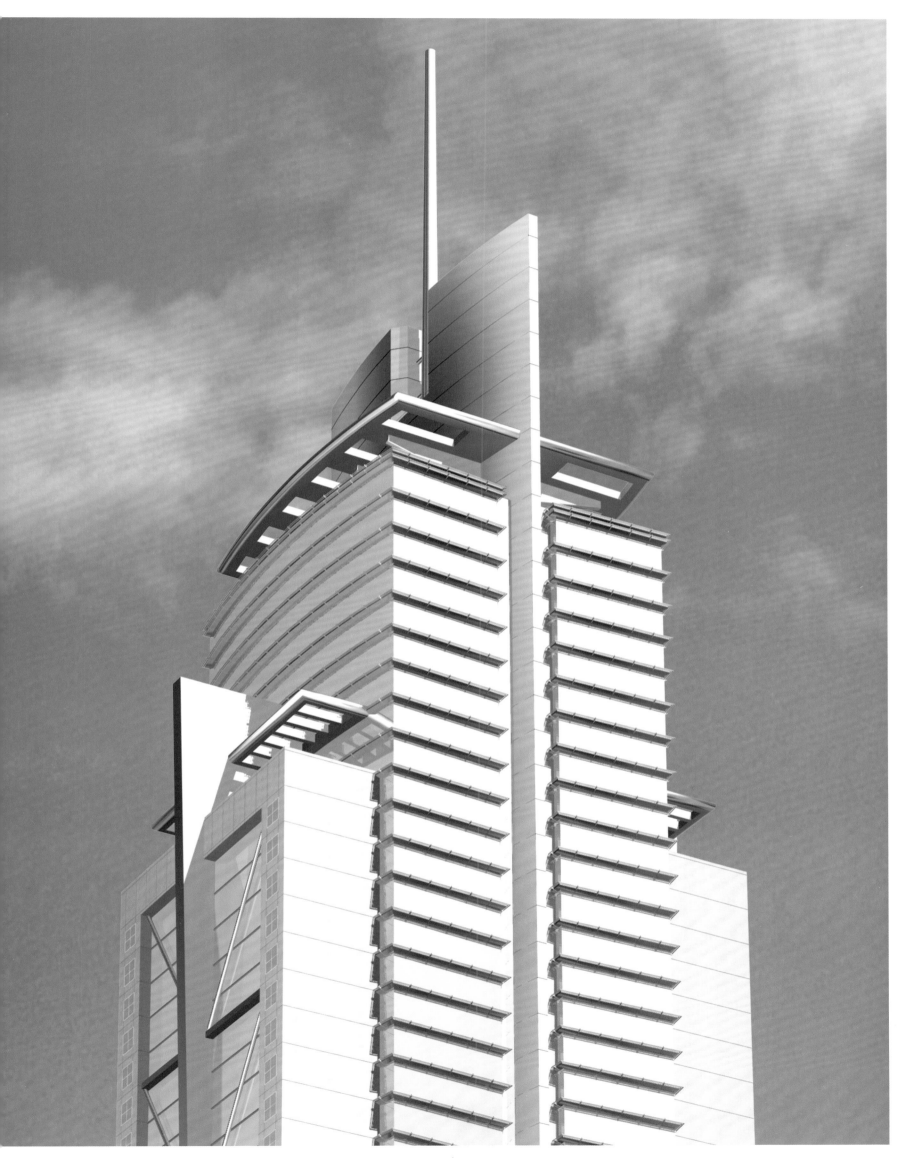

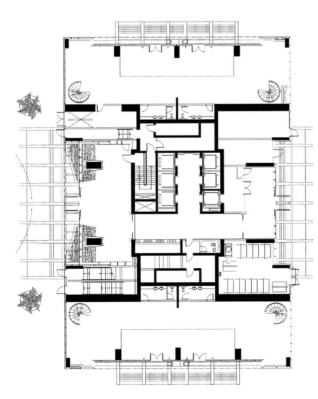

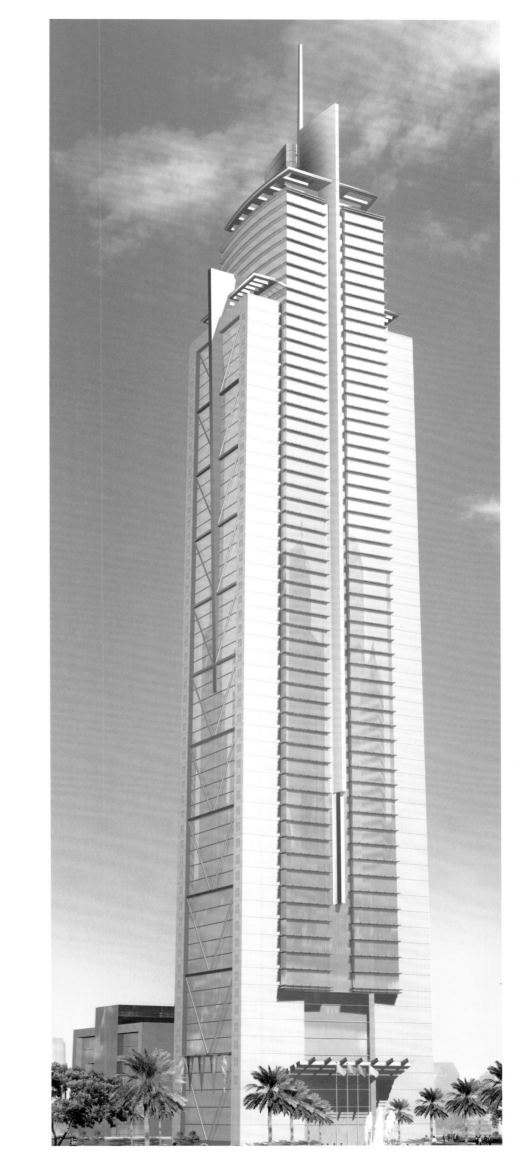

Atkins
Chelsea Tower | 2005
Sheikh Zayed Road
Photos: © Courtesy W S Atkins

251 Meter hoch erstreckt sich dieser Wohntower, der zu den Glanzstücken in Dubais Zentrum zählt. Die gerahmte Spitze fängt sinn-fällig ein Stück Himmel ein. Musische Empfindungen löst die Fassade aus grauem und blauem Glas aus, die einem Klavier zu ähneln scheint. Auch mehr als nur schöner Schein: der mit Palmen umsäumte Pool zu Füßen des Komplexes.

Stretching 251 meters into the sky, this apartment tower is one of the highlights of Dubai's center. The framed tip clearly touches a piece of the sky. The gray and blue glass façade, resembling a piano, causes artistic sensations. The pool surrounded by palms at the foot of the complex is also more than a mere beautiful sight.

Esta torre de viviendas de 251 metros de altura es una de las estrellas de Dubai. La enmarcada cúspide parece hacerse con un trozo de cielo. La fachada revestida de vidrio gris y azul parecida a un piano da rienda suelta a la inspiración. Aún más que pura belleza es la piscina rodeada de palmeras a los pies del complejo.

Cette tour d'habitations qui se dresse avec ses 251 étages compte parmi les joyaux du centre de Dubaï. Le cadre de la pointe semble littéralement attraper un morceau de ciel. La façade artistiquement conçue en verre gris et bleu ressemble à un piano.

Con i suoi 251 metri il grattacielo residenziale Chelsea Tower si staglia all'orizzonte mostrandosi in tutta la sua altezza come una delle strutture più rappresentative del centro di Dubai. La struttura sovrastante che corona l'estremità appuntita sembra voler incorniciare un pezzo di cielo. La facciata in vetro blu e grigio, dall'aspetto simile alla tastiera di un pianoforte, fa esplodere le sensazioni musicali più nascoste. Molto più di un semplice effetto ottico: la piscina circondata da palme ai piedi del complesso.

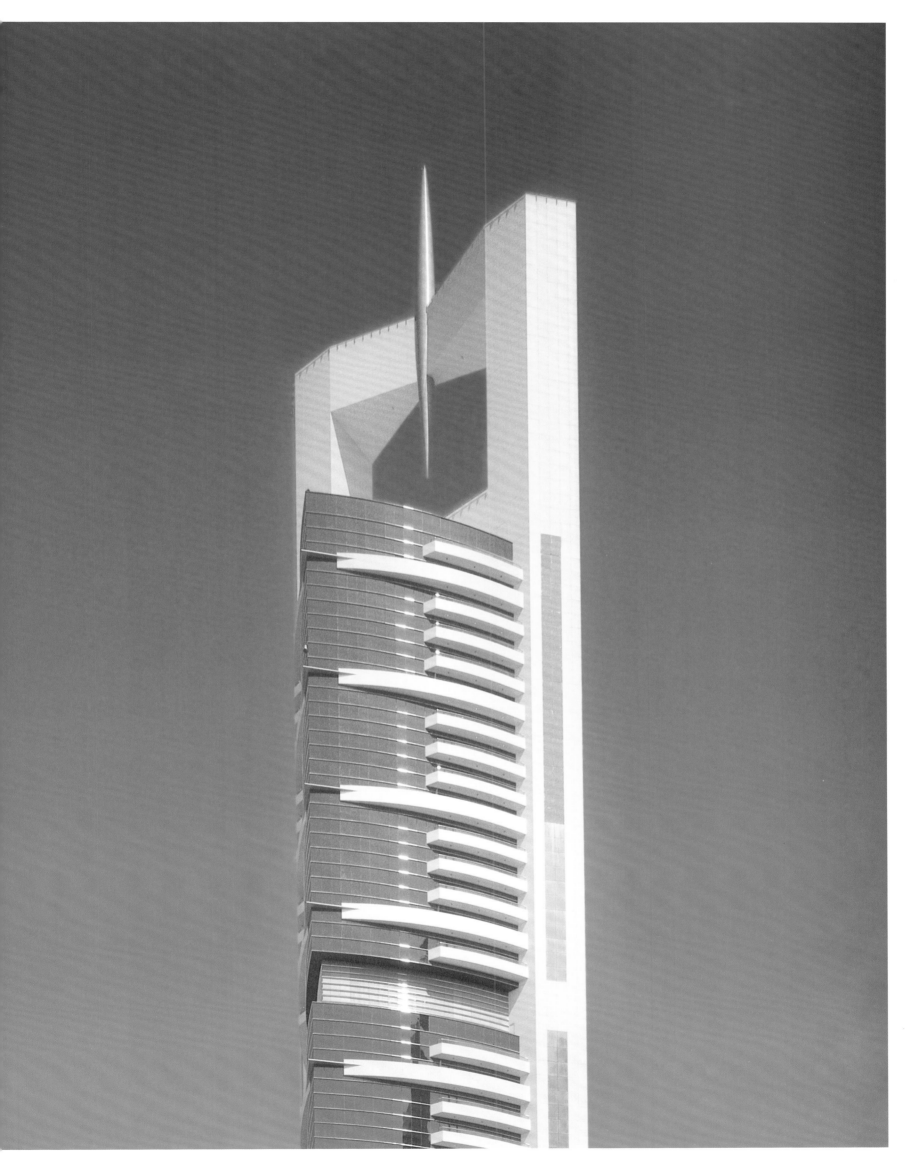

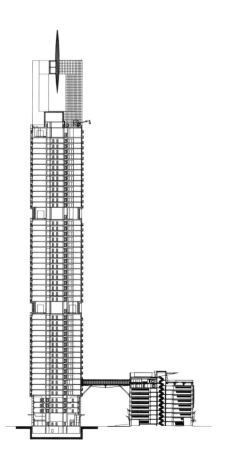

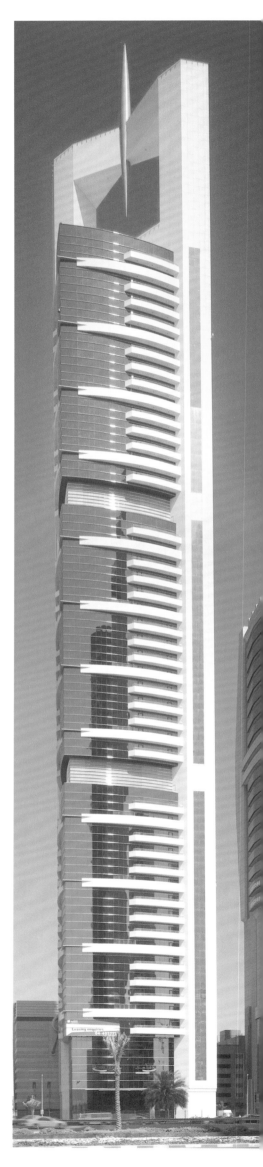

Concept Design by Chapman Taylor,
Detailed Design, Engineering and Supervision by Dewan Architects & Engineers
Pearl Dubai | 2008
Dubai Internet City, Al Sufouh Road
Photos: © Courtesy Dubai Pearl Inc.

Während sich nur unweit die Insellandschaft „Palm Island Jumeirah" ins Meer zeichnet, wächst inmitten von Media-City und Technologiepark ein ganz eigenes Stadtgebilde: neun Wohn- und Hoteltürme, die sich wie ein mit Perlen besetzter Ring im Kreis versammeln. Schmuckstücke darin: Die Royal Hall als Konzerthaus, eine Kunstgalerie und diverse Showcases für Hochtechnologie.

In close proximity to the island landscape "Palm Island Jumeirah" in the sea, a unique city structure is growing in the midst of Media City and technology park. The nine residential and hotel towers are arranged in a circle like a ring studded with pearls. Precious highlights inside it are the Royal Hall as a concert hall, an art exhibition, and various showcases for high technology products.

A poca distancia, el entorno paisajístico de la isla "Palm Island Jumeirah" dibujando el mar, mientras que en medio de la Media-City y el parque tecnológico se abre a la vista otra figura de la ciudad: nueve torres de viviendas y hoteles reunidas como si de un anillo de perlas se tratase. Su interior esconde verdaderas joyas: la Royal Hall como sala de conciertos, una galería de arte y varios expositores de alta tecnología.

Alors qu'à seulement quelque distance de là, le paysage insulaire de « Palm Island Jumeirah » se dessine dans la mer, un ensemble urbain s'élève en plein milieu de la Media City et du parc technologique : des tours d'habitations et d'hôtels se dressent en cercle comme une bague incrustée de perles. Et à l'intérieur se trouvent de véritables bijoux comme la salle de concert du Royal Hall, une galerie d'art et diverses vitrines pour technologie de pointe.

Mentre non troppo lontano il profilo dell'arcipelago "Palm Island Jumeirah" si delinea in mare, nel cuore di Dubai Media City e del parco tecnologico cresce un tessuto urbano del tutto particolare, formato da nove grattacieli residenziali e alberghieri disposti circolarmente come perle incastonate in un anello. Le gemme più preziose: il palazzo dei concerti Royal Hall, una galleria d'arte e diversi esempi "vetrina" di alta tecnologia.

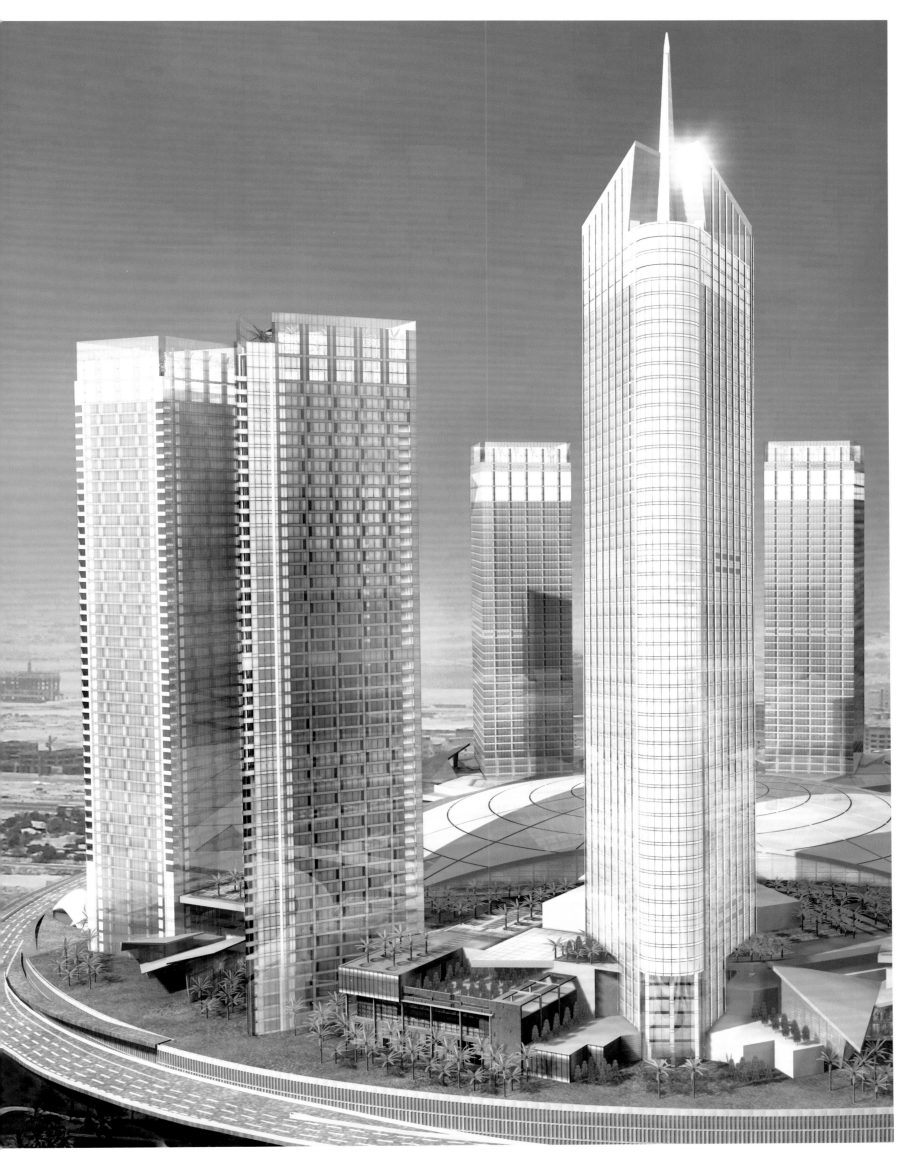

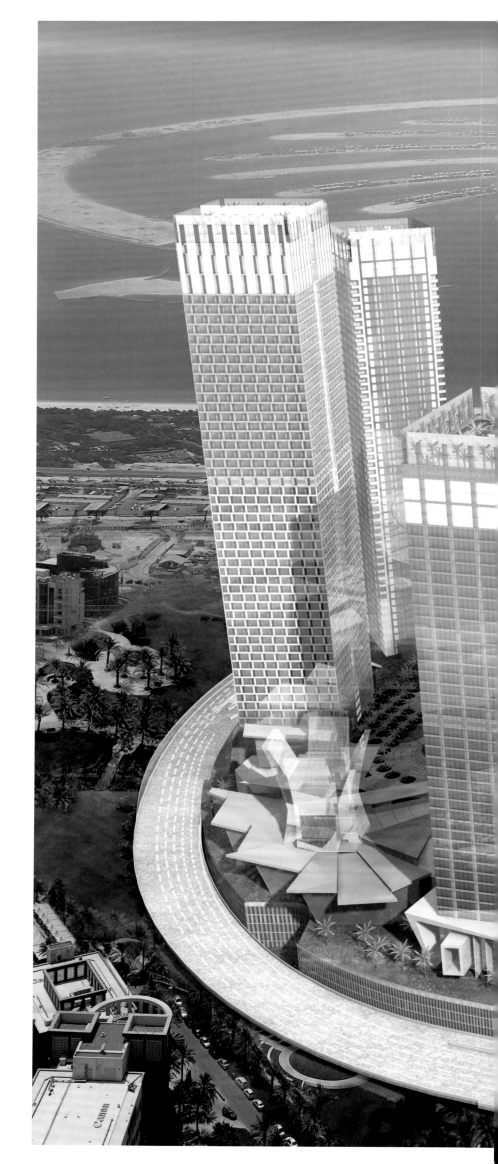

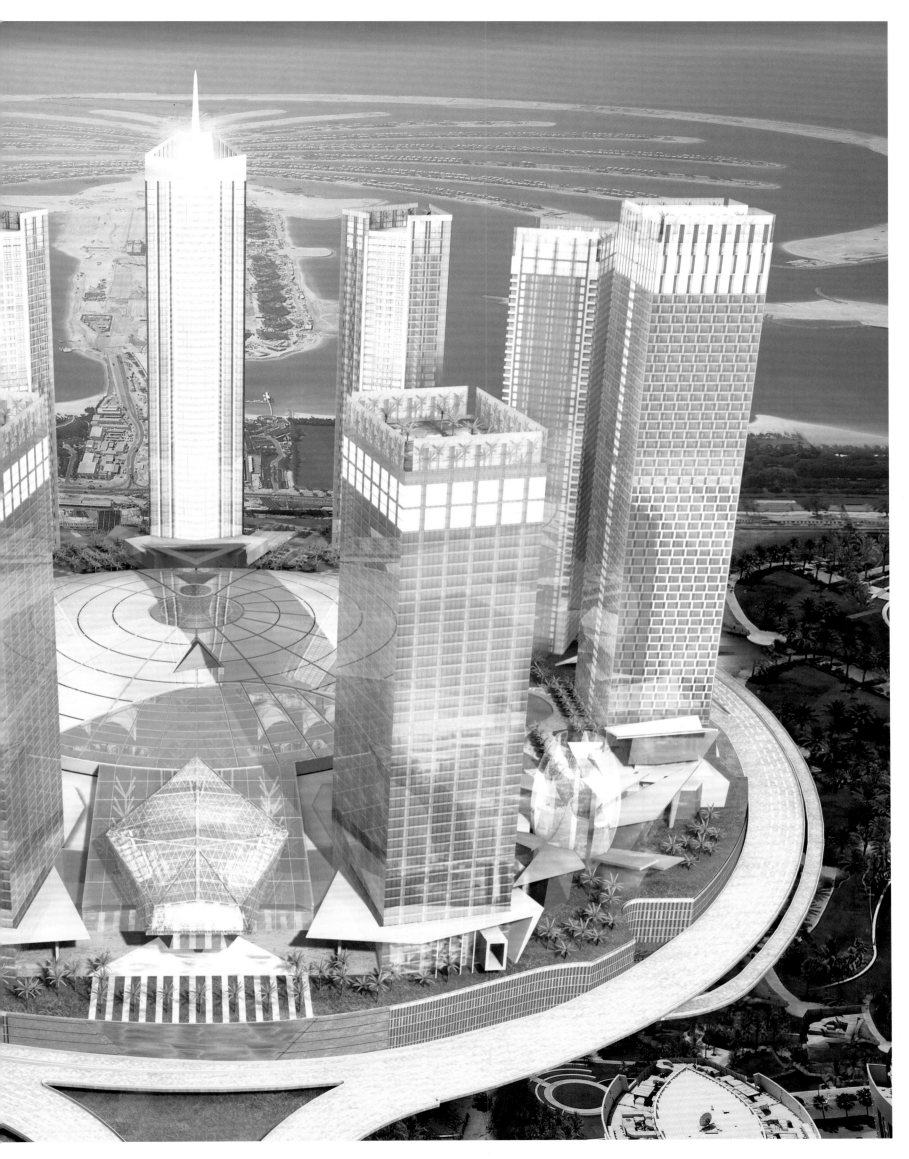

Creative Kingdom, Wilson & Associates
Park Hyatt | 2005
Al Garhound Road
Photos: © Richard Butterfield

Quasi ein Geheimtipp. Denn das Luxushotel „versteckt" sich auf dem Gelände des „Creek Golfclubs". Doch statt „Members only" bedeutet es nur: eine gut gewählte Oase der Ruhe. Hinter dem Entree mit Kuppel öffnet sich eine exklusive Welt: 225 komfortable Zimmer etwa mit offenen Bädern. Lage von Terrassen und Balkonen bieten zudem herrliche Sicht auf den Yachthafen.

Practically an insider tip, as the luxury hotel is "hidden" on the premises of the "Creek Golf Club". However, instead of being restricted to "members only" it offers a well-chosen oasis of peace. Behind the lobby with its cupola roof, doors open to an exclusive world, consisting for example of 225 comfortable rooms with open bathrooms. In addition, the positioning of terraces and balconies offers a wonderful view of the yacht harbor.

Bien se podría decir que se trata de una exclusividad para unos pocos, ya que este hotel de lujo se esconde en el terreno del "Creek Golfclubs". Pero su „Members only" viene a decir simplemente: oasis de tranquilidad escogido. Tras una entrada con cúpula se abre un universo de exclusividad: 225 confortables habitaciones con baños abiertos y una ubicación de las terrazas y balcones con magníficas vistas al puerto deportivo.

C'est quasiment un secret de connaisseurs. En effet l'hôtel de luxe « se cache » dans le parc du «club de golf Creek ». Cependant à la place de « members only », on trouve là simplement un oasis de paix d'un goût parfait. Derrière l'entrée à coupole s'ouvre un monde de raffinement : à peu près 225 chambres confortables avec salles de bain ouvertes. L'agencement des terrasses et balcons procure de surcroît une vue magnifique sur le port de plaisance.

Una soffiata, per così dire. Sì, perché l'hotel di lusso Park Hyatt pare quasi nascosto strategicamente sul terreno del „Creek Golfclub". E questo non vuol dire „Members only", quanto piuttosto: un'oasi di pace nella sua ideale ubicazione. Dietro l'ingresso a cupola si apre un mondo all'insegna dell'esclusività: 225 stanze dotate di tutti i comfort, come ad esempio bagni aperti. Dalle verande e dai balconi è possibile godere di una splendida vista sul porto di yacht.

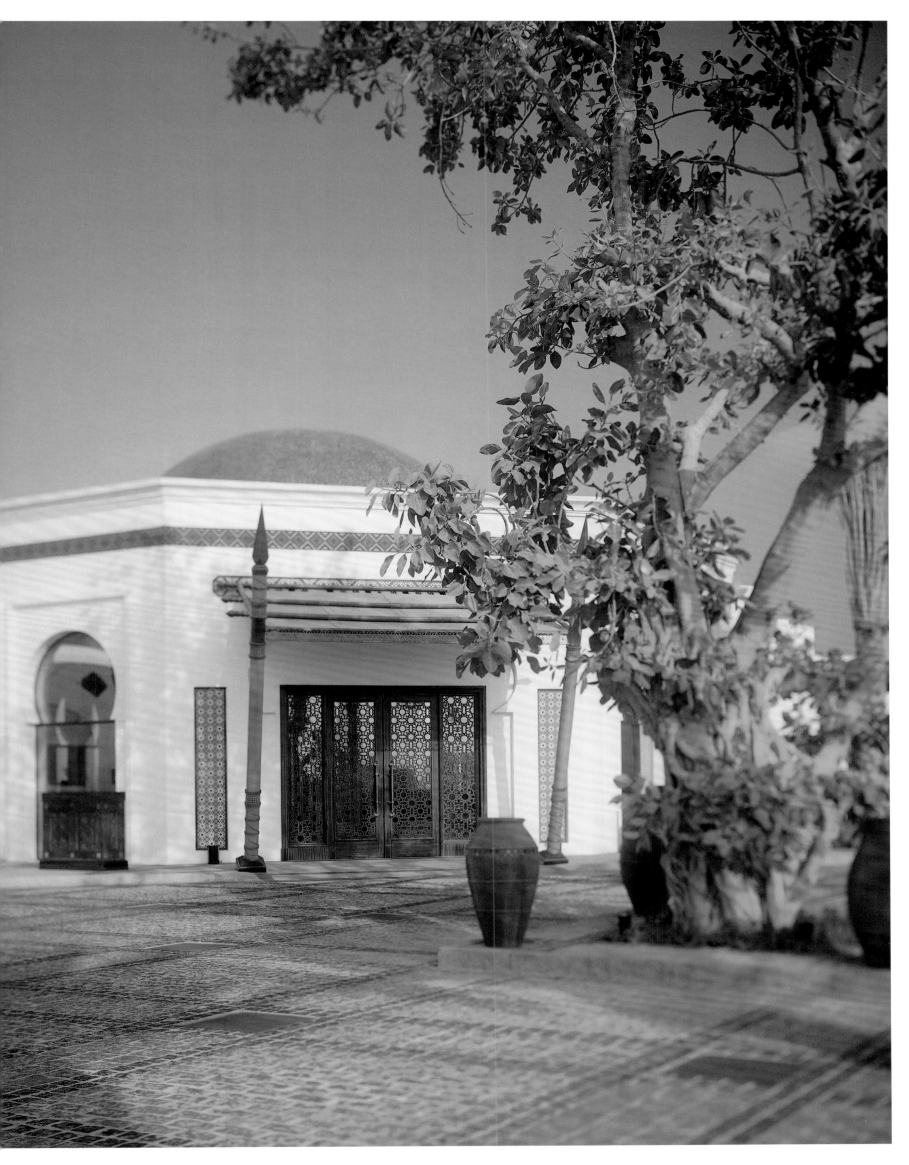

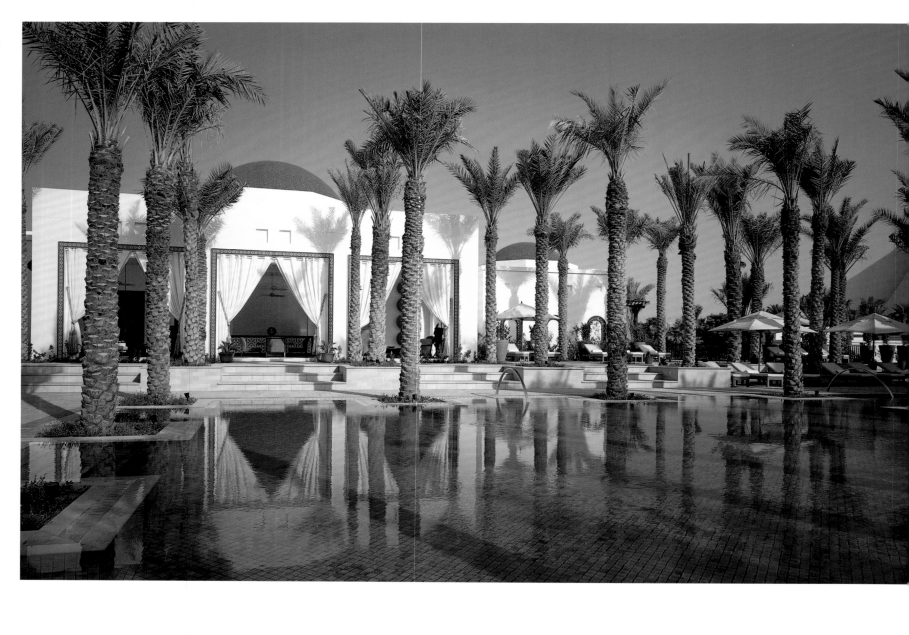

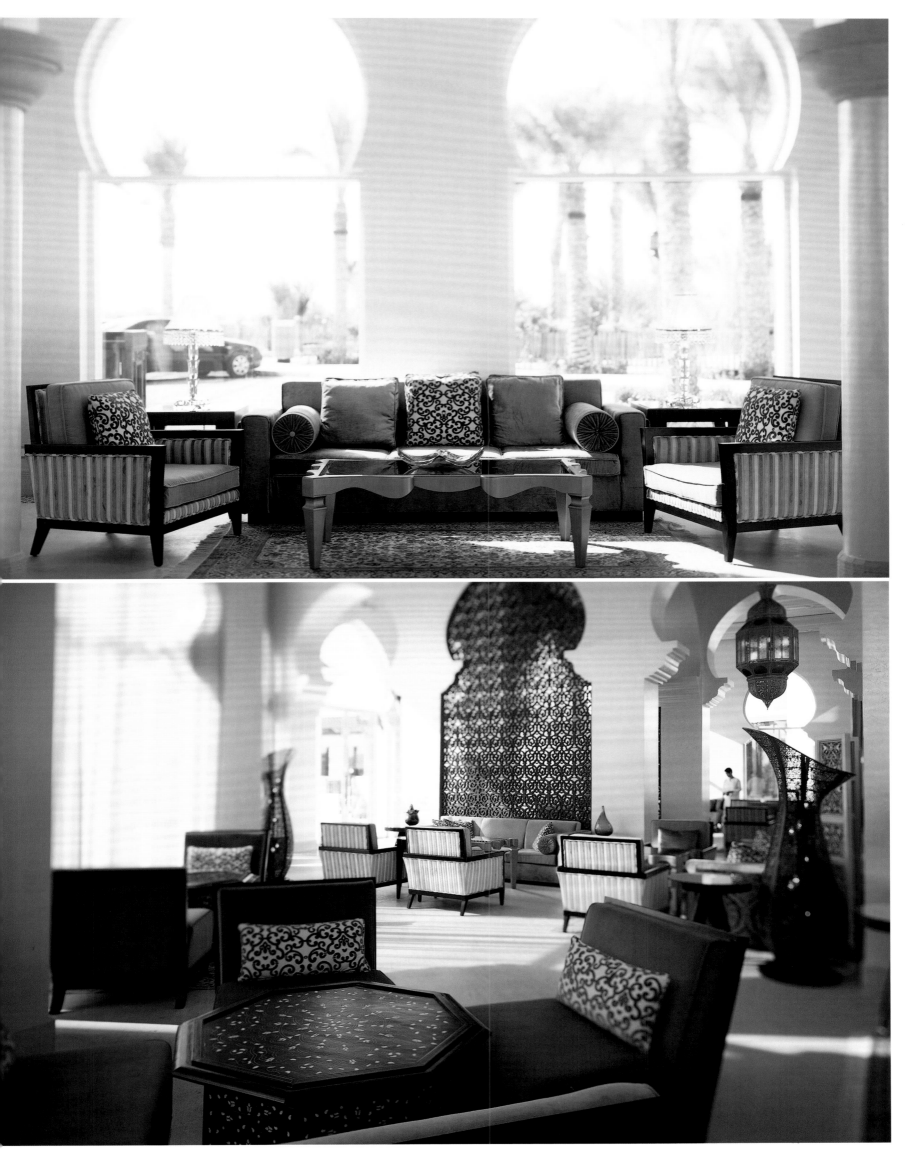

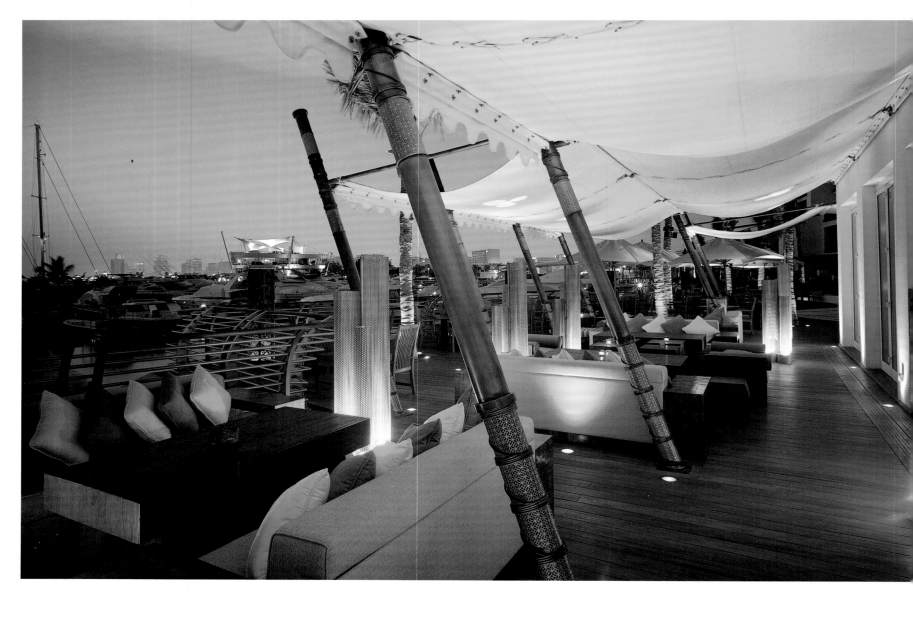

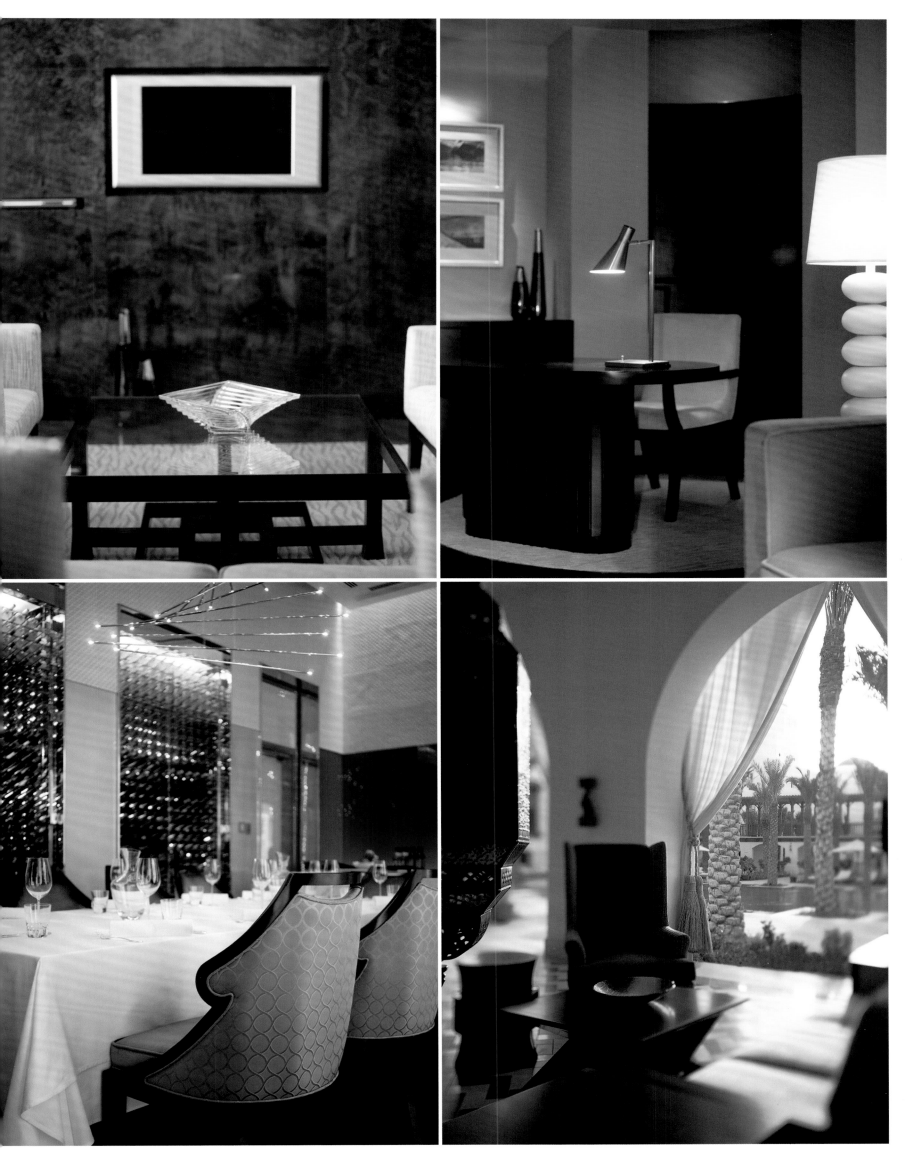

Creative Kingdom, KCA International Designers
Madinat Jumeirah | 2004
Al Sufouh Road
Photos: © Martin Nicholas Kunz, Roland Bauer

Wer den Glanz des alten Arabiens wieder aufscheinen sehen möchte, in diesem Mega-Resort findet er es grenzenlos. Die kleinstädtische Anlage mit diversen Hotels, Villen, Basar, Wasserläufen und einer Palastresidenz spiegelt gedrängt die kulturelle Überlieferung des Orients: verschlungene Pfade, Windtürme, reich verzierte Fassaden und jede Menge authentischer Prunk dahinter.

Those who want to see the lustrous revival of old Arabia, will discover it in this ultra resort in abundance. This compound is a small town, with its diverse hotels, villas, bazaars, waterways, and a residential palace. It densely mirrors the cultural traditions of the Orient of engulfed paths, wind towers, richly decorated façades and plenty of authentic grandiosity to match.

Quienes deseen percibir de nuevo el resplandor de la antigua Arabia lo encontraran sin medida en este gigantesco resort. Una pequeña ciudad con diversos hoteles, villas, bazar, cascadas y una residencia palaciega que transmiten la herencia cultural de Oriente a través de senderos serpenteantes, minaretes, fachadas ricamente decoradas y todo un derroche de esplendor.

Celui qui désire revoir encore l'éclat de la vieille Arabie briller de tous ses feux, pourra le trouver à l'infini dans cette immense station touristique. L'aménagement, qui ressemble à celui d'une petite ville avec divers hôtels, villas, bazar, cours d'eau et un palais résidentiel reflète de façon concise l'héritage culturel de l'Orient : des petites rues tortueuses, des tours à vent, des façades richement décorées et beaucoup de luxe ostentatoire qui se cache derrière.

Chi invece preferisce lo splendore dell'antica Arabia, ne troverà l'esaltazione massima in questo mega resort. Come una piccola città nella città, il lussuosissimo impianto con diversi hotel, ville, bazar, corsi d'acqua e un palazzo residenziale è la sintesi concisa della tradizione culturale dell'Oriente: stradine tortuose, torri del vento e facciate opulente dietro le quali si cela un tripudio di autentico sfarzo.

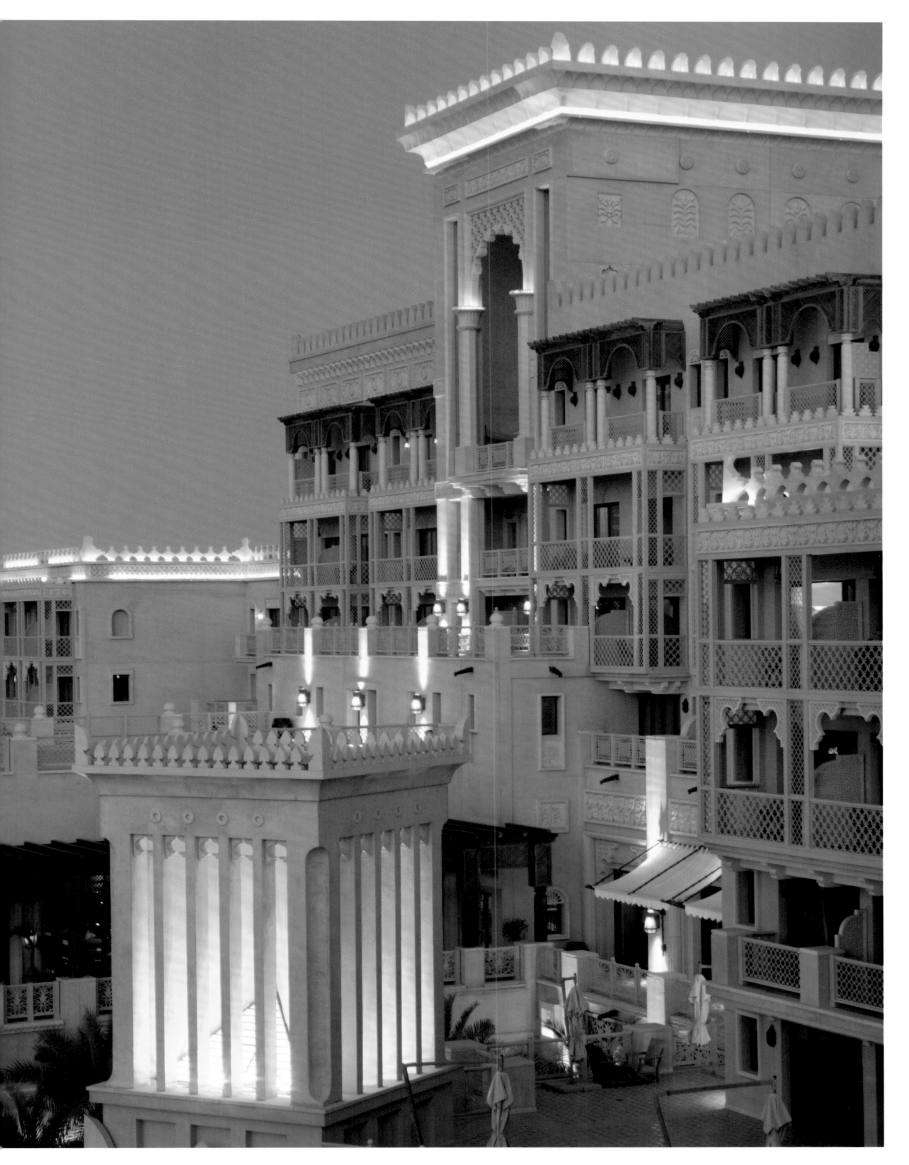

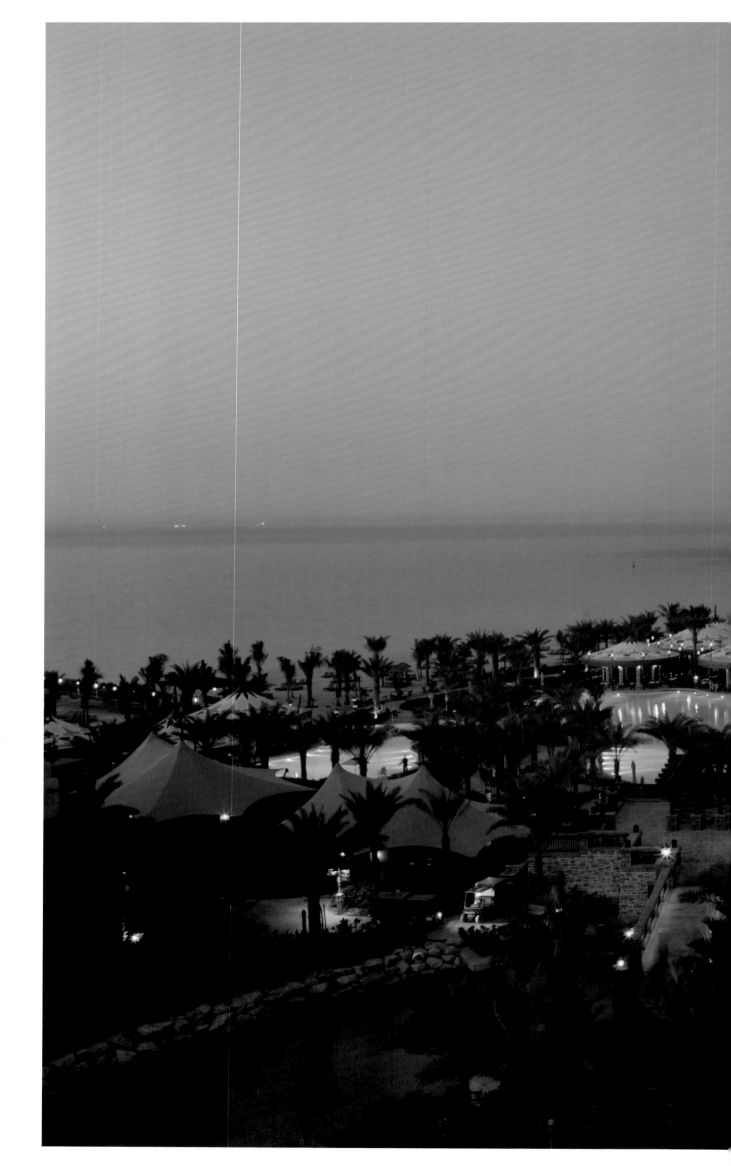

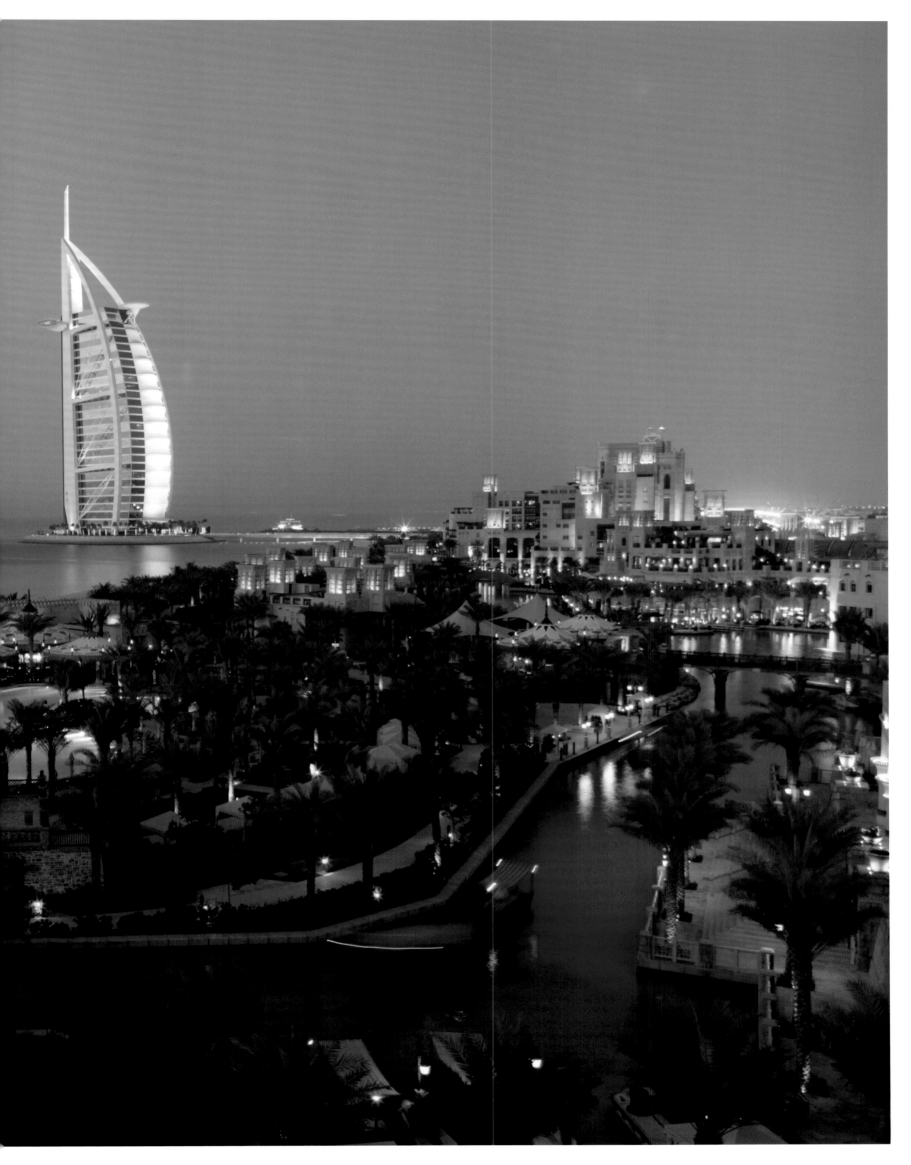

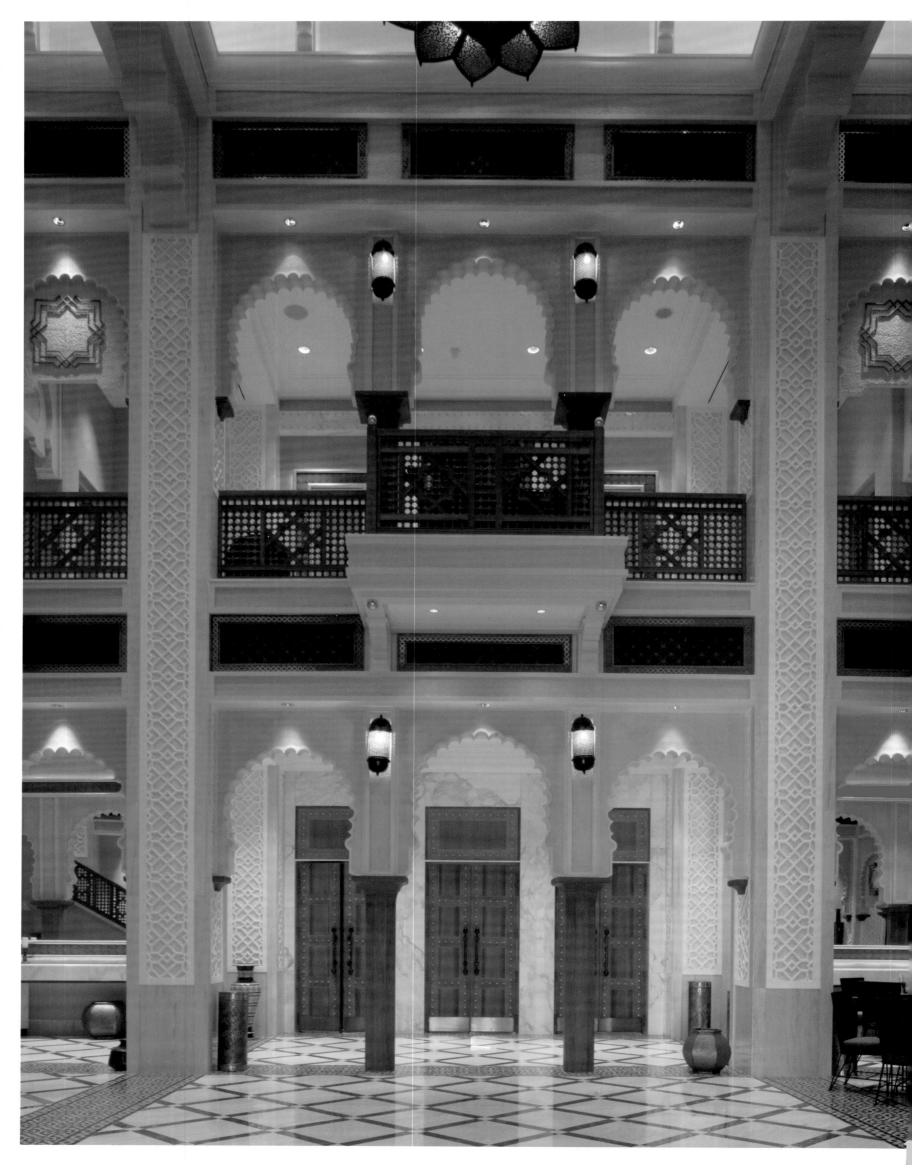

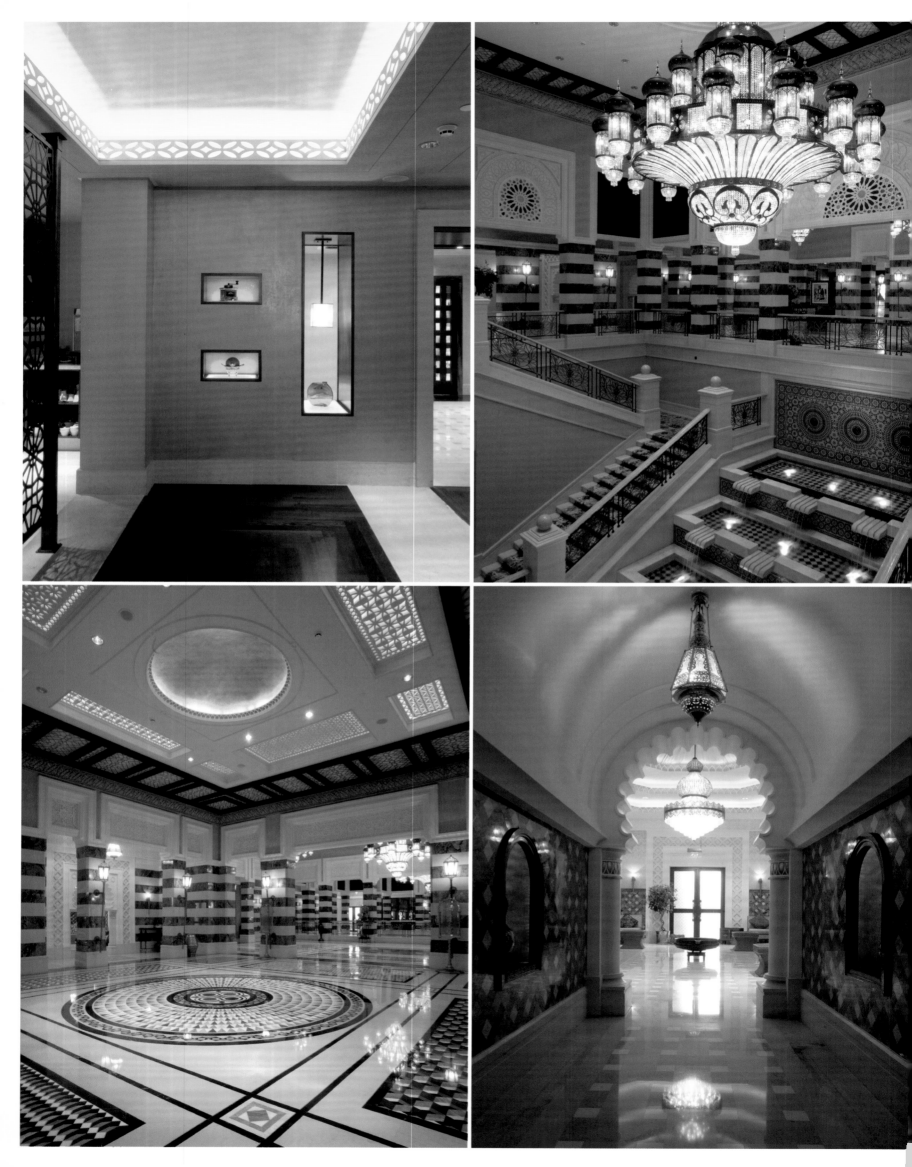

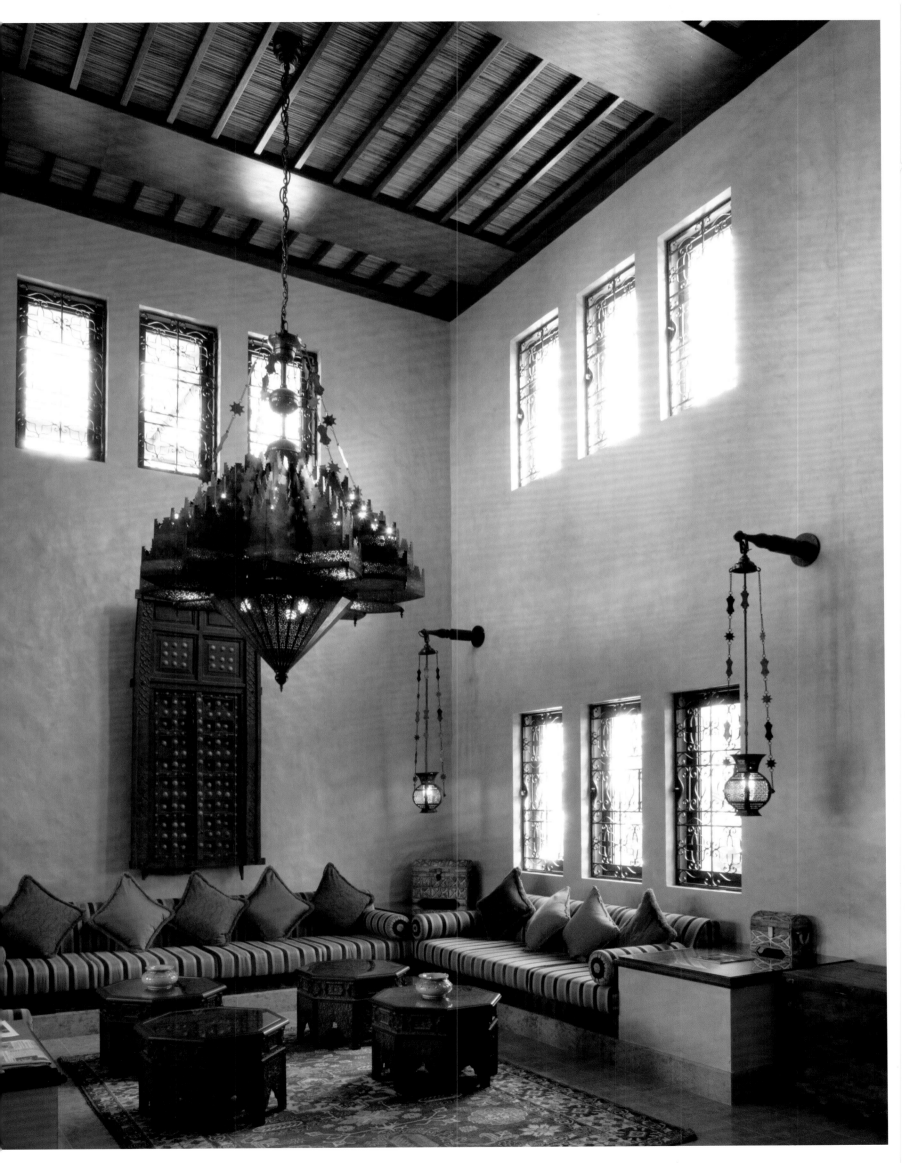

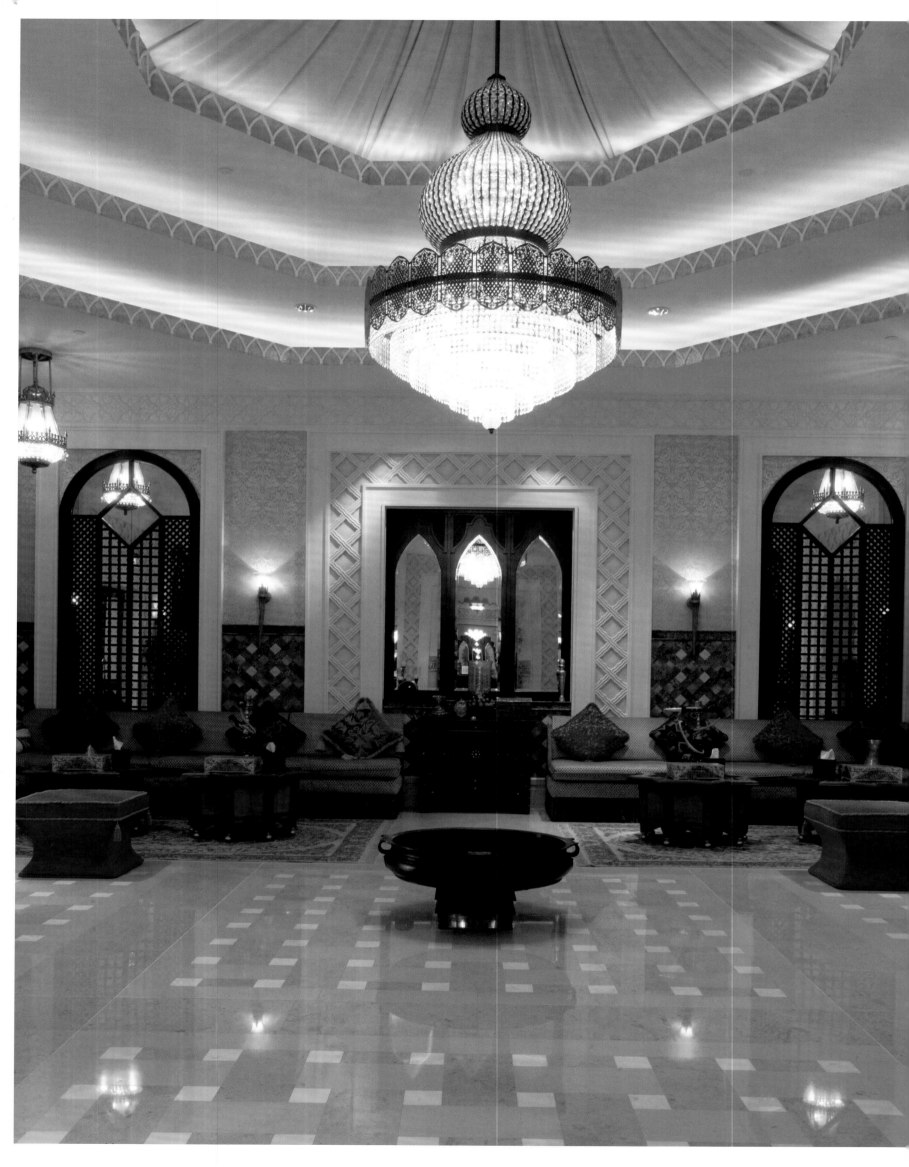

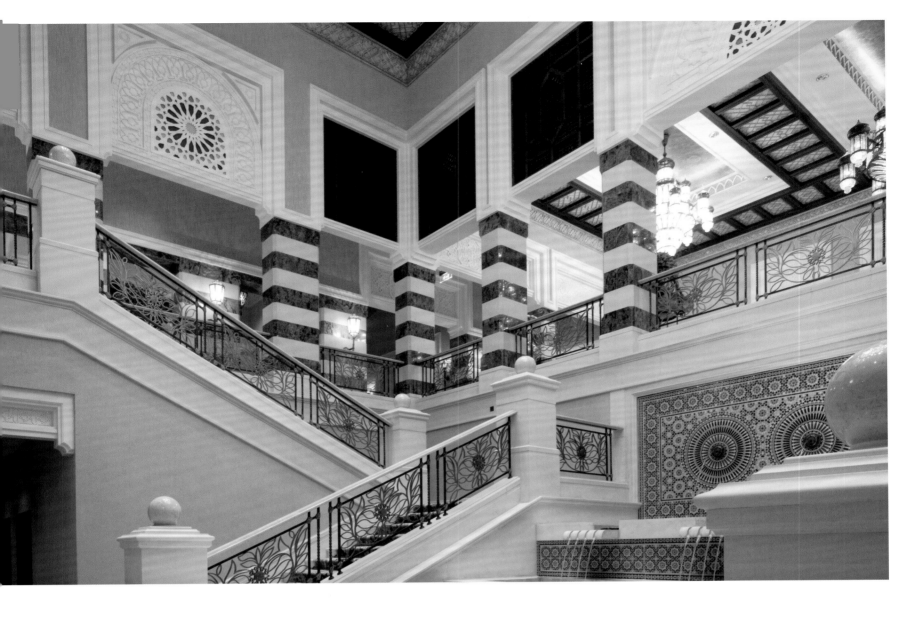

Folli Follie
Folli Follie at Dubai Burjuman | 2005
Trade Centre Road
Photos: © Courtesy Folli Follie

Die Ladenkette Folli Follie zieht Käuferschichten an, die Stil suchen. Dafür setzt die Marke auf kontinentales Storedesign. Heißt: klare Linien und elegante Formen. In Vitrinen aus Kirschenholz und in hell strahlenden Ablagen präsentieren sich Uhren, Taschen und sonstige Accessoires. Die inszenierte Botschaft ist klar: Star ist hier das Produkt von Weltformat.

The Folli Follie chain of stores attracts buyers looking for style. To serve them, the brand relies on continental store design. This means clear lines and elegant shapes. Watches, purses and other accessories are presented in cherry wood show cases and brightly illuminated displays. The applied message is clearly that world-class products are the stars of these stores.

La cadena de tiendas Folli Follie atrae la atención de un tipo de clientela en busca del estilo. Para ello, la marca ha apostado por un diseño del comercio de línea continental, es decir, de líneas claras y formas elegantes. En las vitrinas de madera de cerezo y los mostradores de un claro resplandeciente se exponen relojes, bolsos y otro tipo de accesorios que lanzan un mensaje muy definido: aquí la estrella es un producto de formato internacional.

La chaîne de magasins Folli Follie attire des acheteurs qui sont à la recherche de produits de style. C'est pourquoi la marque mise sur un design de magasin continental. Ce qui signifie des lignes claires et des formes élégantes. Des montres, sacs et autres accessoires sont exposés dans des vitrines en bois de cerisier et sur des présentoirs lumineux. Le message ainsi mis en scène est clair : la star est ici le produit d'envergure internationale.

La catena di boutique Folli Follie attira una clientela alla ricerca di stile. La strategia è quella di uno store design di stampo continentale. Ovvero: un ambiente dalle linee essenziali e dalle forme eleganti. Orologi, borse ed altri accessori si presentano al cliente in vetrine in legno di ciliegio e scaffalature sapientemente illuminate. Il messaggio che si vuole trasmettere è chiaro: protagonista assoluto è il prodotto di griffe di fama internazionale.

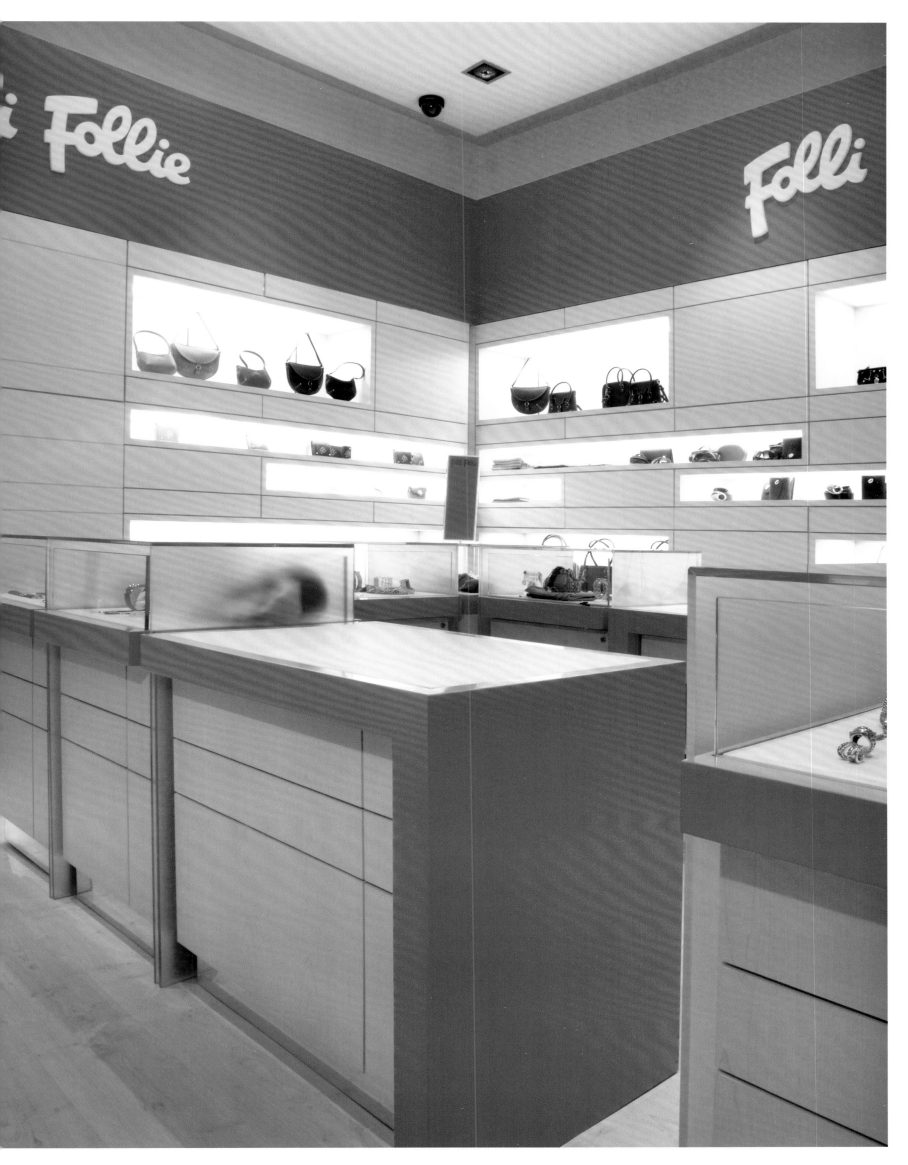

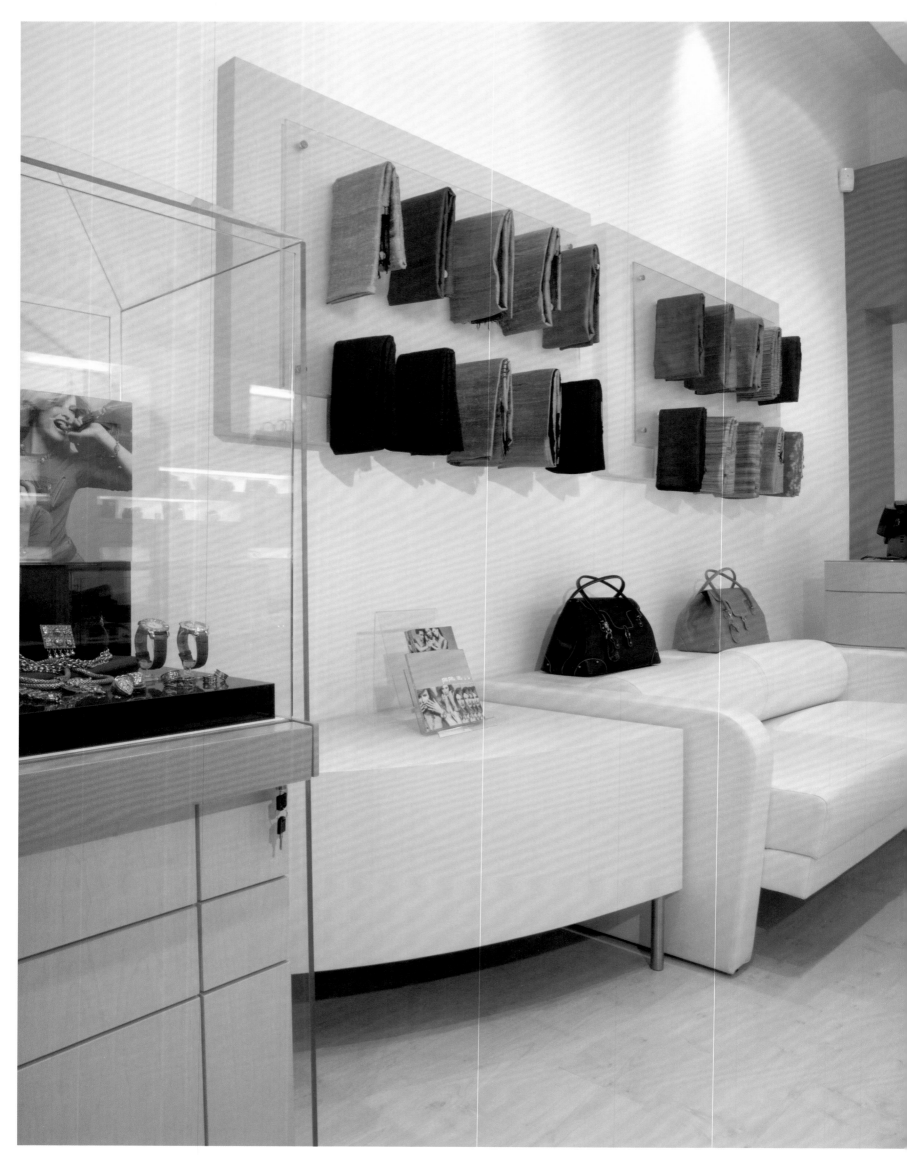

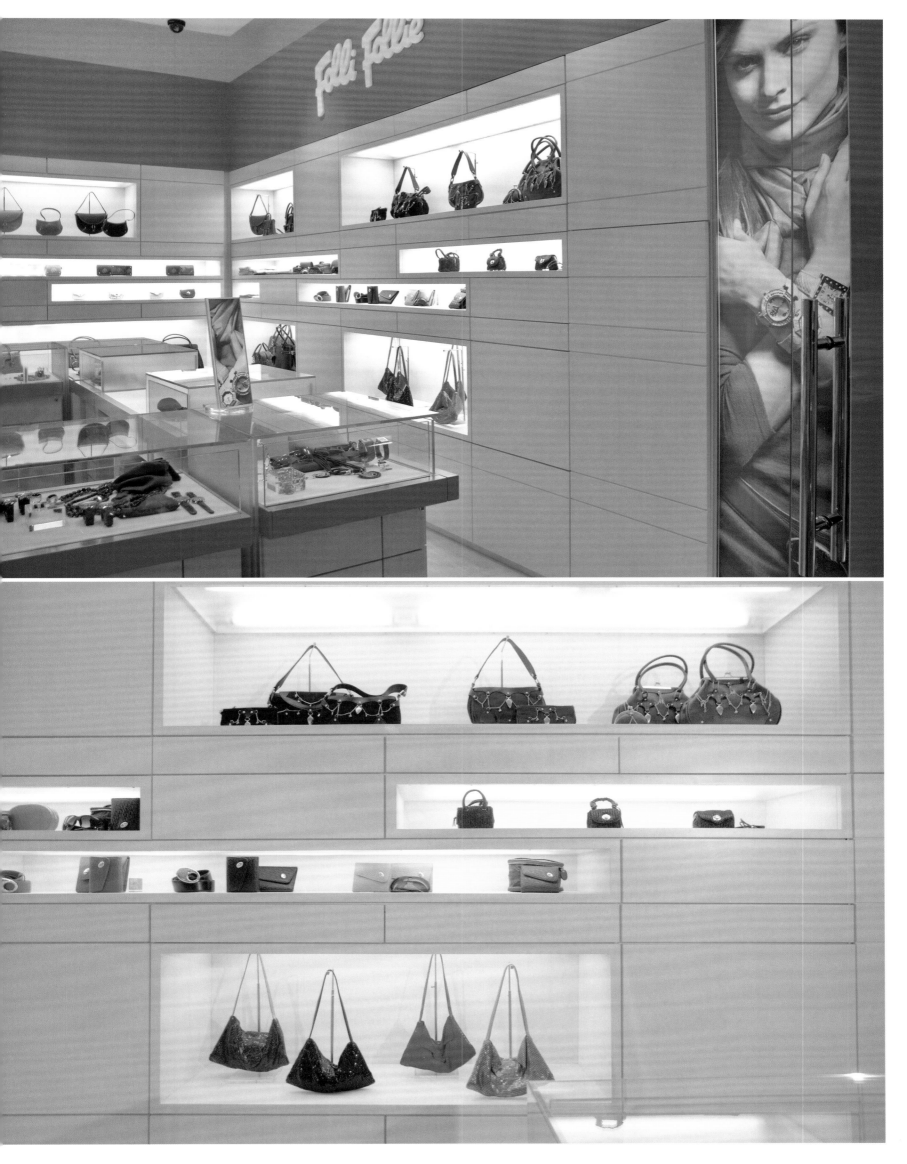

Keith Gavin, Godwin Austen Johnson, Karen Wilhelmm, Mirage Mille
Jumeirah Bab Al Shams | 2004
Close by the Endurance Village
Photos: © Martin Nicholas Kunz, Roland Bauer

Tür zur Sonne – so heißt übersetzt das Ende 2004 eröffnete Ferienhotel. Mitten in der Wüste gelegen, gleicht die Anlage einem arabischen Fort. Mit spürbarer Liebe zum Detail huldigen Architektur und Ausstattung ein traditionelles Bild vom alten, oft geheimnisumrankten Orient. Wahre Oasen für die Augen sind Palmengarten, Wasserläufe, Spa und Lounge auf dem Dach.

The door to the sun is the translation of the name of this vacation hotel, inaugurated in late 2004. Located in the desert, the construction resembles an Arabic fortress. With loving attention to detail, the architecture and furnishing pay homage to the traditional image of the ancient, often mysterious, Orient. The palm gardens, the water streams, spa, and a lounge on the roof are sights for sore eyes.

Puerta al sol; ese es el significado del nombre de este hotel de vacaciones que abrió sus puertas a finales de 2004, y que semeja una fortaleza árabe en medio del desierto. De la arquitectura e interiores se desprende un amor por el detalle y éstos revelan la imagen tradicional y frecuentemente misteriosa de Oriente. Los jardines de palmeras, arroyos, spa y lounge de la terraza son un verdadero oasis para los sentidos.

Porte du soleil, c'est la traduction du nom de l'hôtel qui a ouvert ses portes fin 2004. Situé au milieu du désert, il ressemble à un fort arabe. Avec un goût sensible pour le détail, l'architecture et l'aménagement rendent hommage à l'image traditionnelle d'un Orient passé, souvent plein de secrets. Les jardins de palmiers, ruisseaux, spa et salons qui se trouvent sur le toit sont de véritables oasis pour les yeux.

Porta sul sole – questa è la traduzione letterale del nome dell'hotel inaugurato alla fine del 2004. Situata in mezzo al deserto, la struttura ha le sembianze di un fortino arabo. Architettura e arredamento indulgono all'amore per il dettaglio, evocando l'immagine tradizionale dell'antico Oriente, spesso avvolto nel mistero. Vere oasi per i sensi sono il giardino di palme, i corsi d'acqua, la zona lounge e spa ubicate sul tetto.

66

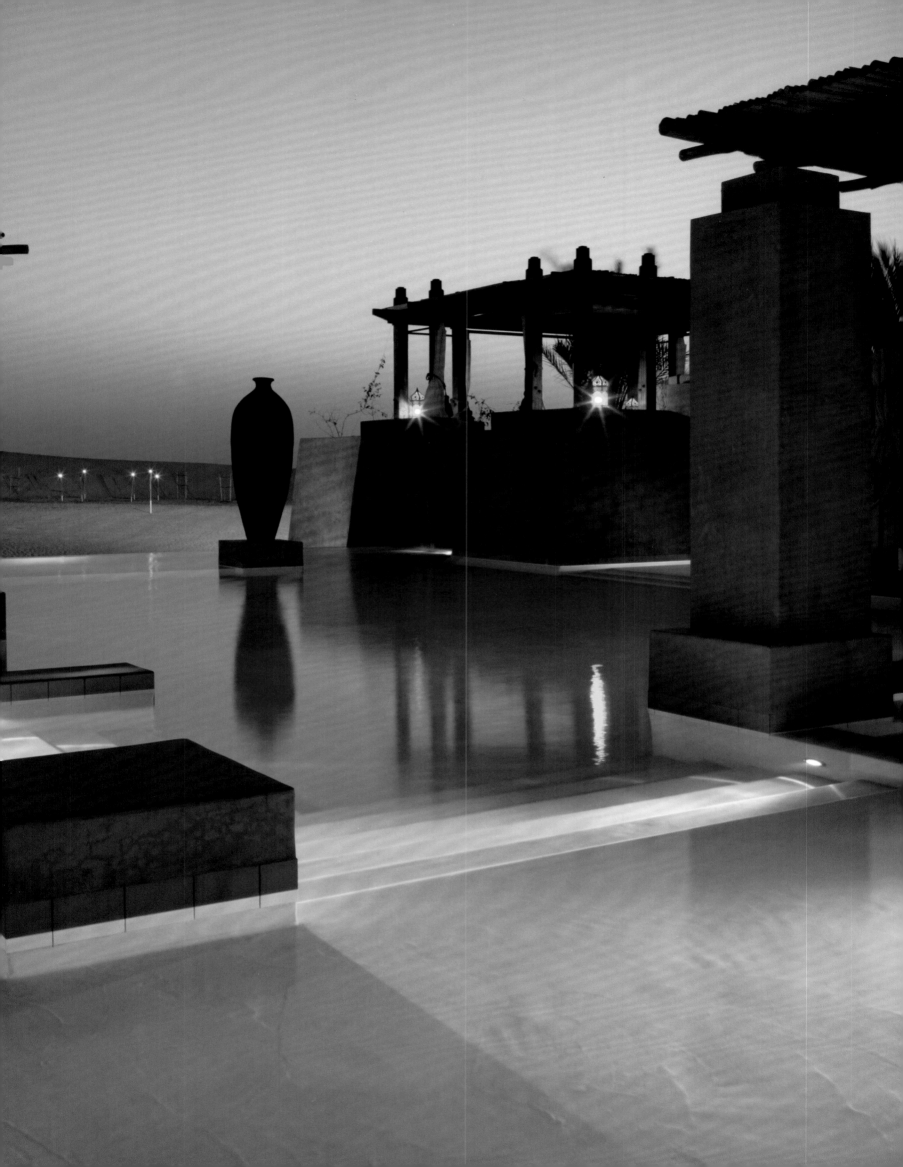

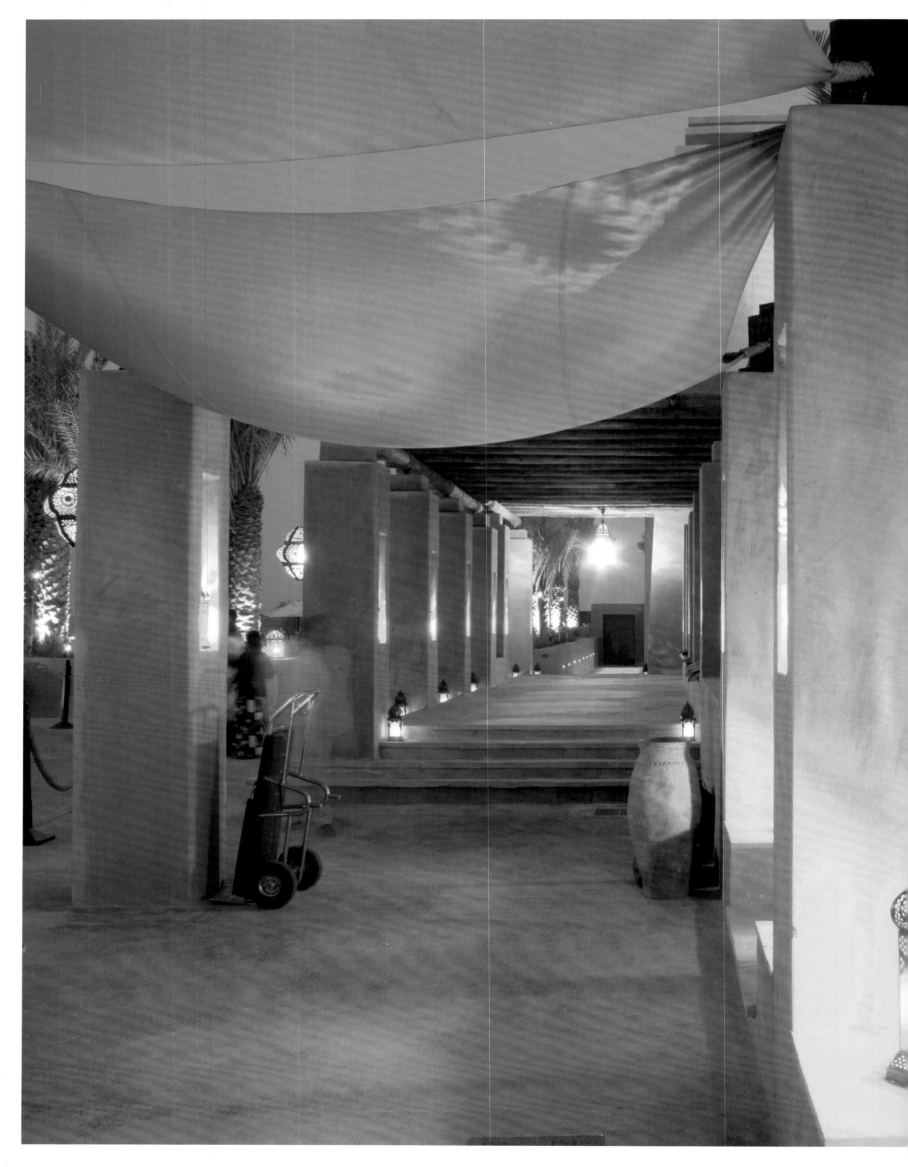

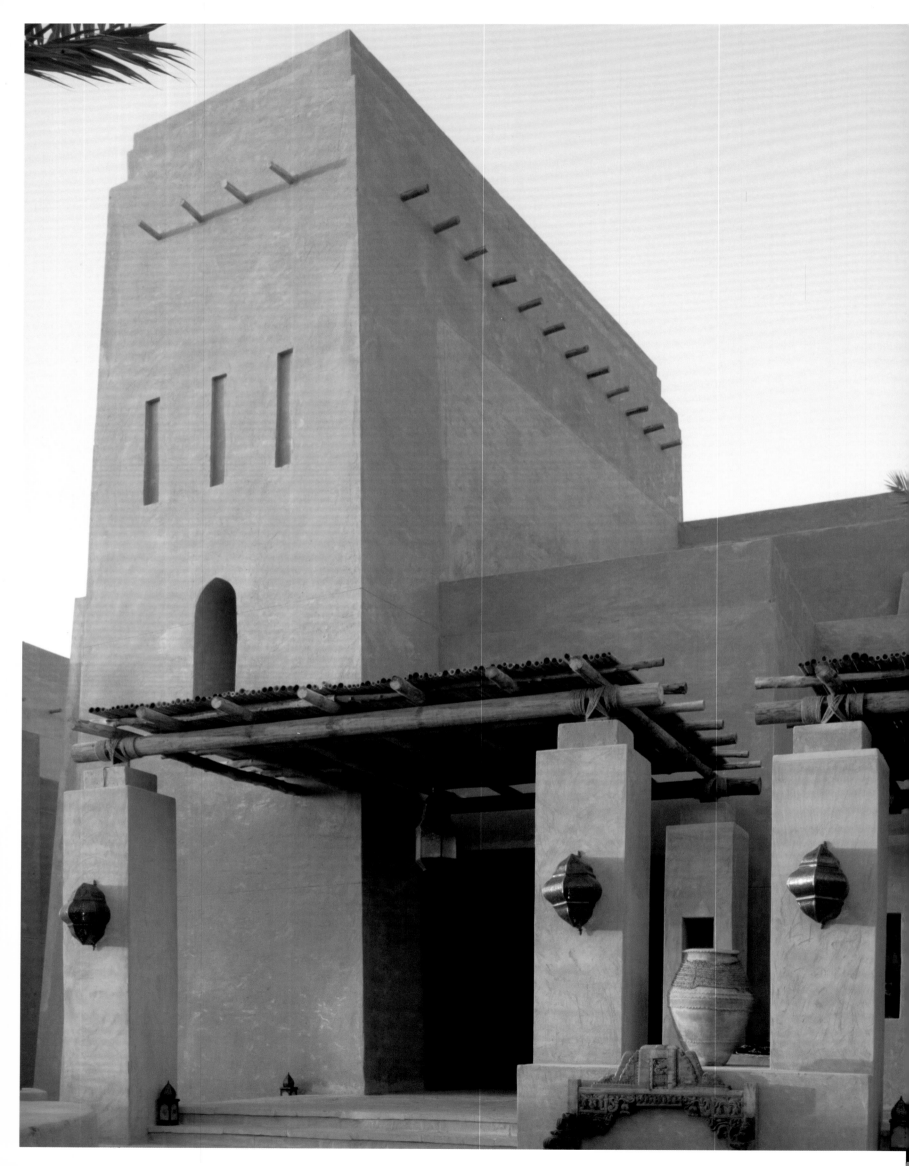

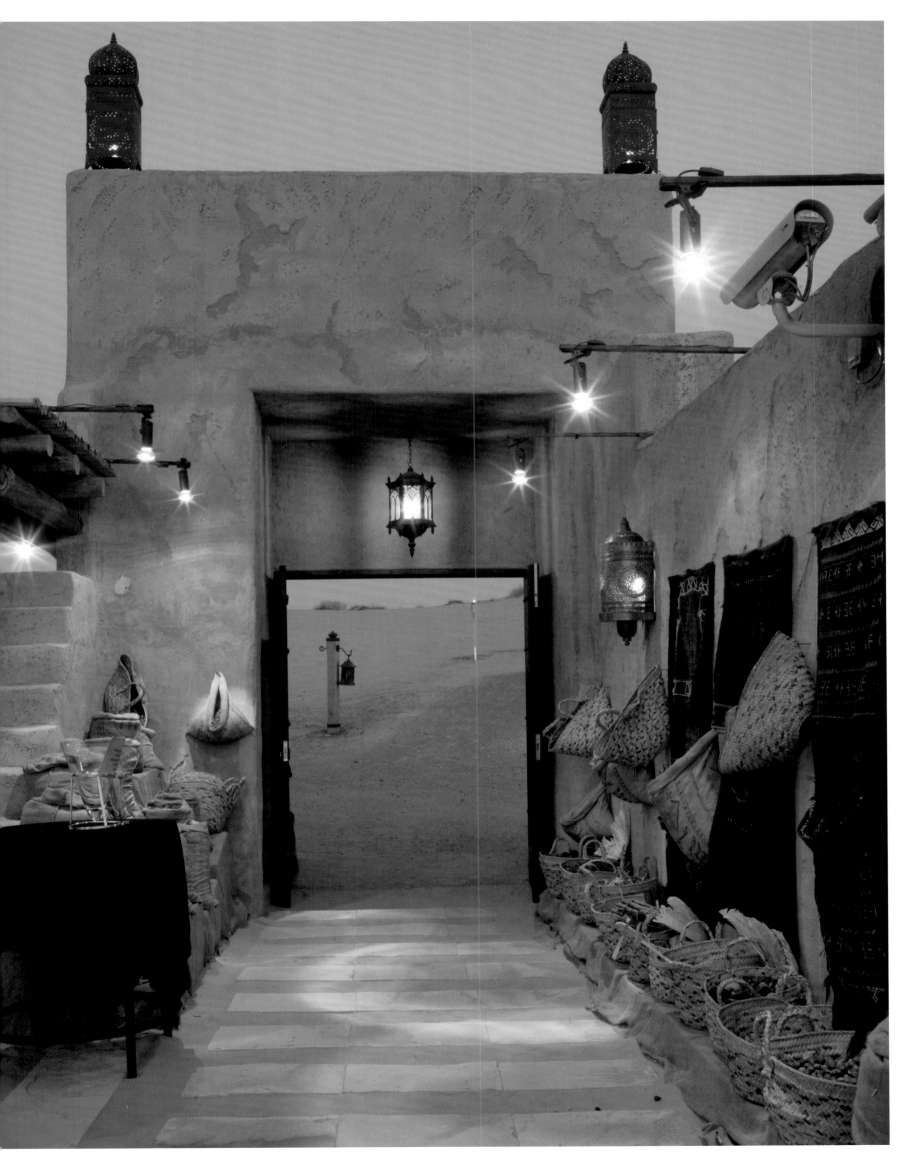

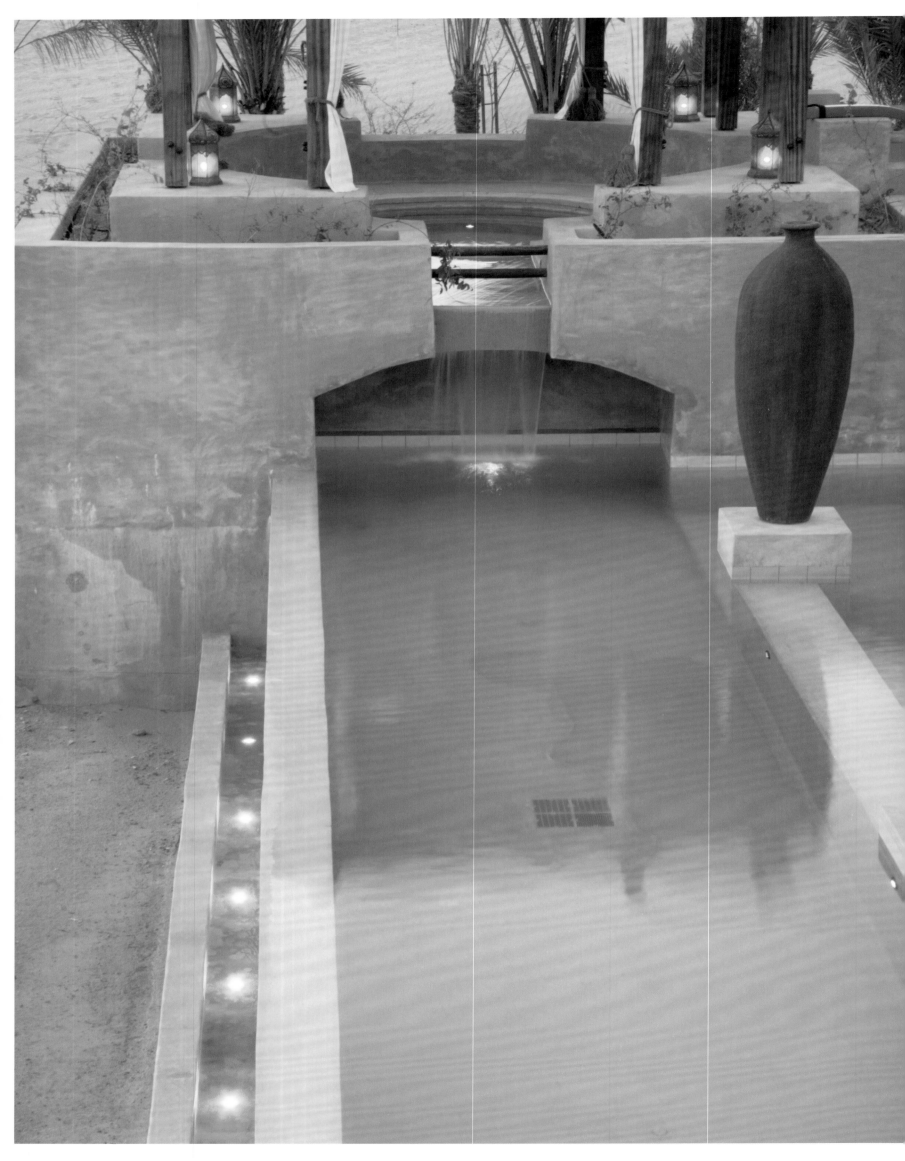

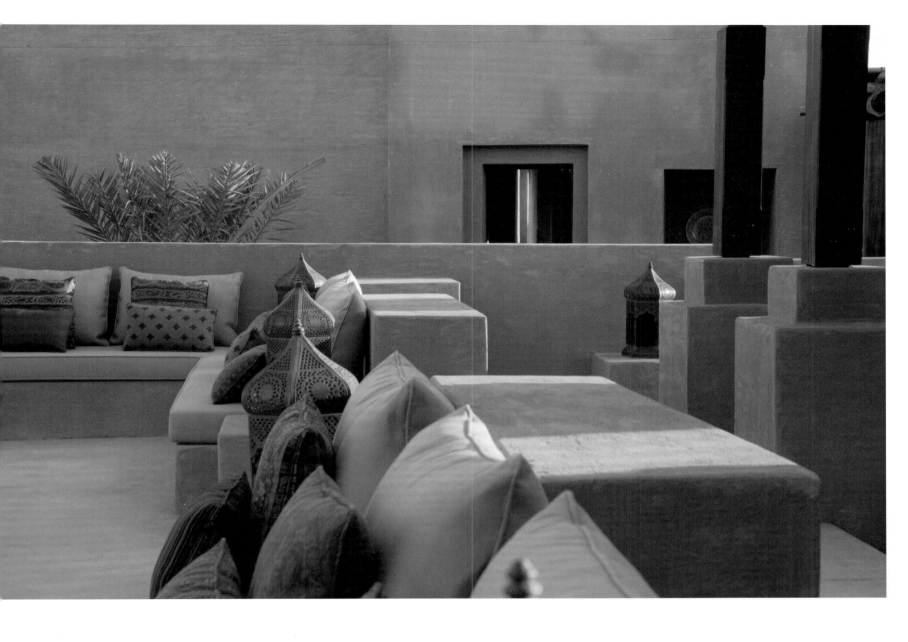

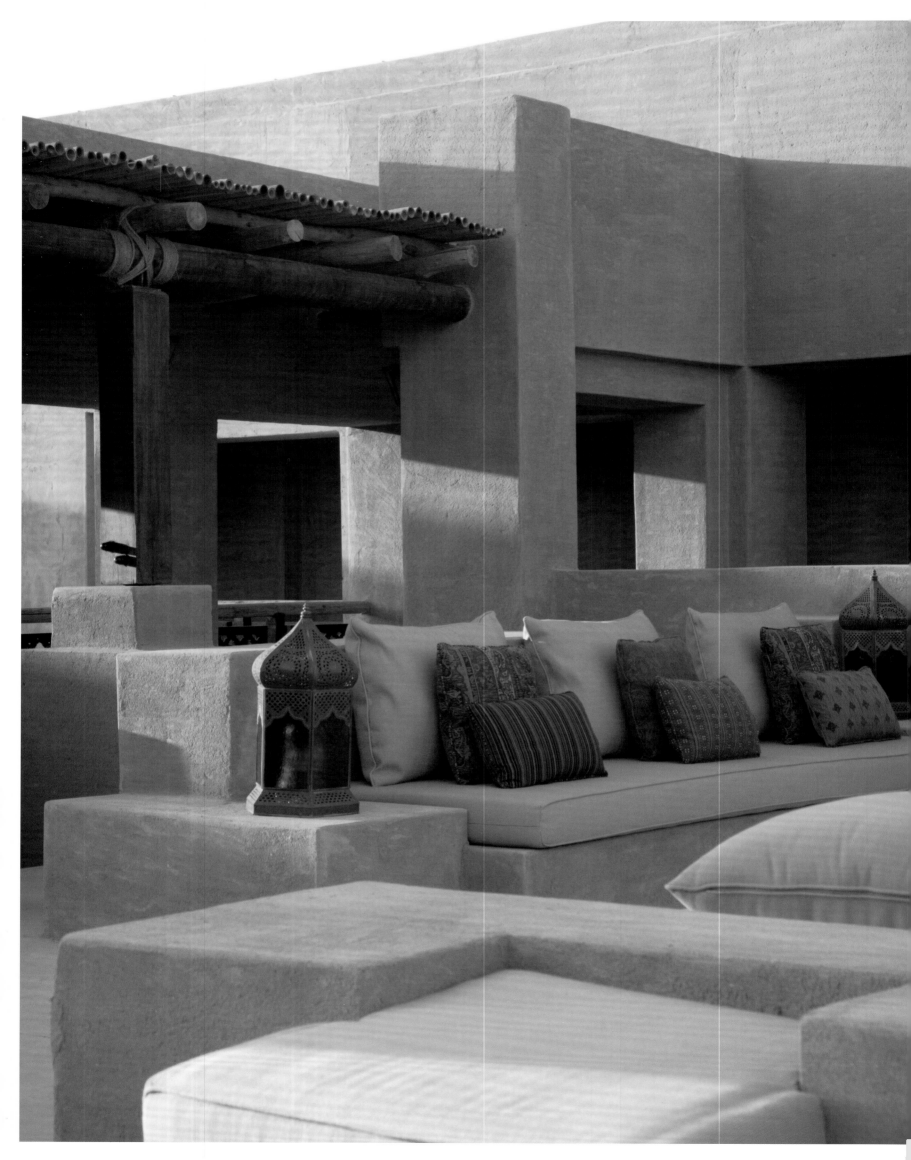

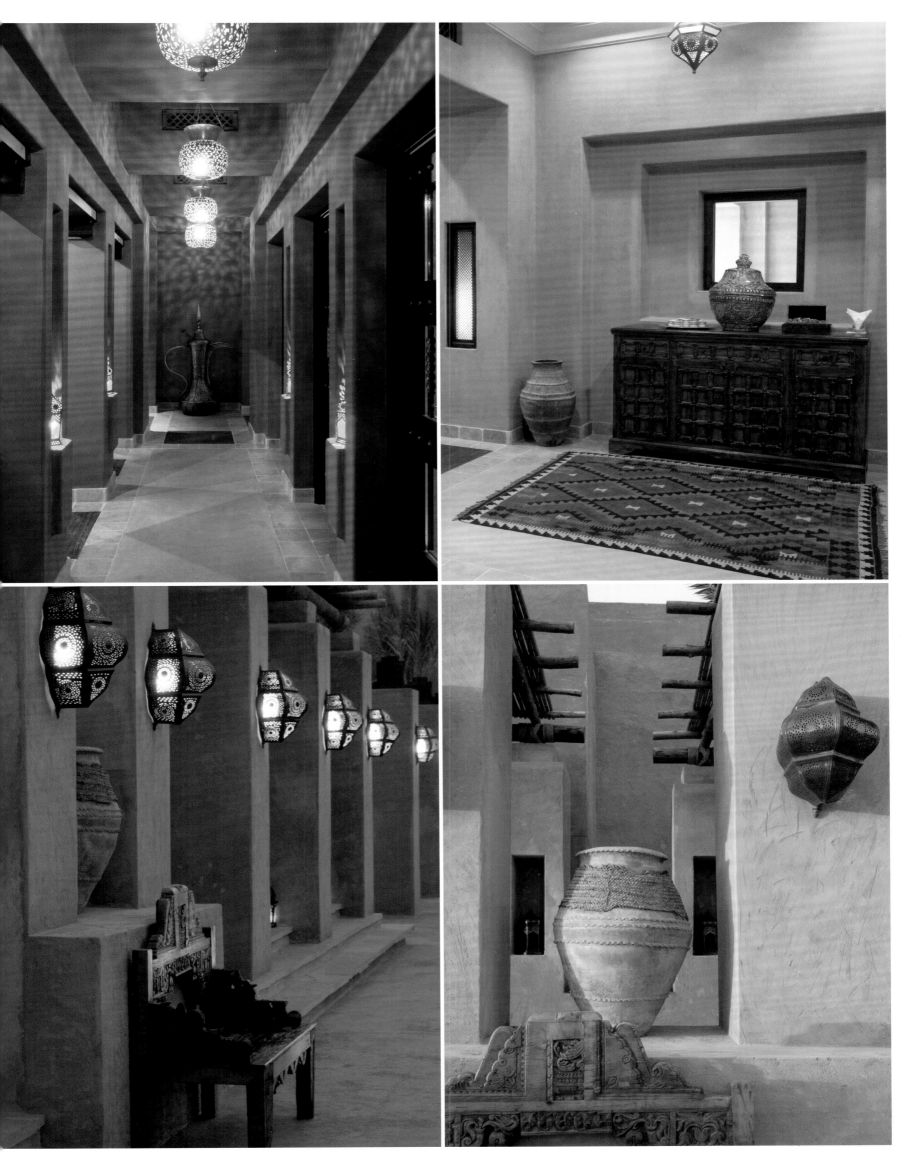

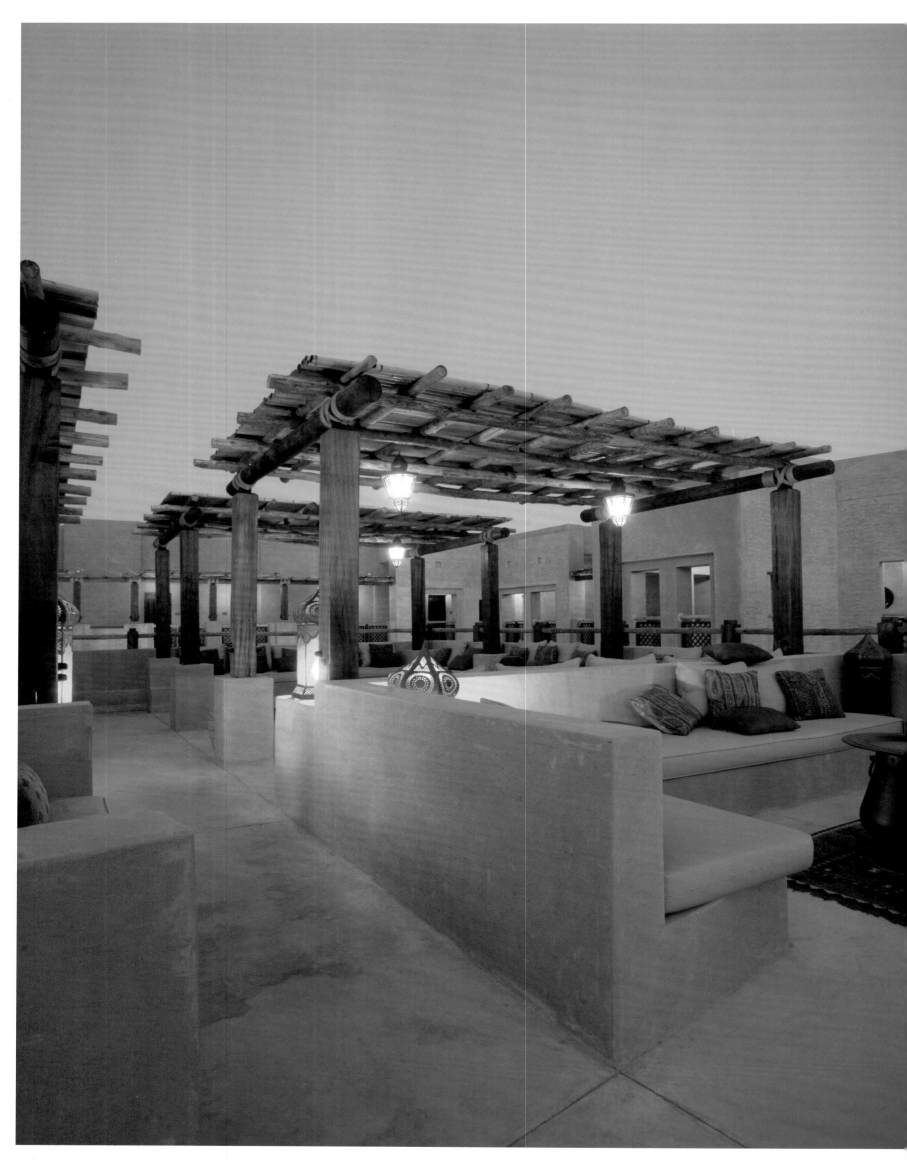

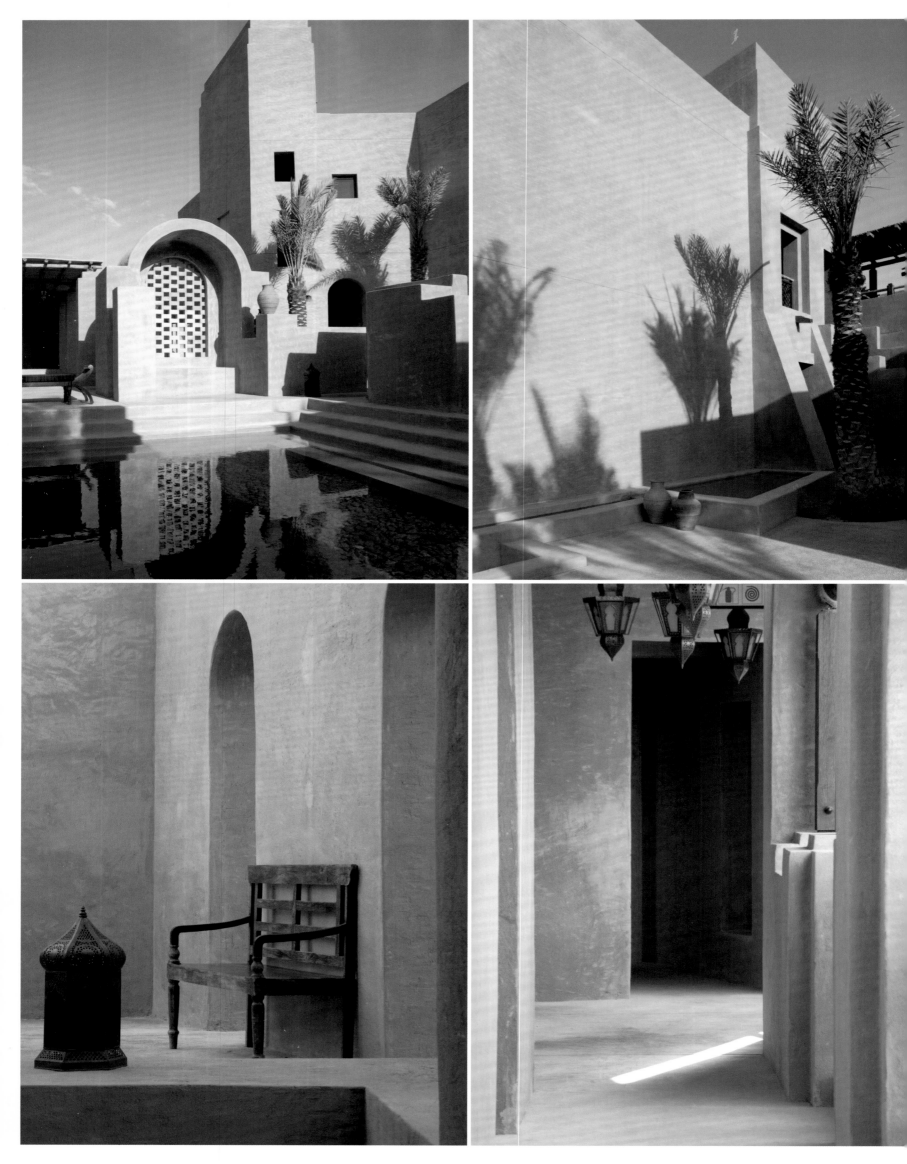

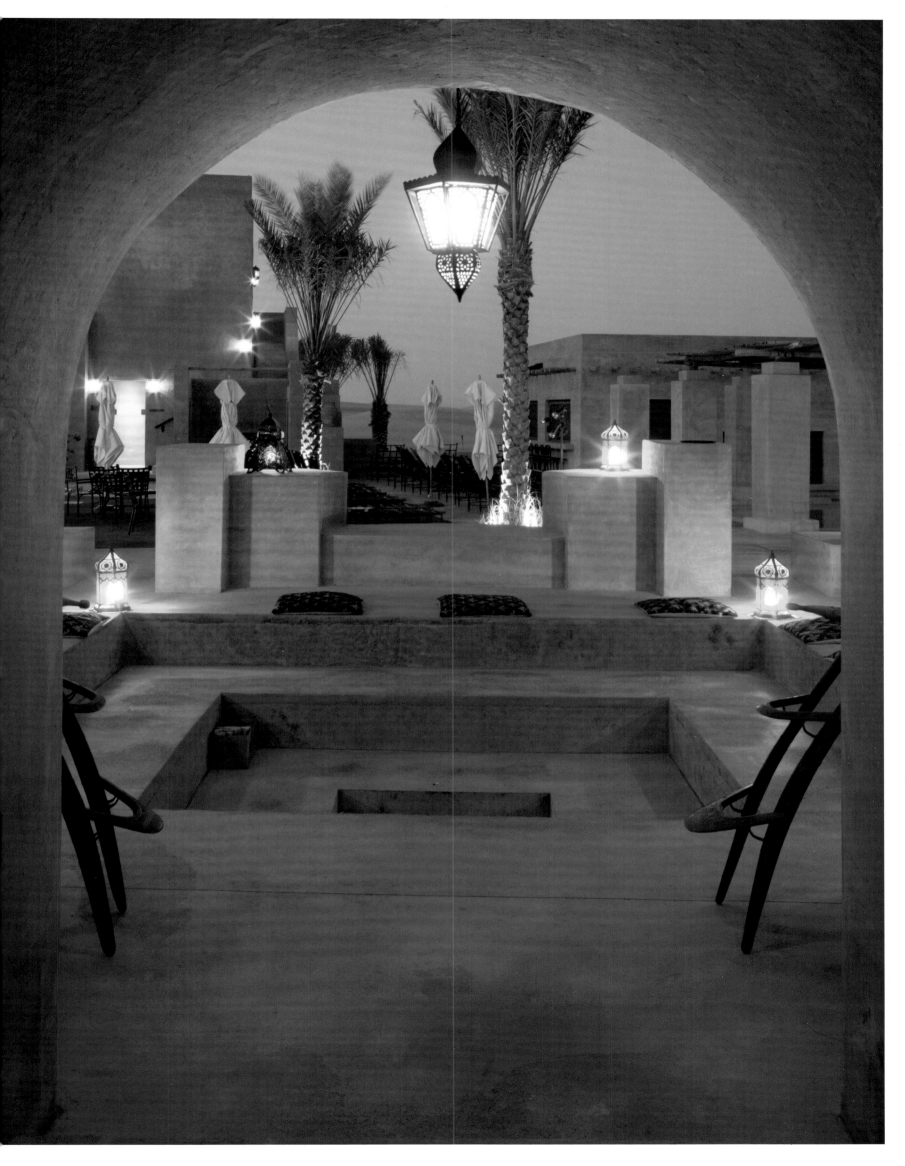

Gensler
DIFC Gate Building | 2004
The Gate
Photos: © Courtesy Gensler Architects

Nicht ganz unabsichtlich ähnelt The Gate dem Triumphbogen. Letztlich steht der Bau jedoch als symbolkräftiges Entree zum wichtigsten Finanzmarkt im mittleren Osten. Im Innern finden die Verwaltung der „Financial City" und das neue Zentrum der Börse Platz. Hinter den ruhigen Fronten mit symbolischem Kreuzbandrelief pulsieren so quirlige Herzen unter Geldstrom.

The resemblance of The Gate with the triumphal arch is not totally accidental. After all, the building represents the main entrance to the Middle East's most important financial market. It houses the administration of the "Financial City" as well as the new financial market center. Behind the quiet fronts, with their symbolic cross relief decoration, lively hearts beat to the rhythm of the flow of the money.

Si The Gate se parece al arco del triunfo no es por azar, puesto que al fin y al cabo la construcción se erige como entrada extraordinariamente simbólica al más importante mercado financiero de Oriente Medio. Su interior alberga la administración de la "Financial City" y el nuevo centro de la bolsa. Tras los sosegados muros con simbólicos relieves cruzados se agita el pulso del dinero.

Ce n'est pas complètement involontairement que The Gate ressemble à un arc de triomphe. En fait, la construction représente pourtant une porte d'entrée symbolique du plus important marché financier du Moyen Orient. À l'intérieur se trouvent l'administration de la « Financial City » et le nouveau centre de la Bourse. Derrière les façades tranquilles avec leurs bandeaux de croix très symboliques, des flux d'argent font battre des cœurs emballés.

La somiglianza con l'Arco di Trionfo non è del tutto fortuita, soprattutto se si considera il forte carico metaforico di questa struttura che rappresenta concretamente e figuratamente una grande porta che si apre sul mercato finanziario più importante del Medio Oriente. Al suo interno trovano posto l'amministrazione della „Financial City" nonché il nuovo centro borsistico. Dietro l'apparente tranquillità delle facciate sormontate da un simbolico fregio con motivo incrociato, il cuore del mondo finanziario pulsa al ritmo frenetico dei flussi di denaro.

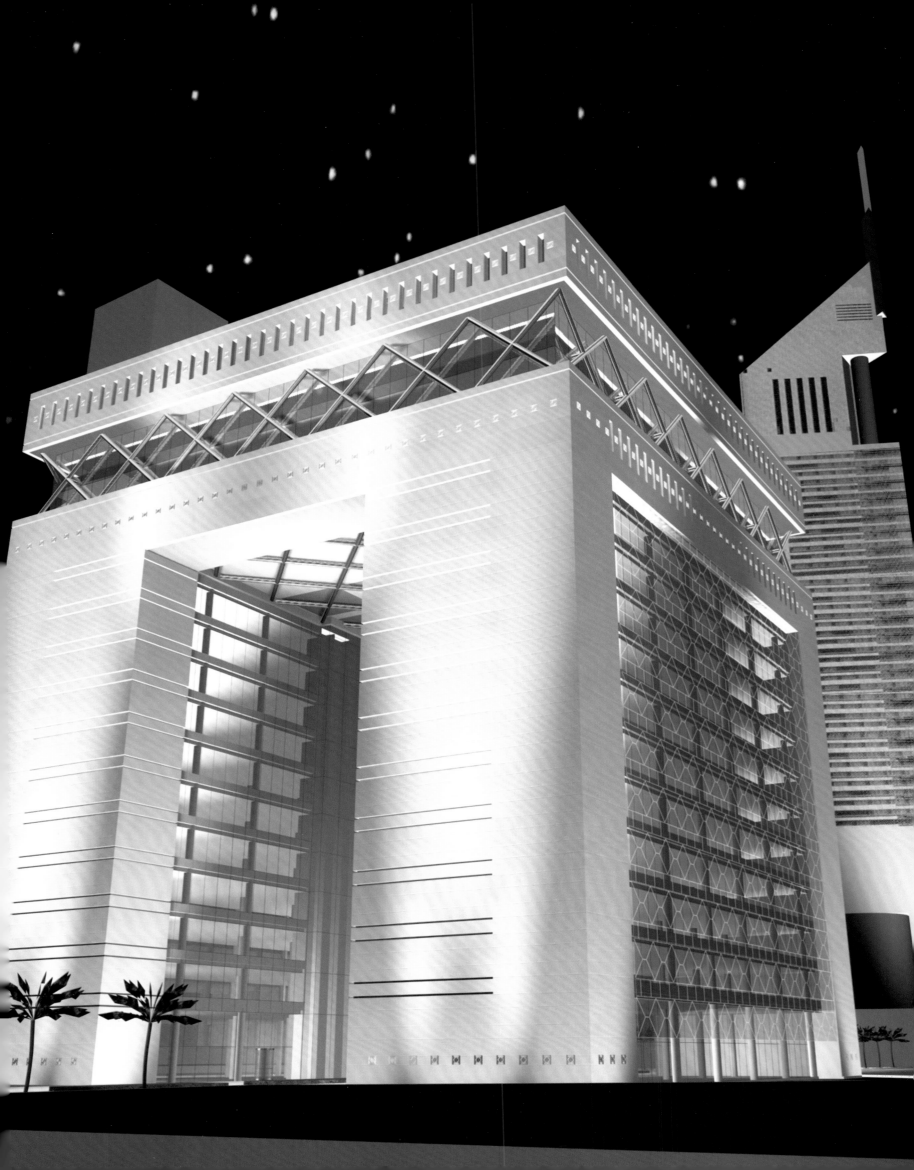

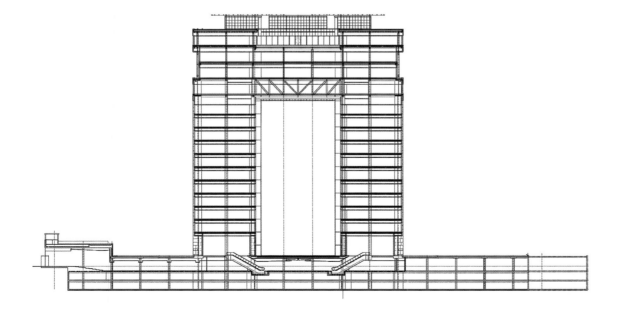

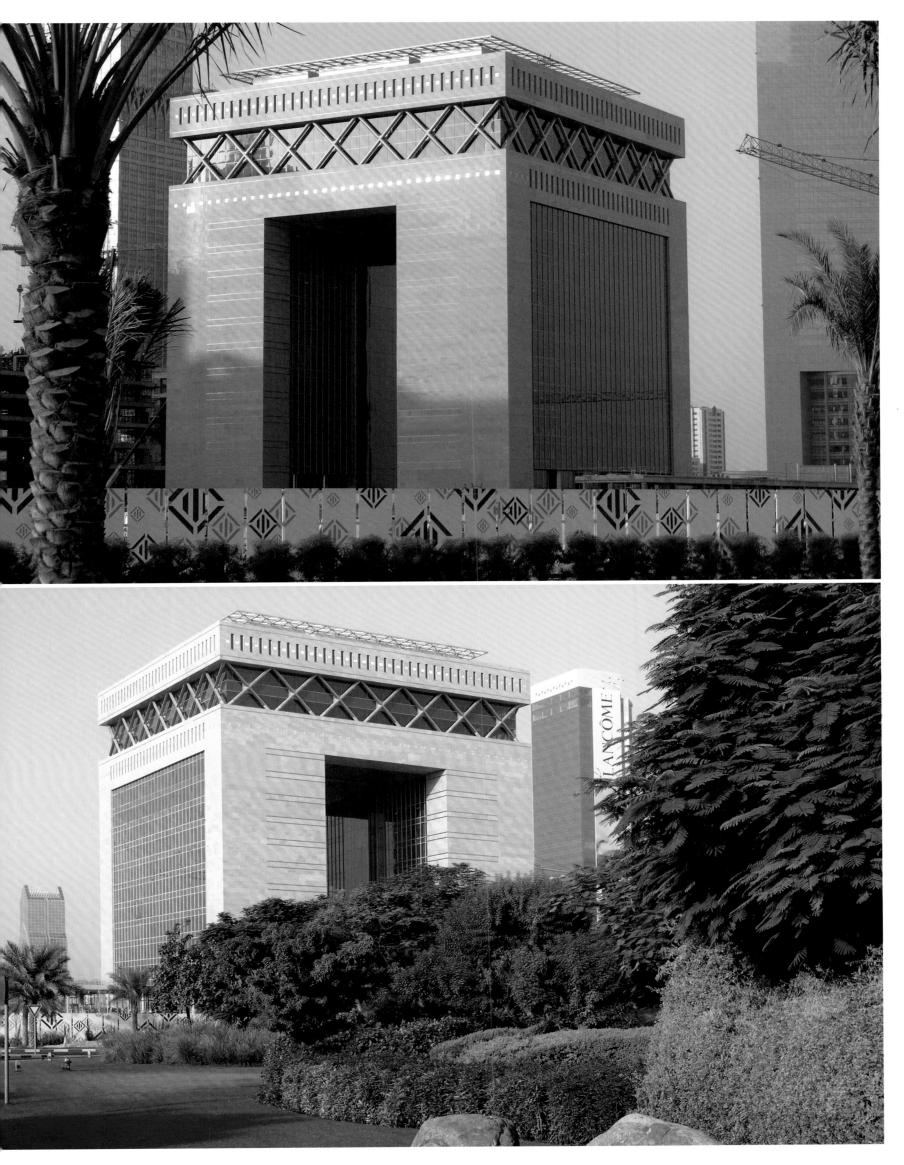

gmp – von Gerkan, Marg und Partner Architects
Dubai Sports City | 2007
New Emirates Road
Photos: © Courtesy gmp (87-91, 94-97), courtesy Dewan Architects (92/93)

Dubais Sportstadt – das ist auf der ganzen Welt der erste umfassende Sportkomplex aus einem architektonischen Guss. Auf 4,6 Quadratkilometern drängt sich dicht an dicht eine multifunktionale Stadienlandschaft. Von hoher Prägnanz: die Stahlhüllen der Veranstaltungsorte mit ihren Dächern aus Zeltfalten. Teil des Projekts ist zudem eine Shopping-Mall für Sportbedarf.

Dubai's sports city—this is the world's first comprehensive sports complex made of a single architectural cast. Its 4.6 square kilometers are crowded with multifunctional stadiums. Highly visible: the steel covers of the different localities with their roofs consisting of tent folds. The project also includes a shopping mall for sports equipment.

La ciudad deportiva de Dubai es el primer complejo de deportes del mundo construido en un sólo bloque arquitectónico. A lo largo de 4,6 kilómetros cuadrados se extiende un paisaje de pabellones en racimo. Especialmente significativas son las cubiertas de acero de los espacios de eventos con techos de carpa. El centro comercial de material deportivo es un elemento más de este proyecto.

La cité sportive de Dubaï est le premier complexe sportif du monde complètement conçu dans une unité architectonique. Des stades sportifs serrés les uns contre les autres forment sur 4,6 kilomètres–carré un paysage aux fonctions multiples. Les enveloppes d'acier des lieux de spectacles avec leurs toits pliés comme des toiles de tente sont très impressionnants. Le projet inclus aussi un centre commercial pour articles de sport.

Dubai Sports City: la prima città dello sport al mondo ad essere stata concepita architettonicamente come un ampio complesso sportivo nato da un'unica colata. Una fitta rete di stadi polifunzionali sorge su una superficie di 4,6 chilometri quadrati. Di grande espressività: gli involucri in acciaio con struttura poligonale di copertura a spicchi. Parte del progetto prevede inoltre la costruzione di uno shopping mall per articoli sportivi.

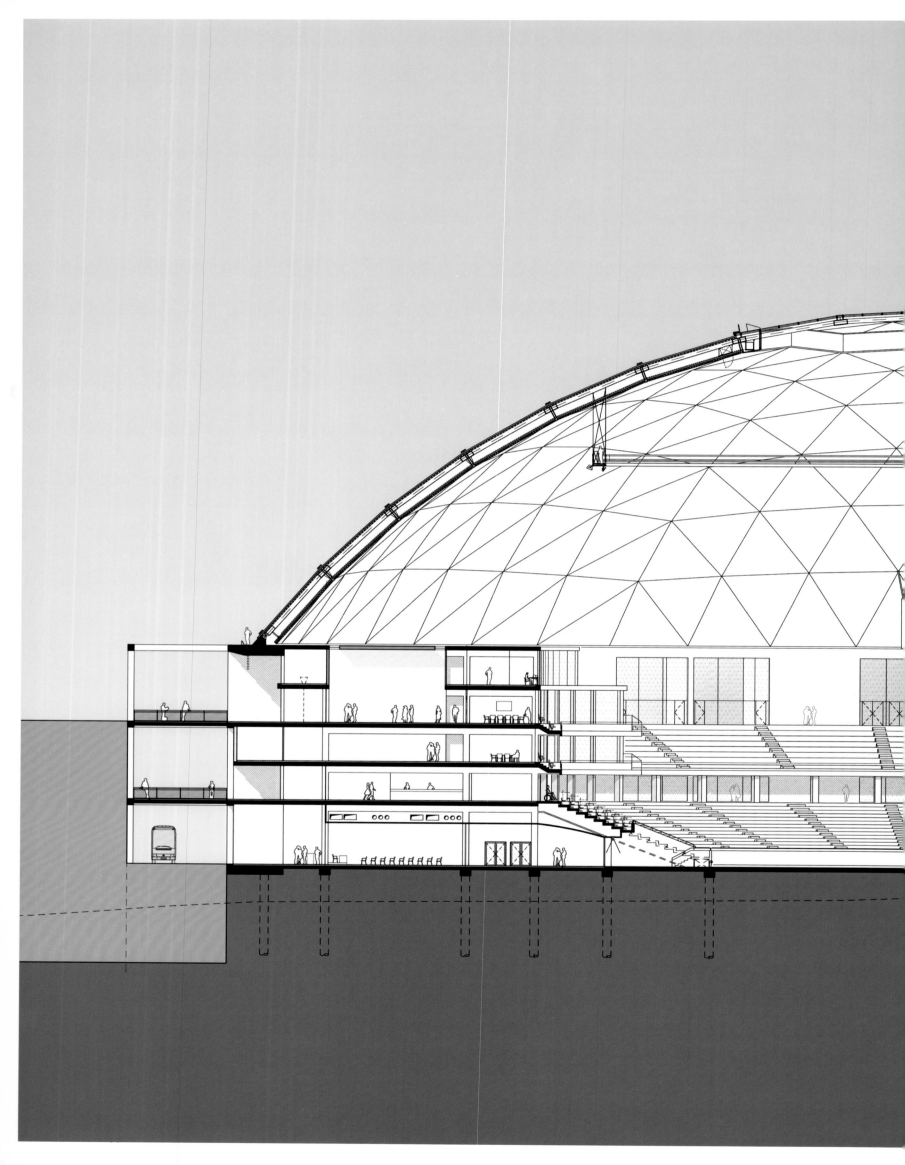

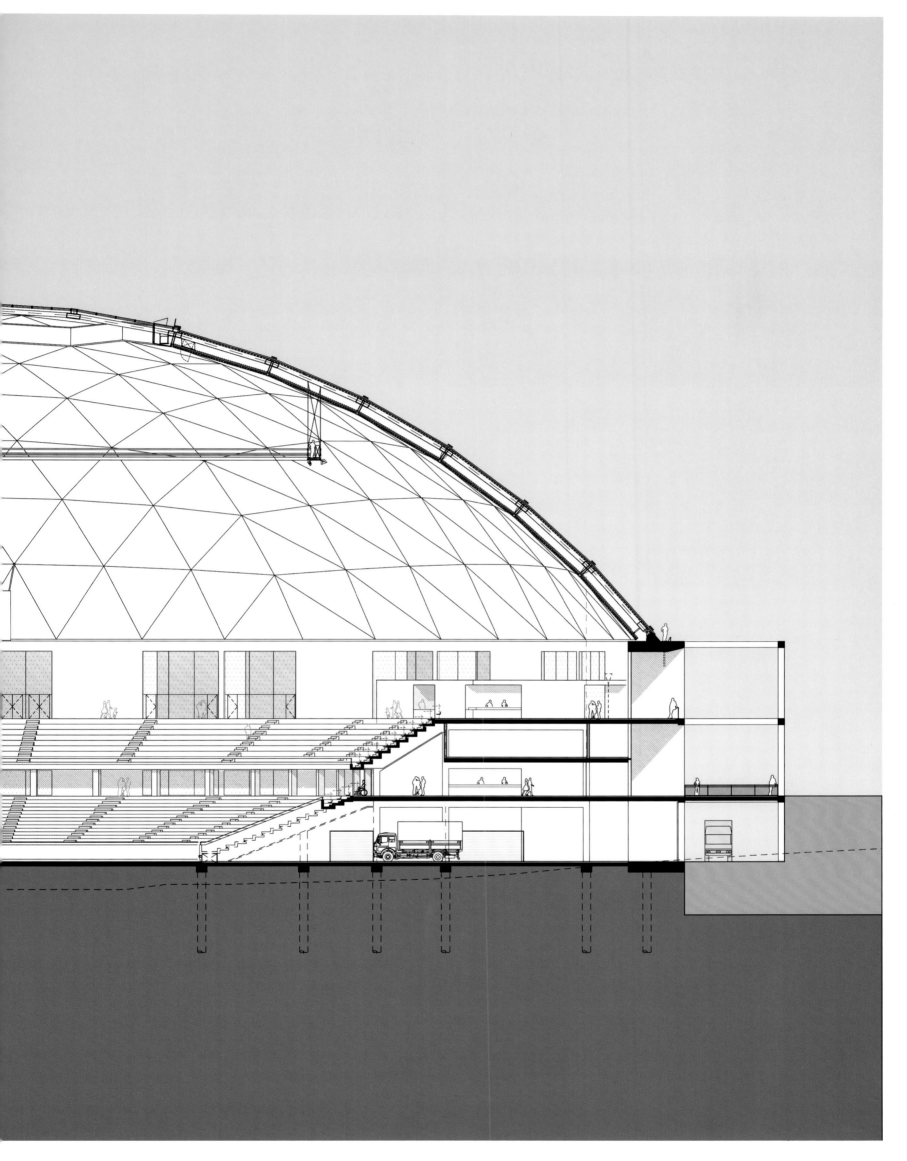

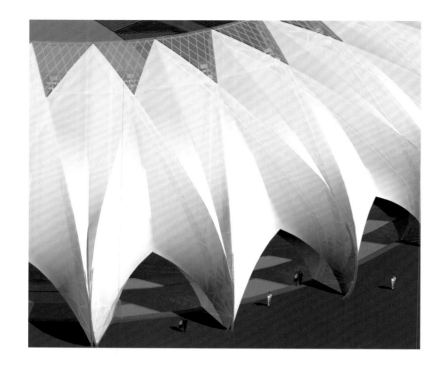

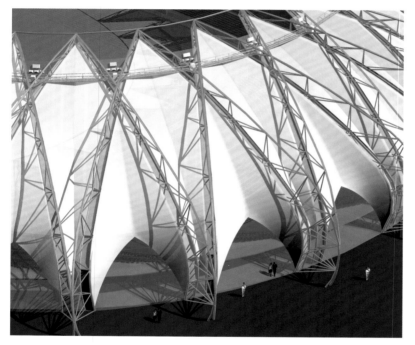

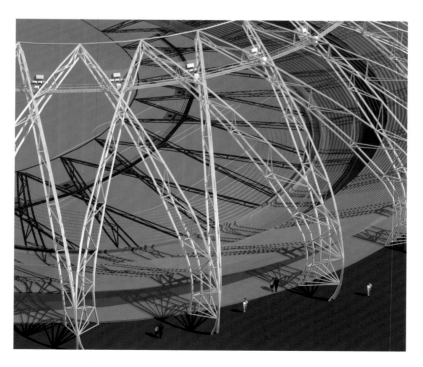

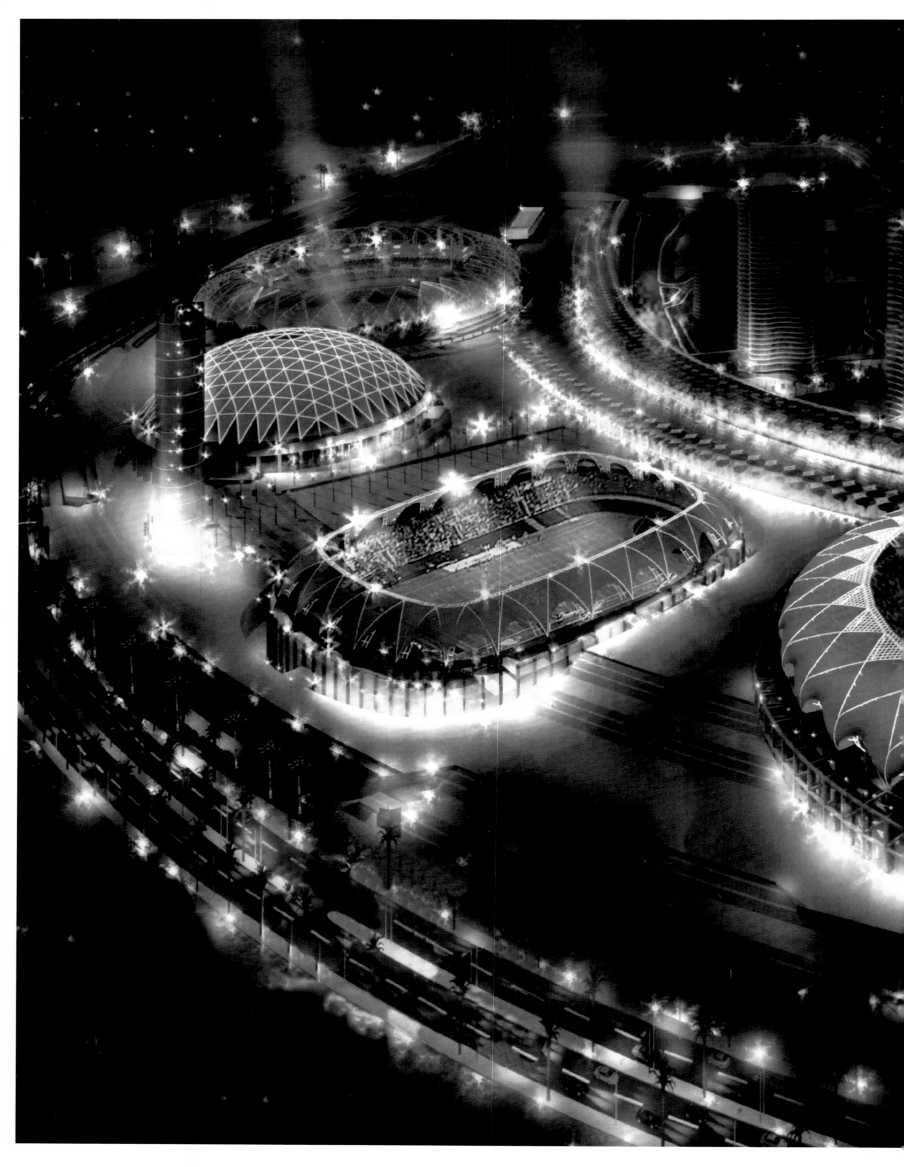

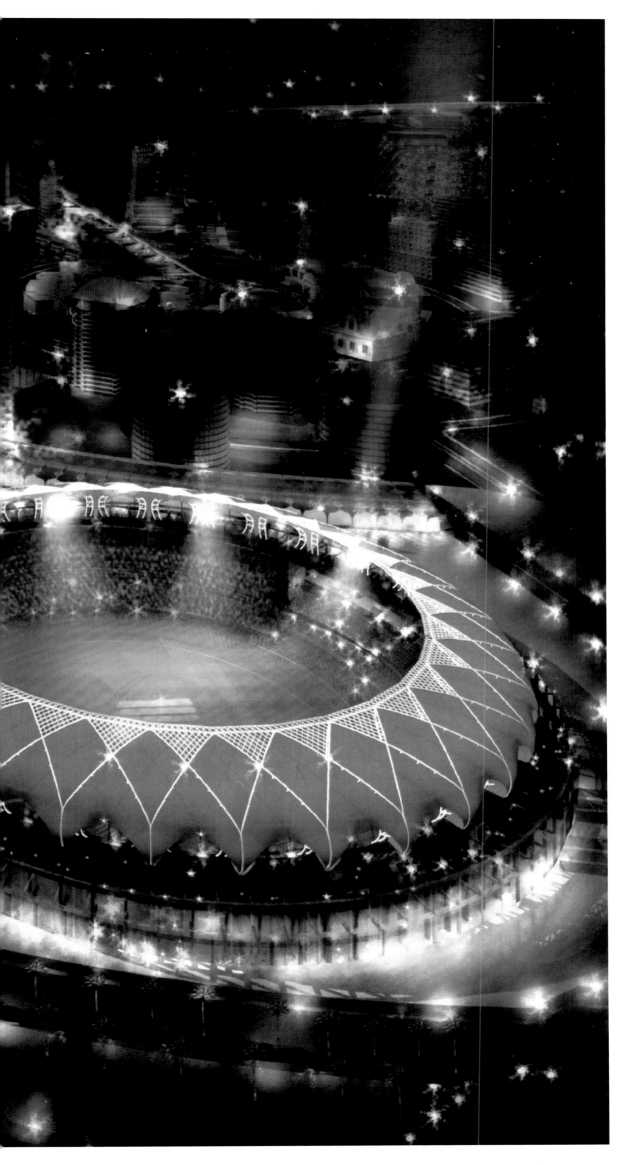

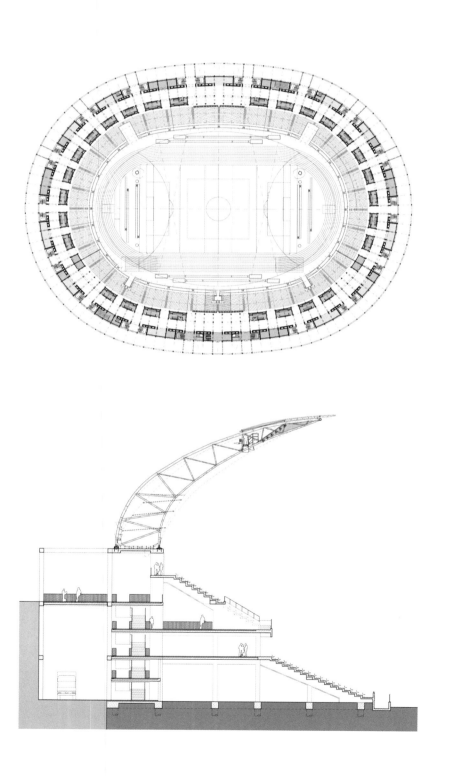

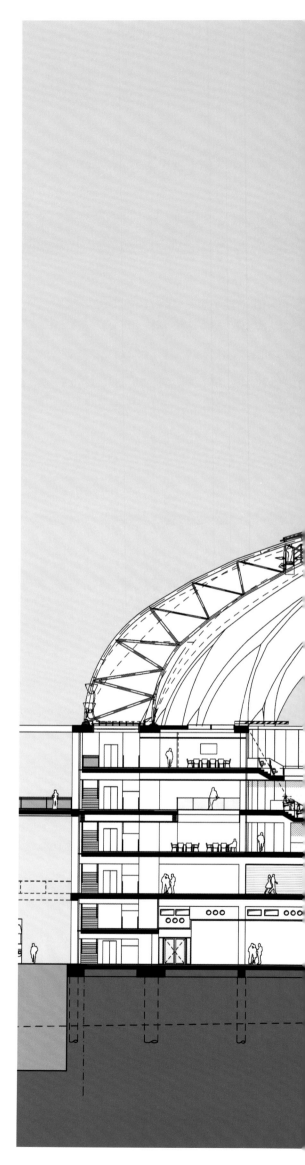

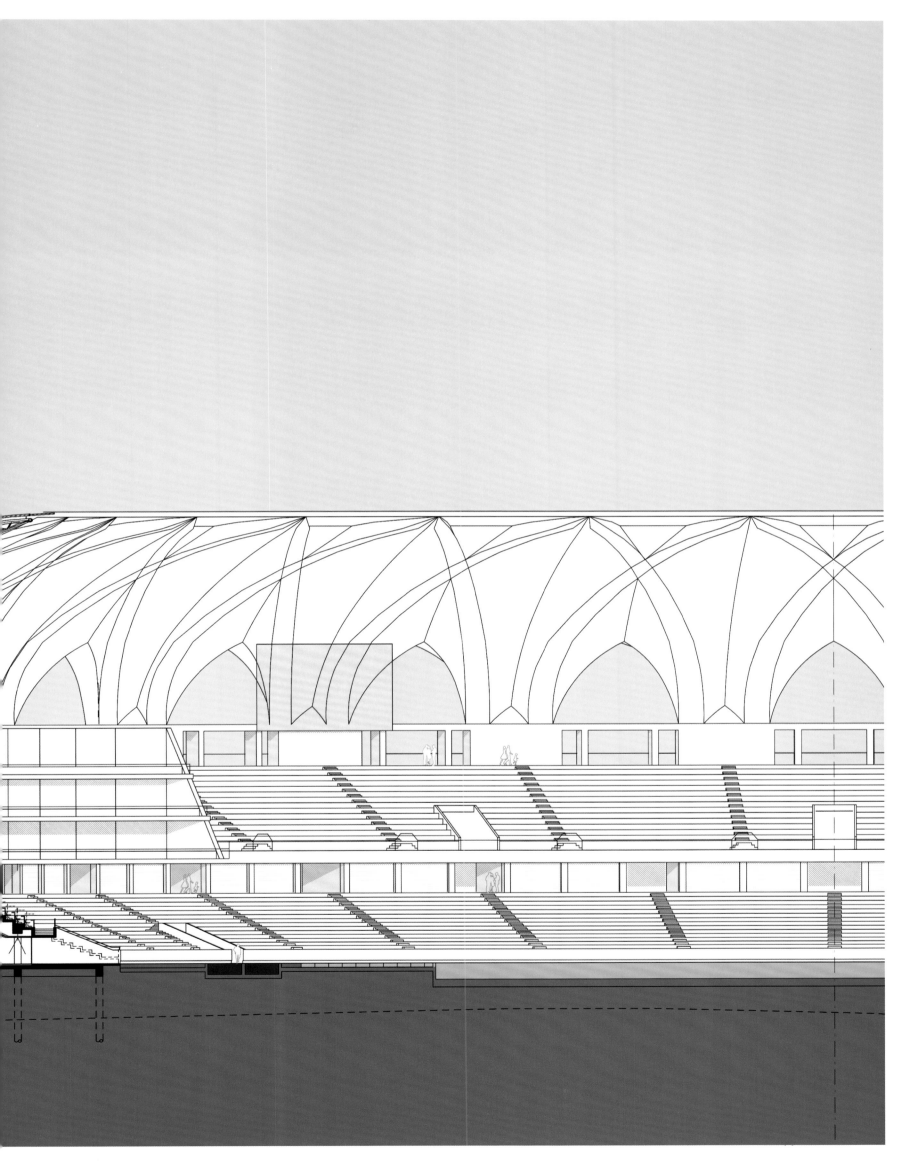

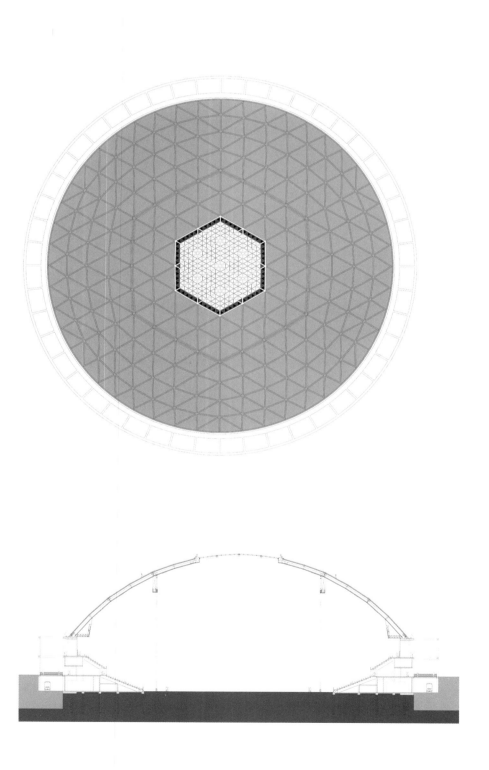

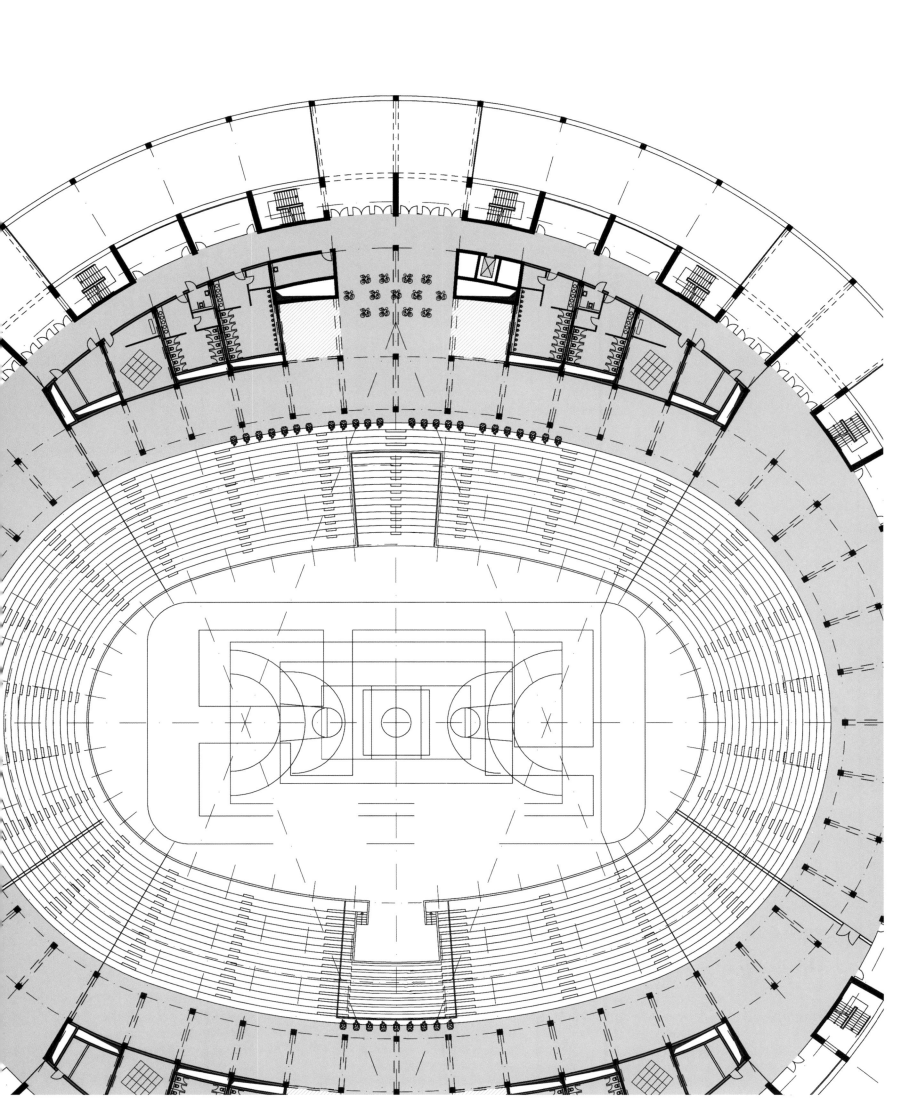

Project development by Joachim Hauser, Architecture by 3deluxe/system modern GmbH
Hydropolis Underwater Resort Hotel | 2007
Dubai
Photos: © foco design (98/99), 3deluxe/system modern GmbH (97, 100/101)

Es gilt als Sensation: ein Unterwasser-Resorts, das die Rede vom Abtauchen im Urlaub wahr macht. Das Leben im Hotel spielt sich submarin ab und bietet geradezu einen Tiefenrausch. So nabelt sich die künstliche Insel wie ein Fötus vom Festland ab – kennzeichnend für die bioenergetischen Formen von Hydropolis. Nachts erstrahlt der sichtbare Rest wie eine Muschel.

Truly sensational: an underwater resort that makes vacation dreams come true. The submarine hotel life offers a literal rapture of the deep. The artificial island is connected to the mainland like a fetus to its mother—in line with the bio-energetic shapes of Hydropolis. During the night, the visible part looks like an illuminated sea shell.

Toda una sensación. Un resort marino que hace realidad el deseo de sumergirse en las vacaciones. La vida del hotel emana un carácter submarino y transporta a las profundidades. La isla artificial se desliga de tierra firme como un feto del cordón umbilical, caracterizando así las formas bioenergéticas de Hydropolis. Durante la noche, las partes visibles resplandecen como una concha.

C'est une véritable sensation : une station touristique consacrée au monde subaquatique, qui donne aux mots « s'éclipser en vacances » une réalité. La vie de l'hôtel se déroule sur un mode subaquatique et procure ainsi une ivresse des profondeurs. L'île artificielle est ainsi détachée du continent à la manière d'un fœtus, ce qui caractérise les formes bioénergétiques d'Hydropolis. La nuit, la partie visible luit comme un coquillage.

È considerato un evento sensazionale: un resort sottomarino in cui l'idea di vacanza come immersione in un mondo totalmente diverso diventa realtà. Nell'hotel sottomarino Hydropolis, ogni momento della vacanza si svolge a stretto contatto con il fondale marino, facendo sperimentare l'ebbrezza da profondità. L'isola artificiale si stacca dalla terraferma come un feto: un'analogia significativa considerate le bioenergie a cui si ispirano le forme di Hydropolis. Di notte il resto visibile riluce come una conchiglia.

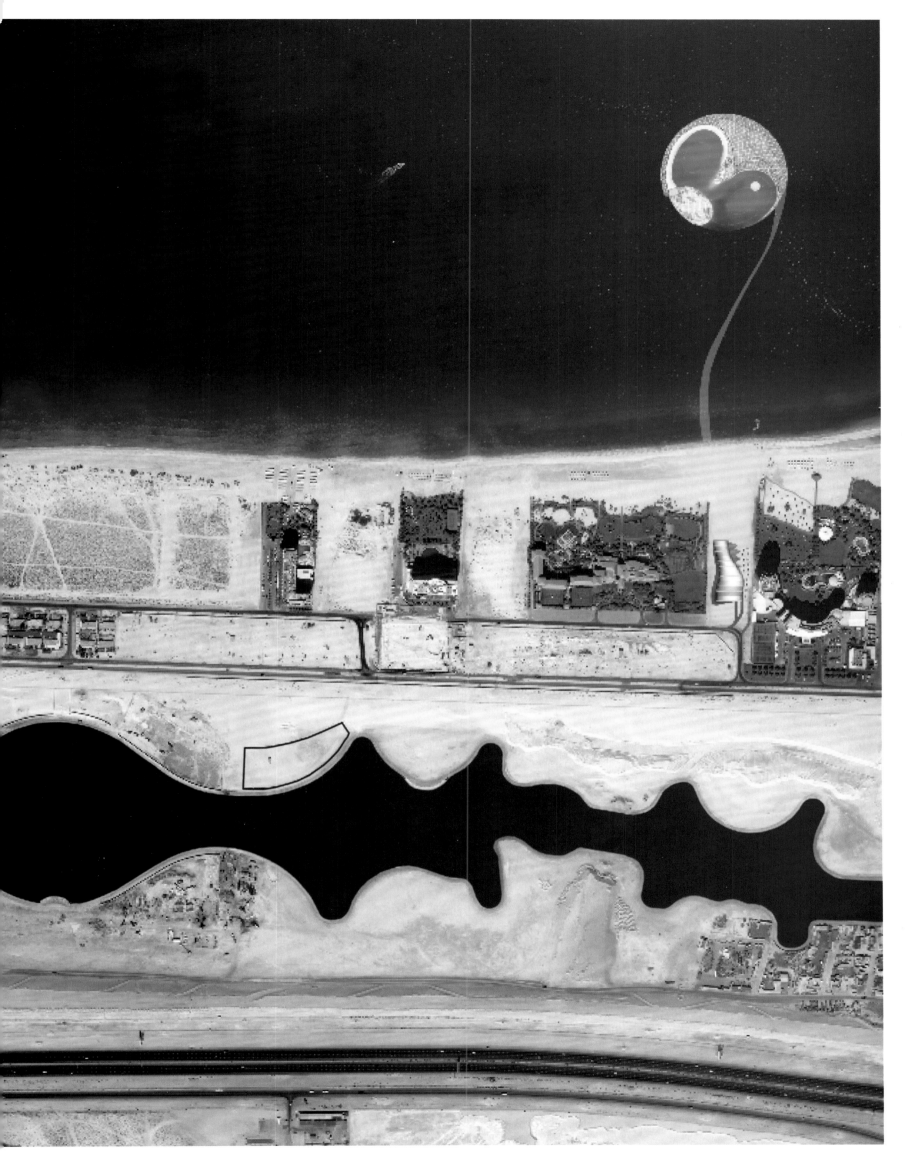

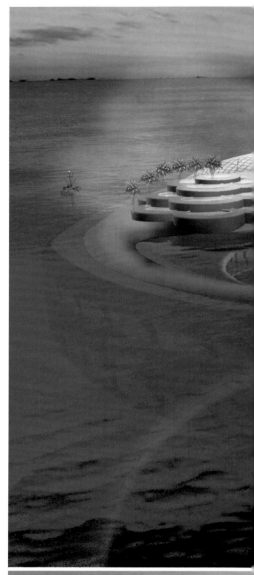

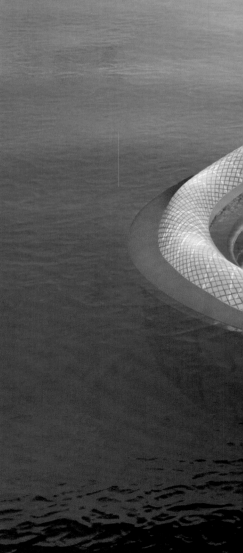

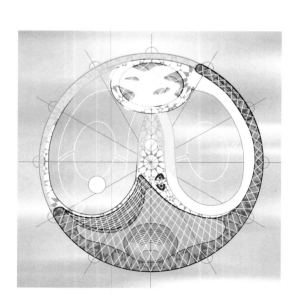

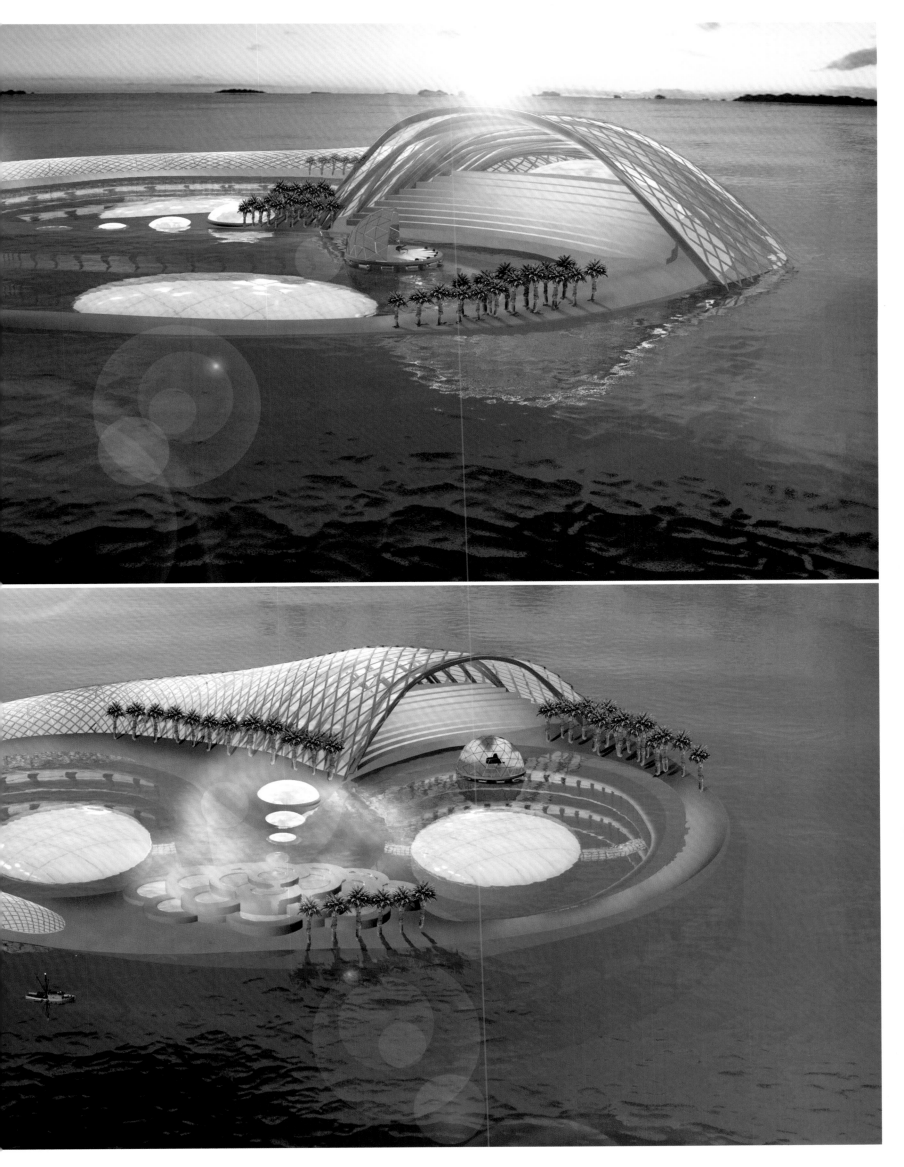

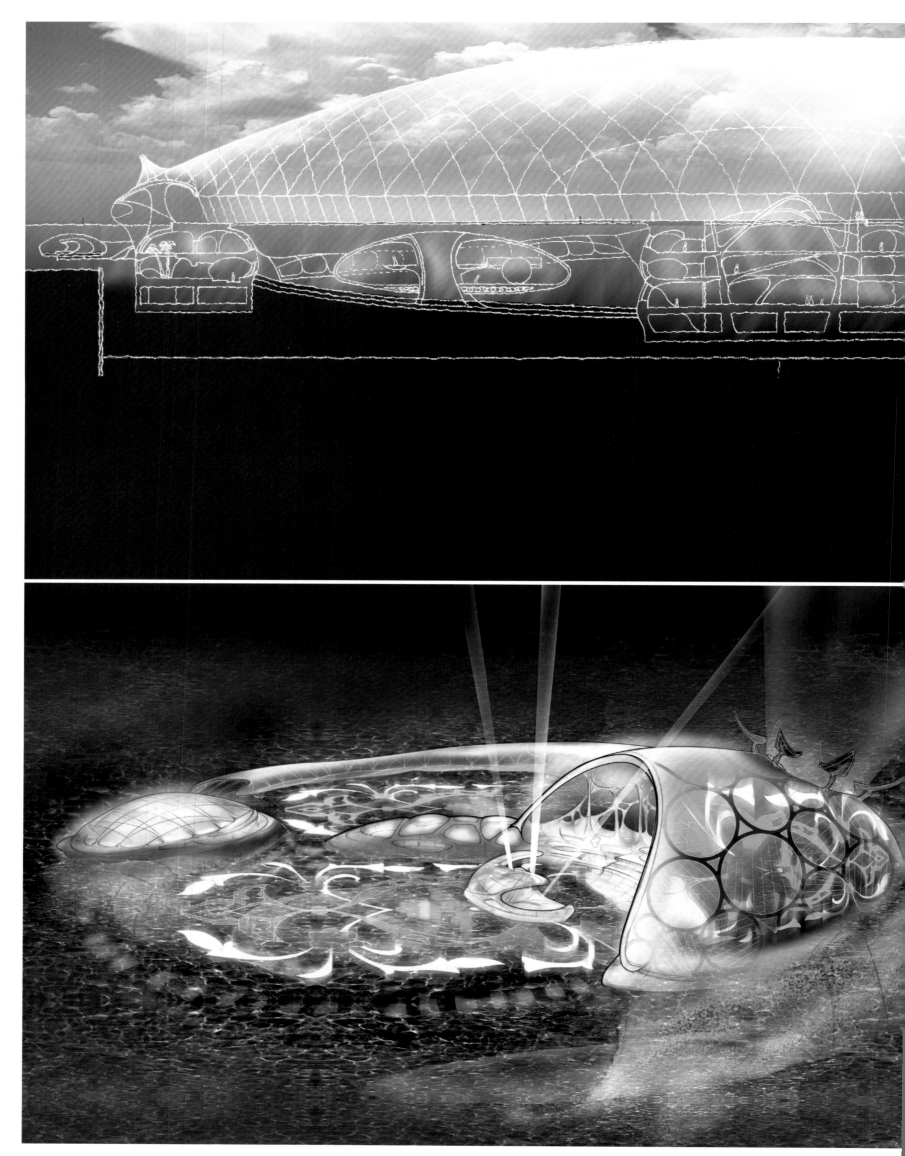

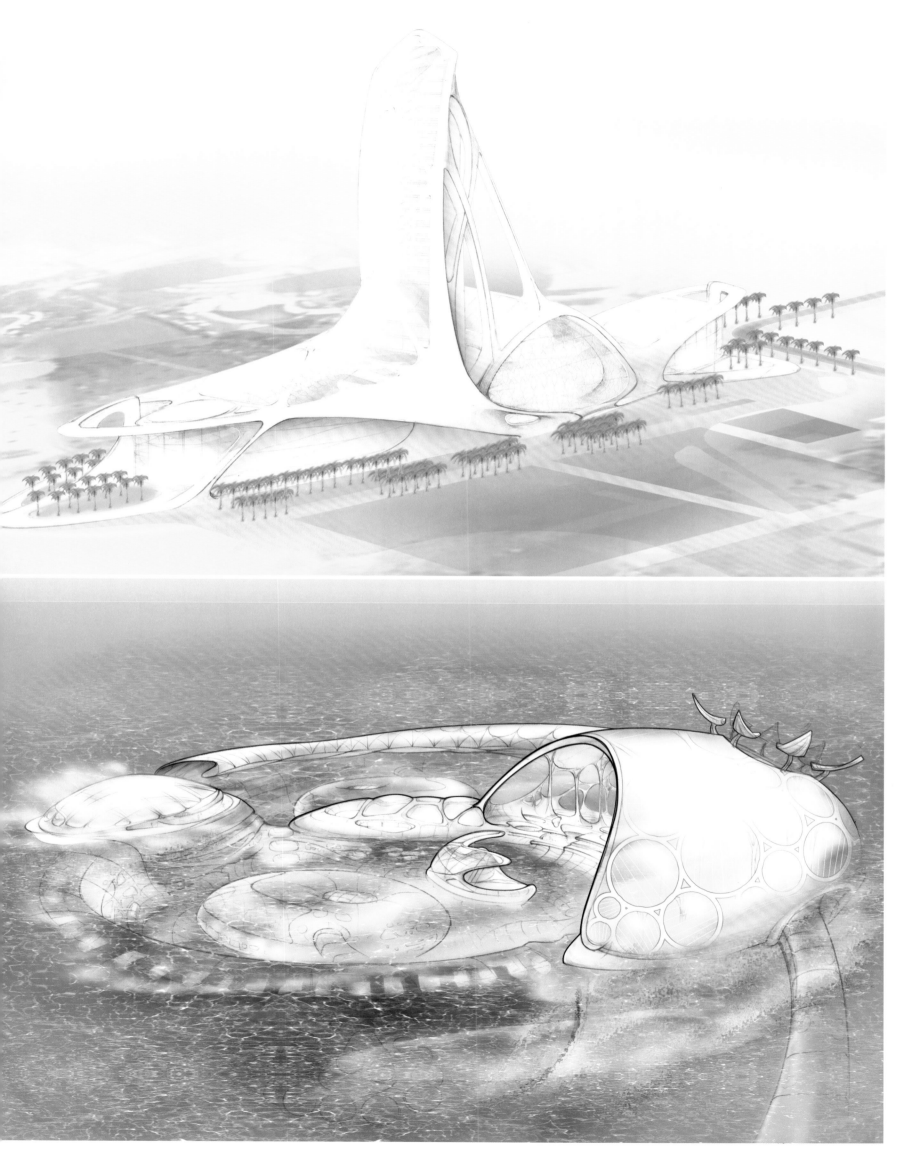

Ho+k Hellmuth, Obata + Kassabaum

Dubai Autodrome | 2004
Emirates Ring Road
Photos: © Courtesy Dubai Autodrome

Am Horizont flimmert die Skyline von Dubai, davor windet sich eine der modernsten FIA-Rennstrecken über 5,39 Kilometer durch den Wüstensand. Der Kurs erlaubt sechs unterschiedliche Streckenführungen mit höchsten Ansprüchen an die Fahrer. Daneben beeindruckt gestalterisch das Verwaltungsgebäude. Das wirkt licht und leichtfüßig, wie es auf seinen dünnen Stützen schwebt.

The skyline of Dubai shimmers on the horizon and right in front of it winds one the most modern FIA race tracks of 5.39 kilometers through the desert sand. The track can take six different shapes with the highest demands on the drivers. The design of the office building is also impressive, seeming weightless and light-footed on its slim pillars.

Con el horizonte de Dubai fulgurando a lo lejos, uno de los circuitos de la FIA de fórmula uno más modernos se extiende en 5,39 kilómetros, a través de la arena del desierto. El recorrido propone a los conductores seis circuitos diferentes a los niveles más exigentes. Al lado se levanta el edificio de oficinas con su imponente estructura, que parece flotar luminosa y ligera sobre sus estrechos apoyos.

Alors qu'à l'horizon scintille la silhouette de Dubaï, sur le devant un circuit automobile FIA des plus modernes avec plus de 5,39 kilomètres se déroule dans le désert. Le circuit comprend six parcours différents qui exigent les plus grandes qualités de la part du pilote. La forme du bâtiment de bureau située à côté est impressionnante. La manière dont il flotte sur ses fins piliers lui confère un caractère aéré et élancé.

Sullo sfondo orlato dallo skyline di Dubai all'orizzonte, ecco l'autodromo di Dubai, uno dei più moderni circuiti FIA, che si snoda fra la sabbia desertica per 5,39 chilometri. Il percorso mette alla prova i piloti con sei diversi tipi di tracciato molto impegnativi. La construzione di ufficio a lato del circuito si impone all'attenzione per la sua luminosità e leggerezza, sottolineata dall'esilità delle colonne su cui la struttura pare essere appena appoggiata.

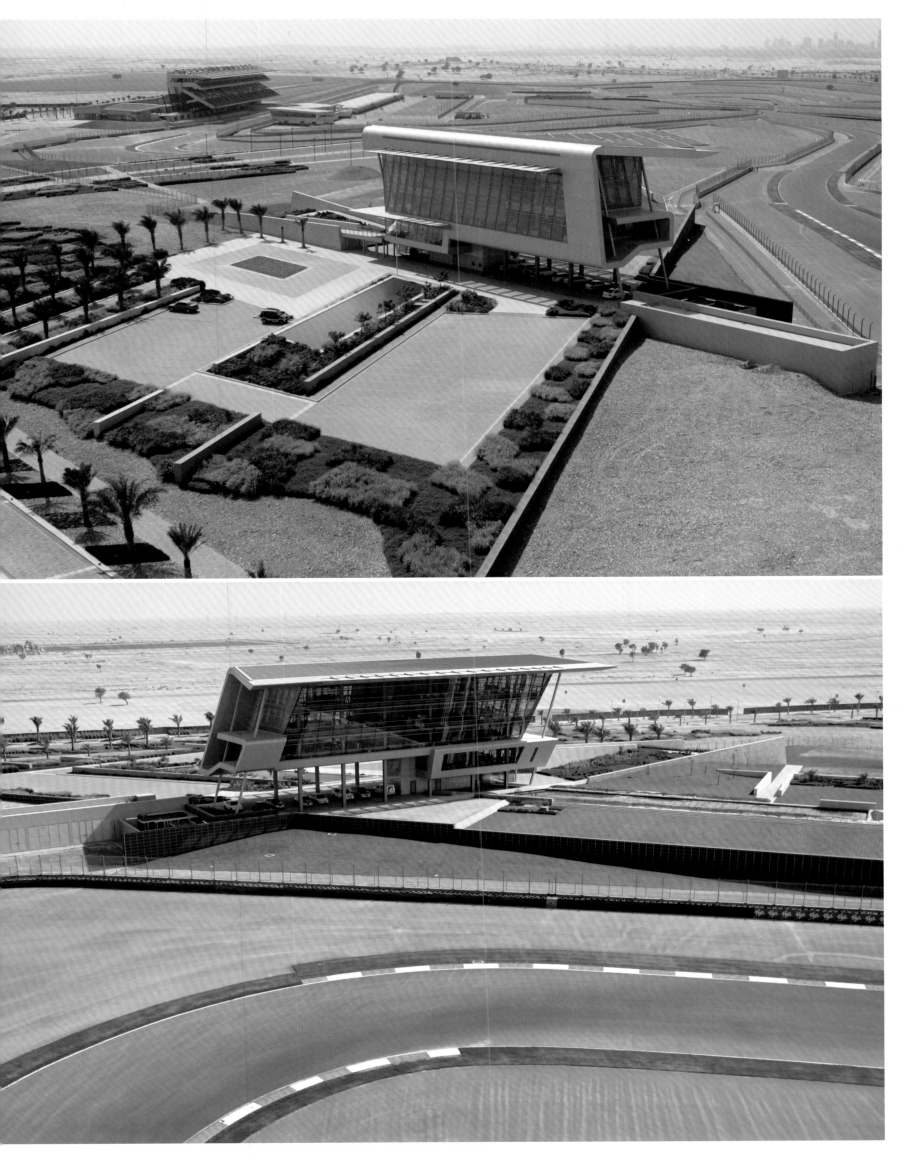

Concept/Scheme Design by Jung Brannen Associates,
Detailed Design, Engineering and Supervision by Dewan Architects & Engineers
Media-1 | 2007
Media City
Photos: © Jung Brannen, Dewan Architects

Pixel, diese kleinste Einheit der digitalen Welt, steht architektonisch Pate für den Al Jabar Tower. Wie ein Schleier umhüllt ein Mosaik von gläsernen Panelen das sich nach oben hin verjüngende Stahlgebäude. Das Gemeinschaftsprojekt amerikanischer und arabischer Planer setzt einen dynamisch wie luzide wirkenden Fingerzeig am Eingang zu Dubais Media-City.

A pixel, the smallest unit in the digital world, was the architectural inspiration for the Al Jabar tower. A mosaic of glass panels covers the upward tapering steel building like a veil. The joint project by American and Arab planners presents a dynamic and lucid impression of a pointing finger at the entrance of Dubai's Media city.

El píxel, la mínima unidad del mundo digital, tiene su modelo arquitectónico en la Al Jabar Tower. Un mosaico de paneles de vidrio envuelve como un velo hacia lo alto un joven edificio de acero. El proyecto llevado en común por planificadores americanos y árabes constituye un punto de atención dinámico y lúcido a las puertas de la Media-City de Dubai.

Le pixel, la plus petite unité du monde digital, a inspiré l'architectonique de la tour Al Jabar. Une mosaïque de panneaux de verre enveloppe comme un voile la structure métallique qui se rétrécit vers le haut. Le projet collectif des planificateurs américains et arabes ouvre la voie d'une manière aussi dynamique que lucide à l'entrée de la Media City de Dubaï.

La scoperta del pixel, la più piccola unità del mondo digitale, è la condizione sine qua non che ha reso possibile la concezione architettonica dell'Al Jabar Tower. Come una garza leggerissima, una miriade di tasselli in vetro avvolge l'edificio in acciaio dalla forma che va assottigliandosi verso l'alto. Nato da un progetto comune di architetti americani ed arabi, l'Al Jabar Tower, posto strategicamente all'entrata di Dubai Media City, si carica di una forza simbolica tanto dinamica quanto trasparente.

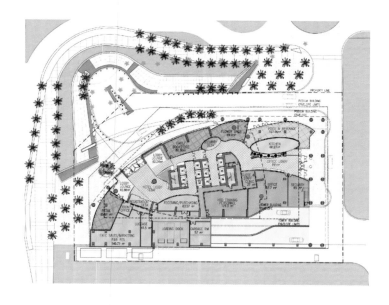

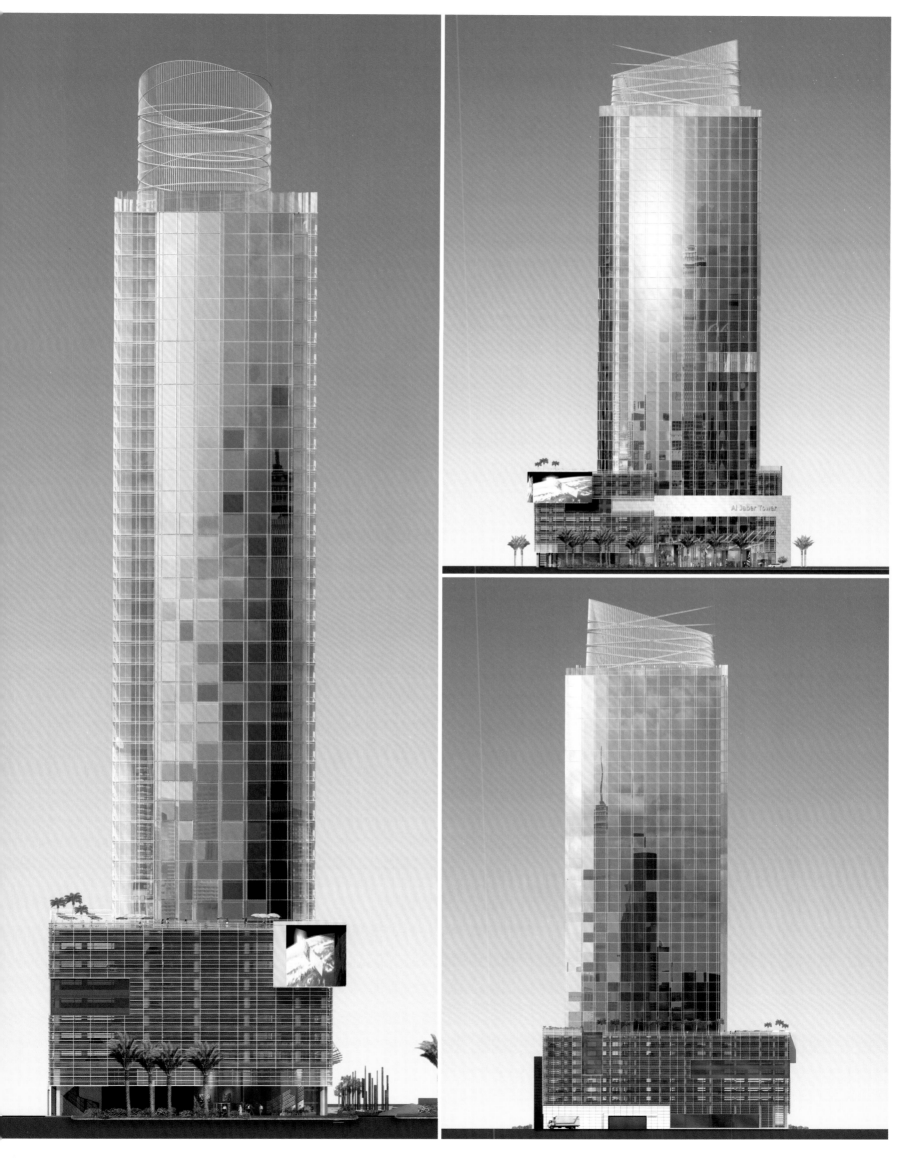

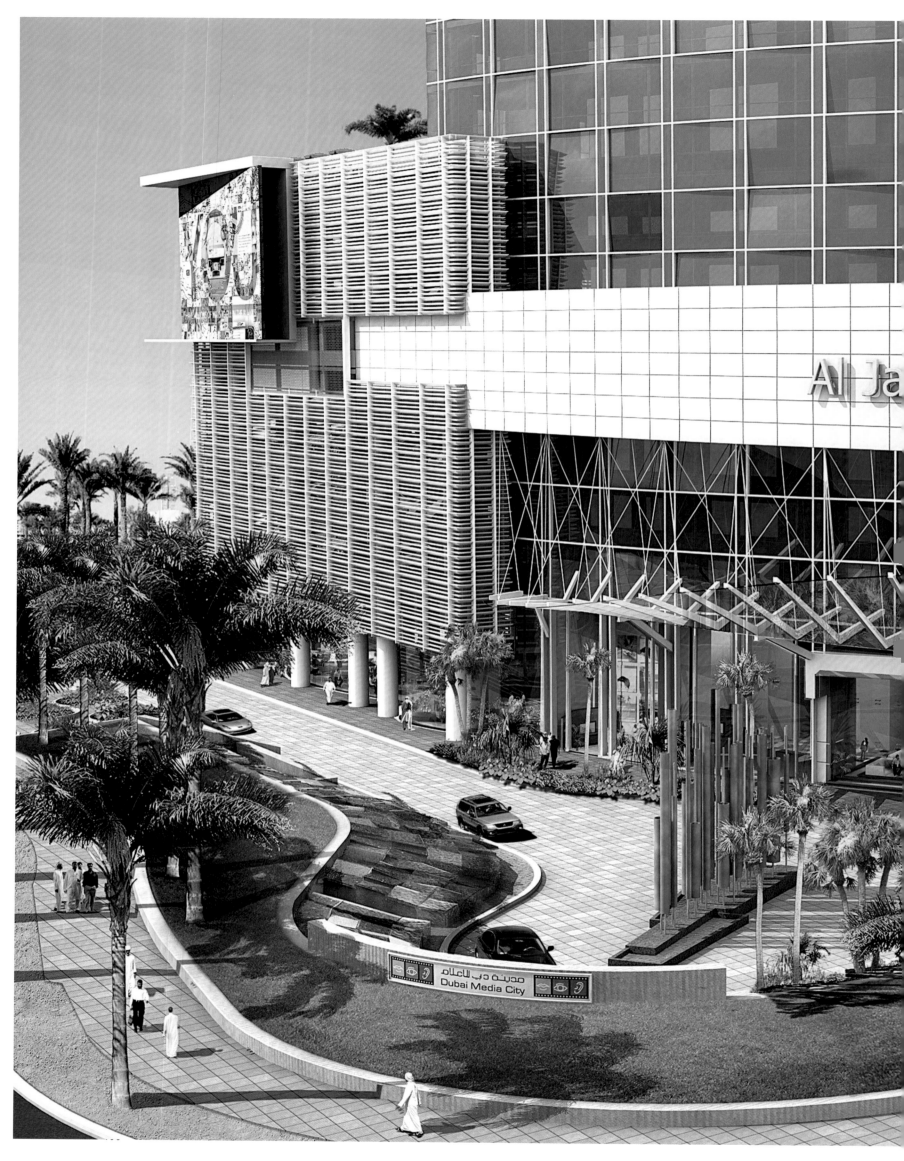

KCA International Designers
Al Mahara at Burj Al Arab | 1999
Jumeirah Beach Road
Photos: © Courtesy Jumeirah

Als säße man mitten in der Unterseewelt, so mutet dieses spektakuläre Restaurant im Hotel des Burj Al Arab an. Vom Boden bis zur Decke reflektieren Design und Interieur alle Schattierungen des Meeres. Ein umspannendes Aquarium in der Mitte des Raumes verstärkt dieses Empfinden. Zum visuellen Entree gehört eine simulierte Reise unter Wasser.

This spectacular restaurant in Burj Al Arab gives visitors the impression of sitting in the midst of a deep sea world. From the floor to the roof, the design and interior reflect every shade of the sea. An encompassing aquarium in the center of the room amplifies this sensation. A simulated undersea journey is part of the visual offerings.

Un espectacular restaurante en el hotel de Burj Al Arab, que parece trasladar al fondo marino. Desde el suelo hasta el techo está vestido de un diseño e interiores que reflejan todas las facetas del mar, aún más acentuado si cabe por un amplio acuario ubicado en el centro de la sala. Como entremés visual se ofrece un viaje simulado bajo el agua.

Ce restaurant spectaculaire de l'hôtel de Burj Al Arab donne l'impression que l'on est assis dans un univers subaquatique. Du sol au plafond, le design et l'architecture intérieure reflètent toutes les facettes de la mer. Un aquarium entoure le milieu de la pièce et renforce cette impression. Une simulation de voyage sous-marin sert d'entrée visuelle.

Un'immersione fino al fondale sottomarino: questa è la sensazione che si avverte entrando nello spettacolare ristorante ubicato nell'hotel Burj Al Arab. Dal pavimento al soffitto, le soluzioni di design e arredamento riflettono tutte le sfumature cromatiche del mare. Un acquario a tutto tondo al centro della sala intensifica l'effetto. Ne è preludio visivo la simulazione di un viaggio sott'acqua.

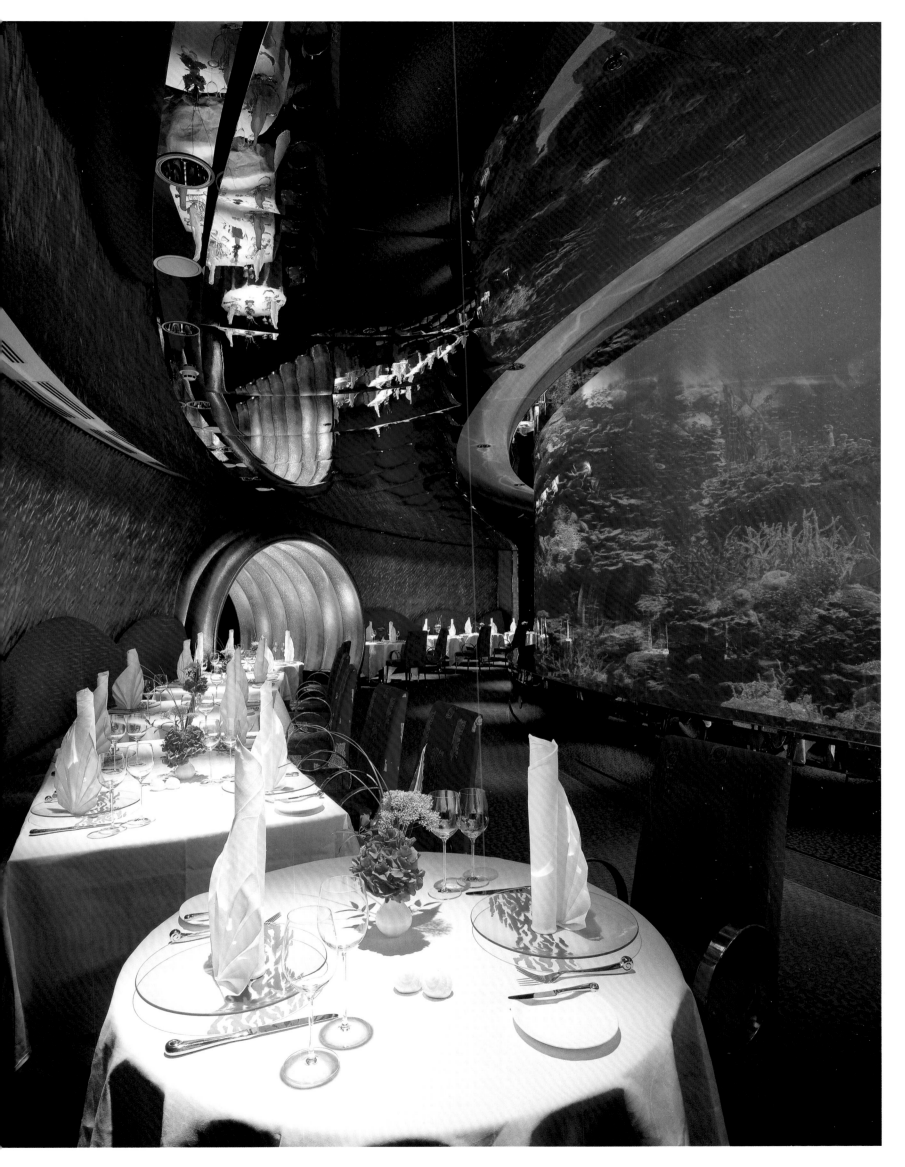

KCA International Designers
Arboretum at Al Qasr Hotel, Madinat Jumeirah | 2004
Al Sufouh Road
Photos: © Courtesy Jumeirah

Der Sultanspalast Al Quasr gehört zu den exklusivsten Hotels im Madinat-Resorts. Entsprechend edel ausgestattet treten die diversen Restaurants dieses Objekts auf. Das Arboretum im Parterre setzt auf die authentische Erscheinung: eine großzügige und hohe Räumlichkeit, das Interieur originalgetreu und dazu eine freundlich helle Farbgebung. Dezent treten die Accessoires in den Hintergrund.

The Al Quasr Sultan's palace is among the most exclusive hotels of the Madinat resort. Accordingly, its various restaurants are elegantly decorated. The Arboretum on the ground floor has an authentic appearance: spacious and high-ceilinged rooms and a true-to-nature interior with friendly and bright colors. The accessories remain modestly in the background.

El palacio de los sultanes Al Quasr se considera uno de los hoteles más exclusivos del resort Madinat. La elegante decoración de sus restaurantes da muestra clara de ello. El arboretum de la planta baja evidencia autenticidad: una amplia estancia de techo elevado con un interior fiel al original, en tonos alegres y claros y enmarcado por accesorios discretos de fondo.

Le palais du sultan Al Quasr fait partie des hôtels les plus luxueux des complexes touristiques Madinat. Les divers restaurants de cet ensemble sont aménagés avec l'élégance correspondant à leur classe. L'arboretum au rez-de-chaussée mise sur l'authenticité : un espace haut et vaste, un aménagement intérieur fidèle à l'original et de surcroît des coloris agréablement clairs. Les accessoires apparaissent discrètement à l'arrière-plan.

La residenza del sultano è uno degli hotel più prestigiosi del Madinat Resort. All'insegna dell'esclusività è anche l'arredamento dei diversi ristoranti distribuiti su tutta la sua superficie. L'Arboretum, ubicato nel parterre, punta sull,autenticità: spazi ampi, soffitti alti, interni ricostruiti fedelmente nonché un'armoniosa scelta cromatica che privilegia le tonalità chiare. I complementi d'arredo colpiscono per la loro sobrietà.

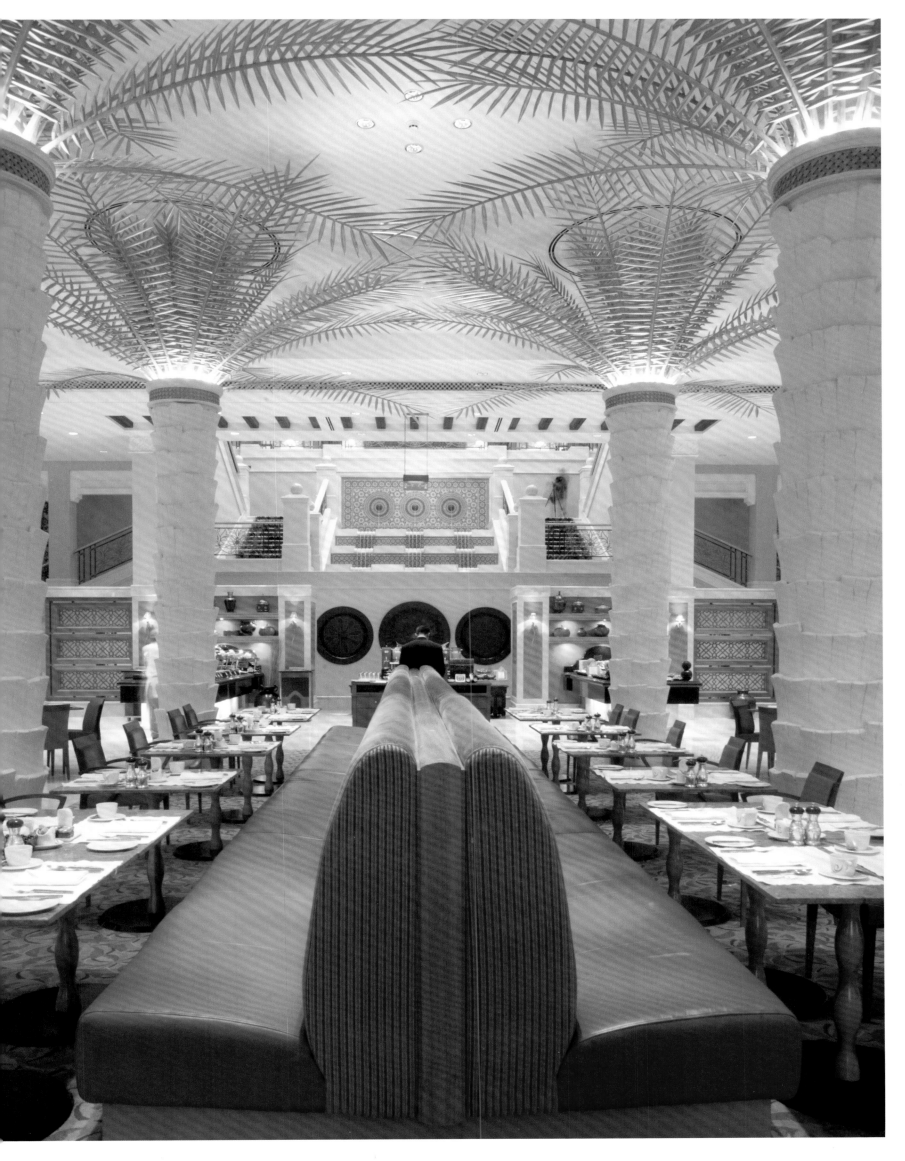

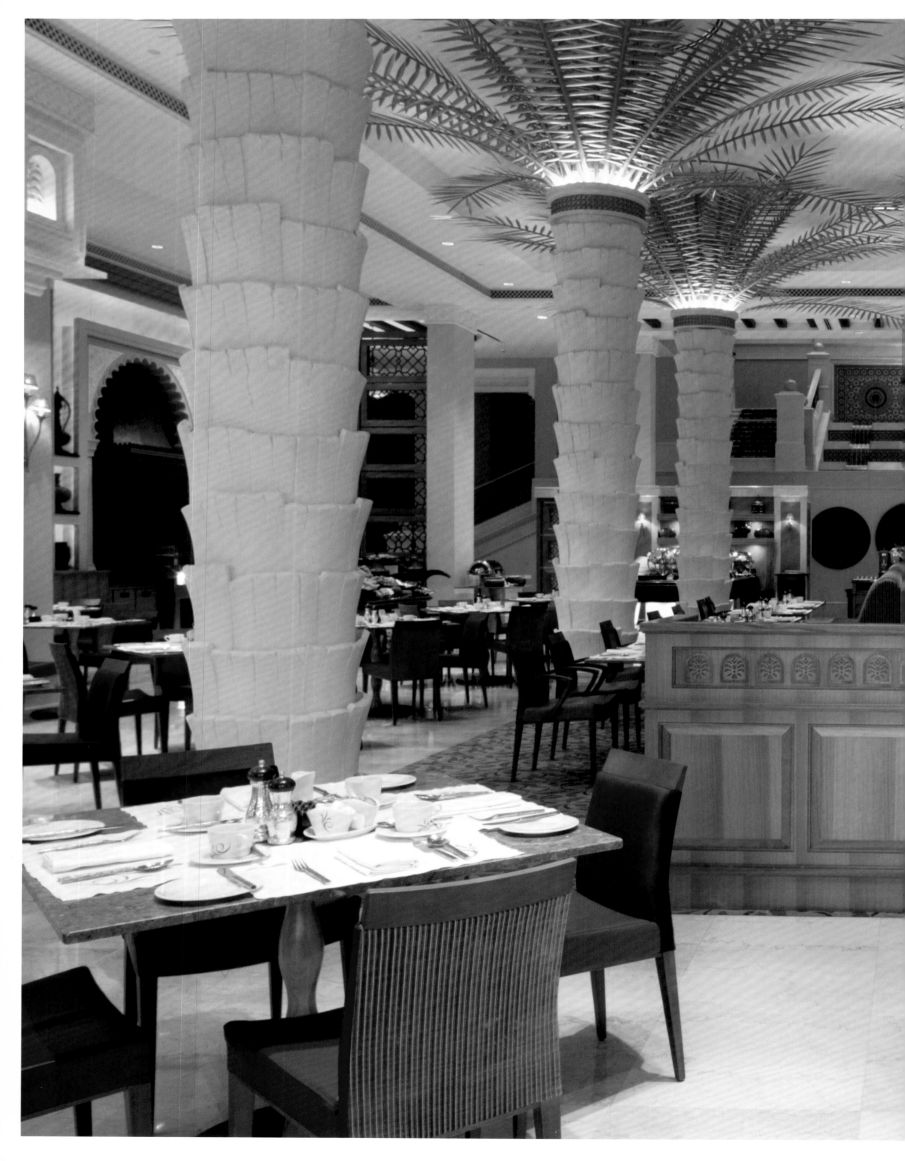

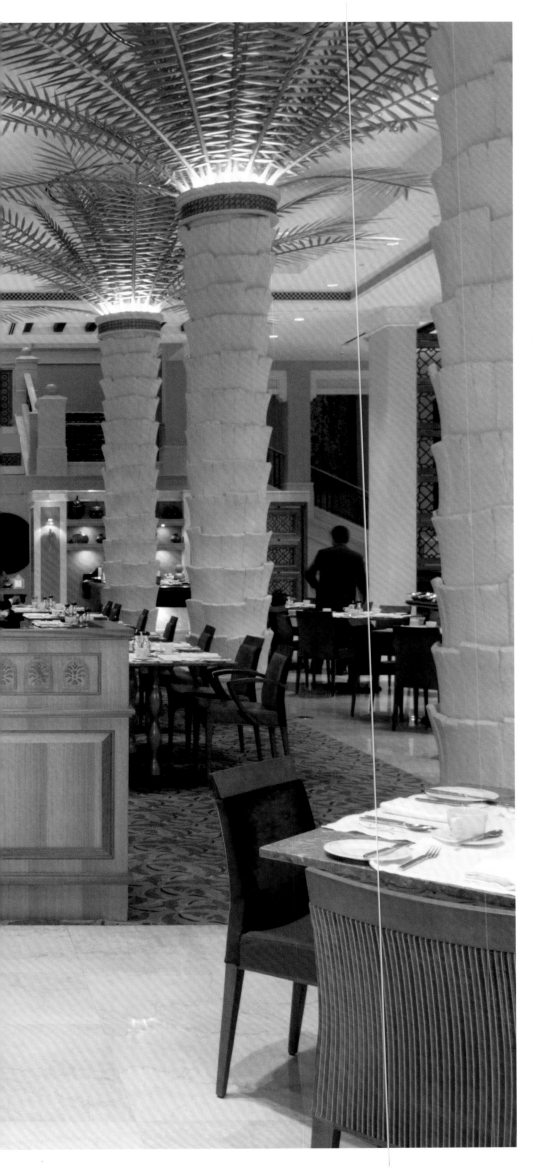

KCA International Designers

Pierchic Restaurant at Madinat Jumeirah | 2004
Al Sufouh Road
Photos: © Courtesy Jumeirah

Zum Madinat-Resort gehört ein kilometerlanger Strand, an dem eigens ein Pier angelegt wurde. Dort – am Ende des Holzsteges, das imposante Burj Al Arab scheint schon greifbar – wartet das Pierchic. Doch es ist mehr als die exponierte Lage, die das Seafood-Restaurant auszeichnen: Zur idyllischen Terrasse fügen sich urbanes Design und kühl-romantische Lichteffekte.

The Madinat resort include a beach stretching along several kilometers with a specially-constructed jetty. There, at the end of the wooden landing stage, with the impressive Burj Al Arab seemingly within reach, lies the Pierchic. But the seafood restaurant is not only distinguished by its prominent location, as it also features an idyllic terrace coupled with urban design and cool-romantic light effects.

El resort Madinat cuentan con una playa kilométrica y embarcadero propio. Siguiendo hasta el final de la pasarela de madera se llega al Pierchic, desde donde, casi al alcance de la mano, se levanta la imponente figura del Burj Al Arab. Pero si este restaurante marisquería es excelente no se debe sólo a su privilegiada ubicación, sino más aún a la fusión entre diseño urbano y los frescos y románticos efectos de luz de su idílica terraza.

Le complexe touristique Madinat possède un kilomètre de plage sur laquelle un embarcadère a été spécialement aménagé. Le Pierchic attend là, au bout du ponton de bois, d'où l'imposant Burj Al Arab semble presque à portée de main. Ce n'est pas seulement le site très en vue qui distingue le restaurant de poissons, mais aussi la terrasse idyllique qu'accompagnent un design urbain et des effets de lumière d'un romantisme rafraîchissant.

Del Madinat resort fa parte anche una spiaggia lunga chilometri per la quale è stato creato appositamente un molo. È proprio all'estremità del pontile di legno, dove la maestosa vela del Burj Al Arab è già così vicina che sembra di poterla toccare, che si trova Pierchic. Ma non è solo la posizione d'eccezione a contraddistinguere questo ristorante di pesce: l'idilliaca terrazza trova un'armoniosa continuazione all'interno nello stile metropolitano e negli effetti luminosi giocati sul contrasto freddo-romantico.

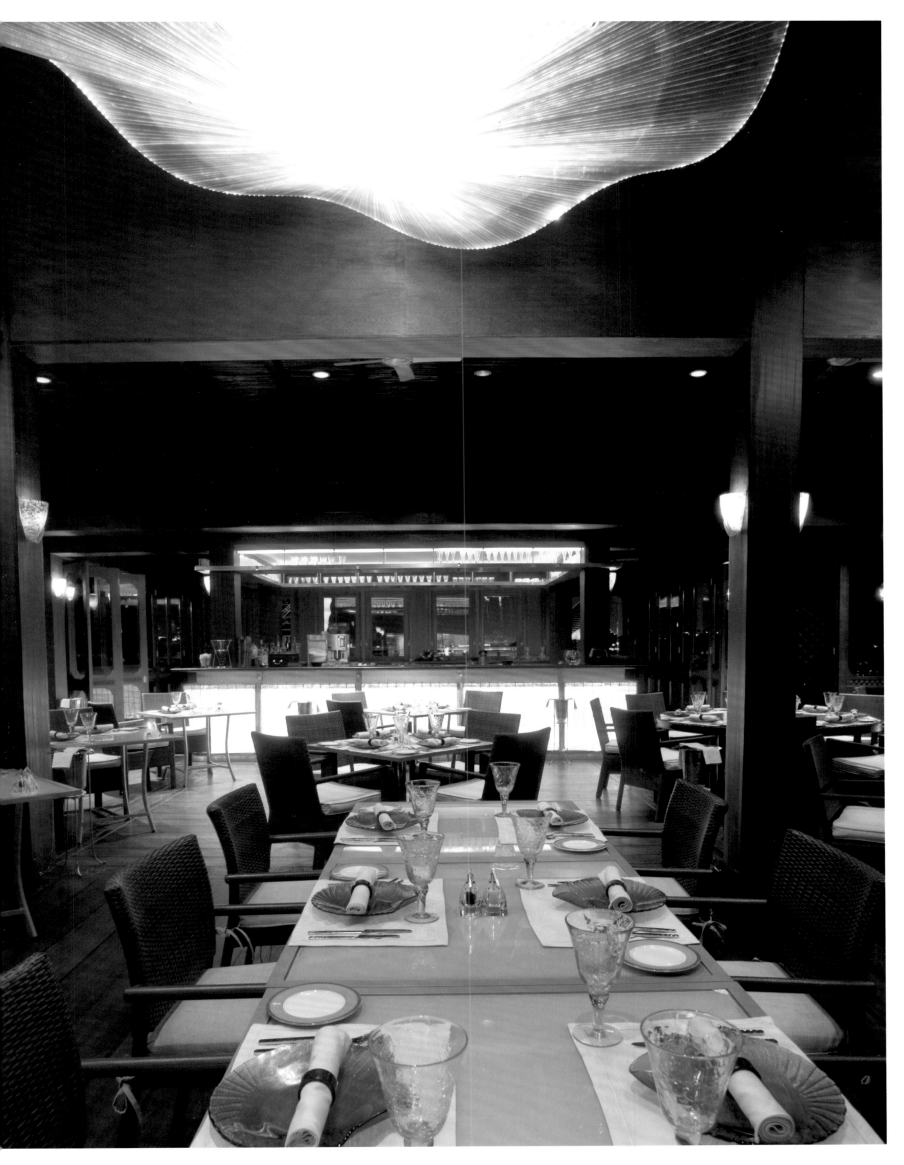

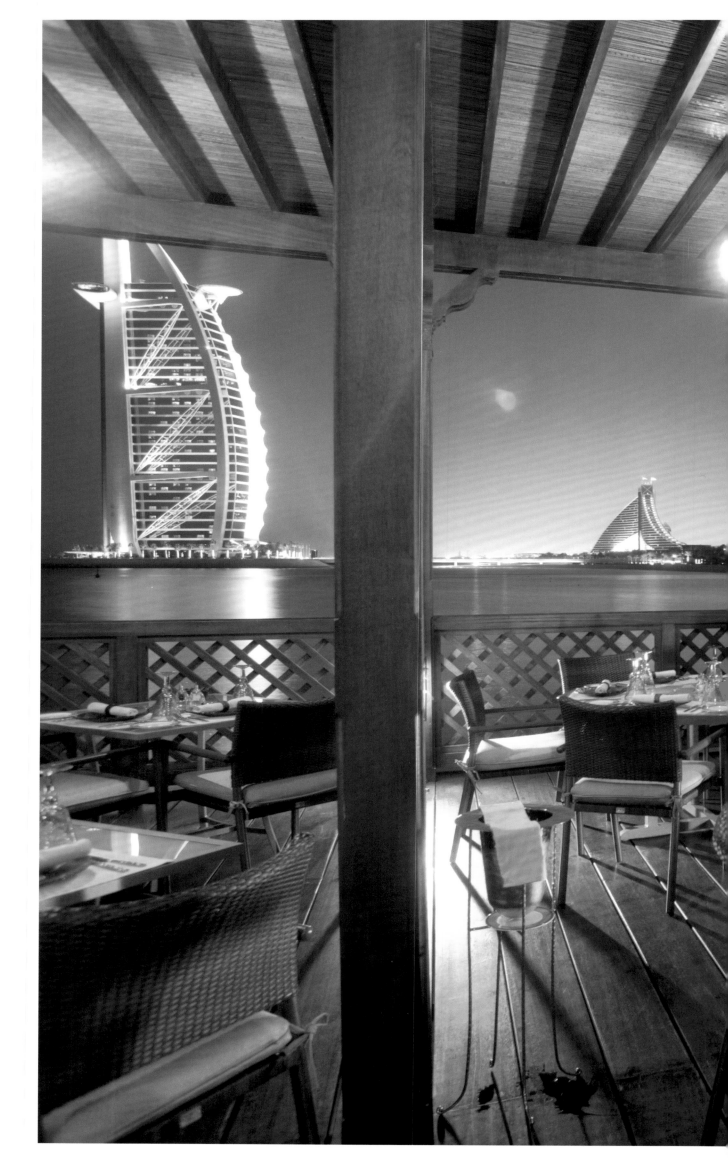

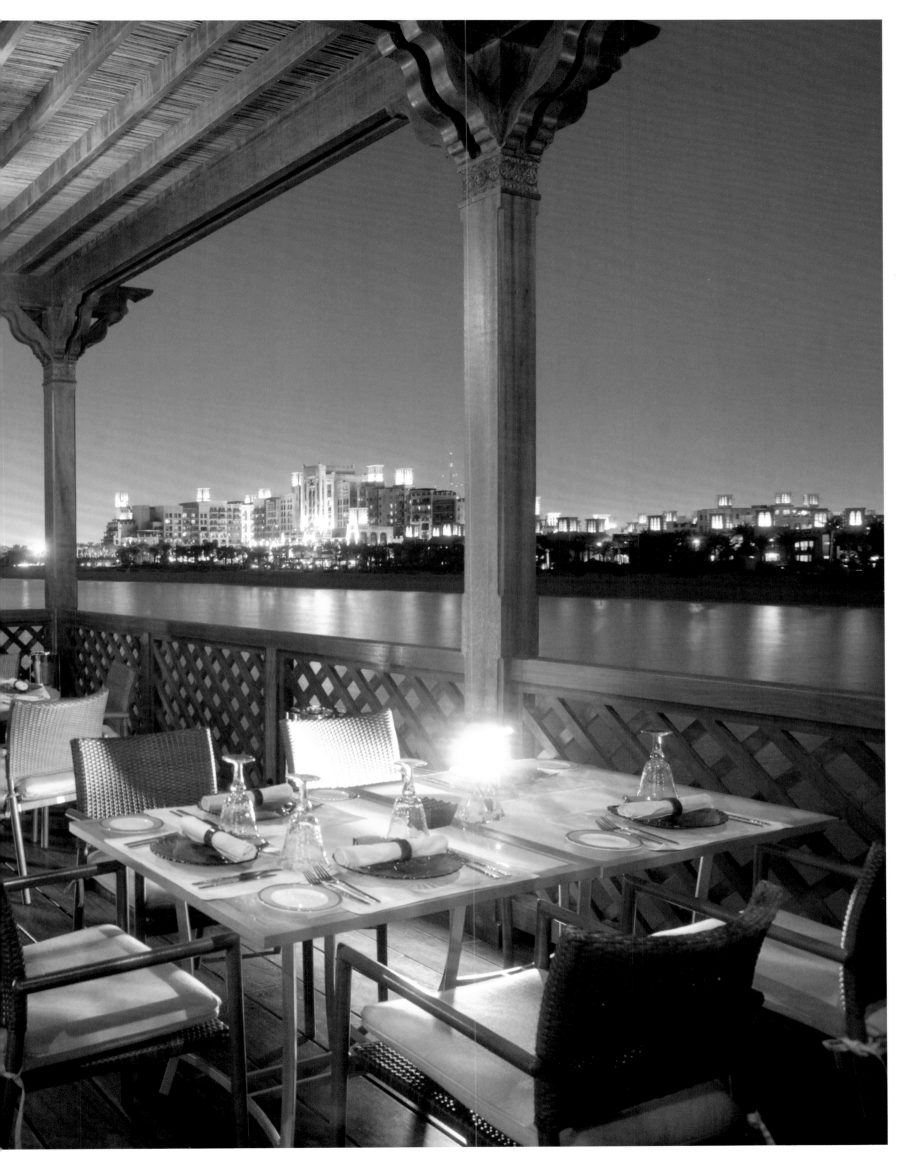

KCA International Designers

Segreto at Madinat Jumeirah | 2004
Al Sufouh Road
Photos: © Courtesy Jumeirah

Was die arabische Kultur an figürlicher Darstellung verbietet, das macht sie allemal wett durch ihren Sinn für Ornamente und Muster. Derart lässt sie sich vorzüglich mit dem klaren Stil der Klassischen Moderne verbinden. Das Restaurant Segreto belegt dies par excellence: Das wirkt edel in Gestalt und Material und umrahmt würdig die gehobene italienische Küche des Restaurants.

The Arabic culture forbids figurative art, but it more than compensates for this by its sense for ornaments and design. This way, it can be successfully linked with the clear style of classical modernity. Segreto restaurant is excellent proof of this. It comes across as noble in both shape and material, creating the perfect setting for its high class Italian cuisine

Lo que la cultura árabe tiene de renuncia a la representación de figuras lo sustituye por un intenso sentido por la ornamentación y el dibujo; y que se complementa de forma excelente con el límpido estilo de la modernidad clásica. El restaurante Segreto es su claro reflejo de ello: forma y materiales elegantes para acoger a la digna excelencia de la cocina italiana.

La culture arabe compense l'interdit de la représentation figurative dans son sens toujours affirmé de l'ornement et du motif. Elle s'accorde de cette manière parfaitement avec le style clair d'un moderne classique. Le restaurant Segreto en est la preuve par excellence : l'élégance, présente dans l'agencement comme dans les matériaux, offre un cadre digne de la cuisine italienne de grande classe du restaurant.

Il divieto di raffigurazione della tradizione culturale araba le impone un limite apparente che essa ha largamente compensato sviluppando una grande sensibilità per gli elementi ornamentali e i motivi decorativi. Questo le permette di conciliarsi perfettamente con lo stile sobrio della modernità classica. Il ristorante Segreto ne offre una sintesi armoniosa, dando vita ad uno stile raffinato nelle forme e nei materiali, in ideale sintonia con la sofisticata cucina italiana del ristorante.

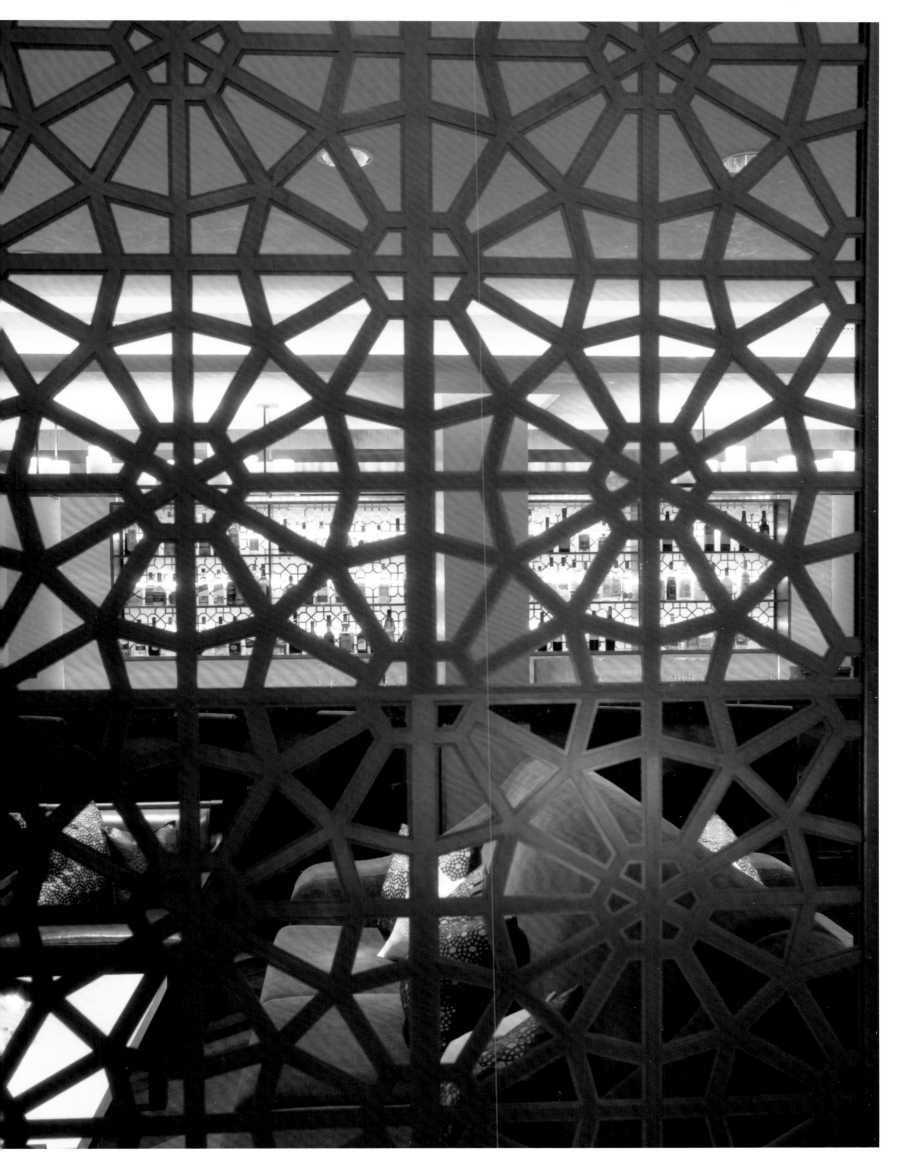

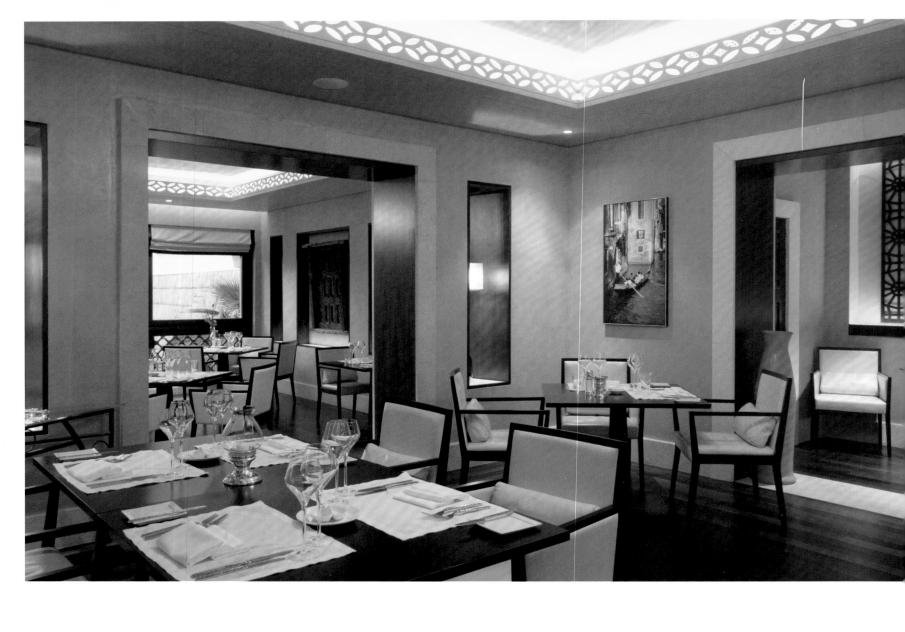

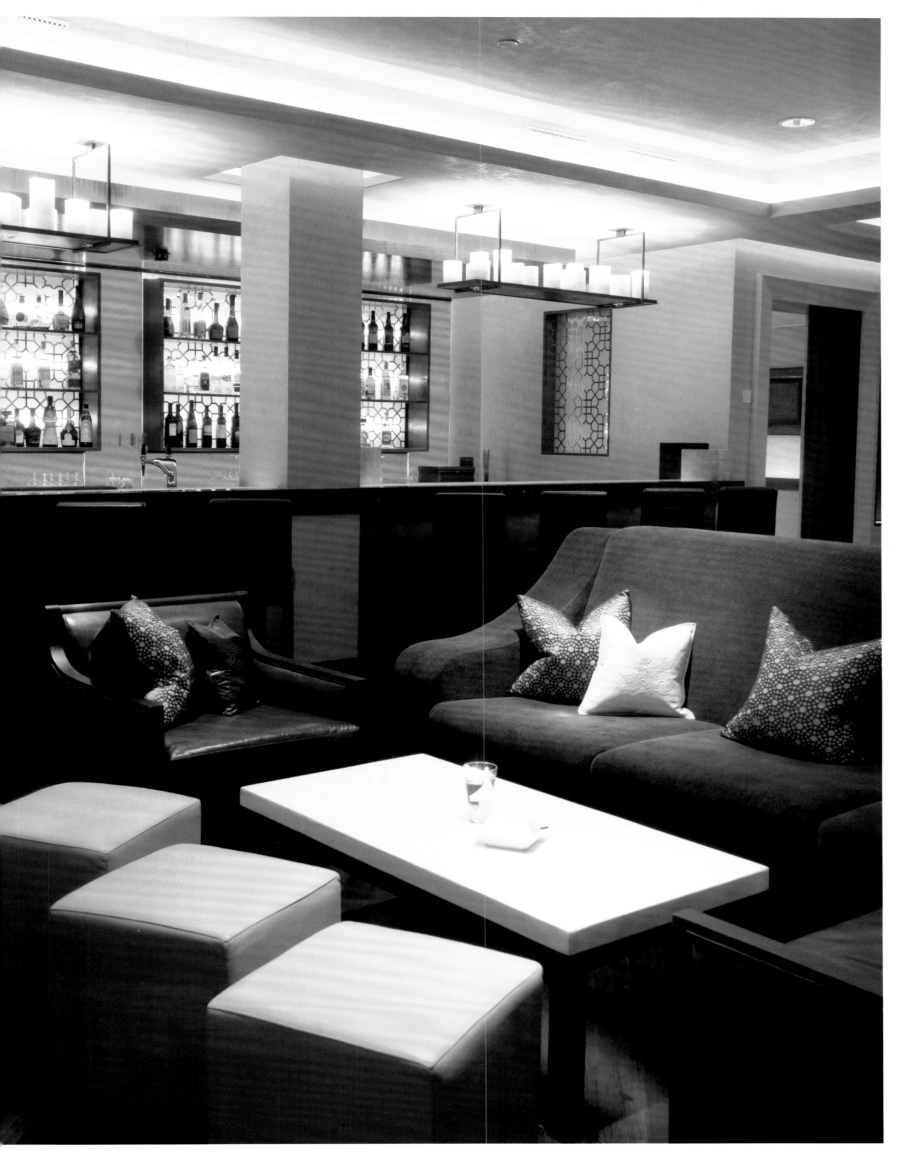

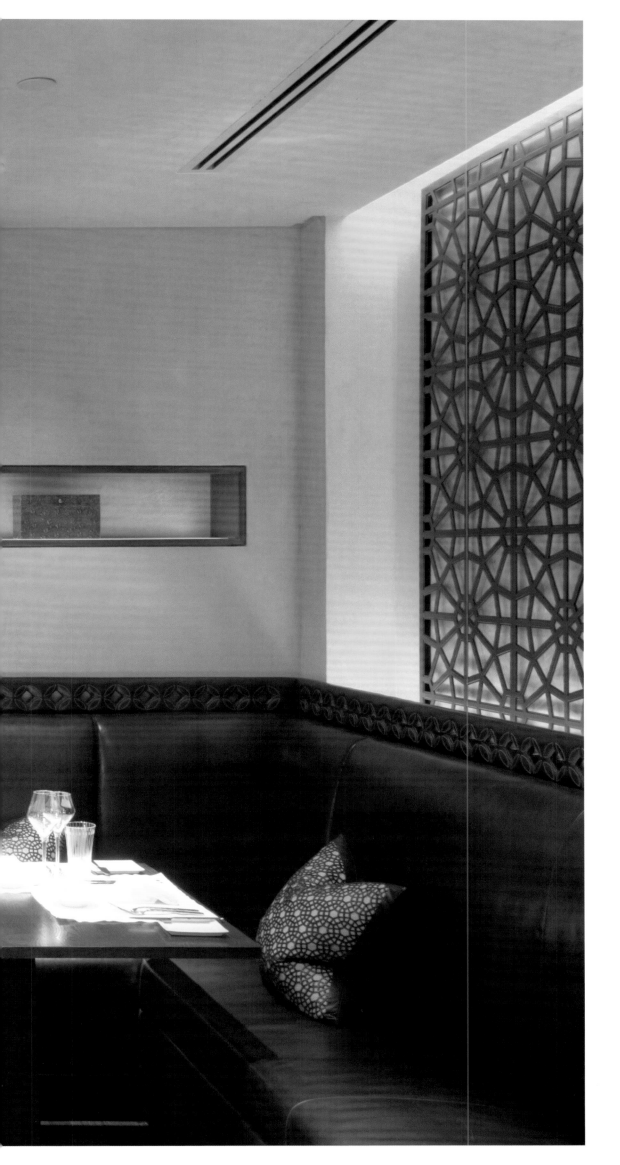

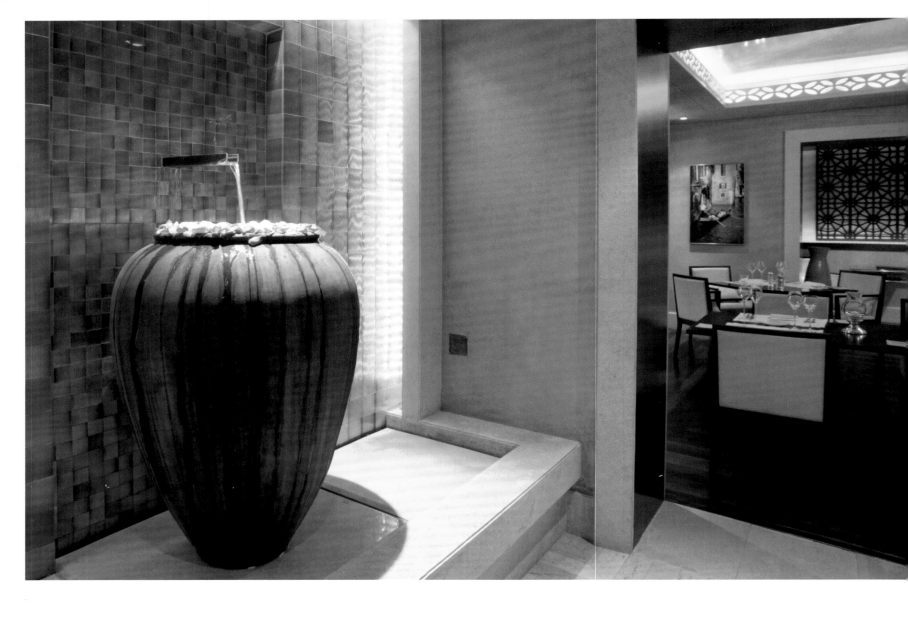

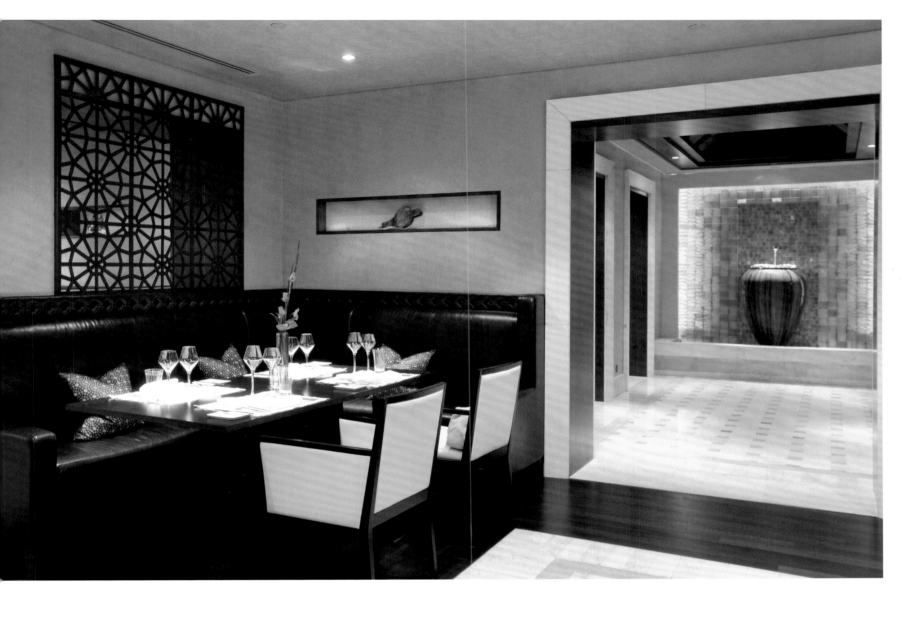

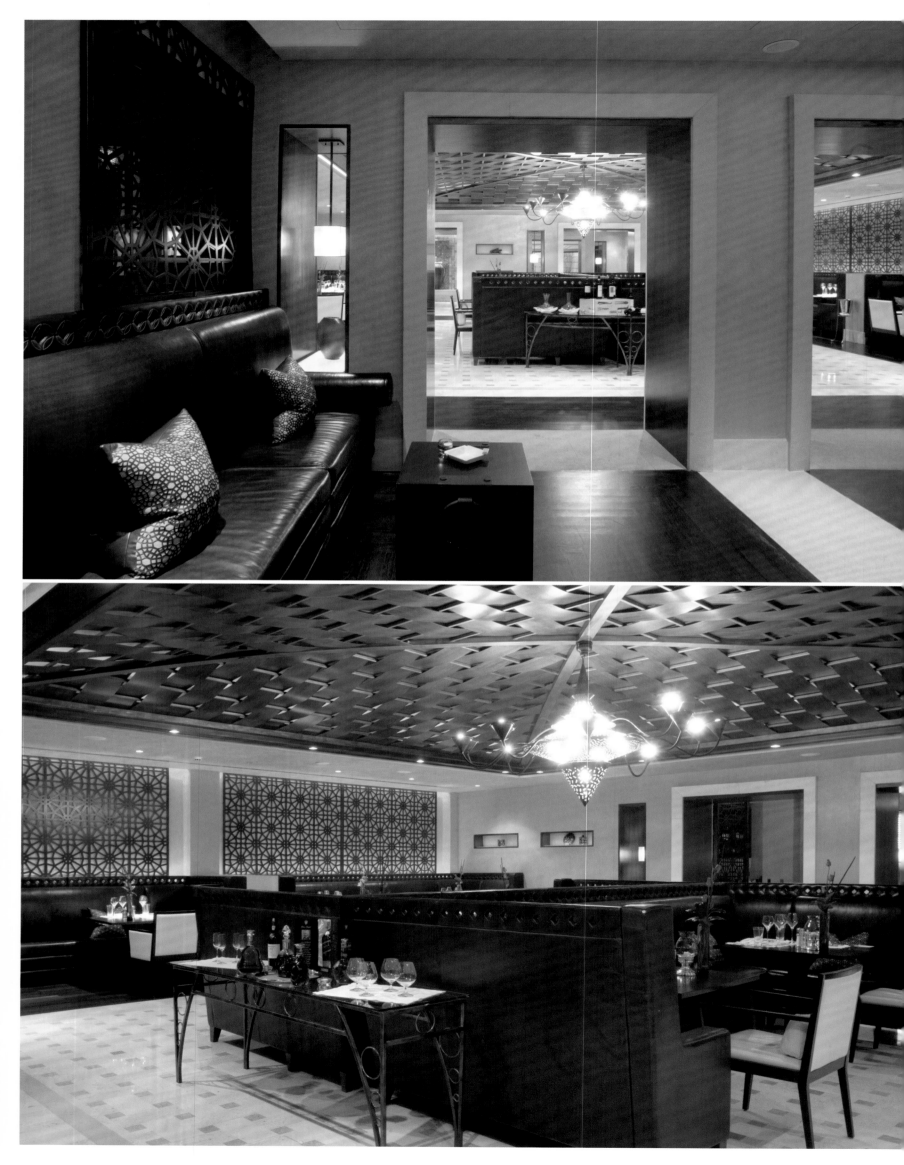

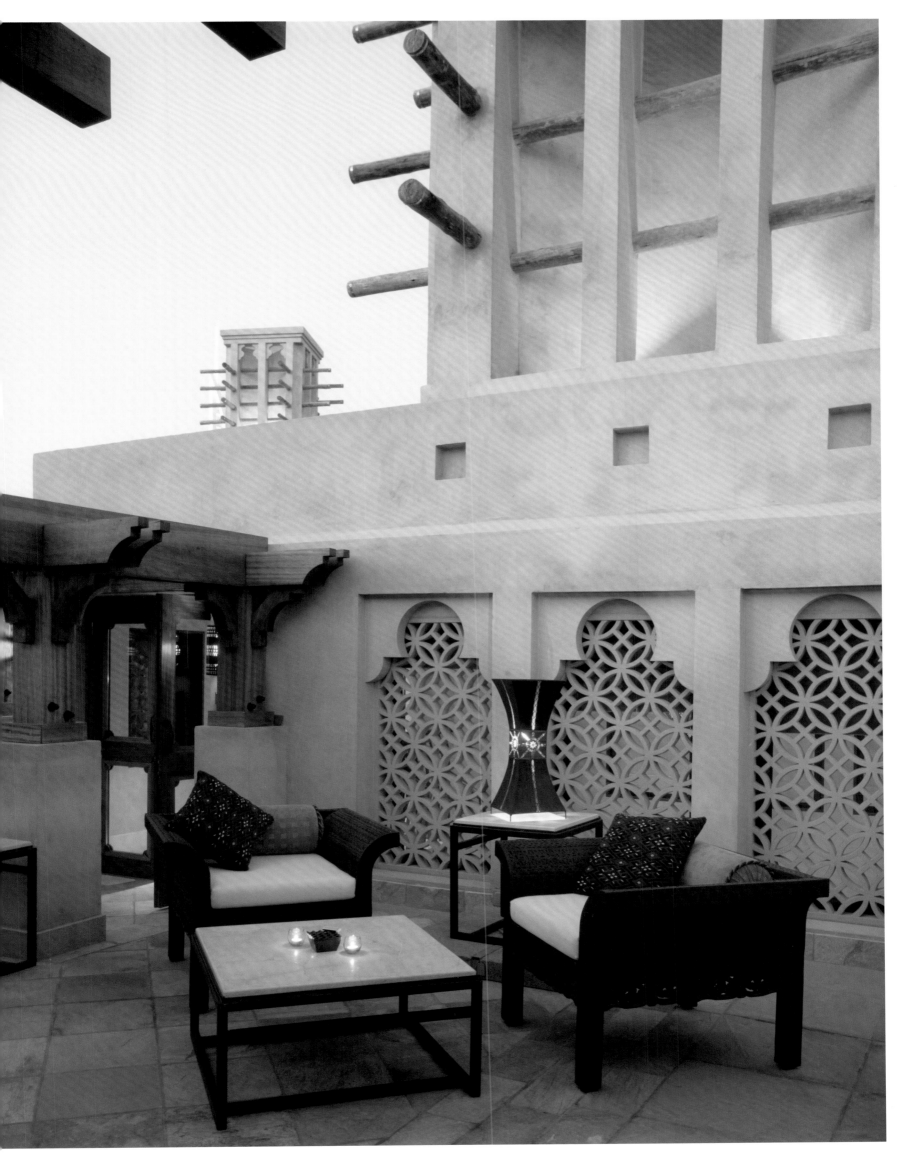

KCA International Designers
Six Senses Spa at Madinat Jumeirah | 2004
Al Sufouh Road
Photos: © Roland Bauer, courtesy Jumeirah

Die Spa umsäumen Wasserkanäle und Gärten mit Bambus, Palmen und Hibiskus. Ein Ort zur inneren Einkehr, der sich auch in den warmen Farben und liebevollen Details des traditionellen Designs reflektiert. Private Rückzugsräume stehen zur Verfügung wie auch zwei Suiten für frisch Vermählte. Der Wellness-Bereich gilt derzeit als der größte im ganzen Mittleren Osten.

The spa is surrounded by waterways and gardens filled with bamboo, palms and hibiscus. It is a place to find inner peace, which is also reflected in the warm colors and loving details of the traditional design. The spa offers private rooms as well as two honeymoon suites. The wellness area is currently the largest in the Middle East.

Este spa es un lugar de recogimiento recorrido por canales, jardines de bambú, palmeras e hibiscos, que se refleja en el diseño tradicional con colores cálidos y cuidados detalles. El spa cuenta con estancias privadas para poder retirarse así como con dos suites para recién casados. El espacio wellness es actualmente el mayor de Oriente Medio.

Le spa borde des canaux et des jardins de bambous, palmiers et hibiscus. Un endroit pour une retraite intérieure, ce que reflètent aussi les couleurs chaudes et les détails soignés du design traditionnel. Des salles pour se retirer sont à disposition ainsi que deux suites pour jeunes mariés. L'espace de bien-être passe pour être actuellement le plus grand de tout le Moyen Orient.

L'area spa è circondata da corsi d'acqua e giardini con bambù, palme ed ibisco. Un luogo ideale dove ritrovare l'armonia interiore, lasciandosi ispirare dalle tonalità calde e dai dettagli del design tradizionale scelti con cura. Per godere della propria privacy sono disponibili stanze appartate e due suite per novelli sposi. Per le sue dimensioni la zona wellness detiene attualmente il primato assoluto in tutto il Medio Oriente.

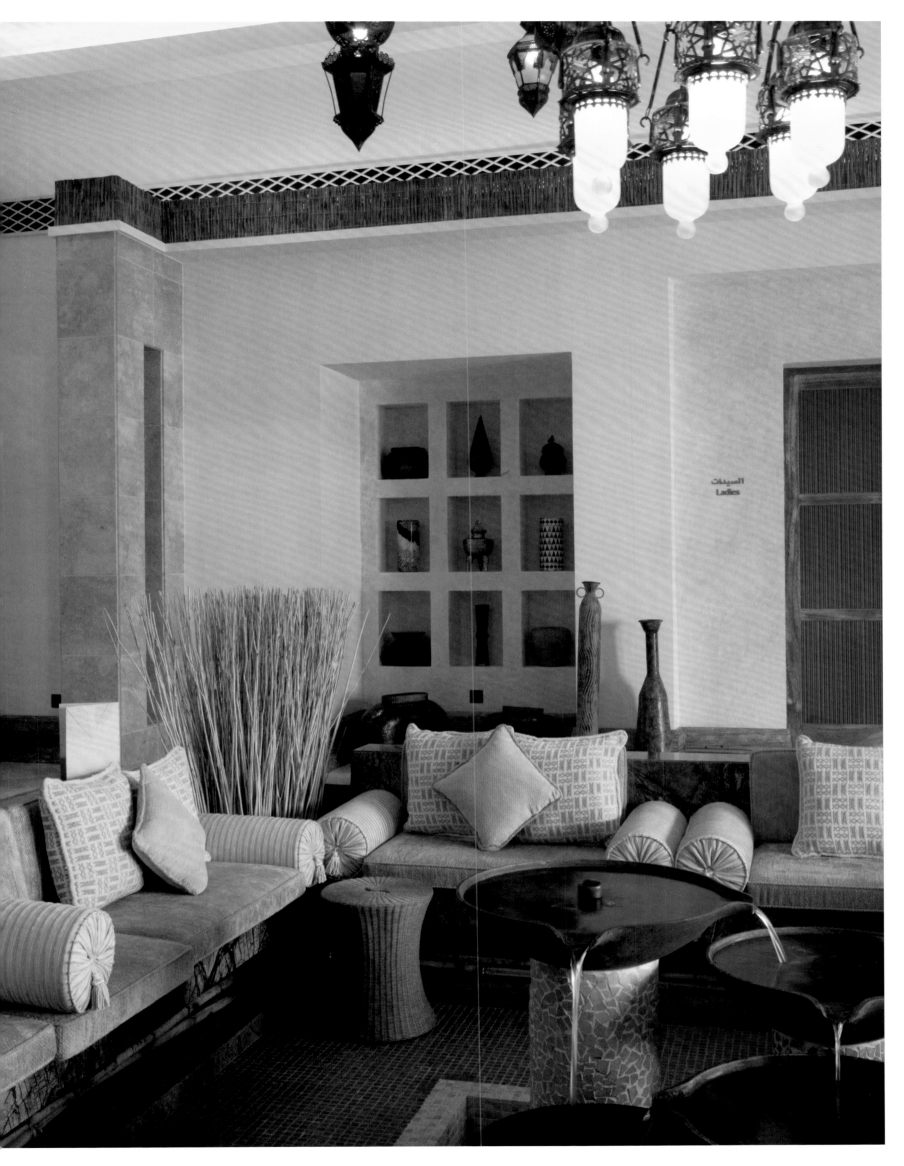

السيدات
Ladies

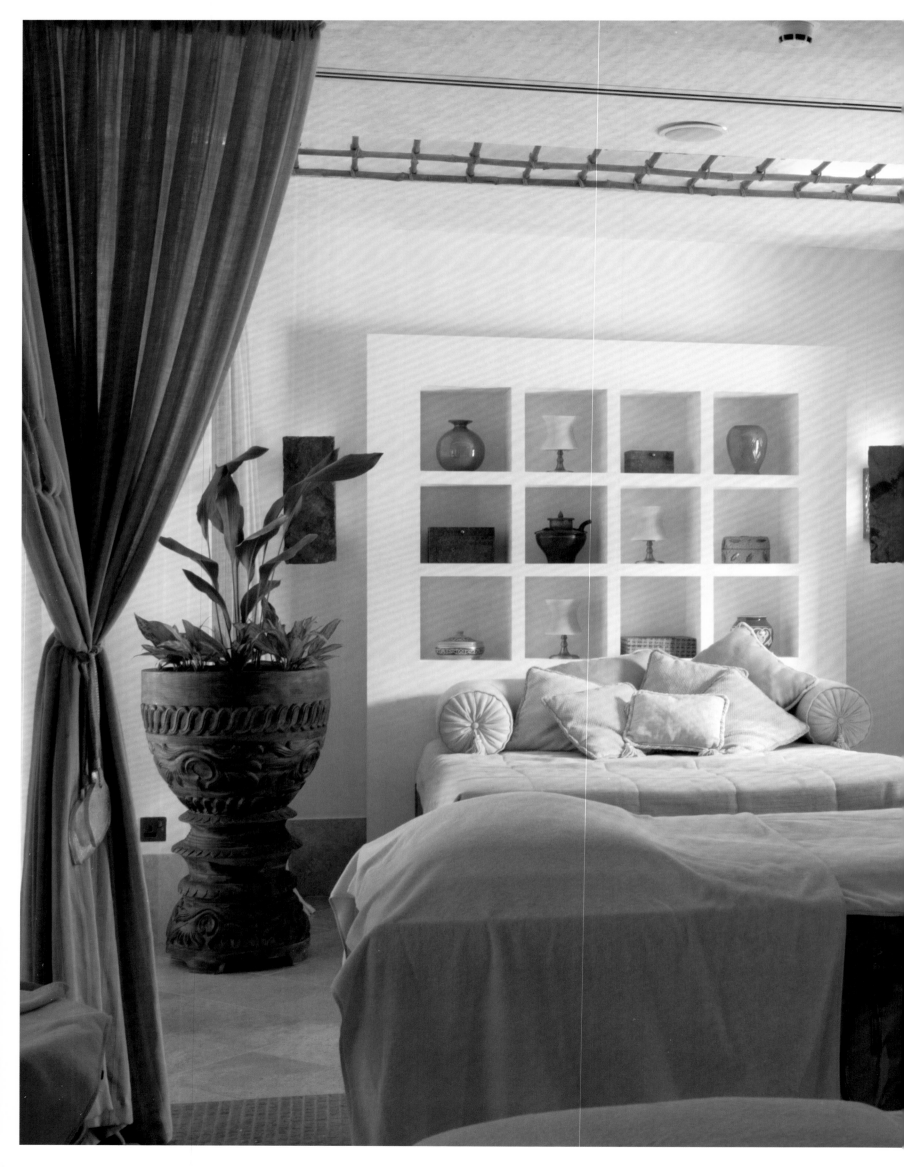

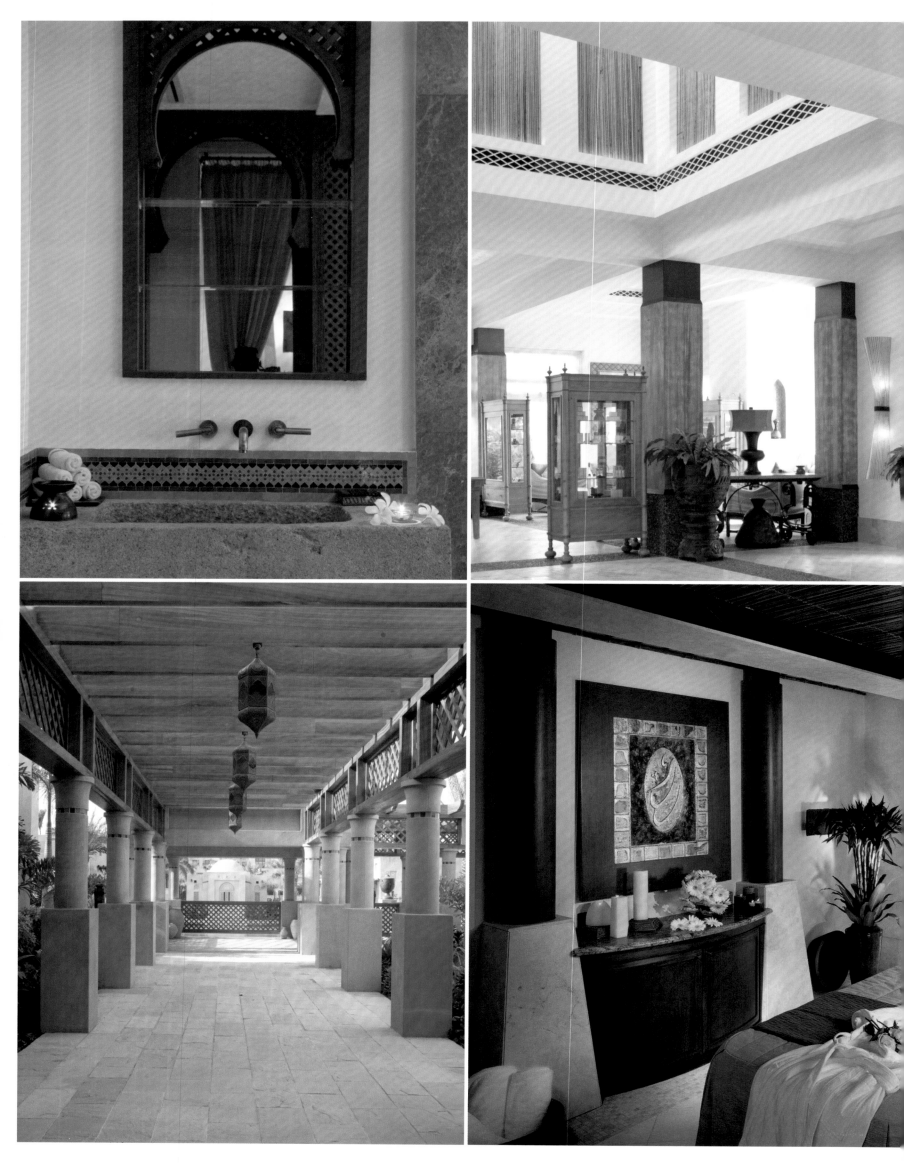

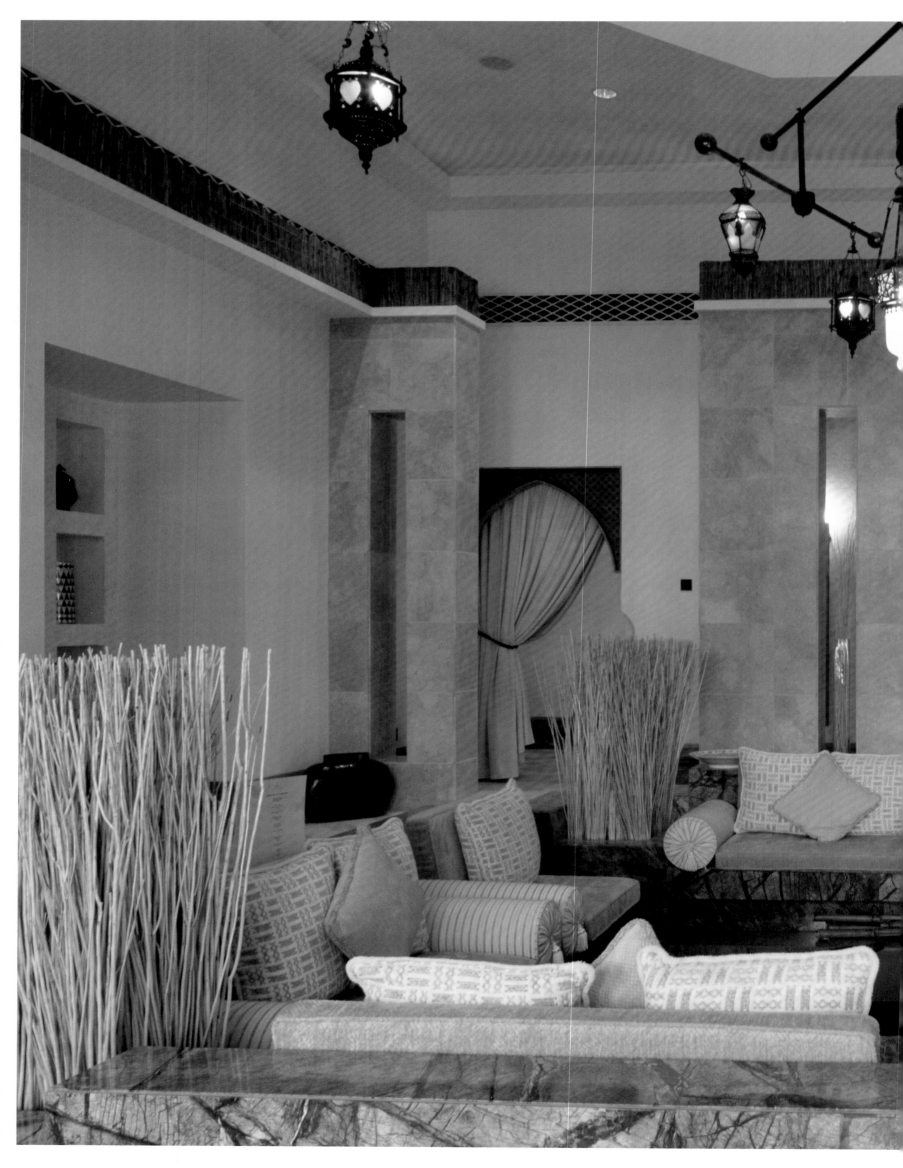

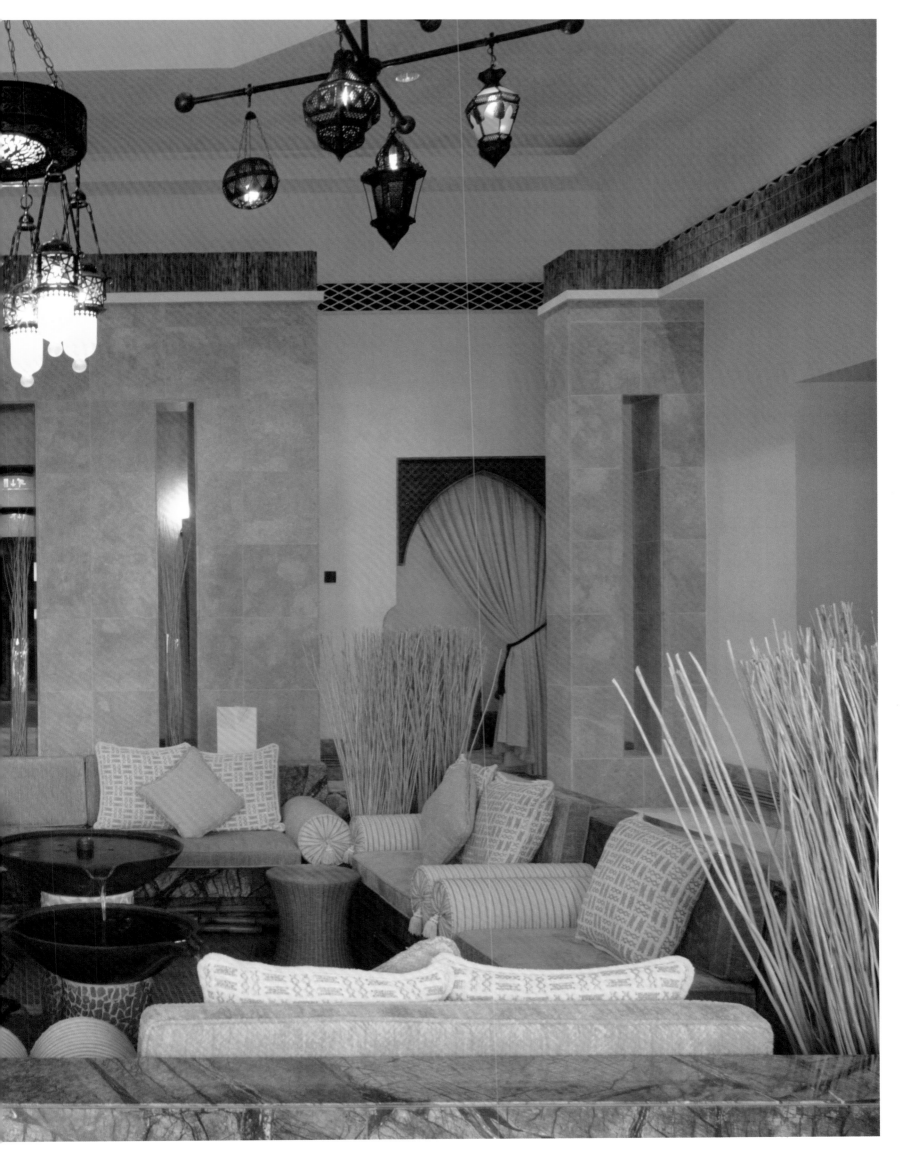

KCA International Designers
The Wharf at Madinat Jumeirah | 2003
Al Sufouh Road
Photos: © Courtesy Jumeirah

In der alt-arabischen Kulisse des Madinat-Resorts beschwört das Restaurant „The Wharf" die Seefahrertradition von Land und Leuten. Davon zeugen Fässer im Dekor und Kupferkessel. Mit einer Spelunke hat das Gewölbeambiente jedoch wenig gemeinsam. Das Design betont das gepflegt Weltläufige. Romantik steckt in der freien Sicht auf die vorbeihuschenden Wassertaxis.

As part the ancient Arabic setting of the Madinat-Resort, The Wharf" restaurant conjures up the seafaring tradition of the country and its people. This is depicted in kegs and copper cauldrons. However, the vault decoration has little in common with a dive. The design accentuates the elegant spaciousness, while the free view of the swiftly passing water taxis creates a sense of romance.

Insertado en el escenario de la antigua Arabia del resort Madinat el restaurante "The Wharf" encarna la tradición marinera del país y su gente. Las calderas de cobre y los toneles de la decoración dan muestra de ello. Si bien en este ambiente de bóvedas no hay rastro del carácter de taberna; más bien, del diseño se desprende una cuidada habilidad. Las amplias vistas al agua y a las embarcaciones taxi que circulan dan el toque de romanticismo.

Dans le décor d'ancienne Arabie du centre touristique Madinat, le restaurant « The Wharf » évoque les traditions de marins du pays et des gens. Les tonneaux qui servent de décoration et les chaudrons de cuivre en témoignent. L'ambiance de l'espace voûté est pourtant loin d'être celle d'un endroit populaire. Le design confère un côté mondain très soigné. La large vue sur les bateaux-taxis qui glissent sur l'eau ajoute une touche romantique.

Sullo sfondo della scenografia araba antica ricreata nel Madinat Resort, il ristorante „The Wharf" si contraddistingue per l'evocazione di atmosfere della tradizione marinara. All'occhio attento non ne sfuggono le numerose tracce rappresentate dalle botti e dai grandi paioli di rame sapientemente allestiti. Tuttavia le sale con soffitto a volta hanno ben poco in comune con una bettola. Il design mette piuttosto in risalto dettagli curati di gusto internazionale. L'ampia panoramica sui taxi sull'acqua di passaggio concede una sottile vena romantica.

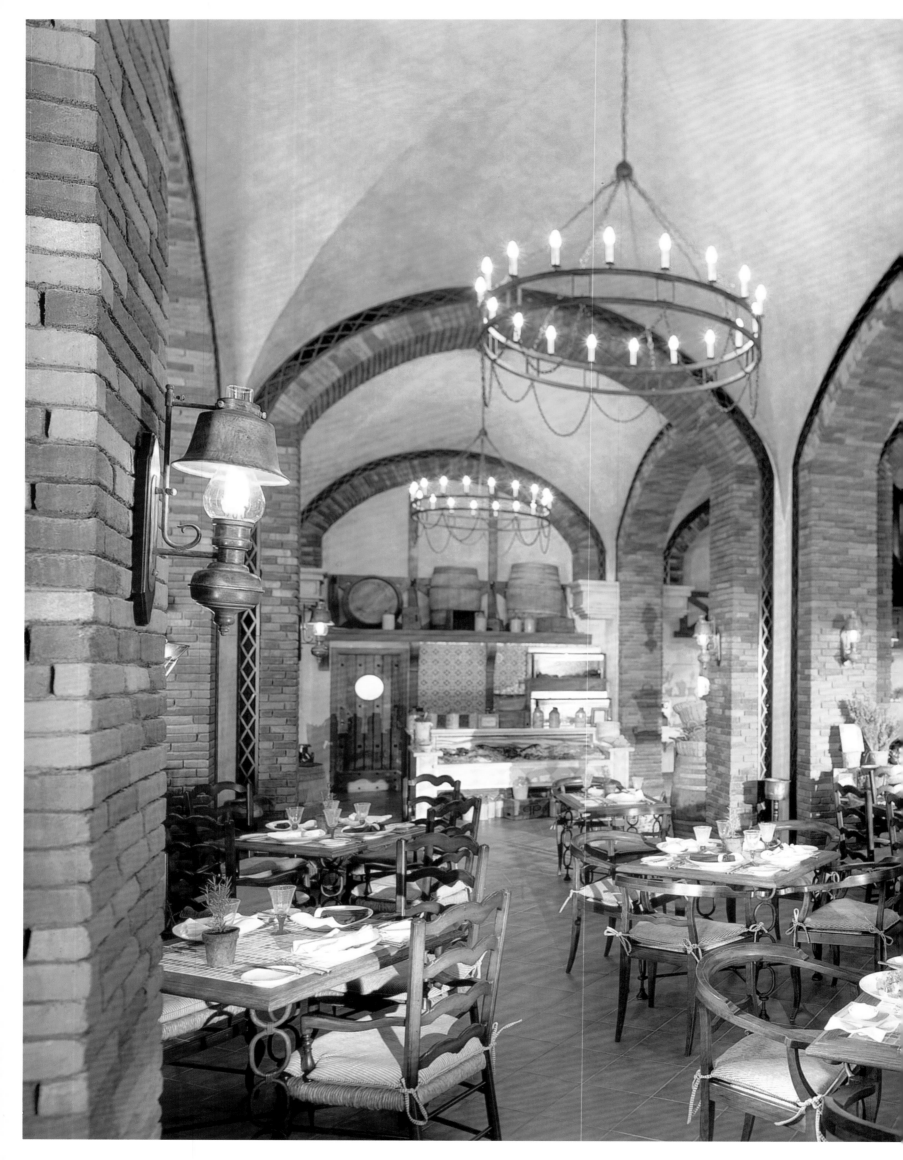

Louis Vuitton Malletier Architecture Department

Louis Vuitton at Dubai Burjuman | 2005
Trade Centre Road
Photos: © Courtesy Louis Vuitton, Stéphane Muratet, LB Production

Die Nobelmarke aus Paris versteht sich darauf, die eigene klassische Linie in immer neuem Umfeld zu platzieren. Der Labelshop in der Burjuman Mall ist ein gutes Beispiel dafür. Außen wirbt ein Layout, das an eine publizierte Modestrecke erinnert. Innen mutet die Auslage wie eine stilvoll jung sortierte Bibliothek an. Was besagen mag: Bei uns gibt es nur Erlesenes.

The noble brand from Paris is an expert in placing its classic line repeatedly in a new setting. The label shop in Burjuman mall is a perfect example of that. Outside beckons a layout that is reminiscent of a well known fashion mile. The display inside resembles a stylish young library. "We only offer select items", is the statement of such a style.

La prestigiosa marca de París sabe sin duda encontrar siempre un entorno diferente para emplazar su clásica línea propia. Su tienda ubicada en la Burjuman Mall es clara muestra de ello. El exterior recuerda una colección publicada. En el interior se presentan los artículos como en una joven y estilosa biblioteca, en la que sólo tiene cabida lo selecto.

La grande marque parisienne a un véritable talent pour présenter la ligne classique, qui lui est personnelle, dans un cadre toujours nouveau. Le magasin labelisé dans le centre commercial Burjuman en est un très bon exemple. À l'extérieur, c'est un agencement qui rappelle un magazine de mode qui exerce son attraction. A l'intérieur, la présentation évoque une bibliothèque élégante, moderne et rangée avec soin. Ce qui signifie : ici il n'y a que de la qualité.

La griffe esclusiva della capitale francese è maestra nel saper creare di volta in volta l'ambientazione ideale per la sua linea classica. Ne è un ottimo esempio il negozio monomarca ubicato nel Burjuman Mall. L'accattivante layout esterno ricorda una nota passerella di moda. All'interno invece l'esposizione è risaltata da scaffalature sulle quali la merce è disposta con gusto e fresca creatività. Come a voler dire: qui regnano raffinatezza ed esclusività.

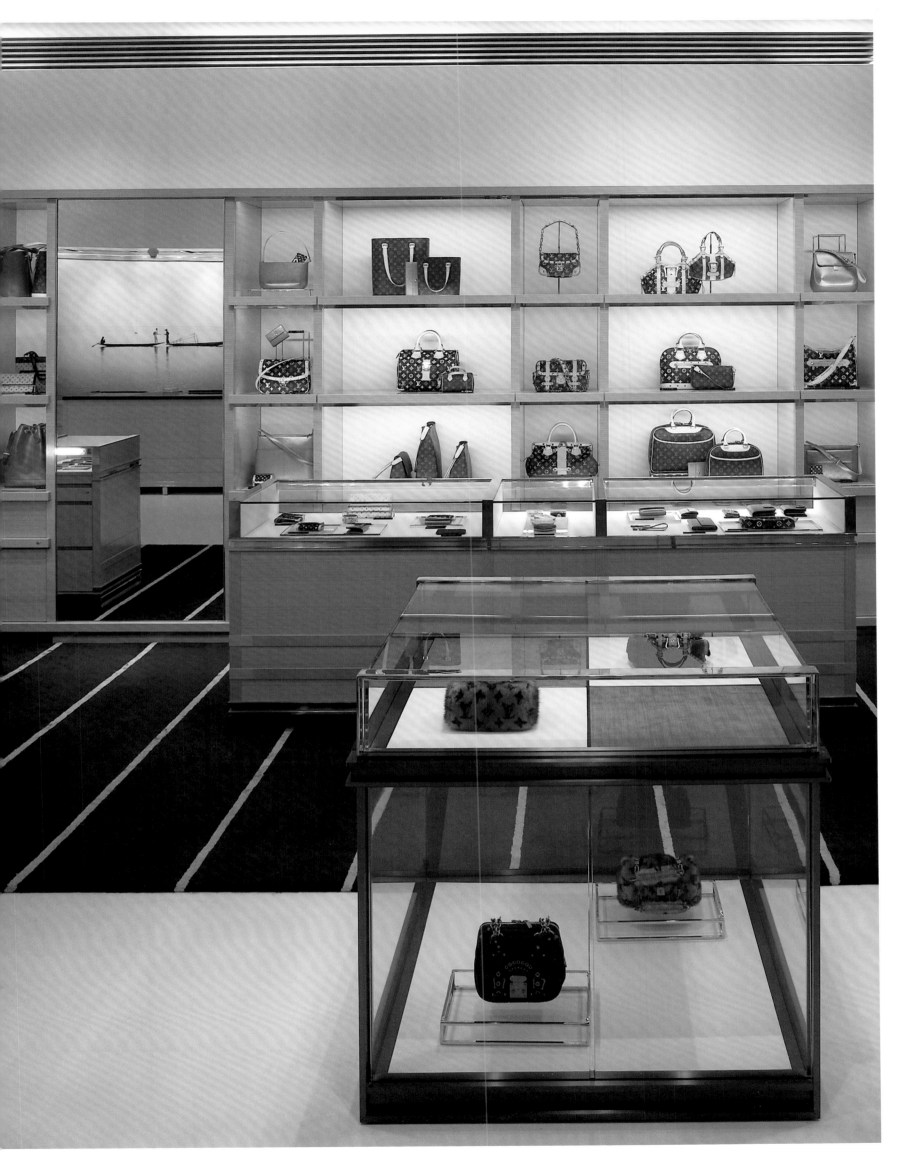

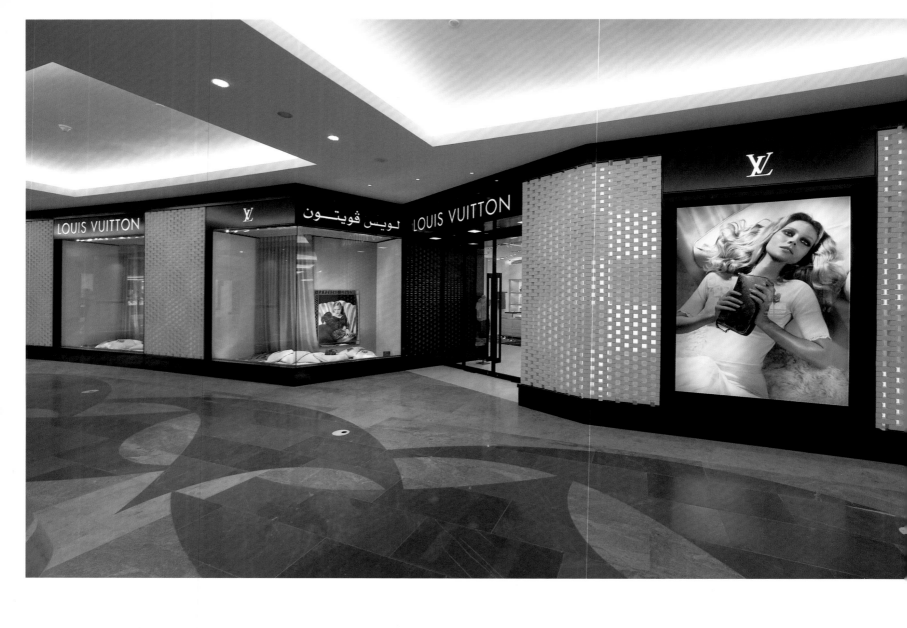

Mel McNally Design International
Lotus One | 2004
Sheikh Zayed Road
Photos: © Courtesy Lotus One, Krastin Shopov

Lotus One gehört zweifellos zu den aktuellen Highlights in Dubais Tausend-und-eine-Nachtleben. Dem Restaurant liegt ein asiatischer Touch inne. Schillernd indes die Cocktailbar und Lounge. Hier fühlt man sich ins Mark einer Metropole getroffen, mit tiefkühlen Lichteffekten und extraordinärem Designmobiliar. Ach, möge Sheharazade hier nur ewig säuseln.

Lotus One belongs without a doubt to the current highlights of Dubai's nightlife inspired by Arabian nights. An Asian touch inside the restaurant is evident. On the other hand, the cocktail bar and lounge are iridescently decorated. One gets the feeling here of being in the core of a metropolis, with cool light effects, and extraordinary designer furniture. If only Scheherazade would murmur here forever.

Actualmente Lotus One es sin duda uno de las estrellas de las mil y una noches de Dubai. El restaurante respira un aire asiático y encierra un fulgurante cocktailbar y un lounge. Todo ello concebido para sentirse en la médula de una metrópoli vestida de gélidos efectos de luz y un diseño de mobiliario extraordinario. Y que Sherezade susurre eternamente.

Lotus One compte sans conteste parmi les actuels lieux les plus courus des mille et une nuits de Dubaï. Le restaurant possède une touche plutôt asiatique alors que le bar à cocktail et le salon sont chatoyants. On se sent ici en plein cœur d'une métropole, avec des effets de lumière glacials et un mobilier d'un design extraordinaire. Ah, si seulement Shéhérazade pouvait ici encore et toujours murmurer ses mots!

Nello scenario dell'attuale vita notturna da mille e una notte di Dubai, Lotus One riveste indubbiamente un ruolo di assoluta preminenza. Il ristorante si caratterizza per un tocco asiatico, il cocktail bar e l'area lounge invece per gli effetti cangianti. È in questo contesto, con i suoi glaciali giochi di luce a contrasto e mobili design esclusivi, che si ha l'impressione di essere arrivati a scoprire il vero carattere metropolitano ... e che lo spirito di Sheharazade aleggi qui indisturbato in eterno.

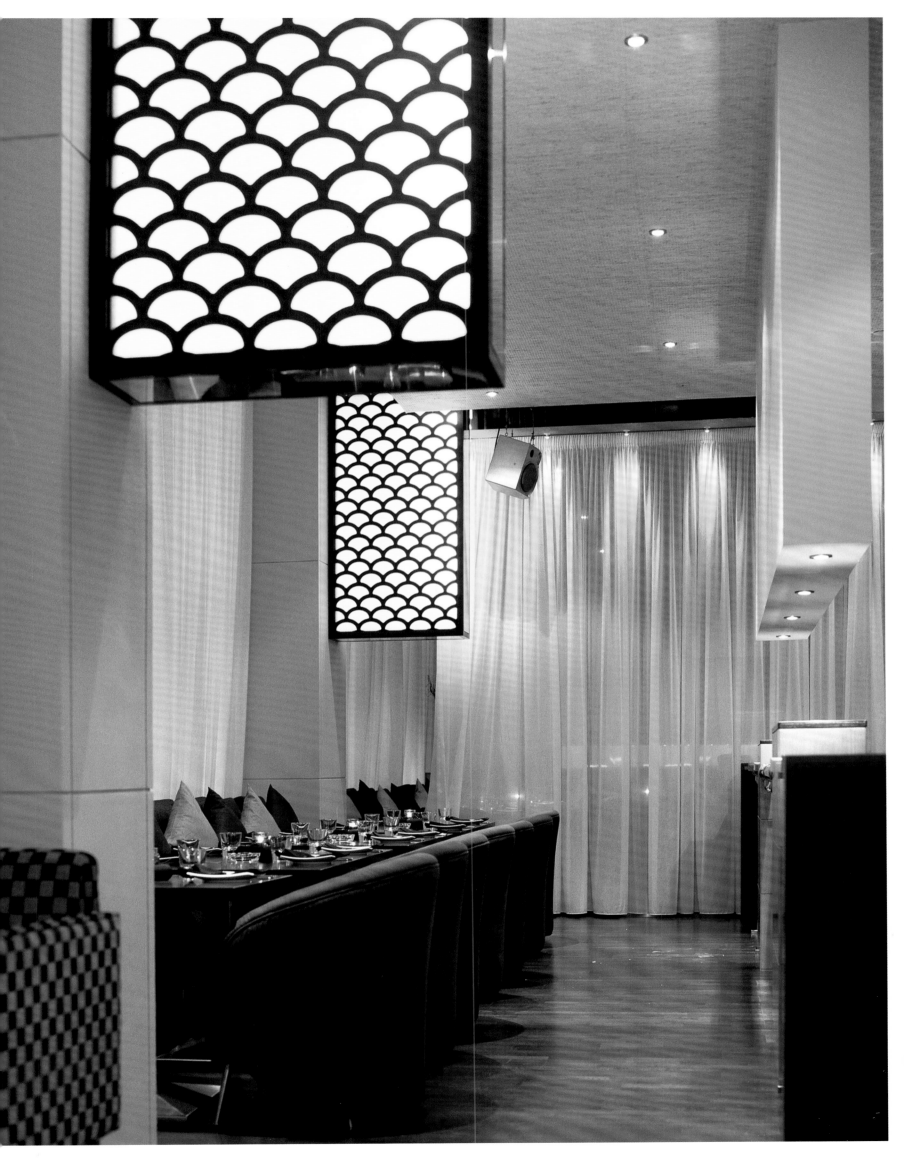

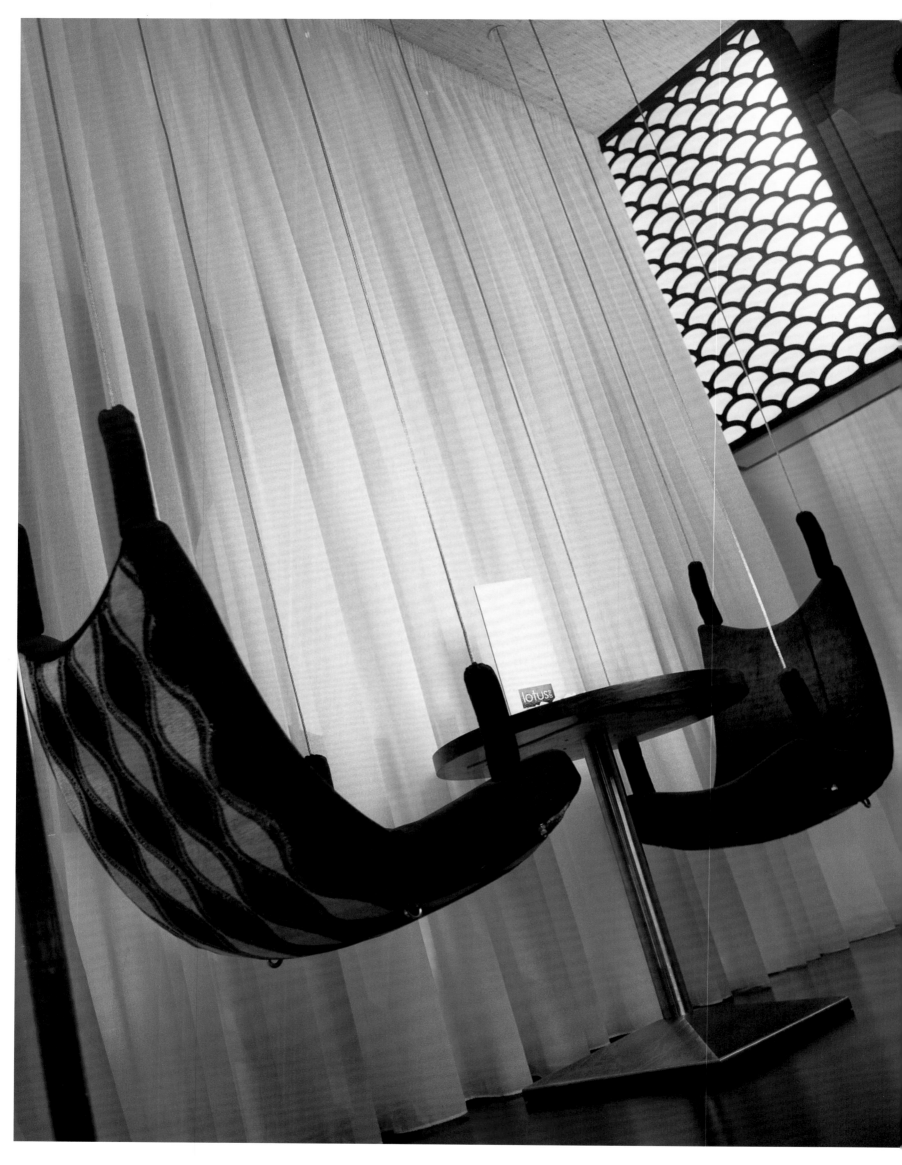

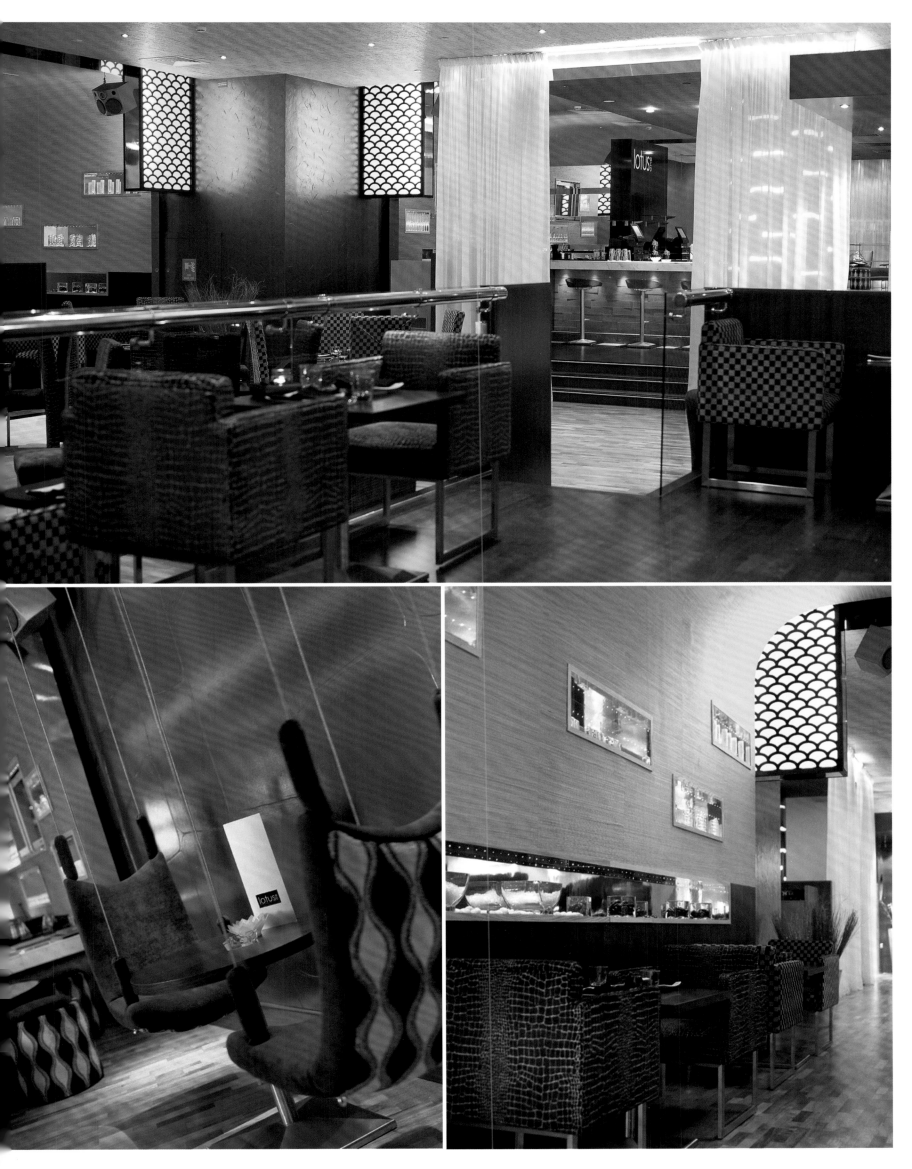

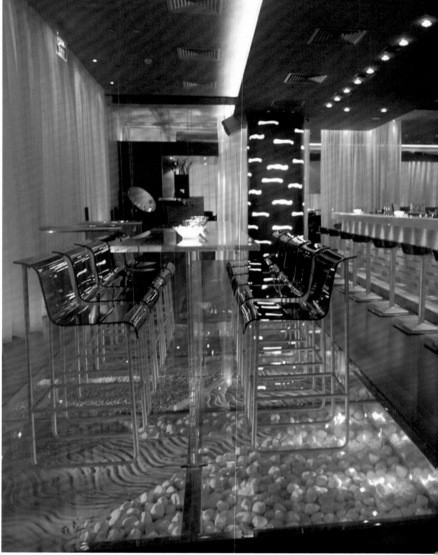

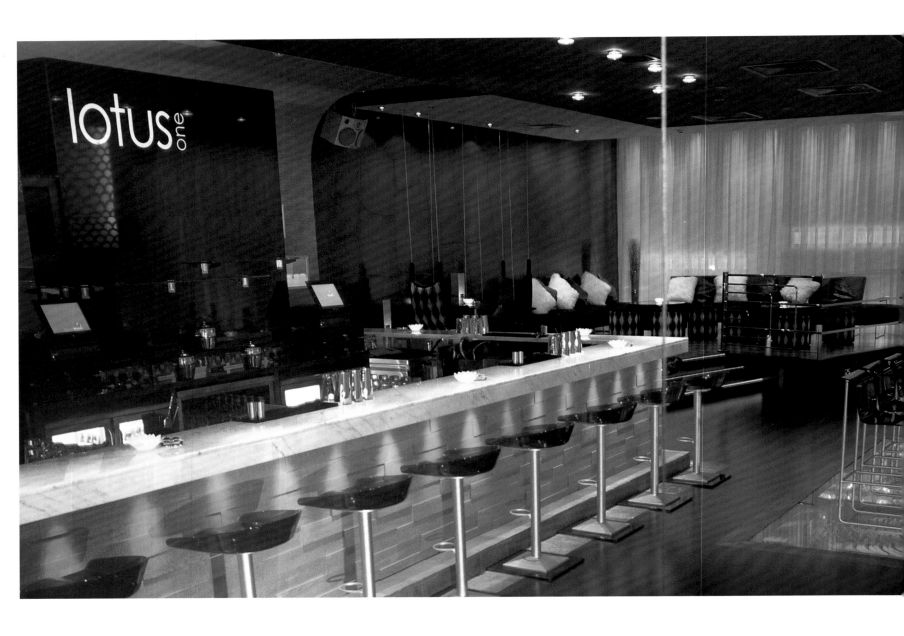

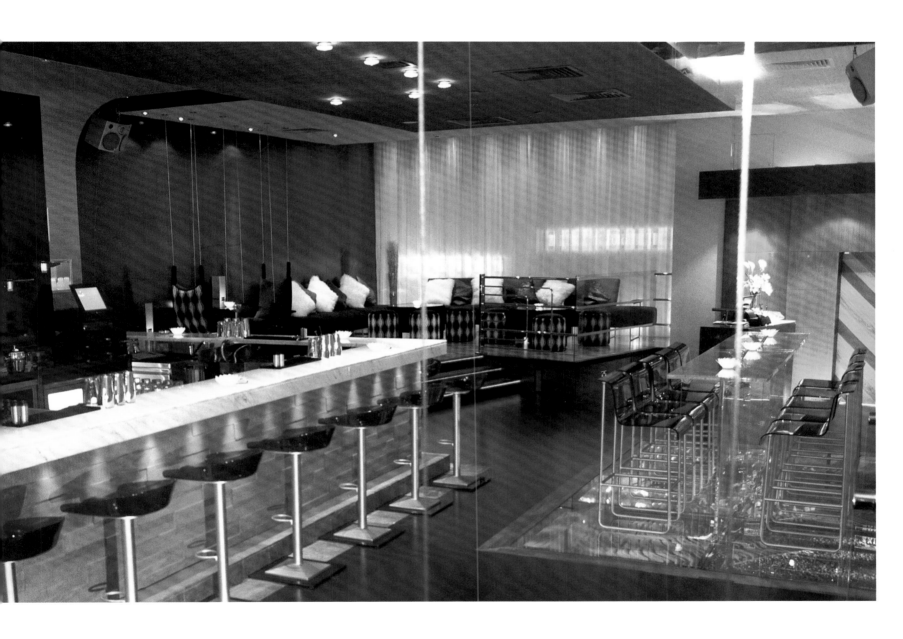

Nakheel
Dubai Waterfront
Sheikh Zayed Road
Photos: © Courtesy Nakheel

Um die bereits errichtete Palmeninsel schmiegt sich das neue Projekt der Dubai Waterfront. Hunderte Kilometer von Strand, Baufläche für Luxushotels und Villenviertel sowie ein Zugang zu einer Wasserwelt im Inneren des Landes werden realisiert. Das Flechtwerk aus Inseln ist durch Brücken verbunden und lässt auf über 80 Quadratkilometer eine Art Venedig von Dubai entstehen.

The new Dubai Waterfront project embraces the already constructed palm island. Hundreds of kilometers of beach, construction areas for luxury hotels and villas, as well as access to an underwater world in the middle of solid land are being created. The network of islands is connected by bridges, creating a "Venice" of Dubai on area of more than 80 square kilometers.

Entorno a la isla de palmeras ya concebida se emplaza el nuevo proyecto Dubai Waterfront: cientos de kilómetros de playa, superficies para hoteles de lujo y zonas residenciales de mansiones, además del acceso a un mundo submarino que se hace realidad en el interior del país. El entramado de islas se comunica por puentes, convirtiendo a los más de 80 kilómetros cuadrados en una especie de Venecia de Dubai.

Le nouveau projet de Dubai Waterfront se blottit autour de l'îlot de palmiers déjà construit. Des centaines de kilomètres de plages, des terrains de construction pour des hôtels de luxe et des quartiers résidentiels ainsi qu'un accès à un univers aquatique à l'intérieur du pays vont être réalisés. Les îles de ce réseau sont reliées par des ponts et transforment ainsi plus de 80 kilomètres-carré de Dubaï en une sorte de Venise.

Il nuovo progetto Dubai Waterfront si modella attorno al già esistente complesso artificiale dell'Isola delle Palme e prevede la realizzazione di centinaia di chilometri di spiaggia, di area edificabile per hotel di lusso e quartieri residenziali esclusivi nonché di una lingua di mare che si insinua nell'entroterra. L'intreccio di isole è collegato da ponti grazie ai quali, su una superficie di oltre 80 chilometri quadrati, sorge una sorta di seconda Venezia.

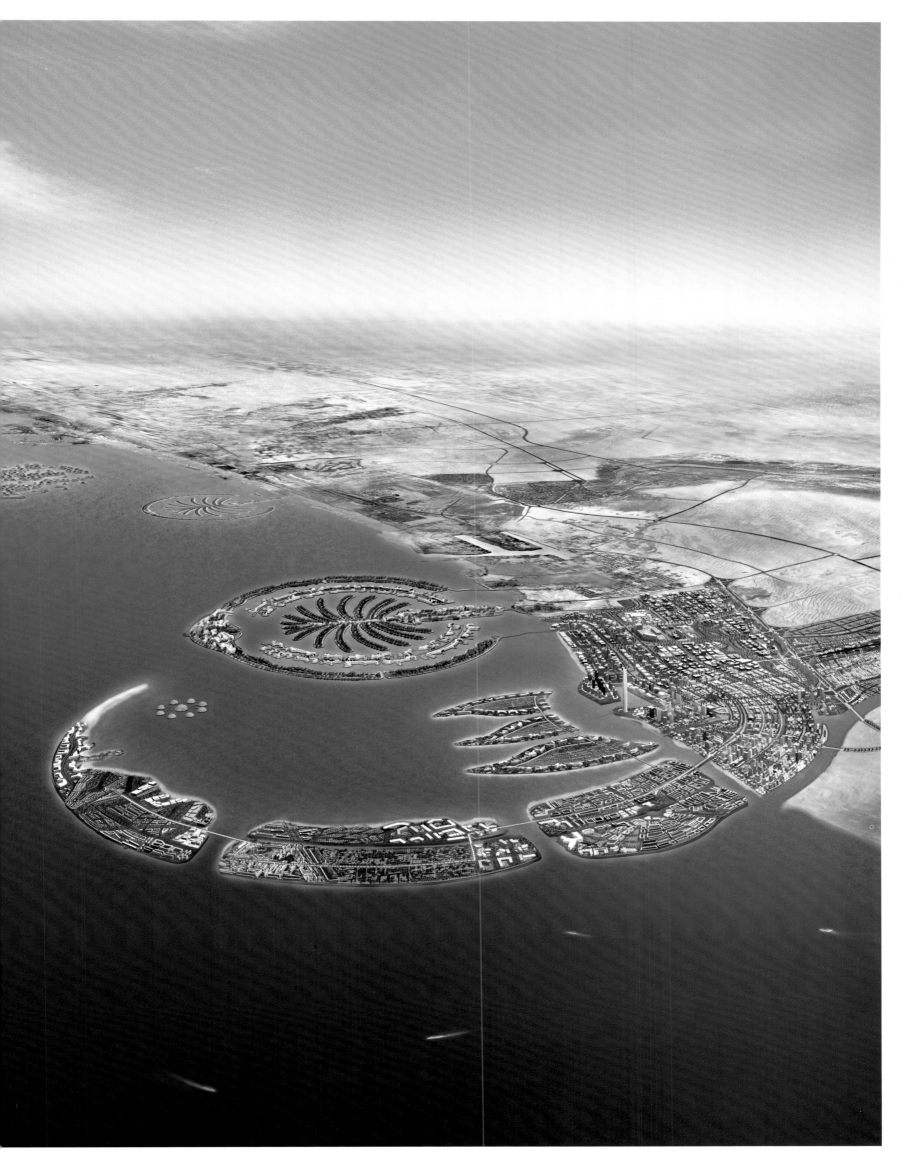

NORR Group, Carlos Ott
National Bank of Dubai headquarters I 1998
Baniyas Road
Photos: © Courtesy Government of Dubai, Department of Tourism and Commerce Marketing

Das Gebäude gilt als ein Wahrzeichen der Stadt, in der sich Tradition und Moderne spiegeln. Eine große, goldene Glasfassade prägt den Bau. Sie wölbt sich wie ein Segel, das gehalten wird von zwei massigen Stützen. Die markante Architektur richtet sich zum alten Hafen aus und reflektiert von dort sowohl die alten Dhows wie die nahe Skyline von Dubai.

One of the city's monuments, the building reflects both the traditional and modern. It is distinguished by a large golden glass façade that bulges like a sail supported by two massive pillars. The impressive architecture is pointed towards the old port from where it reflects the old dhows as well the nearby skyline of Dubai.

Este emblemático edificio de la ciudad, caracterizado por una gran fachada dorada de vidrio es el reflejo de tradición y modernidad. Se trata de una estructura henchida como una vela sujeta por dos masivos puntales. El llamativo edificio está orientado hacia el antiguo puerto y desde allí refleja los viejos dhows y la cercanía al horizonte de Dubai.

Le bâtiment, dans lequel se reflètent la tradition et la modernité, est un emblème de la ville. La construction est marquée par une grande façade de verre dorée. Soutenue par deux énormes piliers, elle se gonfle comme une voile. La remarquable architecture est tournée vers le vieux port et reflète ainsi aussi bien les vieux boutres que la silhouette toute proche de Dubaï.

L'edificio viene considerato il vero emblema di una città caratterizzata dalla sintesi perfettamente riuscita fra modernità e tradizione. L'elemento architettonico di maggior rilievo è rappresentato dalla grande facciata dorata, che si dispiega come una vela sorretta da due massicci montanti. La costruzione di grande effetto è rivolta verso il vecchio porto e ne riflette tanto le tradizionali imbarcazioni (dhow) quanto il vicino Dubai skyline.

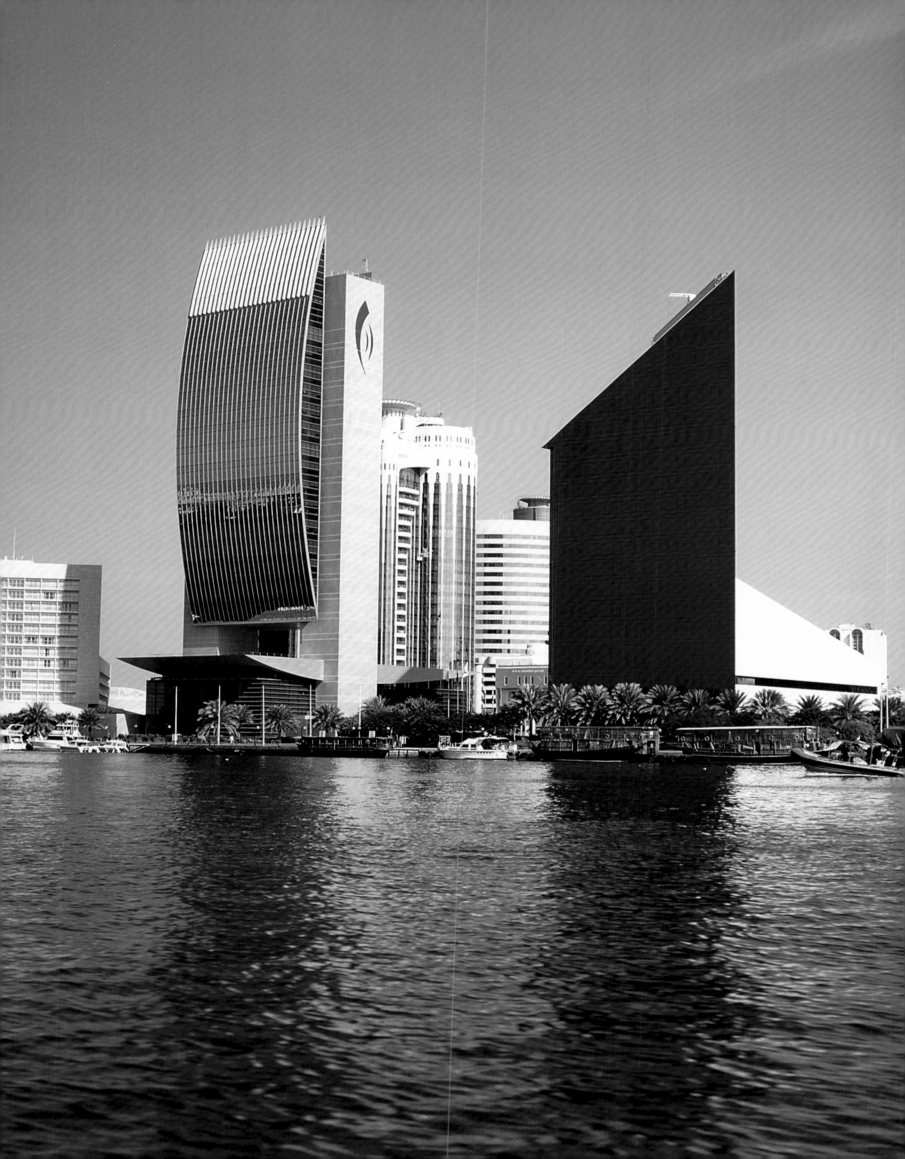

NORR Group, Hazel W.S. Wong
Emirates Towers | 2000
Sheikh Zayed Road
Photos: © Courtesy Government of Dubai, Department of Tourism and Commerce Marketing

Die zwei markanten Tower geben sich nicht nur mit den schrägen Abschlüssen als Geschwister zu erkennen. Der größere von bei-den beherbergt Büroräume, der kleinere ein Hotel der Luxusklasse. Beide eröffnen sensationelle Ausblicke auf Meer und City dank Glasfassade und Panoramaaufzüge. Innen besticht das zeitgenössisch europäische Design.

Not only their slanting tops identify the two prominent towers as twins. The larger one houses offices, while the smaller one consists of a luxury hotel. Their glass façades and panorama elevators offer sensational views of the sea and the city. Their interior is distin-guished by modern European design.

Las dos llamativas torres parecen emparentadas no sólo por la igualdad de sus cúpulas ladeadas. La mayor alberga oficinas y la más pequeña un hotel de lujo. Y ambas cuentan con unas sensacionales vistas al mar y a la ciudad, gracias a sus fachadas de vidrio y ascensores panorámicos. Los interiores se caracterizan por un estilo europeo contemporáneo.

Ce ne sont pas seulement les plans inclinés de leurs sommets qui font de ces deux remarquables tours des tours jumelles. La plus grande abrite des bureaux, la plus petite un hôtel de luxe. Les deux offrent une vue sensationnelle sur la mer et la ville grâce à des façades vitrées et des ascenseurs panoramiques. À l'intérieur, c'est le design européen contemporain qui exerce sa séduction.

La somiglianza fra le due torri, ben visibili da ogni punto della città, non si limita solo alle linee oblique che ne caratterizzano le estremi-tà. La più alta delle due ospita uffici, la più piccola un hotel di lusso. Grazie alle facciate in vetro e agli ascensori a vista, si può godere da entrambe di splendidi panorami sul mare e sulla city. Gli interni affascinano con design europeo contemporaneo.

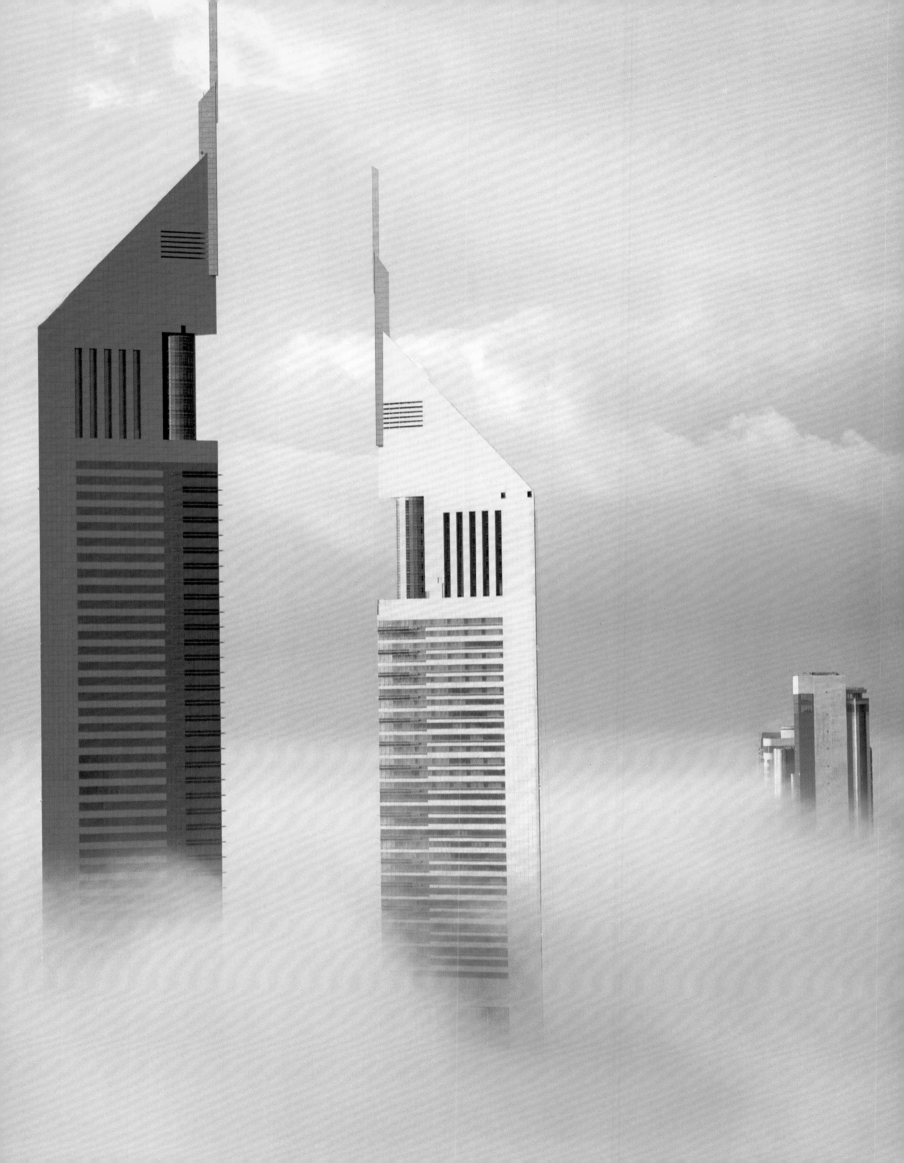

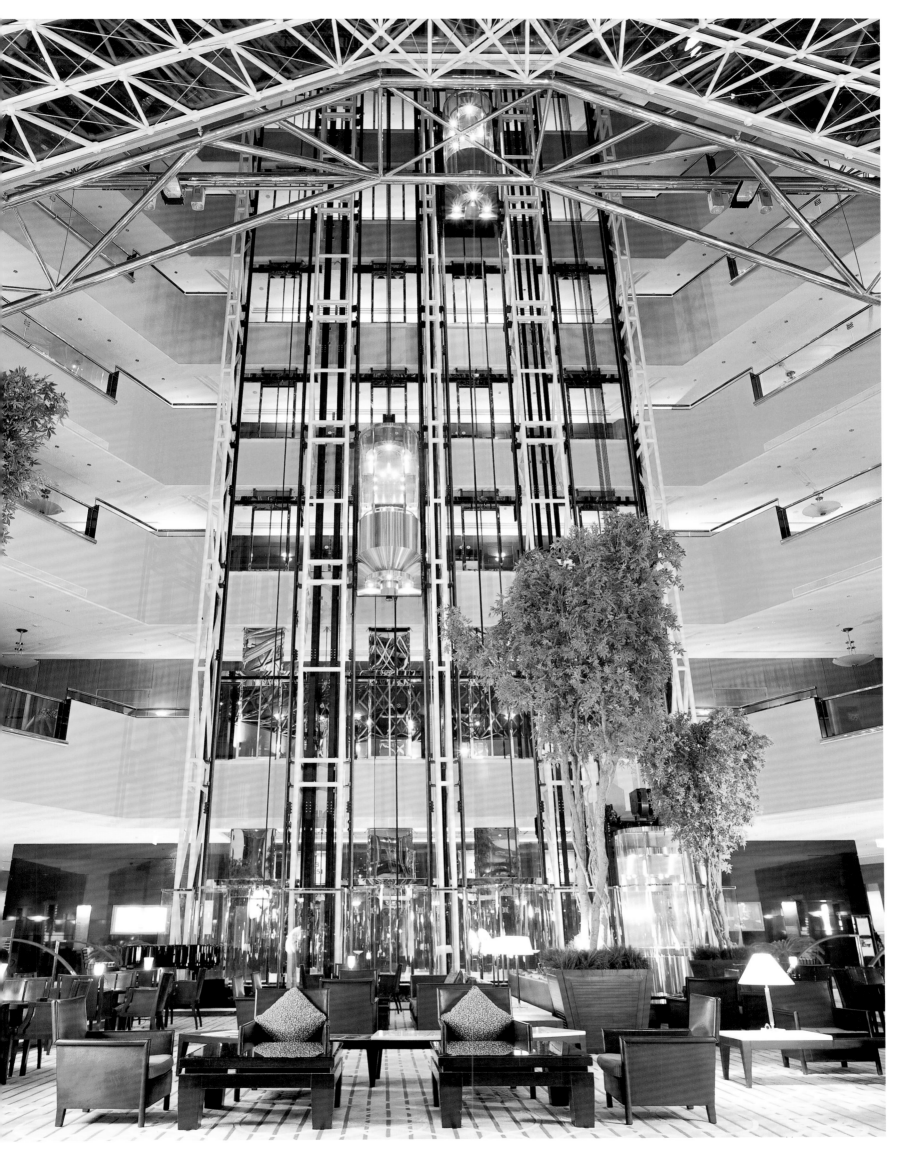

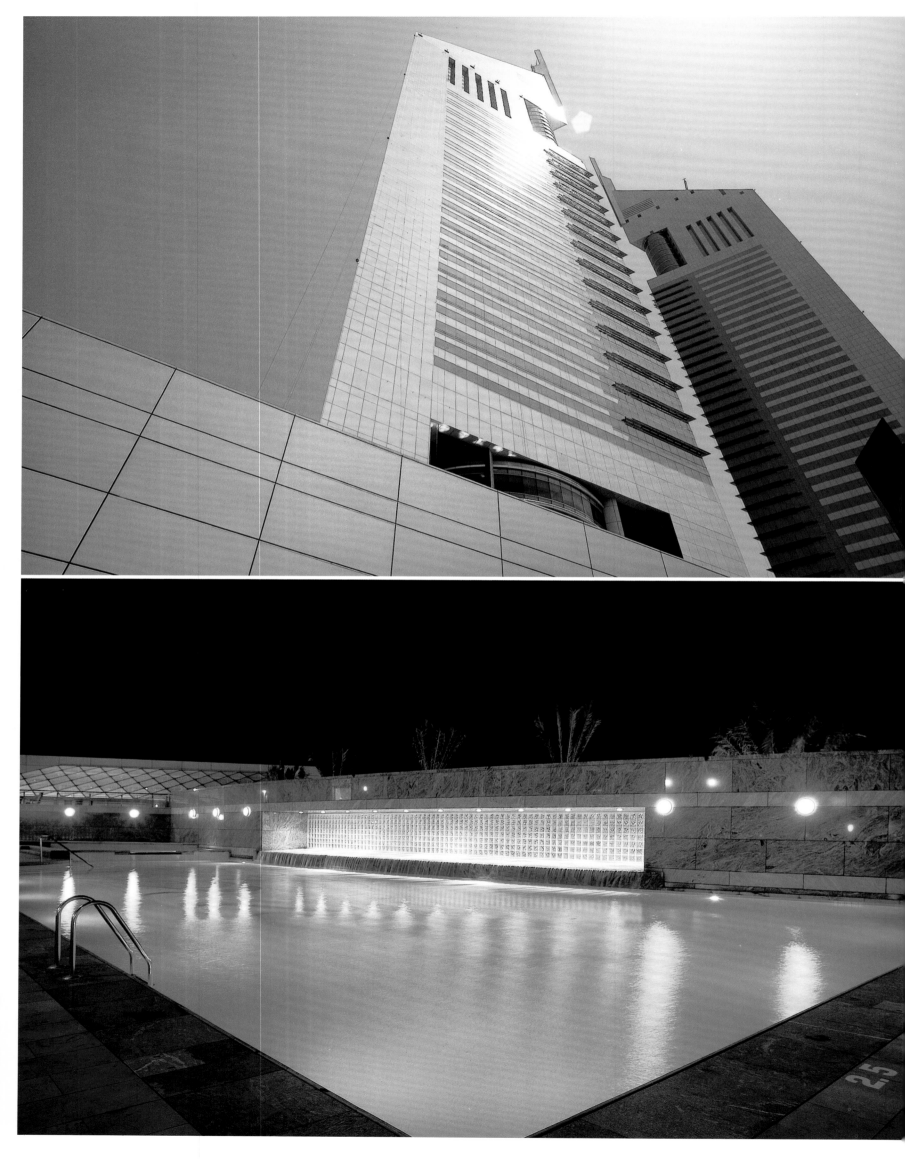

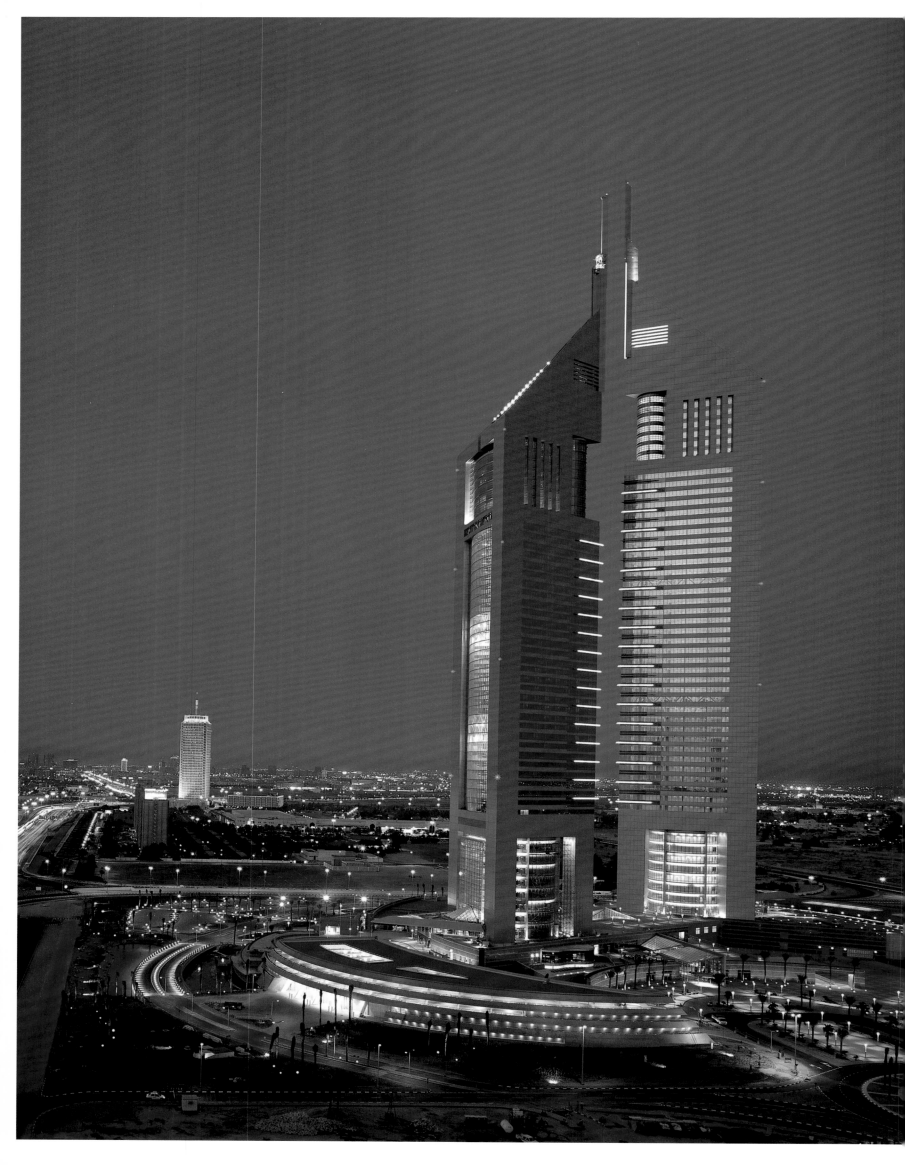

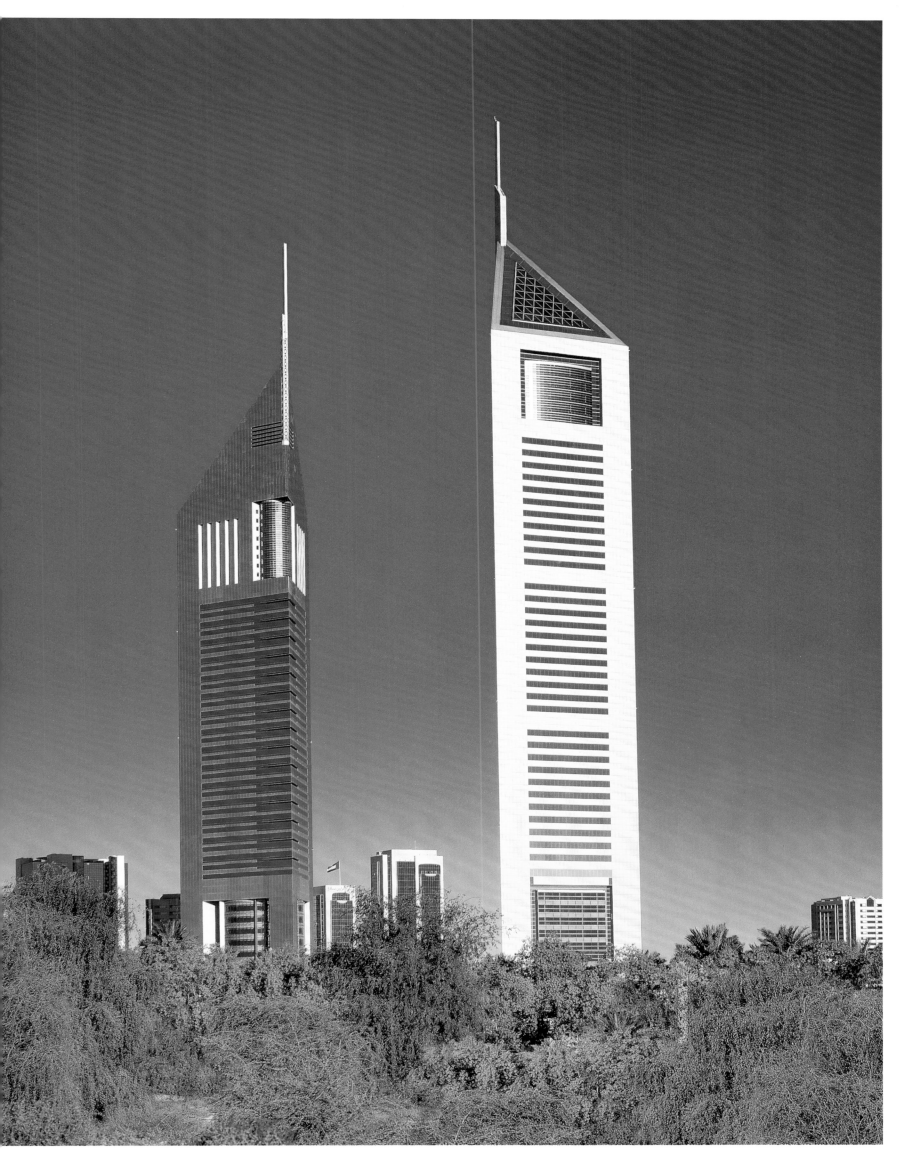

RMJM
Al Gurg Tower | 2008
Regga Al Butten
Photos: © Courtesy RMJM

Al Gurg Tower – das ist Architektur, die gezielt mit Gegensätzen spielt. Prägnant sind die verschachtelten Soliden von kubistischer Anmutung, aus denen für die Apartments solitäre Dachterrassen entstehen. Im Kontrast dazu erhebt sich daneben der gläserne Büroturm. Seine gewölbte Front öffnet nicht nur den Blick zur nahen Bucht, sie hält ihr zugleich einen Spiegel vor.

Al Gurg Tower—the architecture of the tower deliberately uses contrasts. Particularly noticeable are the interlocking solids with a cubist flair that are used to construct roof terraces for the individual apartments. In contrast, the adjacent glass office tower features a rounded front, which not only allows the view to the nearby bay, but also reflects it.

Al Gurg Tower, arquitectura que juega con contrastes intencionadamente. En ella destacan sus bloquesencajonados de apariencia cubista, de los que resultan áticos aislados para apartamentos; en contraste se levanta al lado una torre de oficinas de vidrio, de una forma abovedada que sirve de espejo y lanza además las vistas a la cercana bahía.

La tour Al Gurg est une architecture qui joue sciemment avec les contrastes. L'imbrication des volumes, très remarquables avec leur caractère cubiste, permet de dégager des terrasses privatives pour les appartements. La tour de verre abritant des bureaux qui s'élève à côté vient former un contraste. Sa façade incurvée ouvre non seulement la vue sur la baie toute proche mais joue aussi le rôle de miroir où celle-ci peut se refléter.

Al Gurg Tower – questa è architettura che gioca sapientemente con i contrasti. Di grande effetto sono soprattutto le forme geometriche ad incastro dalla grazia cubista dalle quali si ricavano per i lussuosi appartamenti delle terrazze coperte al riparo da sguardi indesiderati. In evidente contrasto, a lato, la torre in vetro sede di uffici. La sua facciata arrotondata non apre allo sguardo solo la visuale sulla baia vicina, ma le offre nel contempo la superficie su cui riflettersi.

RMJM
Capital Towers | 2006
Sheikh Zayed Road
Photos: © Courtesy RMJM

In prominenter Lage beim Dubai Welthandelszentrum ragt dieser im rechten Winkel angelegte Hotel- und Verwaltungskomplex auf. Grazil sind die filigrane Rhythmik der Stockwerke und die zarten Verbindungsglieder der Türme. Die gläserne Hülle teilt zudem jeden Quader in dreieckige Segmente. Ein weiterer Glaswürfel, seitlich platziert, beherbergt ein Luxus-Spa.

This hotel and office complex juts in at a right angle, in the prominent area near the Dubai World Trade Center. The filigree rhythm of the floors and the delicate connecting elements of the towers are graceful. The glass hull divides each block into triangular segments. Another glass cube, laterally placed, houses a luxury spa.

Este complejo hotelero y de oficinas dispuesto perpendicularmente cuenta con una ubicación privilegiada, en pleno corazón del Centro de Comercio Internacional de Dubai. La estructura de filigranas que compone las plantas y los sutiles elementos que unen las torres están cargados de gracilidad. La cubierta de vidrio divide cada paralelepípedo en segmentos triangulares. El cubo acristalado ubicado en el lateral alberga un spa de lujo.

Ce complexe hôtelier et de bureaux construit en angle droit s'élève dans un lieu de premier plan, près du Centre de Commerce International de Dubai. Le rythme en filigrane des étages et les délicats éléments de liaison entre les tours apparaissent graciles. L'enveloppe de verre partage de surcroît chaque parallélépipède en segments triangulaires. Juste à côté un autre cube de verre abrite un spa luxueux.

Posizionato in modo ideale per la vicinanza al Centro Affaristico di Dubai, questo complesso alberghiero e uffici posto in angolo retto spicca per l'esilità conferitagli dall'alternanza filigranata di strutture a piani e delle sottili torri che fungono da elementi di raccordo. L'involucro in vetro suddivide inoltre ciascun parallelepipedo in segmenti triangolari. Un'ulteriore struttura cubica in vetro, posta lateralmente, ospita un lussuoso centro spa.

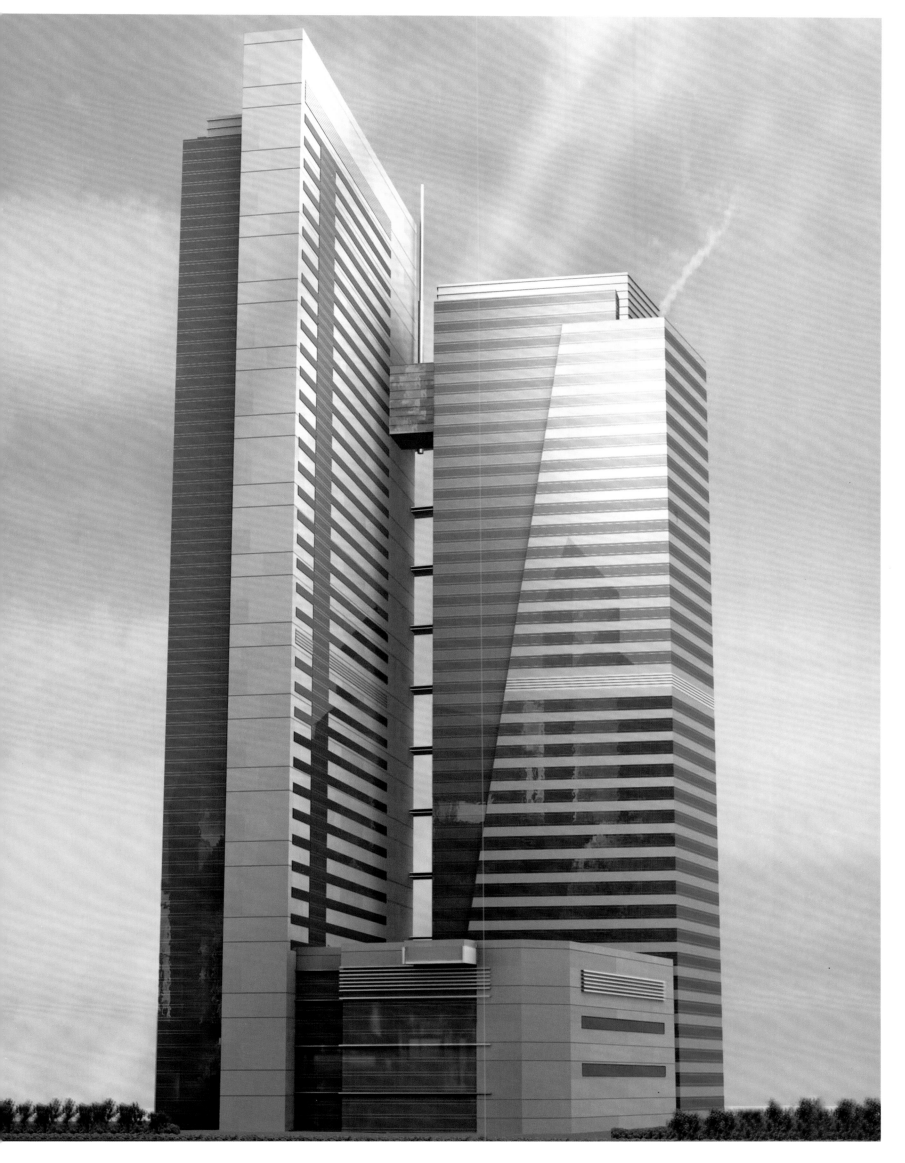

RMJM
Dubai International Convention Centre | 2003
Sheikh Zayed Road
Photos: © Courtesy DWTC

Ein Büro- und ein Hotelturm umschließen den einen Trakt des Messezentrums. Im Dunkeln glitzern und leuchten sie wie kantige Diamanten. Der belebten Hauptstraße zugewandt laden derweil transparent umschlossene Arkaden in eine 250 Meter lange Mall ein. Herzstück des Objekts ist die gigantische Eventhalle. Zudem warten Shops und Restaurants von internationaler Klasse.

One office tower and one hotel tower surround one section of the fair center. In the dark, they glitter and shine like sharp-edged diamonds. Facing the lively main street, transparently engulfed arcades lead to a mall of 250 meters. The heart of the building is the gigantic event hall. In addition, there are shops and restaurants of international class.

Una torre de oficinas y una torre de hotel se reúnen entorno a una parte del recinto ferial, brillando en la oscuridad como dos perfilados diamantes. Orientadas hacia la agitada calle principal, atraen la atención las Arcadas transparentes que encierran el centro comercial de 250 metros de longitud. La joya de este objeto es el gigantesco salón de actos. Junto a él se ubican comercios y restaurantes de nivel internacional.

Un tour de bureaux et un tour d'hôtel entourent une des ailes du centre commercial. Elles brillent et luisent dans la nuit comme les facettes d'un diamant. Dirigées vers la rue principale animée, des arcades entourent avec transparence une galerie commerciale longue de 250 mètres. Une gigantesque salle de spectacle est le cœur du bâtiment. On y trouve en outre des magasins et restaurants de classe internationale.

Una torretta destinate ad uffici e una torretta di hotel cingono l'ala di collegamento del centro fieristico. Nell'oscurità splendono e rilucono come diamanti sfaccettati. Rivolte verso l'animata strada principale, delle arcate trasparenti invitano a scoprire l'interno del mall lungo 250 metri. La parte centrale del complesso è rappresentata dalla gigantesca sala eventi. Si aggiungono negozi e ristoranti di caratura internazionale.

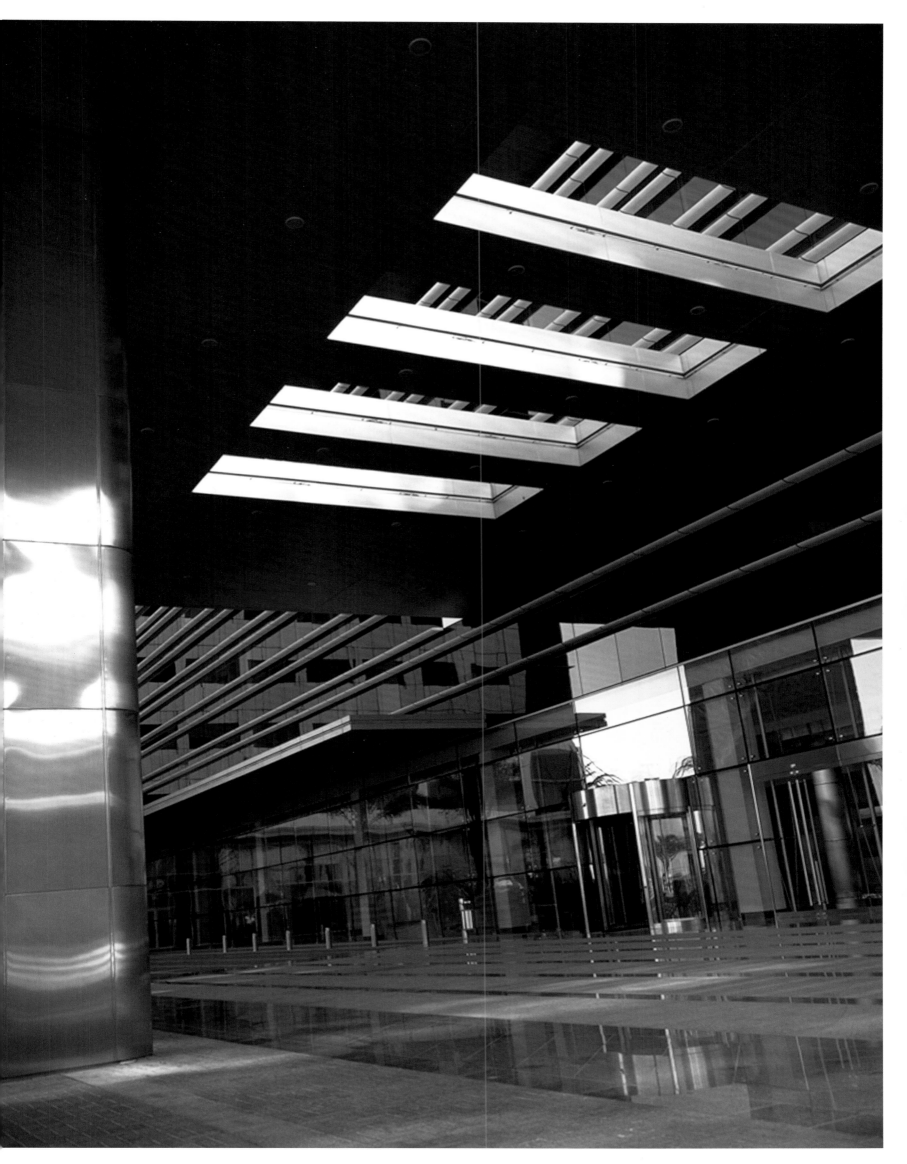

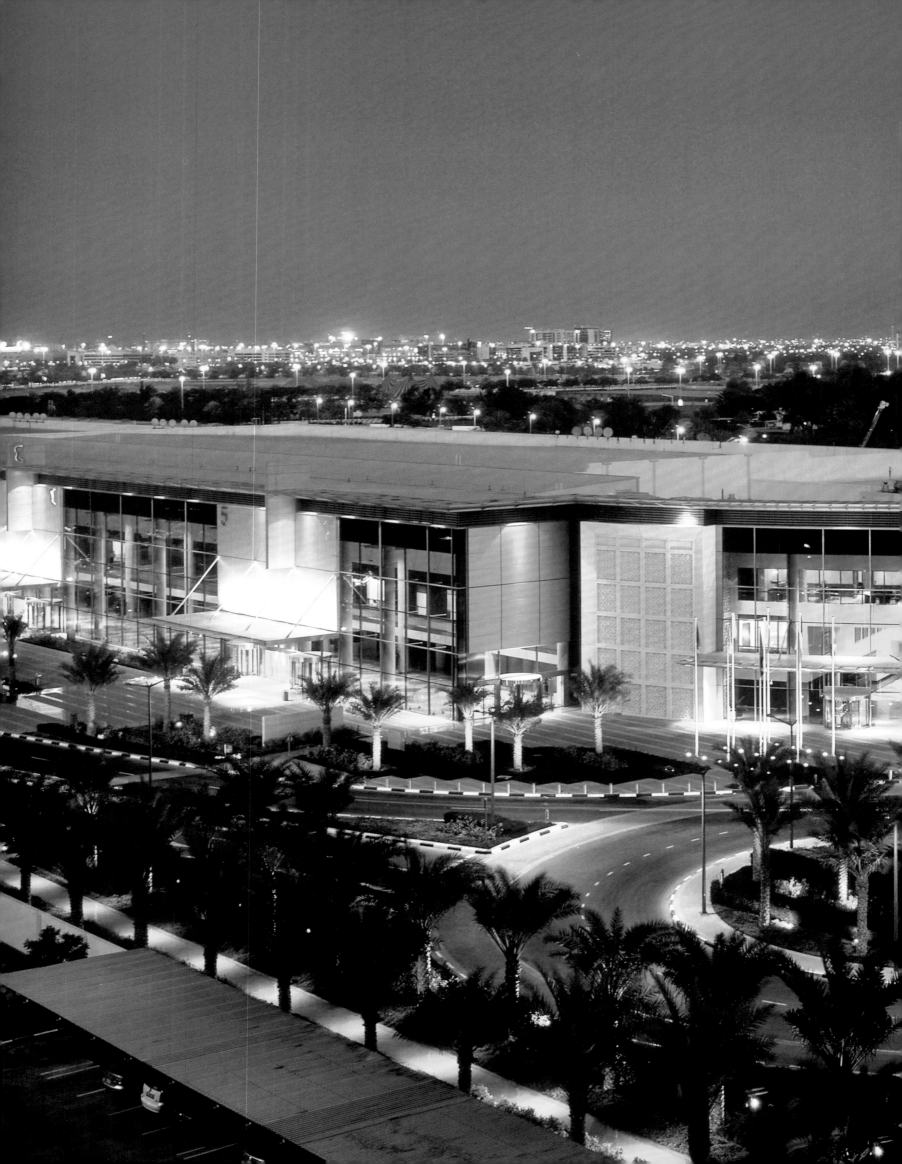

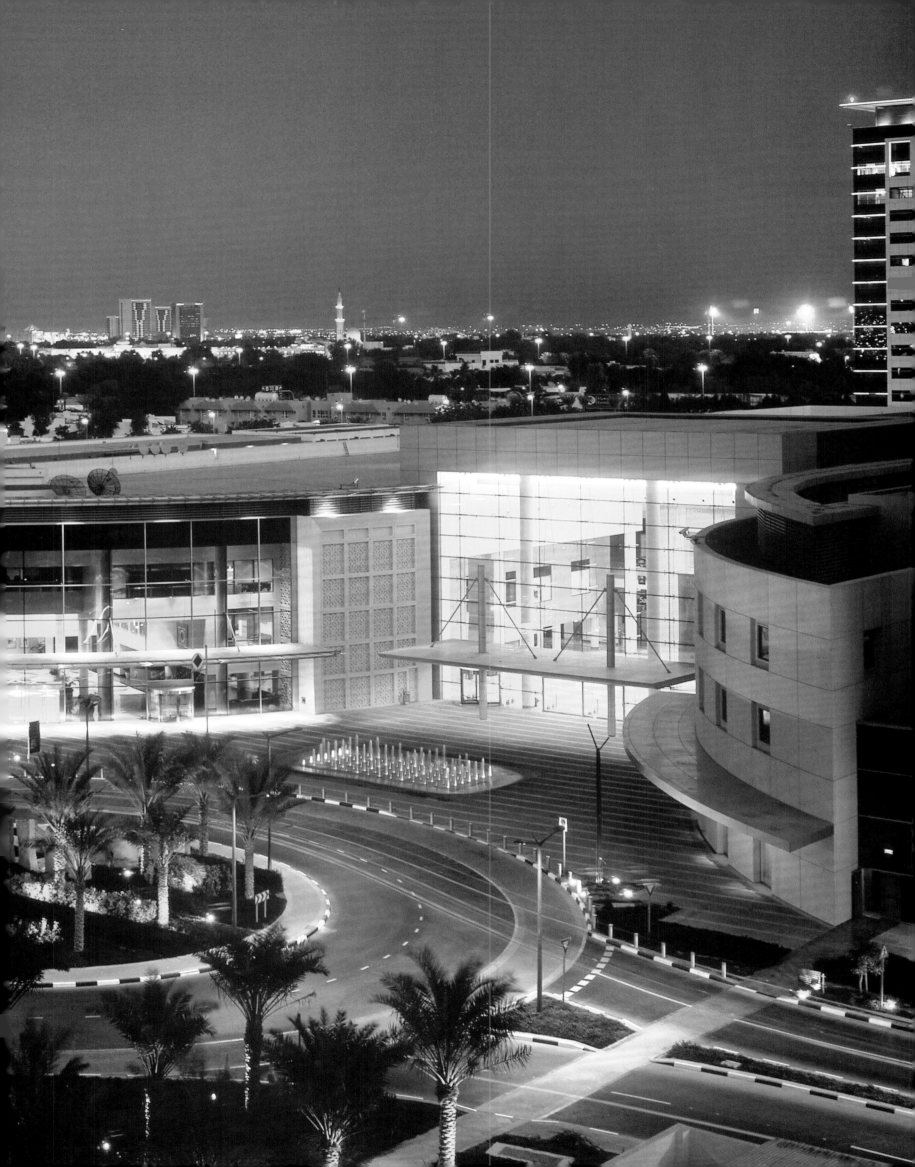

RMJM
Marina Heights | 2006
Dubai Marina
Photos: © Courtesy RMJM

Die Silhouette von Marina Heights erinnert stark an Vorbilder aus dem alten New York. Der Wohnturm gehört zu jenen Bauten in Dubai, die sich durch eine klassische Fassade hervortun: rhythmisch kleinteilig, aber wohl proportioniert, dazu stimmig komponiert vom Podium bis zur Traufe. Das ist schlichte Eleganz, die gerade nachts in eigener Schönheit erstrahlt.

The silhoutte of Marina Heights strongly resembles that of old New York City. The living tower is among Dubai's buildings that are distinguished by their classic façade. It consists of rhythmic small parts, which are well-proportioned and well-composed from the podium to its rooftop. This is simple elegance that especially at night shines in its own glory.

La silueta de Marina Heights recuerda claramente a sus modelos del viejo Nueva York. Esta torre de viviendas es uno de los edificios de Dubai que destaca por su fachada clásica. Una construcción rítmicamente fragmentada y proporcionada, afinadamente concebida desde la base hasta el alero. Su austera elegancia luce una belleza propia especialmente por la noche.

La silhouette du Marina Heights rappelle beaucoup les tours du vieux New York qui lui servent de modèle. Cette tour résidentiel compte parmi les bâtiments de Dubaï qui se distinguent par une façade classique au rythme court mais aux bonnes proportions et de surcroît parfaitement composée du socle aux gouttières. C'est de la pure élégance qui dégage la nuit surtout une beauté particulière.

La silhouette della torre Marina Heights evoca fortemente immagini della vecchia New York. La torre residenziale si inserisce armoniosamente nella tradizione architettonica di quegli edifici di Dubai che si contraddistinguono per la loro facciata classica: suddivisa armoniosamente, ben proporzionata, perfettamente in sintonia in ogni dettaglio, dallo zoccolo alla grondaia. Espressione di pura eleganza, soprattutto la notte quando riluce di bellezza propria.

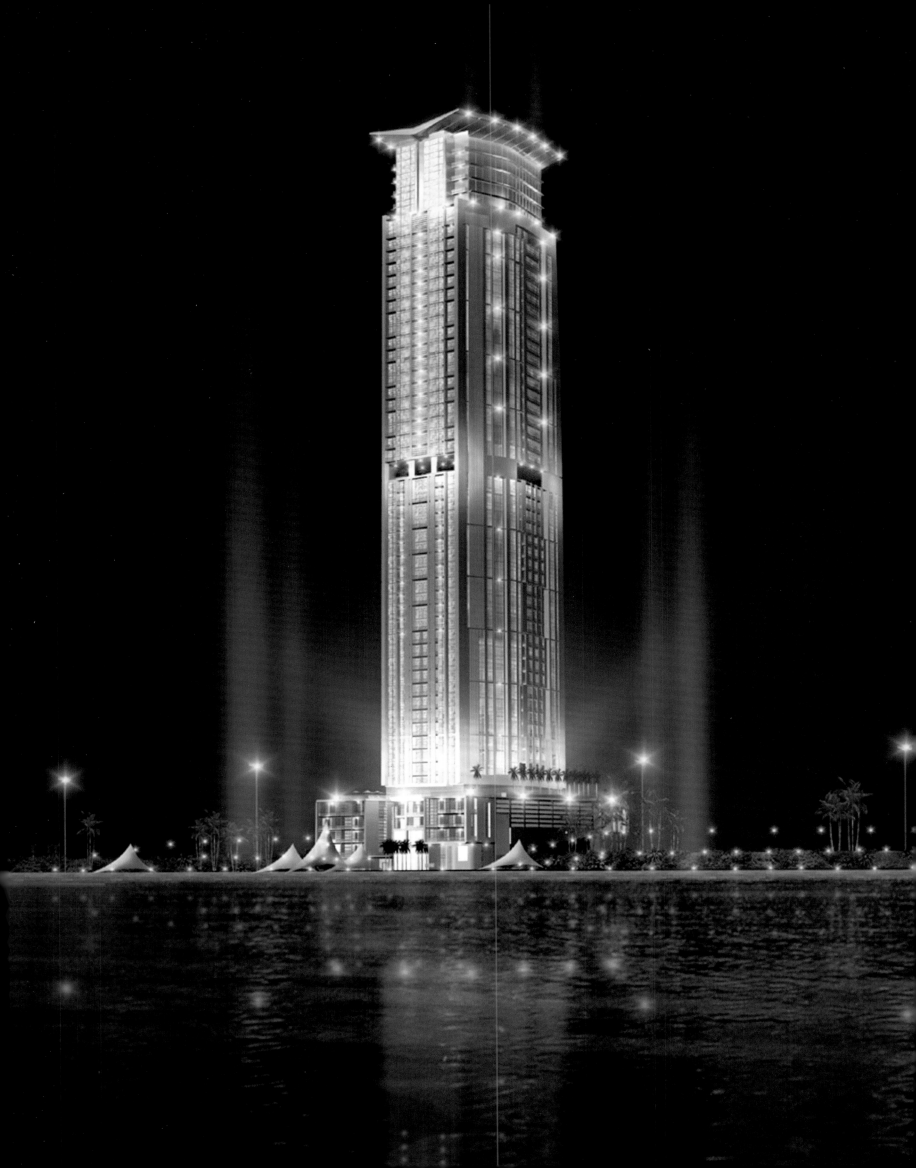

RMJM
The Jewels | 2006
Dubai Marina
Photos: © Courtesy RMJM

Am Tage erregen die nach oben spitz geformten Turmfassaden kaum Aufsehen. Auffällig allein die Balkone, die von allen Seiten das Bild prägen und weite Blicke über das angrenzende Meer eröffnen. Faszination lösen die völlig gleichen Juwelen dafür nachts aus, wenn sie weit über sich hinaus strahlen und wie ein durchleuchtetes Gerippe wirken.

During the day, the upward pointing tower façades do not arouse much attention. Balconies dominate the image from all sides, allowing views far across the adjacent sea. However, the very same jewels are extremely fascinating by night when they radiate far beyond their setting and resembling an illuminated skeleton.

Durante el día las fachadas de estas torres apuntadas apenas llaman la atención; únicamente los balcones que captan la imagen desde todos los ángulos y proponen vistas al mar. Es la noche, sin embargo, la que despierta fascinación hacia estas joyas exactamente iguales, al mostrar su esqueleto luminoso reluciendo hacia la lejanía.

Pendant la journée les façades des tours qui s'étirent en pointe vers le haut n'attirent presque pas l'attention. Seuls les balcons, qui courent sur toutes les faces et ouvrent ainsi une large vue sur la mer toute proche, marquent l'ensemble. Par contre, c'est la nuit que ces joyaux exactement semblables exercent leur fascination, quand ils rayonnent loin autour d'eux et donnent l'impression de voir une radiographie de la structure.

Di giorno le facciate delle torri affusolate non destano particolare scalpore, essendo caratterizzate architettonicamente su tutti i lati solo dai balconi dai quali è possibile spaziare con lo sguardo fino all'orizzonte del mare limitrofo. Tanto più grande è il fascino che suscitano le medesime torri di notte, quando i due gioielli si vestono di una luce che addirittura le supera in altezza e ne illumina l'ossatura come per effetto di una radiografia.

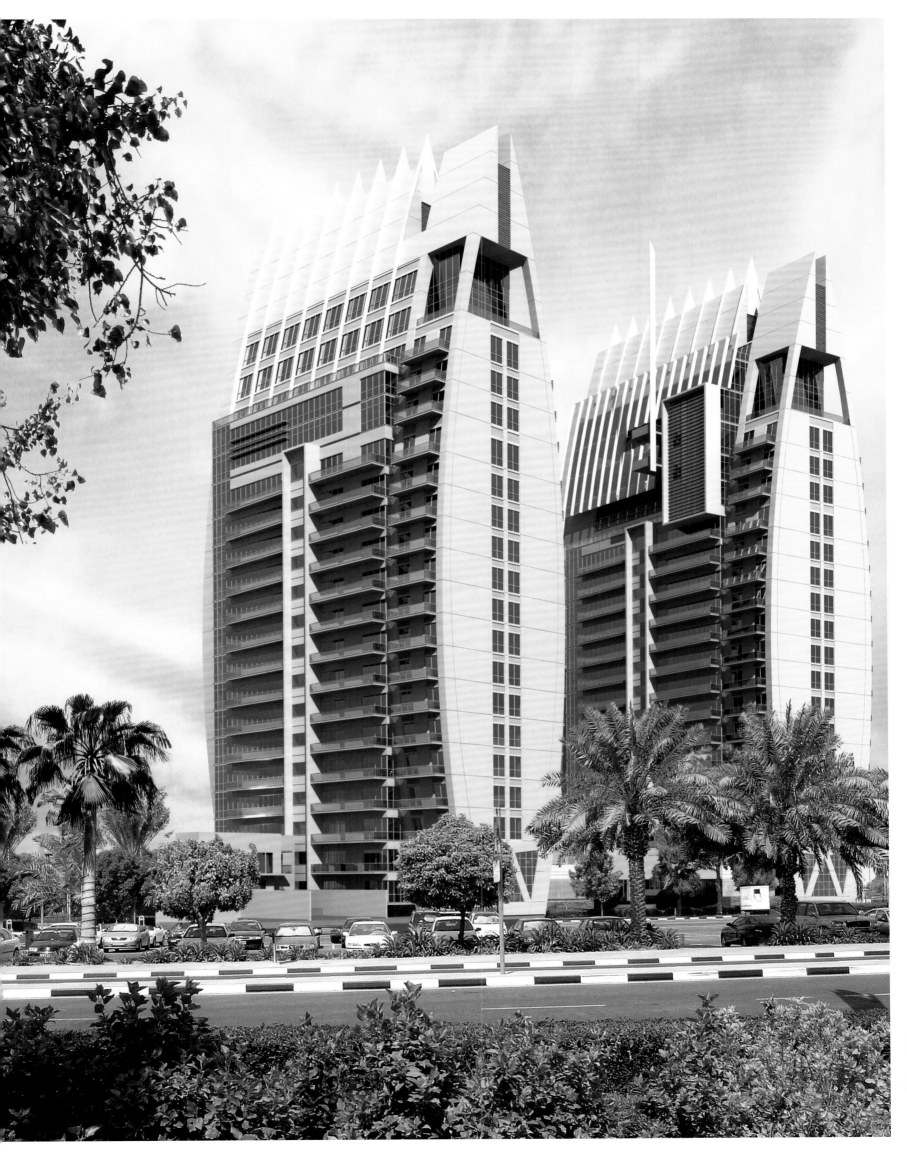

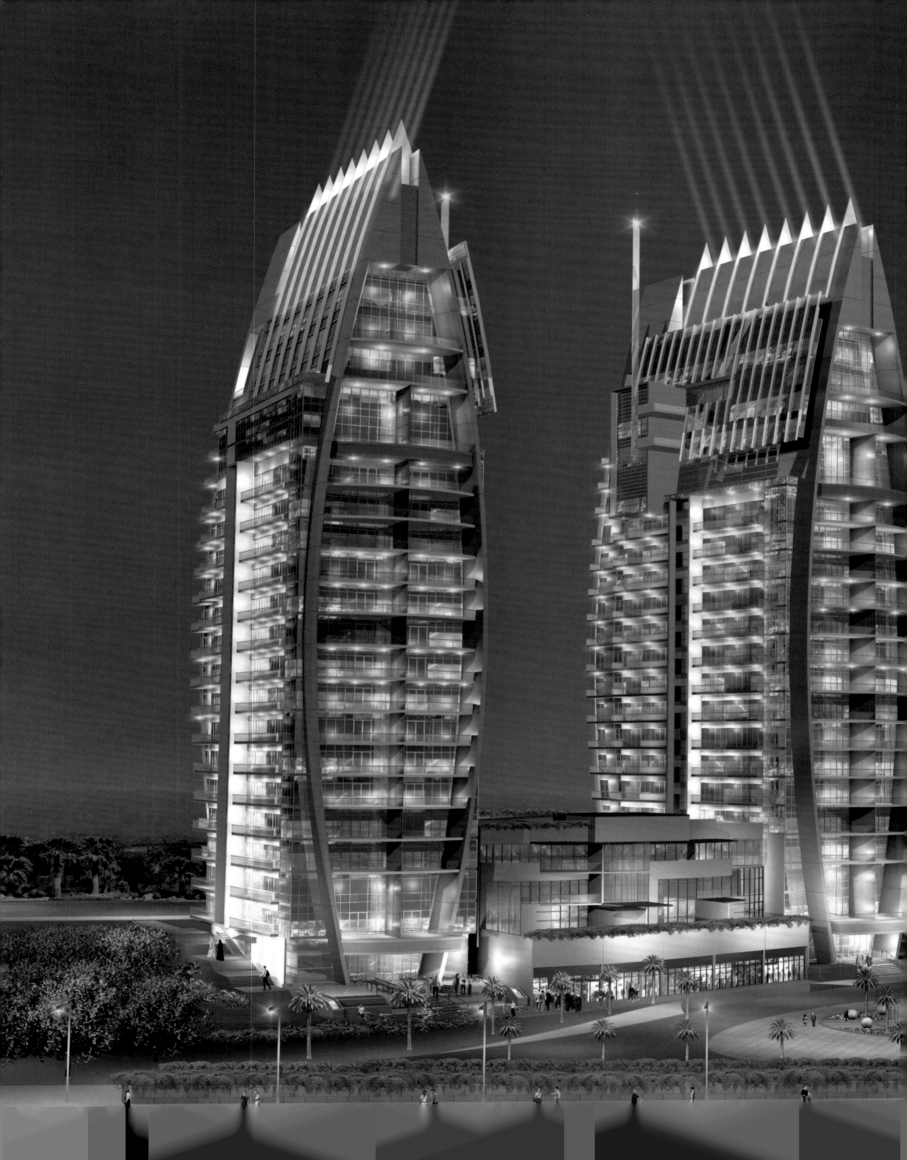

Skidmore, Owings & Merrill LLP

Burj Dubai | 2009
Doha Road – Sheikh Zayed Road
Photos: © Courtesy Skidmore, Owings & Merrill LLP

Superlative umranken das Projekt: ein Luxushotel in Kooperation mit Giorgio Armani und nur hochwertigste Areale zum Leben und Arbeiten. 160 Stockwerke winden sich aus dem Wüstennichts empor, wie Ablagerungen um eine schlanke, spitze Säule. Der Siegerentwurf eines internationalen Wettbewerbs bezeugt Raffinesse, mit einer spiralförmigen Geometrie, die einer Wüstenrose gleicht.

A luxury hotel in cooperation with Giorgio Armani, a project superlatively entwined with the most luxurious areas for living and working. A total of 160 floors wind themselves out of the desert sand upward like sediments around a thin pointed pillar. The winning design of an international competition testifies refinement, with a spiral geometry resembling a desert rose.

Un proyecto de superlativos: un hotel de lujo creado en cooperación con Giorgio Armani y espacios de trabajo y hábitat de alta calidad. En medio de la nada del desierto se alzan 160 plantas adosadas a una estrecha columna puntiaguda. El boceto ganador del concurso internacional es clar muestra de refinamiento, expresado a través de una geometría en espiral, que semeja una rosa del desierto.

Le projet est couvert de superlatifs : un hôtel de luxe créé en collaboration avec Giorgo Armani et essentiellement des espaces de qualité pour vivre et travailler. S'élevant du désert 160 étages s'enroulent et se déposent comme des concrétions autour d'une colonne élancée et pointue. Le projet, qui a gagné ce concours international, est d'un grand raffinement avec sa géométrie en spirale qui ressemble à une rose des sables.

Un progetto che si nutre di superlativi: un hotel di lusso progettato in cooperazione con Giorgio Armani con prestigiosissimi spazi residenziali e lavorativi. 160 piani che sorgono dal nulla e che si avviluppano come sedimentazioni attorno ad una colonna slanciata che va assottigliandosi verso l'estremità finale. Il progetto, risultato vincitore di un concorso internazionale, esprime una perfezione tecnica sintetizzata in particolar modo dalla forma geometrica a spirale che ricorda le sembianze del fiore del deserto.

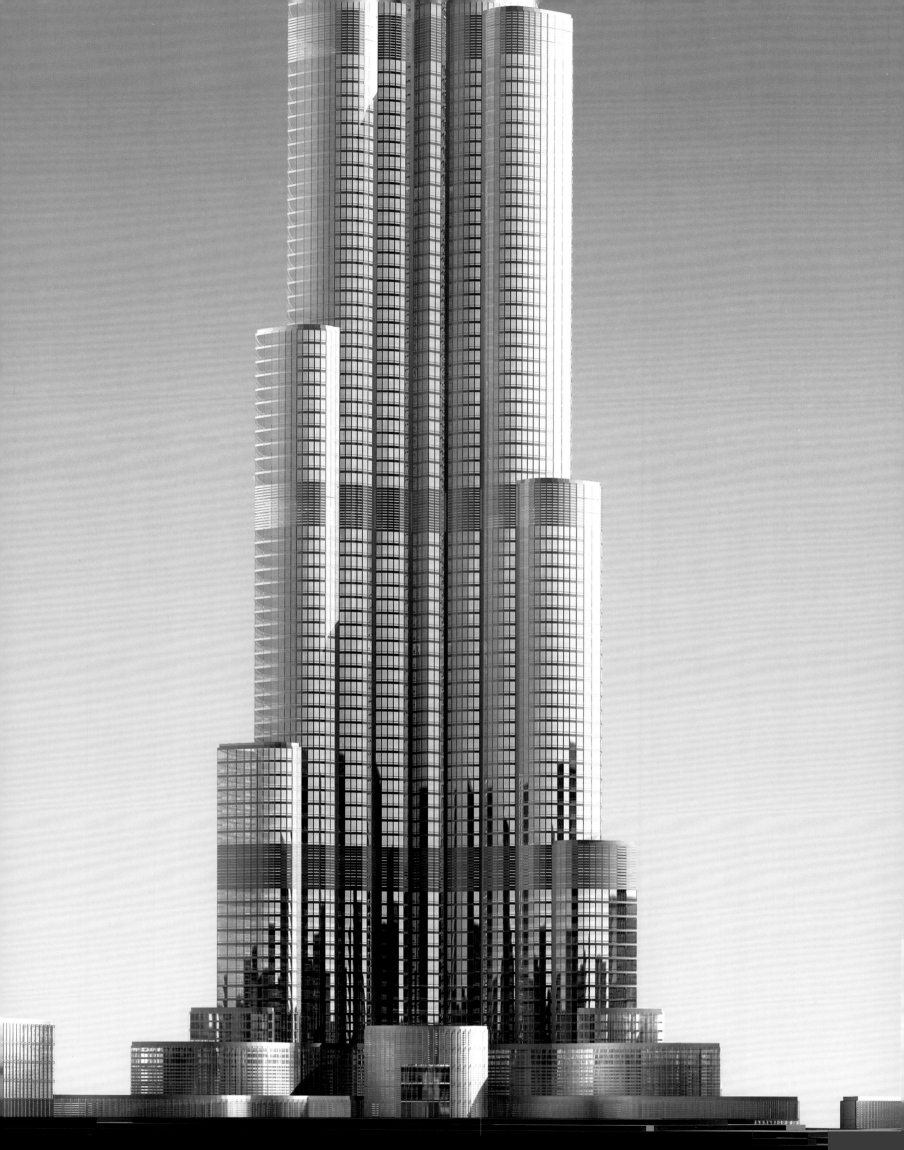

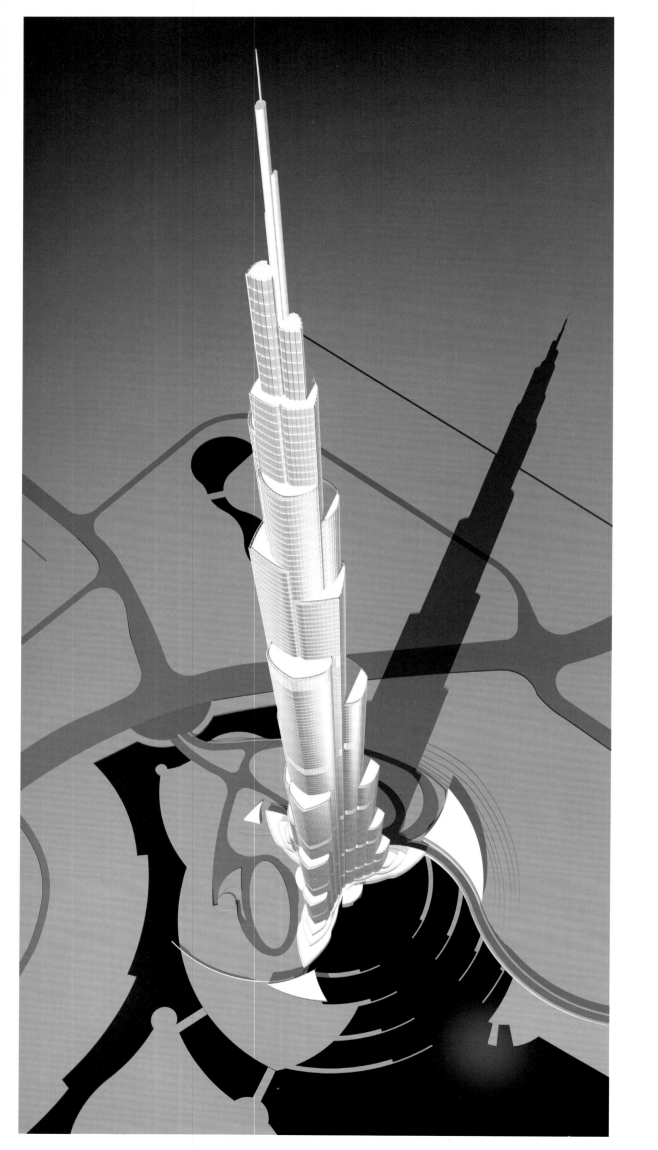

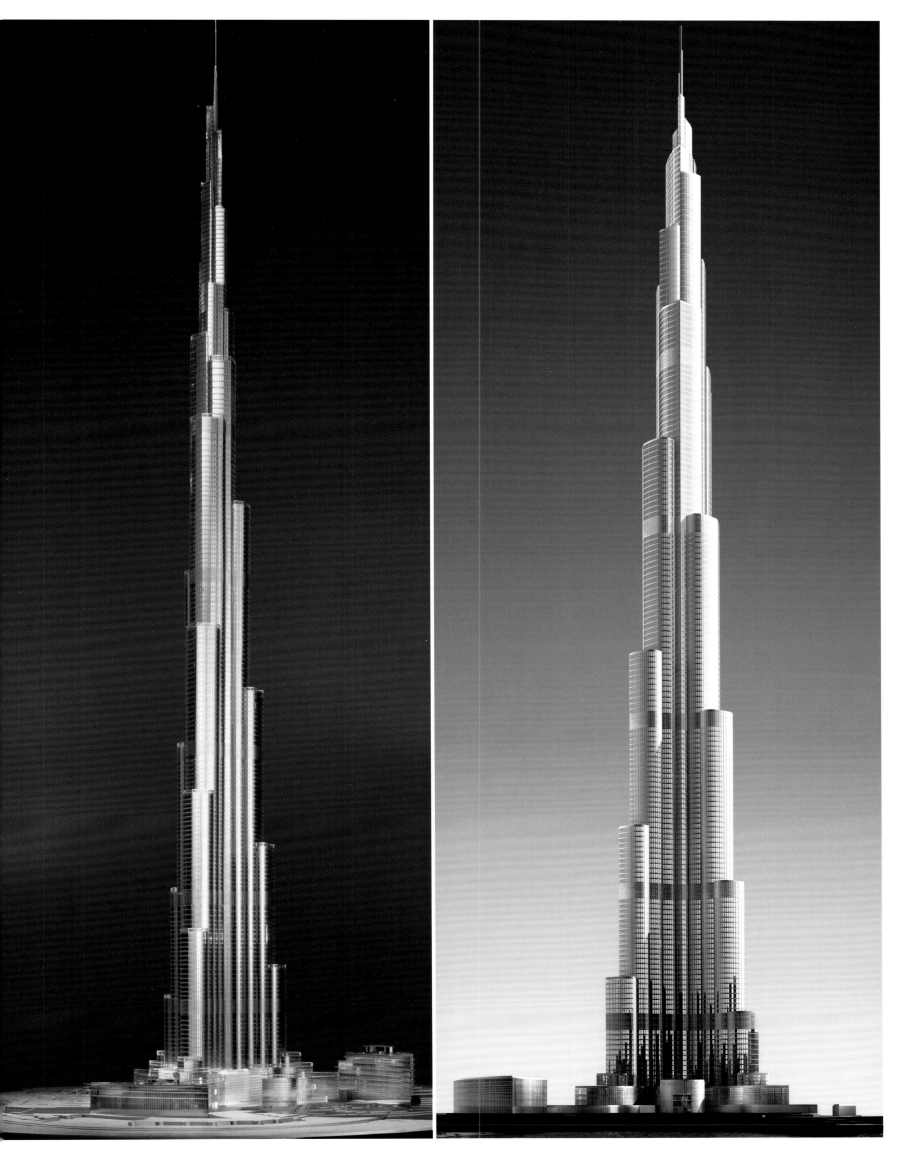

Skidmore, Owings & Merrill LLP
Sun Tower
Photos: © Courtesy Skidmore, Owings & Merrill LLP

Ein Gebäude, das sich neigt, gilt architektonisch als Wagnis. Doch anstatt damit auf den schiefen Turm von Pisa anzuspielen, huldigt das schlanke, schräge Gebilde die Sonnenuhr, mit der arabische Gelehrte als erste den Lauf der Zeiten fixierten. So ist am geneigten Turmstab selbst der gewaltige Umbruch ablesbar, den Dubai als junge Metropole durchläuft.

A tilted building is considered an architectural risk. But, rather than insinuating the leaning tower of Pisa, the slim tilted construction pays homage to the sundial with which Arab scholars for the first time measured the passing of time. The tilted tower itself symbolizes the great changes which Dubai is going through as a young metropolis.

En el mundo arquitectónico construir un edificio inclinado se considera una temeridad. Sin embargo, en lugar de hacer alusiones a la torre de Pisa, esta delgada y torcida figura contiene el reloj de sol con el que los eruditos marcaron el paso del tiempo. Esta estructura inclinada hace patente la impresionante transformación que convierte a Dubai en joven metrópoli.

Un bâtiment incliné passe d'un point de vue architectonique pour une entreprise osée. Cependant au lieu de se référer à la tour de Pise, l'objet élancé et incliné rend hommage à l'horloge solaire avec laquelle les érudits arabes ont été les premiers à mesurer le temps. C'est ainsi que même la tour la plus penchée révèle le profond bouleversement que Dubaï est en train de vivre en tant que jeune métropole.

Una struttura architettonica inclinata è comunemente considerata un'impresa temeraria. Tuttavia, anziché ammiccare alla torre pendente di Pisa, questo edificio slanciato sembra volersi inchinare in segno di rispetto alla scoperta dell'orologio solare per opera degli scienziati arabi, i primi a voler fissare l'incedere del tempo. Alla luce di questa chiave di lettura, il corpo affusolato e inclinato della torre diventa anch'esso simbolo della svolta profonda che la città sta attualmente vivendo in veste di giovane metropoli.

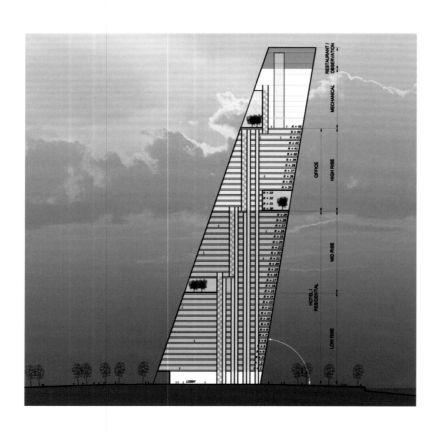

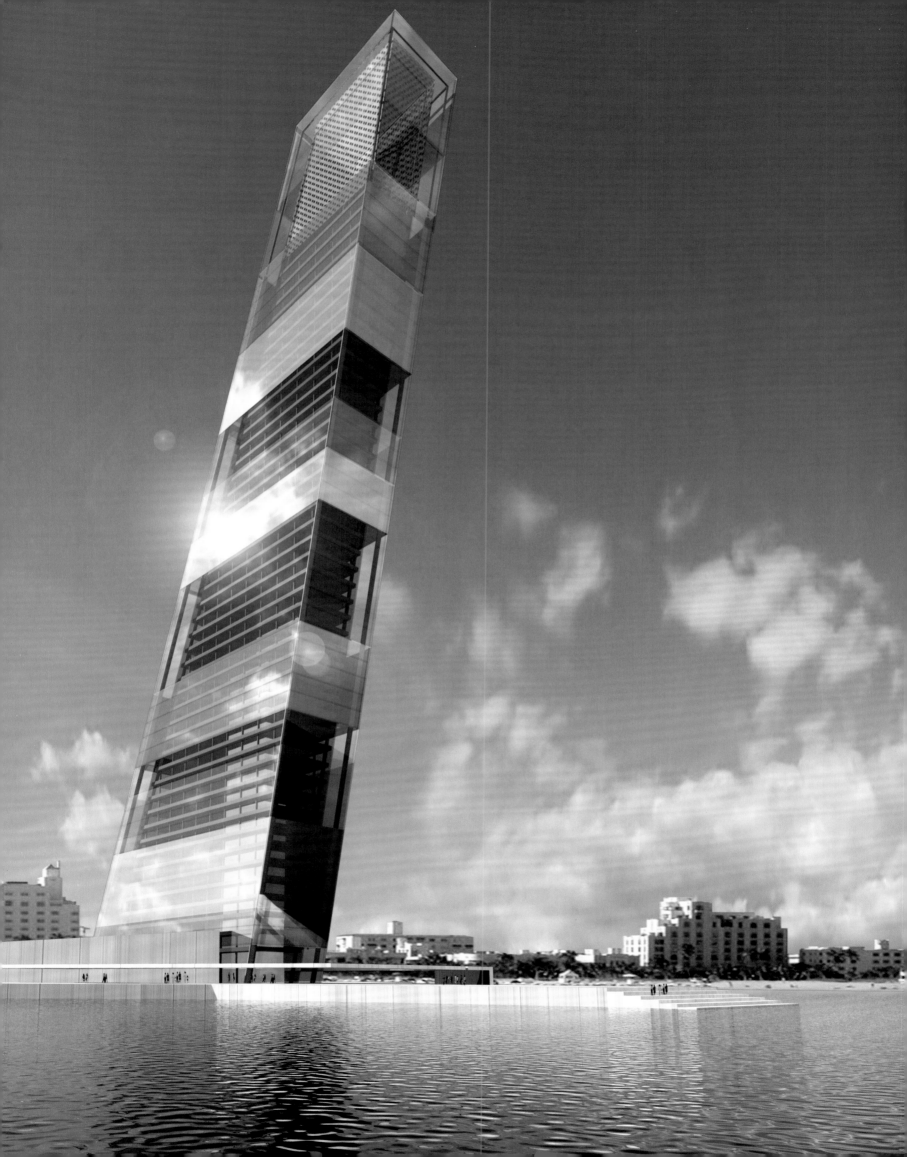

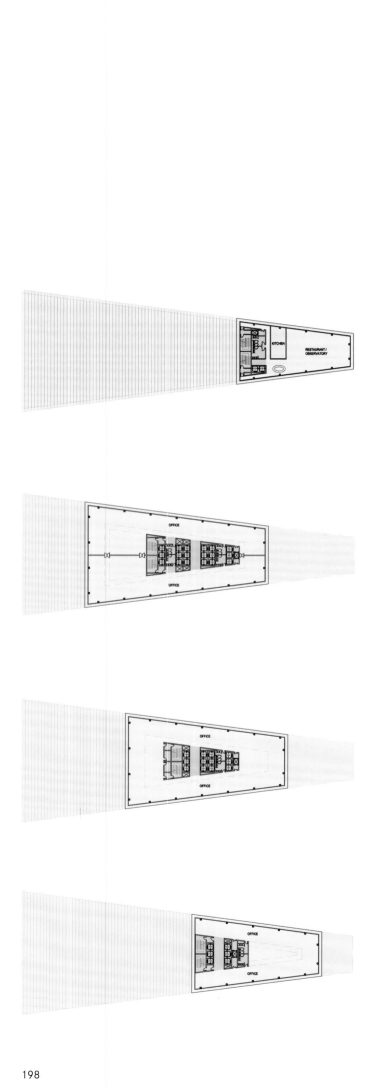

RETAIL

LOBBY

PCS

LOW-
RISE

MID-
RISE

HIGH-
RISE

Wilson & Associates
Givenchy Spa at One&Only Royal Mirage | 2002
Jumeirah Road
Photos: © Martin Nicholas Kunz

In den Gängen des Givenchy Spa fühlt man sich in einen Hamman versetzt. Nur, dass sich die erfrischend kühle Kuppelarchitektur lichtdurchfluteter zeigt und sich noch weit mehr Türen öffnen. So verbindet sich ein Geflecht von kleinen Hallen und stillen Plätzen, die einen ein- und abtauchen lassen: ins kühle Nass oder ins warme Innere der Seele.

In the hallways of the Givenchy Spa one feels transported to a Hammam. Except that the refreshingly cool architecture is more light-flooded and includes far more doors. The spa is a combination of small halls and quiet areas that invite you to take a dive into the cool waters or into the warm interior of your soul.

En los pasillos del Givenchy Spa parece que uno se sumerge en un Hamman. Si bien a ello se añade la frescura cargada de luz de la arquitectura de cúpulas y se abren otras tantas puertas. Así se presenta un entramado de pequeñas estancias y espacios silenciosos que invitan a inundarse a la vez de la fresca humedad y del calor del espíritu.

Les couloirs du Givenchy Spa donnent l'impression que l'on se trouve transporté dans un hammam. Ne serait-ce que grâce à l'architecture des coupoles baignée de lumière qui procure la fraîcheur et les nombreuses portes qui s'ouvrent. C'est ainsi que se crée un réseau de petites pièces et d'endroits tranquilles où on peut s'immerger et se cacher dans la fraîche humidité ou même justement dans l'intimité chaleureuse de l'âme.

Nei corridoi della Givenchy Spa ci si sente direttamente trasportati in un hammam. Con la differenza che questo centro spa è molto più luminoso, grazie alla luce che penetra insieme ad una brezza rinfrescante attraverso la costruzione architettonica a cupola, e che vi si dischiudono molte più porte. È così che nasce un intreccio di spazi delimitati ed angoli tranquilli nei quali immergersi e lasciarsi andare: nell'acqua rinfrescante. Oppure nella calda interiorità della propria anima.

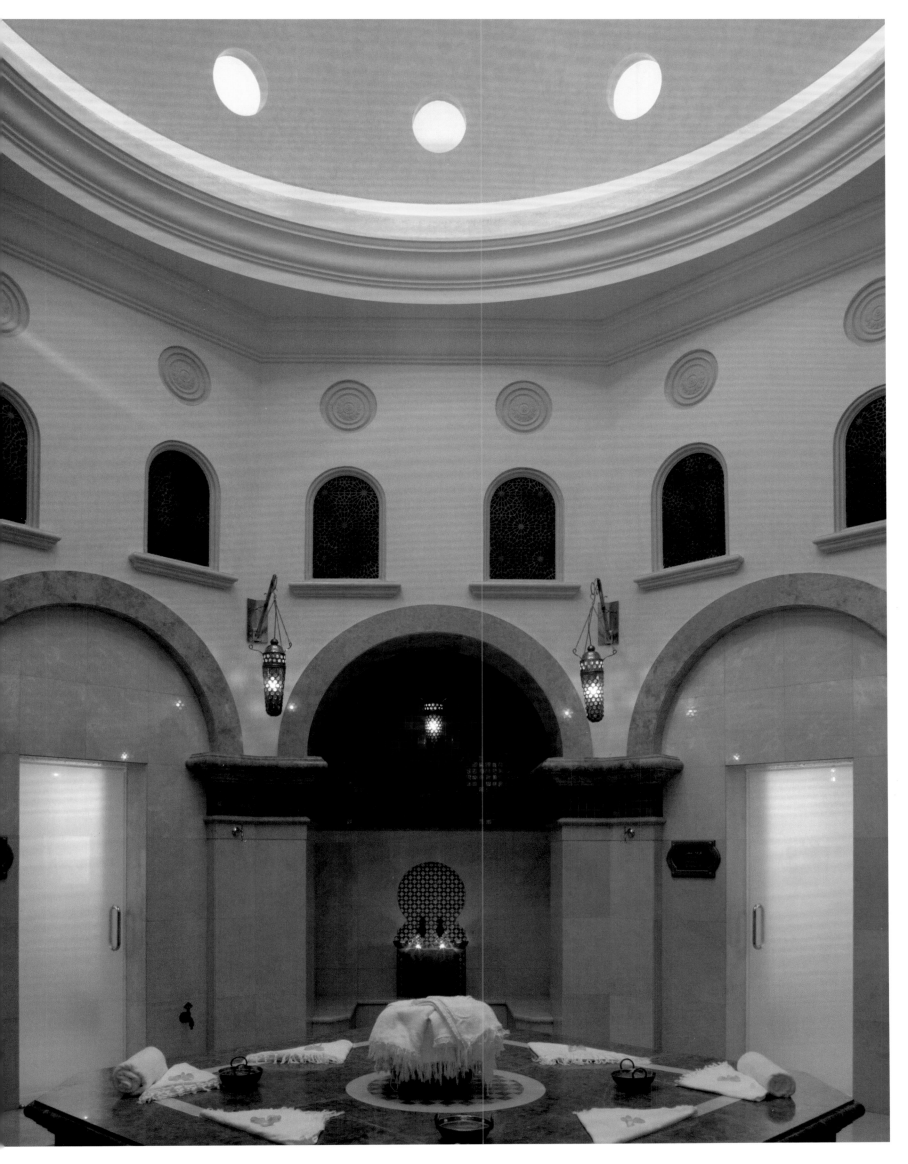

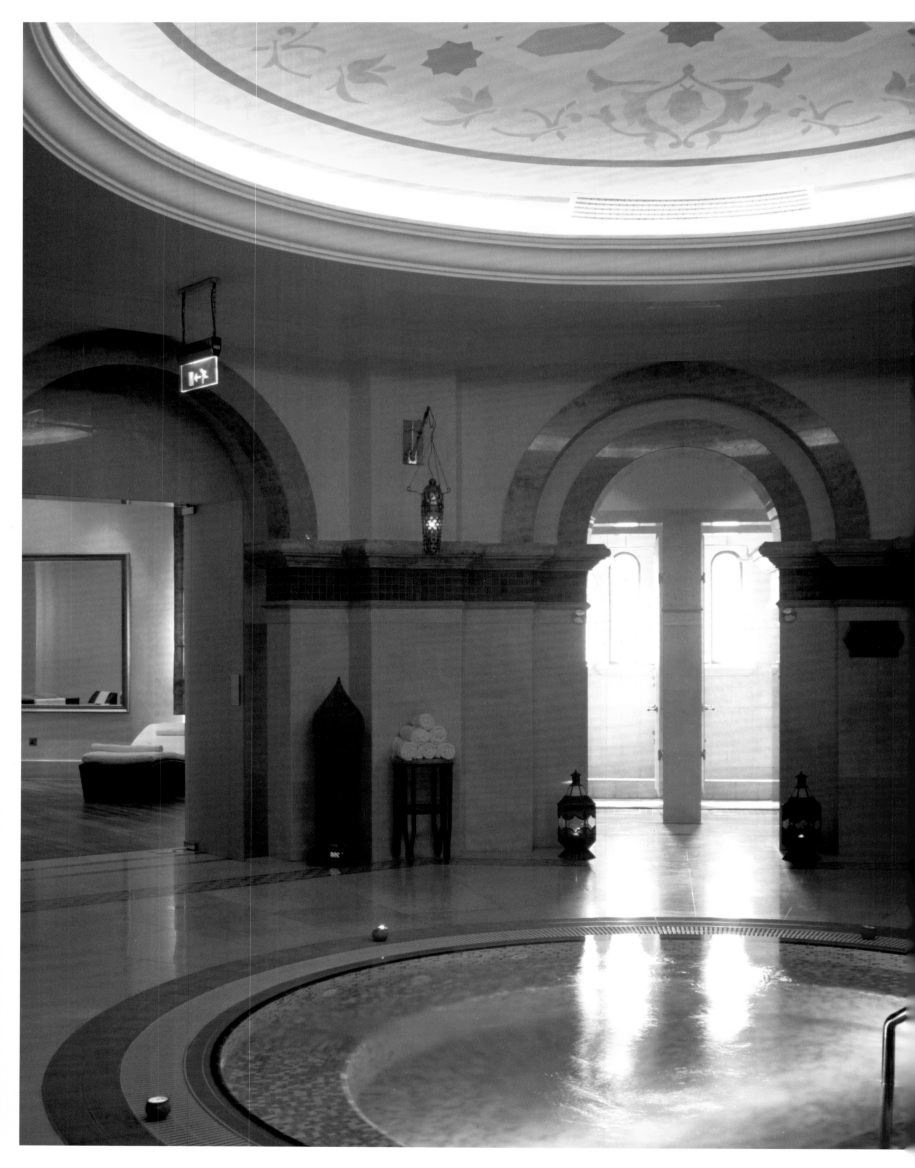

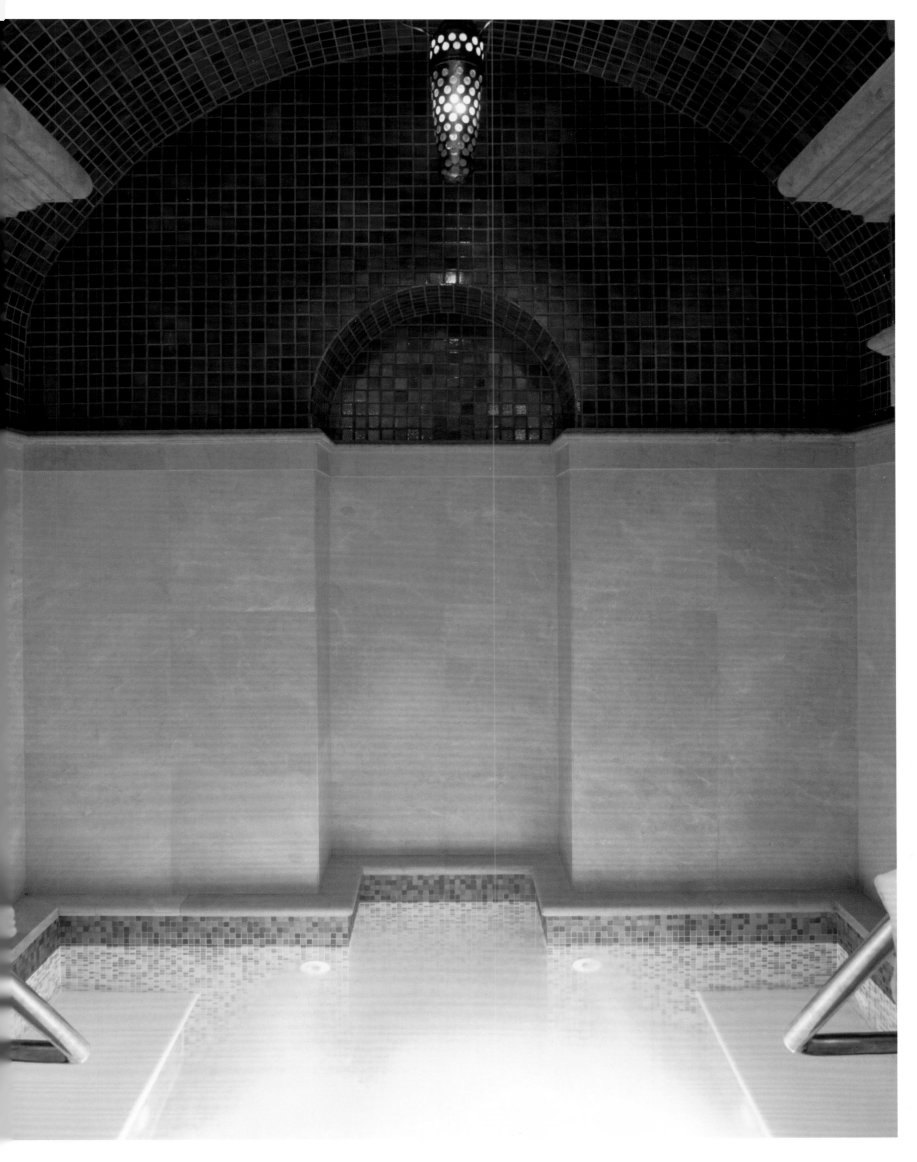

Wilson & Associates
Nina at One&Only Royal Mirage | 2002
Jumeirah Road
Photos: © Courtesy One&Only Royal Mirage (210/211, 213), Martin Nicholas Kunz (209, 212)

Im Restaurant Nina serviert der britische Maitre eine von Indien inspirierte Fusion-Küche. Und das zeigt sich auch in der Gestaltung der drei Etagen: Klirrende Vorhänge, zwiebelspitze Durchgänge und Lichtdurchbrüche, dazu alte Lüster, die ein dämmriges Licht verbreiten. Der Hauch des vorderen Asiens ist hier in fast jedem Winkel zu verspüren.

At the Nina restaurant, the British Maitre serves multicultural food inspired by India. This is also reflected in the design of the three floors. Tinkling curtains, onion-shaped passages and light openings are coupled with old chandeliers that spread a dim light. The touch of Asia Minor can be felt in almost every corner.

En el restaurante Nina el maitre sirve una cocina de fusión de inspiración india, reflejada a la vez en la decoración de las tres plantas. Cortinas de colores vibrantes, pasillos con arcos de herradura apuntados, cortes de luz y viejos lustros de débil destello. La brisa del extremo Oriente se percibe en cada rincón.

Le maître britannique du restaurant Nina sert une cuisine métissée d'inspiration indienne. Et cette touche se fait sentir également dans l'agencement des trois étages : des rideaux qui cliquètent, des passages avec des coupoles et des moucharabiehs, ainsi que de vieux lustres qui répandent une lumière tamisée. On retrouve ce parfum de Proche Orient dans presque chaque recoin du lieu.

Nel ristorante Nina il maître britannico vi servirà delle specialità di cucina fusion di ispirazione indiana. Alla mescolanza di sapori corrisponde la mescolanza di stili nell'interior design dei tre piani: tende tintinnanti, passaggi orientaleggianti e scorci di luce, il tutto alla luce tenue di antichi lampadari. L'atmosfera impalpabile dell'Asia Vicina si avverte pressoché ovunque.

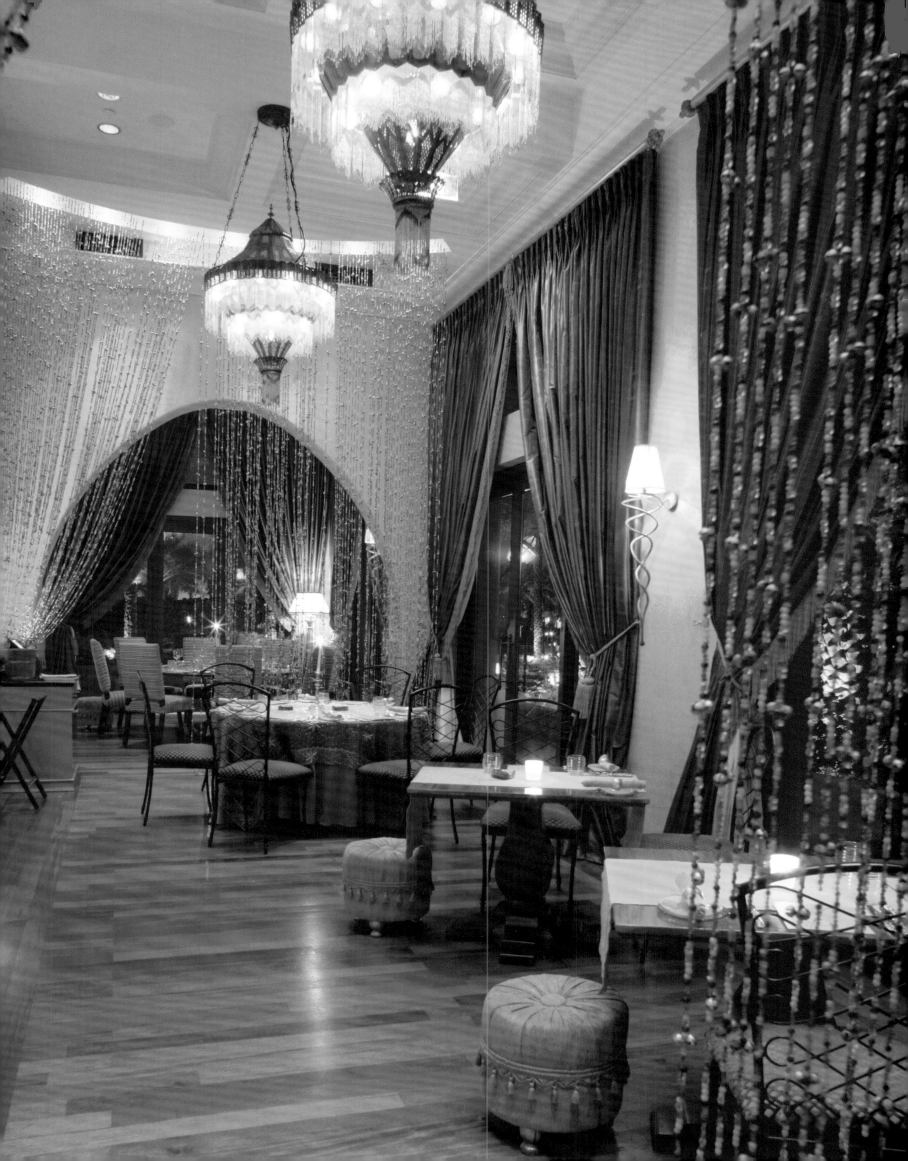

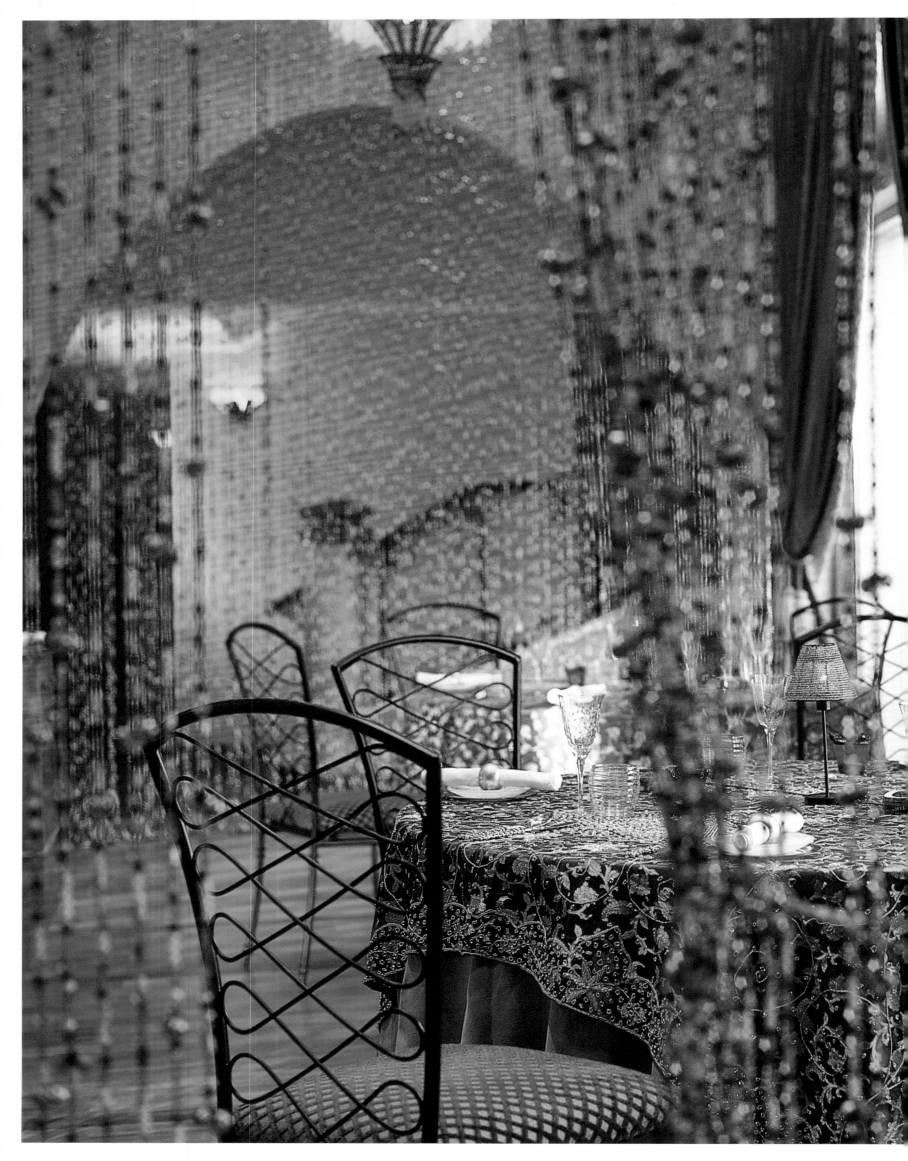

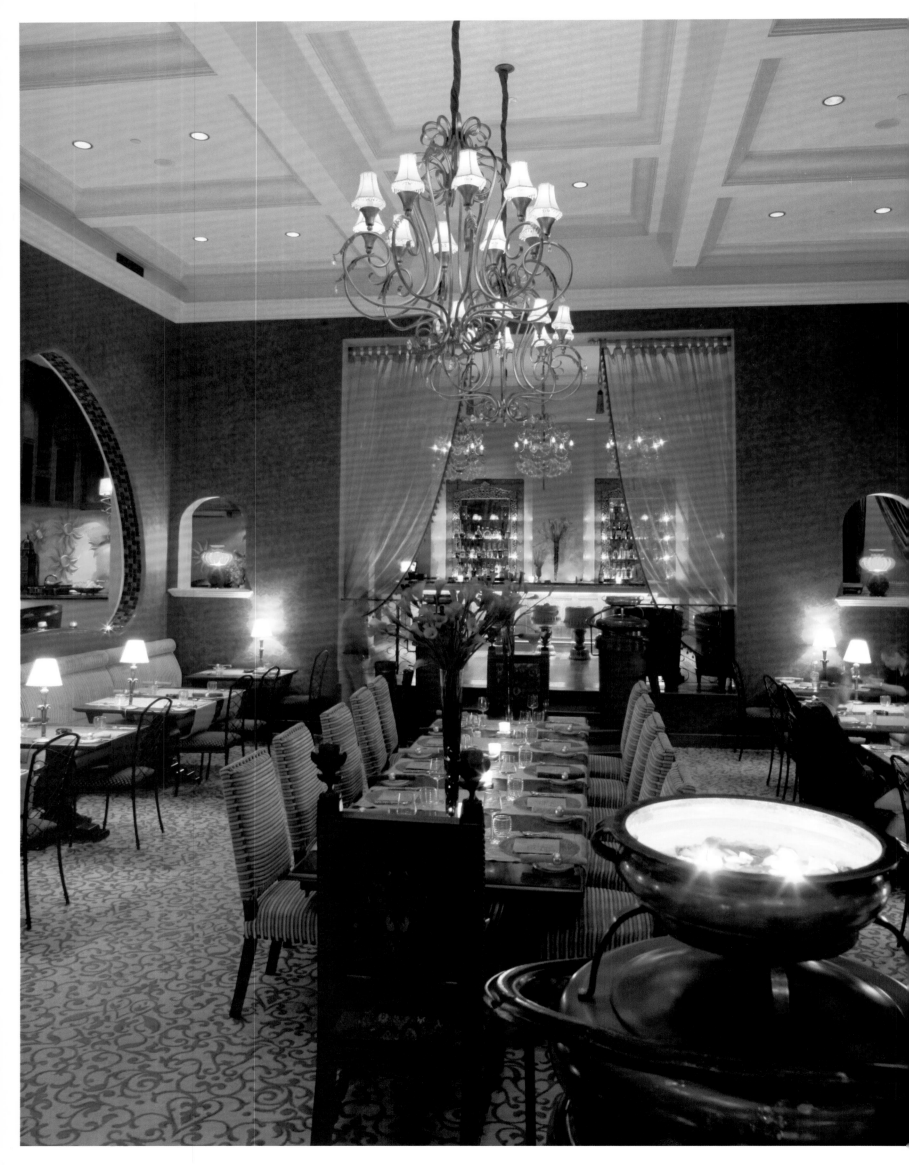

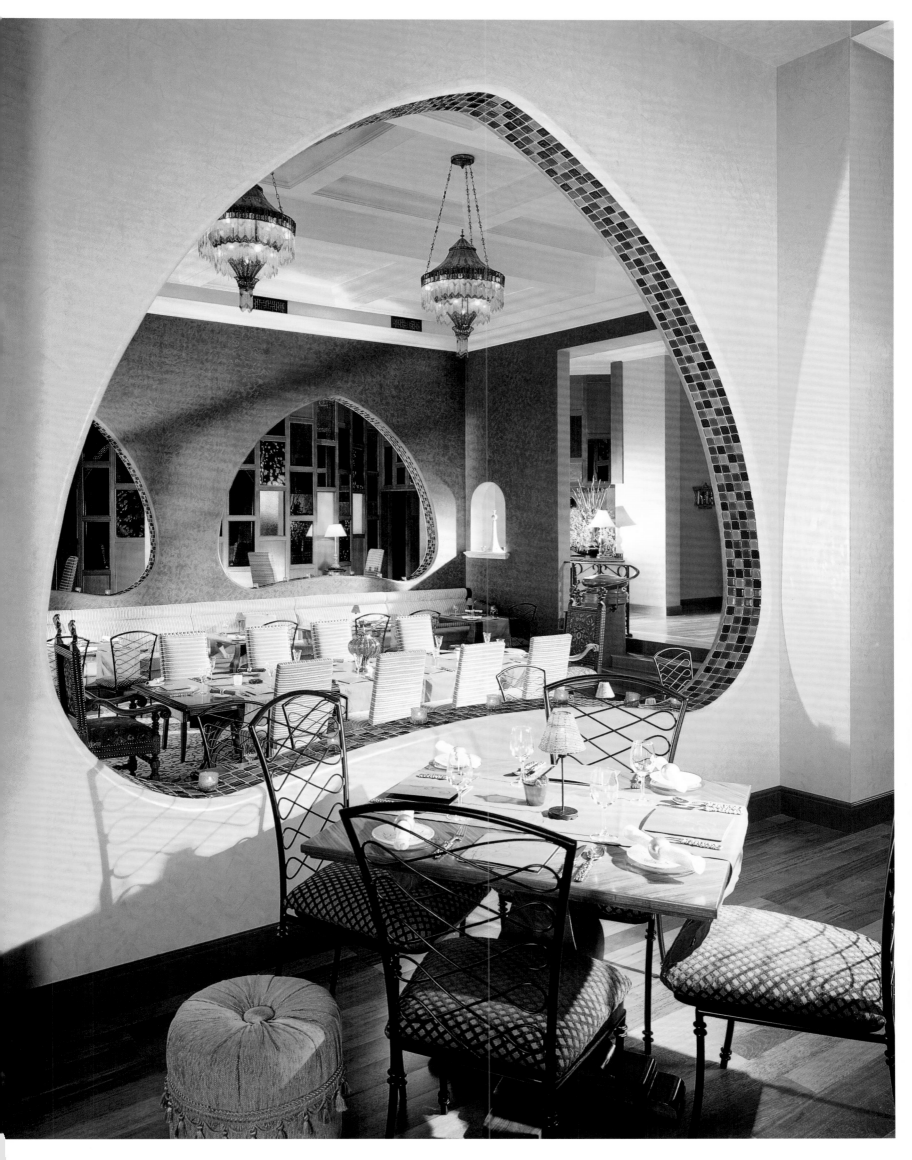

Wilson & Associates
One&Only Royal Mirage I 1999
Al Sufouh Road
Photos: © Martin Nicholas Kunz

Gern pflegen die Resorts vor Ort das überlieferte Erbe des Orients. Und präsentieren, wie hier, die ganze Herrlichkeit von Sultanpalästen. Das bietet verträumte Szenerien, gepaart mit modernstem Luxus. Die abgeschiedene Enklave gleicht einem Dorf aus Residenzen, Restaurants und arabischen Höfen mit einzigartigen, von Palmen umsäumten Winkeln. Ebenso schön: der hauseigene Strand.

The local resorts frequently feature the heritage of the ancient Orient to present, as in this case, the whole splendor of Sultan's palaces. It features dreamy settings coupled with modern luxuries. The solitary enclave resembles a village of residences, restaurants and Arabic courtyards with unique corners surrounded by palms. Equally attractive is the resort's own beach.

Los hoteles de la zona gustan de cuidar la herencia transmitida de Oriente y presentan, como en este caso, la magnificencia de los palacios de los sultanes. Aquí se ofrece un escenario de ensueño unido al lujo moderno. Este apartado enclave semeja un poblado de residencias, restaurantes y patios árabes salpicado de rincones rodeados de palmeras. Otra de las bellezas: la playa propia.

Les stations touristiques de l'endroit entretiennent volontiers l'héritage du passé oriental. Et ils déploient, comme ici, toute la splendeur des palais de sultan. Cela offre des décors idylliques associés à un luxe moderne. L'enclave isolée ressemble à un village composé de résidences, restaurants et de cours arabes avec leurs extraordinaires recoins entourés de palmiers. La plage privée est également très belle.

I resort amano valorizzare in loco la tradizione culturale dell'Oriente. Esaltandone gli elementi oppure, come in questo caso, mostrando tutta la magnificenza dei palazzi di sultani. Questo consente di ricreare delle atmosfere da sogno senza rinunciare al lusso più moderno. Questa enclave isolata assomiglia ad un'oasi composta da residenze, ristoranti e corti arabe impreziosite da angoli paradisiaci delimitati da palme. Di almeno pari bellezza: la prospiciente spiaggia privata.

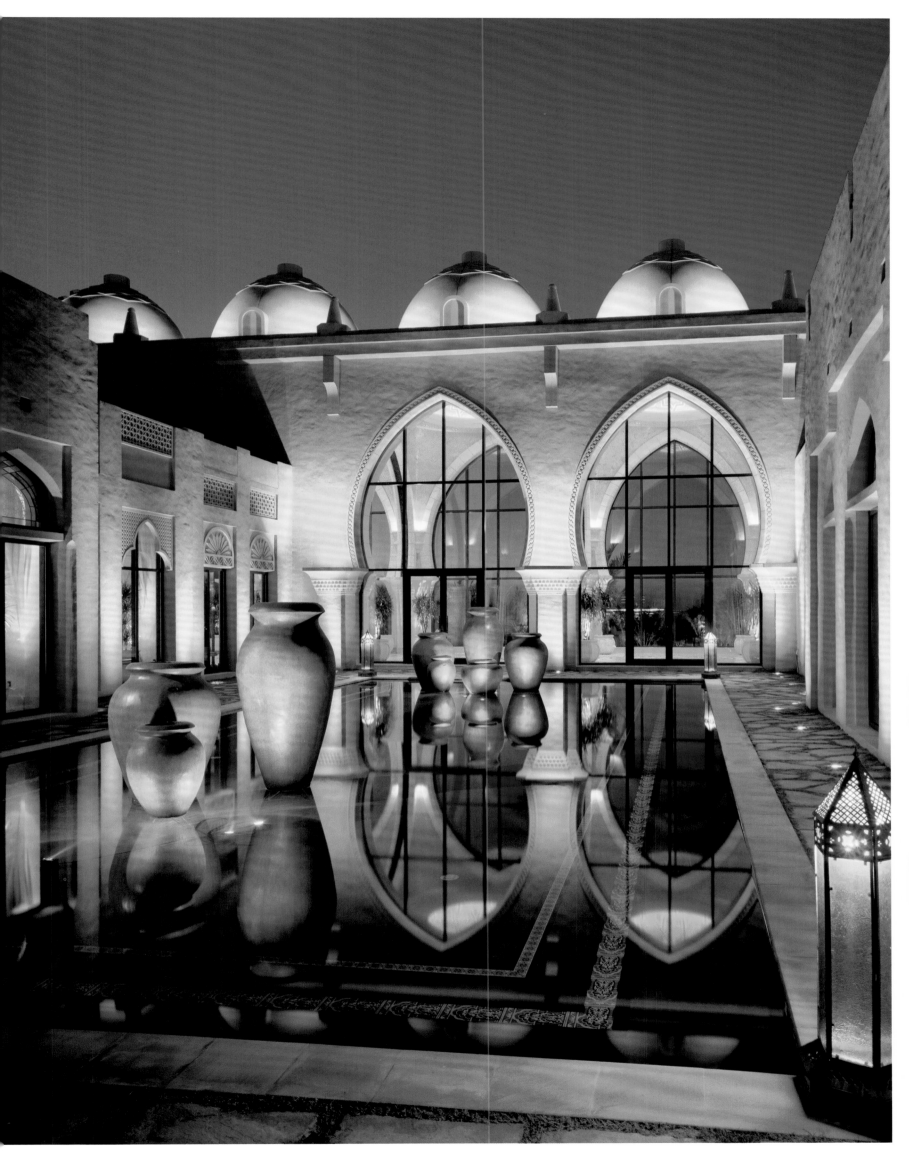

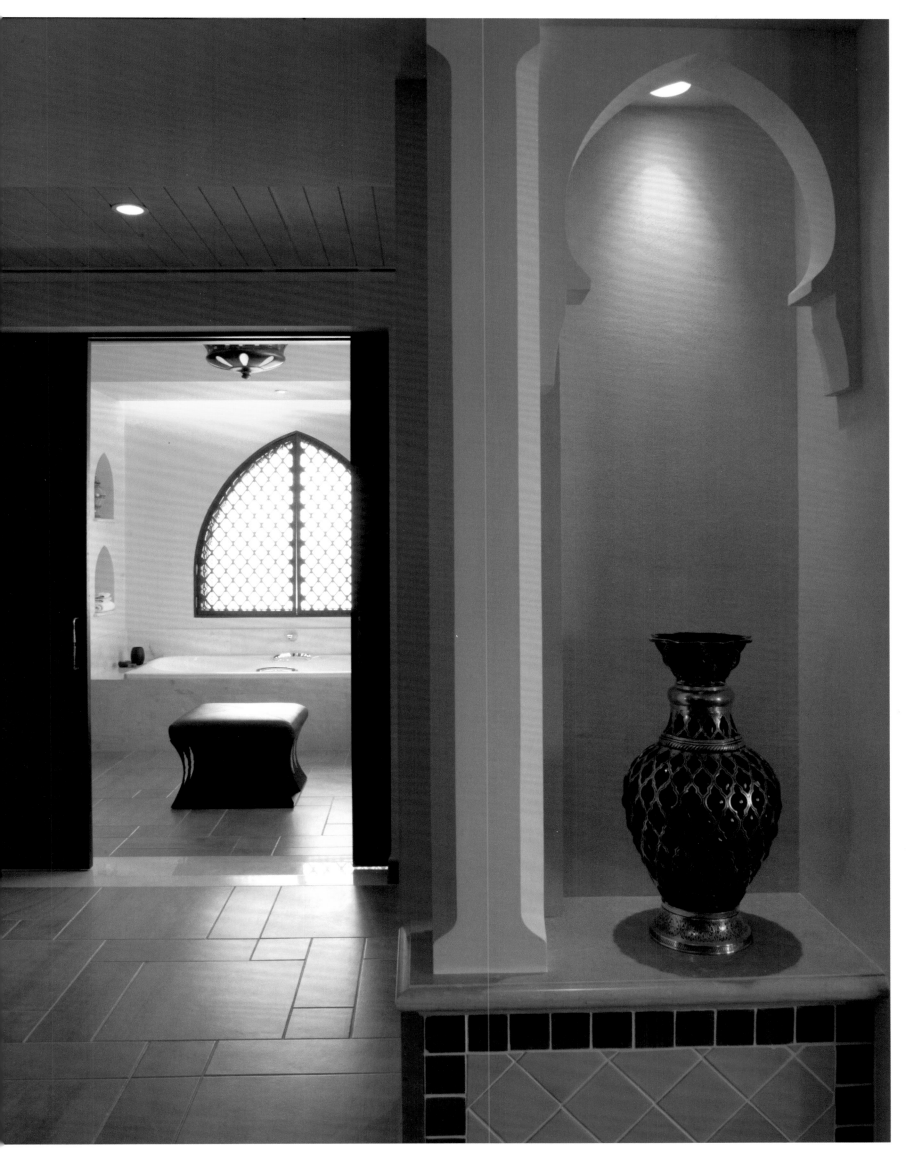

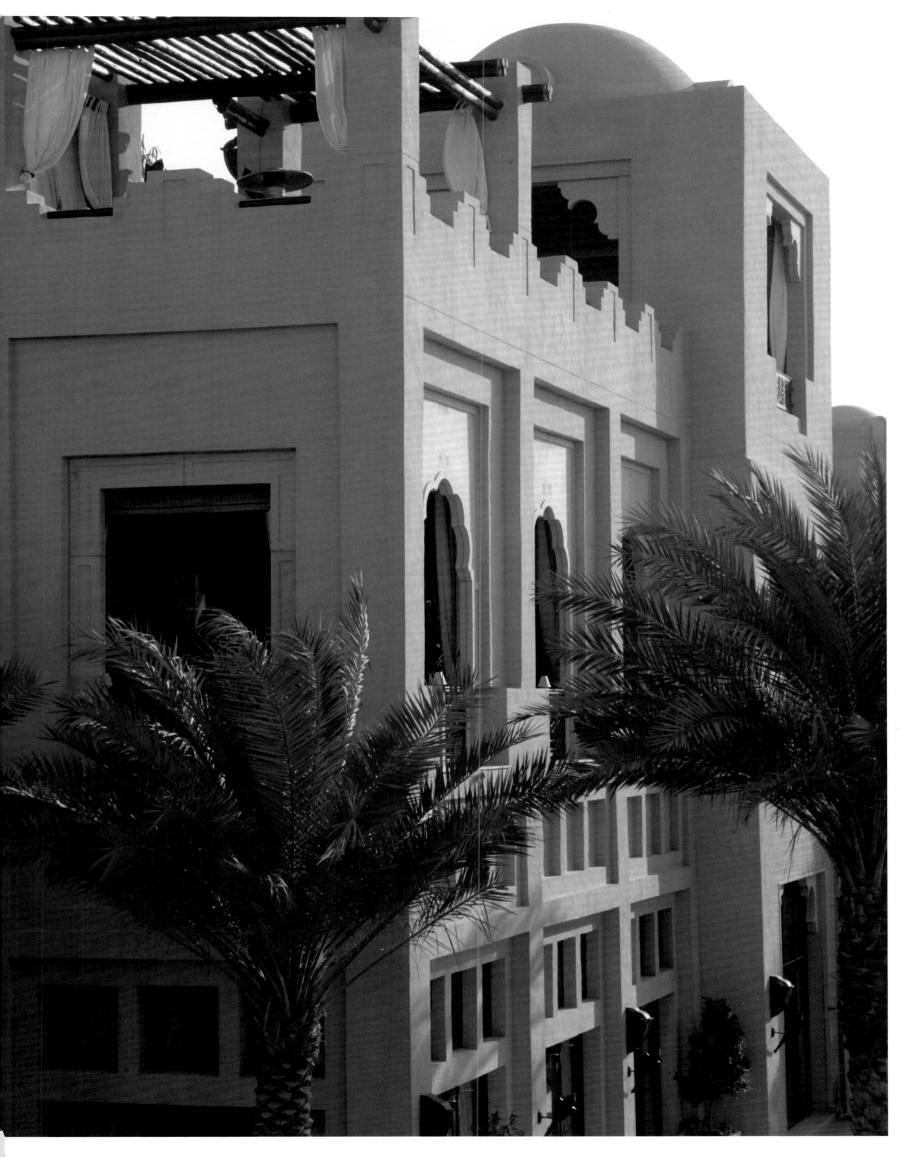

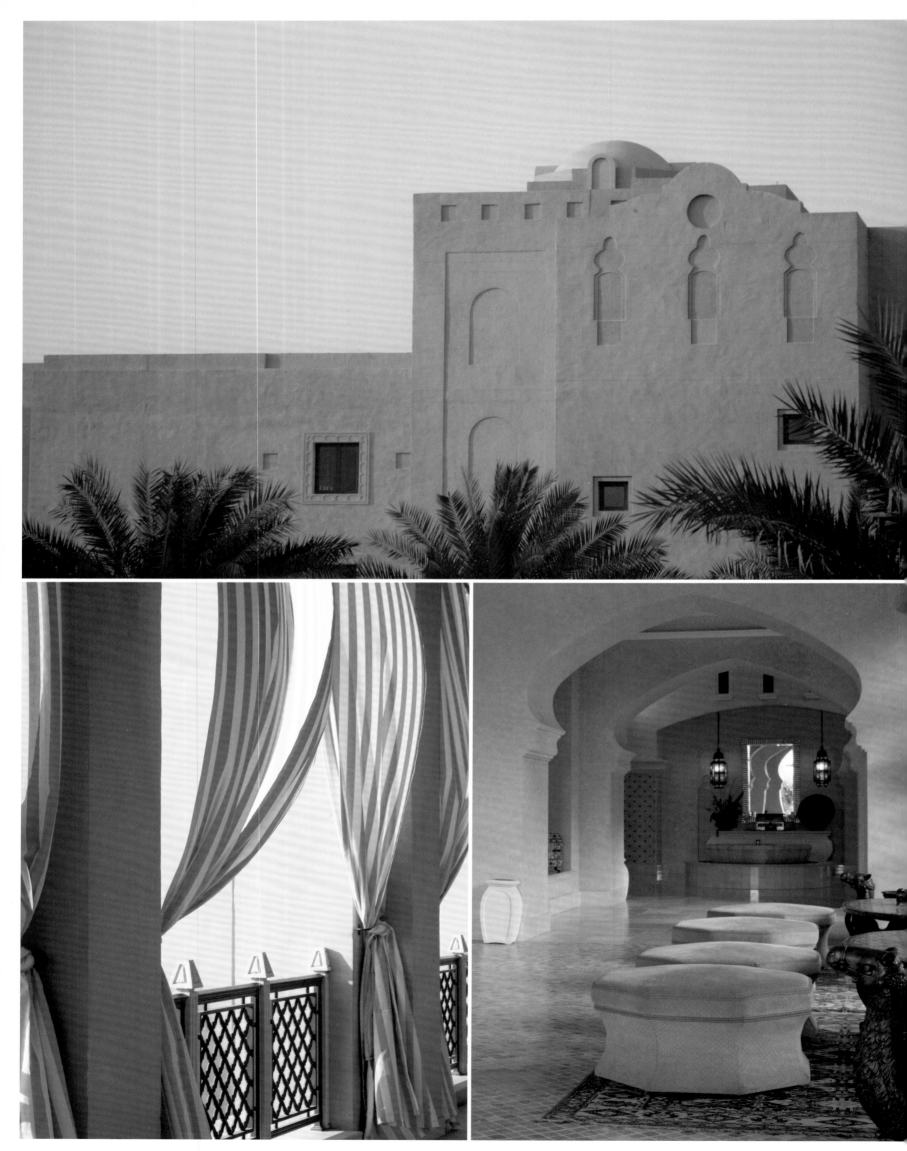

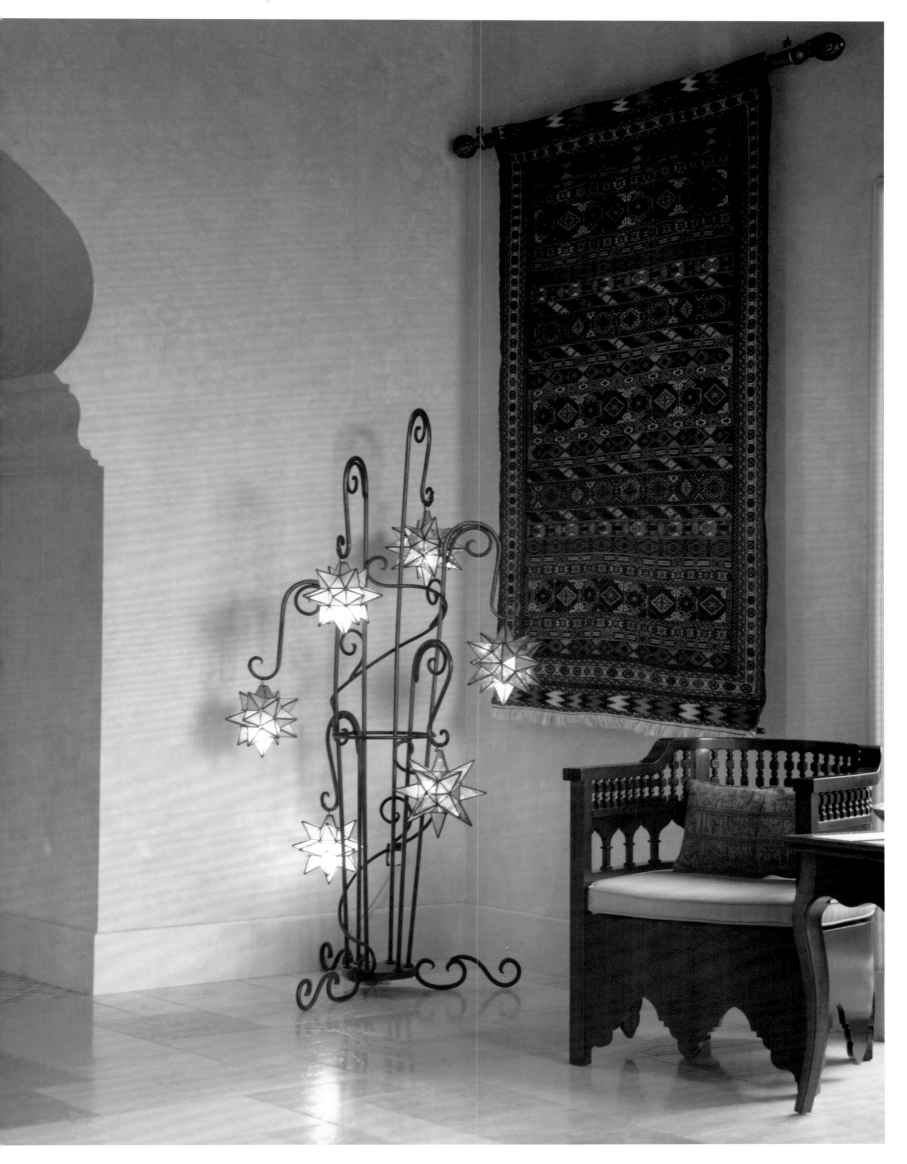

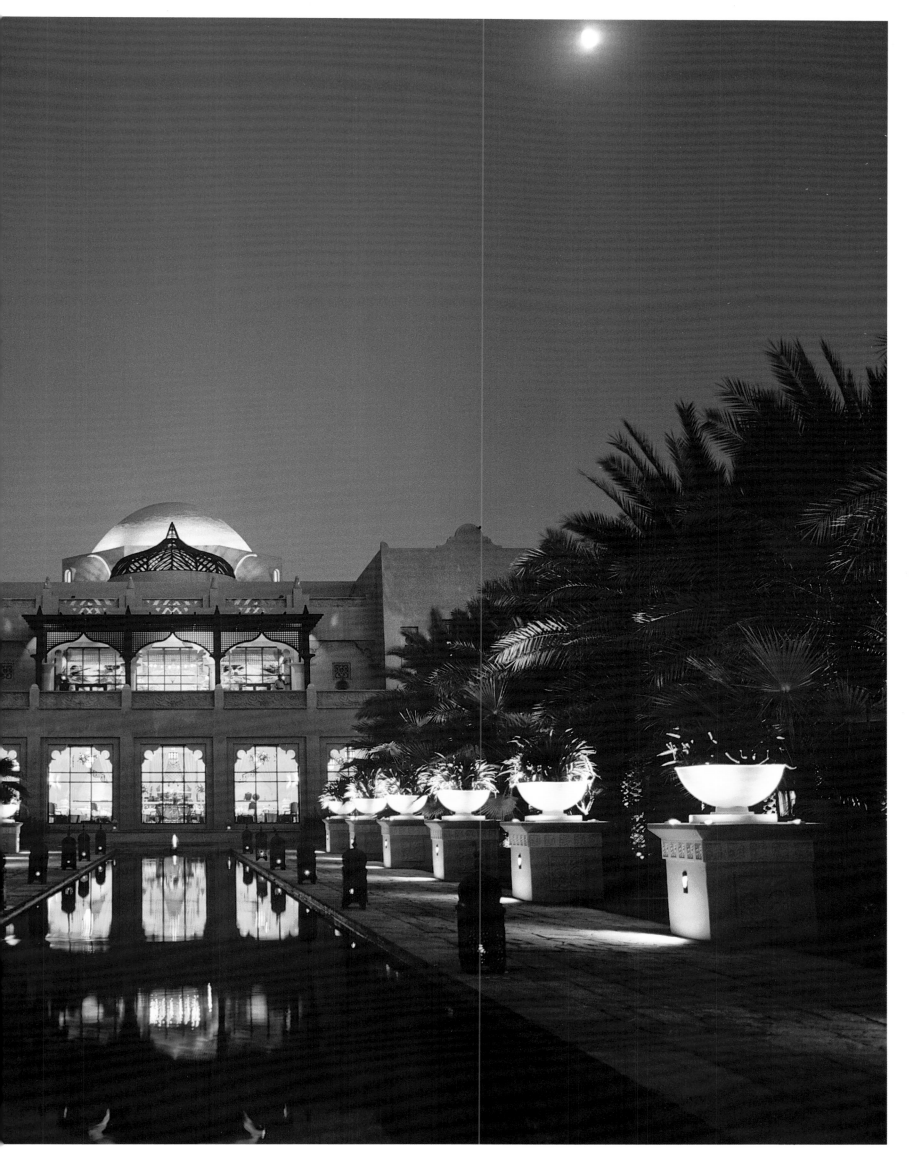

Wilson & Associates
Rooftop at One&Only Royal Mirage | 2002
Jumeirah Road
Photos: © Martin Nicholas Kunz

In der originalgetreuen Kulisse der arabischen Höfe im One&Only Royal Mirage Resorts lockt ein spezieller Ort: Die Rooftop Bar, deren einzige Decke der Himmel als solches ist. Zwischen Türmen, Kuppeln und weißen Vorhängen platziert, warten hier lose arrangiert loungeartige Plätze mit Kuschelkissengarantie. Und ebenso sicher gilt: je später der Abend, desto sternenreicher die Aussicht.

Among the true-to-life setting of Arab courtyards at the One&Only Royal Mirage Resorts one special location attracts visitors. The Rooftop Bar, whose only ceiling is the sky. Among towers, cupolas and white curtains, casually-arranged lounge-style areas offer a comfortably cushioned setting. Certainly, the later the evening, the more star studded the view.

Tras el marco fielmente adaptado al estilo de los patios árabes del resort One&Only Royal Mirage se esconde un lugar especial: el Rooftop Bar, sin otro techo que el cielo abierto. Entre torres, cúpulas y blancos cortinales se reparten de forma desenfadada espacios tipo lounge con acogedoras almohadas para acurrucarse y contemplar un cielo que, cuanto más tarde es más cuajado de estrellas se dibuja.

Avec un décor digne des cours arabes, un endroit particulier du centre touristique One&Only Royal Mirage attire l'attention : le bar Rooftop qui a pour seul plafond le ciel lui-même. Au milieu des tours, coupoles et rideaux blancs des espaces individuels, qui sont agencés comme dans un salon, semblent promettre un confort douillet. Ce qui est certain aussi, c'est que plus la soirée est avancée, plus la vue est étoilée.

Perfettamente inserito nella scenografia fedelmente riprodotta delle corti arabe del One&Only Royal Mirage Resort, il Rooftop Bar è un luogo del tutto speciale, non avendo per soffitto altro (lo dice il nome) che il cielo aperto. Ricco di angoli appartati come una lounge, il Rooftop Bar vi stupirà con le sue sedute relax variamente combinabili, corredate di comodissimi cuscini, disposte fra torri, cupole e giochi di tende bianche. Un ben più che esplicito invito a lasciarsi sprofondare ... soprattutto se nelle ore tarde della serata, preludio di un indimenticabile cielo stellato.

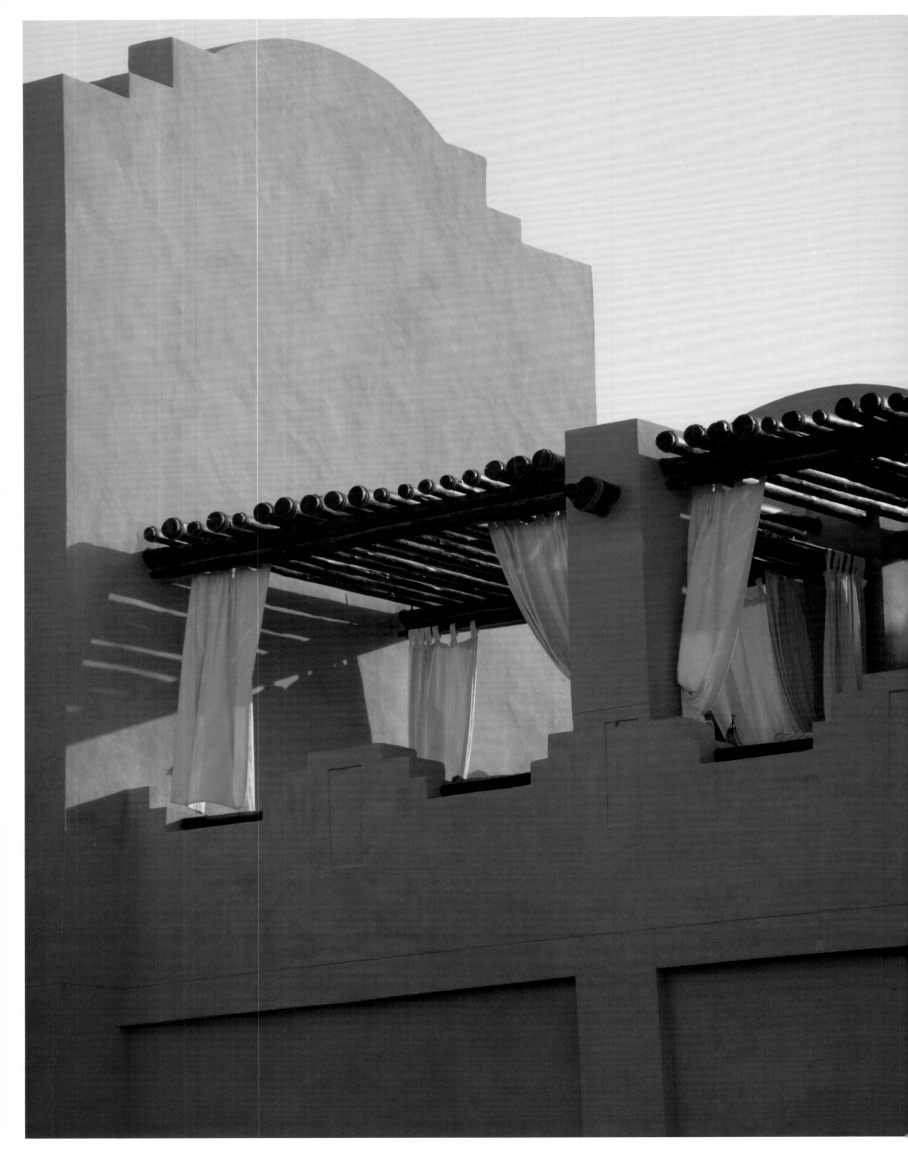

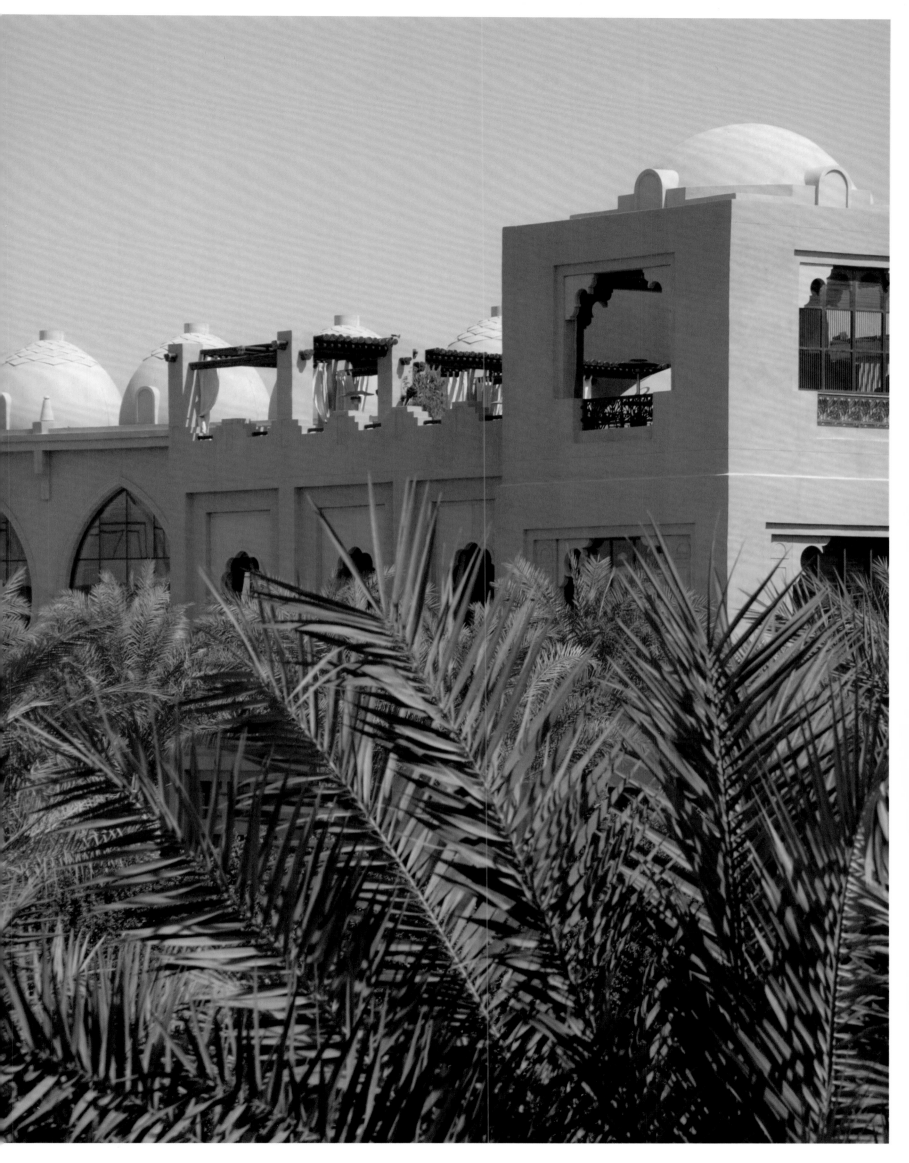

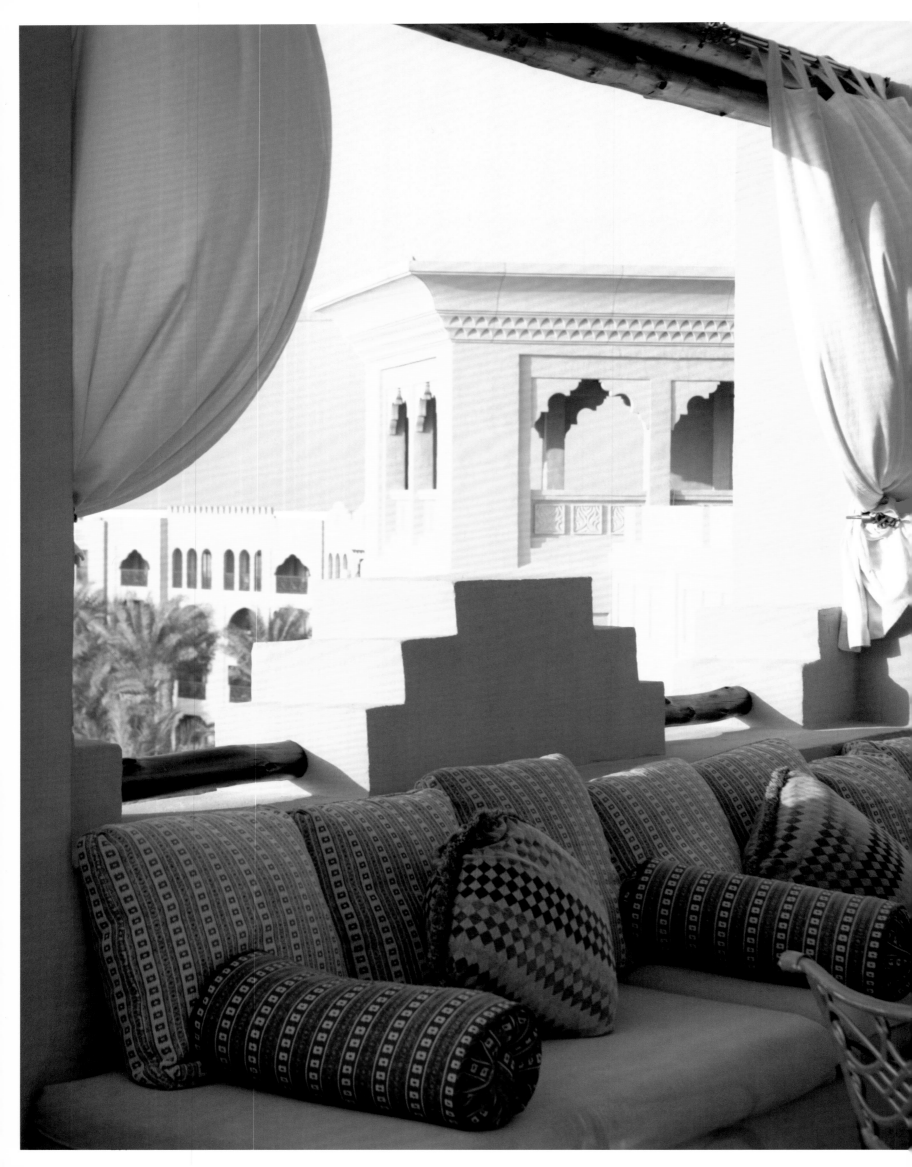

Wilson & Associates
Traiteur at Park Hyatt Dubai | 2005
Al Garhound Road
Photos: © Richard Butterfield

Eleganz und Modernität kennzeichnen die Gestaltung des Park Hyatt Restaurants. Blickfang der offenen Raumarchitektur ist die grazil gewundene Treppe zur zweiten Ebene. Dorthin, zur Weinbar, lockt ein stimmungsstark illuminierter Baldachin, der den Raum vollständig in rosa taucht. Unten, im klar gestylten Restaurant finden sich dezent futuristische Formen.

The design of the Park Hyatt Restaurant is distinguished by elegance and modernity. The central eye catcher of the open room structure is the gracefully winding staircase to the second level. The wine bar located there is dominated by an illuminated baldachin which completely trenches the room in pink. Downstairs, the simply styled restaurant contains moderate futuristic shapes.

Elegancia y modernidad son las marcas significativas del interior del restaurante en Park Hyatt. La grácil y serpenteante escalera que enlaza con el espacio superior capta la atención. Desde allí, hacia la enoteca, la vista se llena de ambiente con un baldaquín iluminado que pinta todo el espacio de una luz rosa. En la parte inferior está ubicado el restaurante, de decoración clara y discretas formas futuristas.

Elégance et modernité sont les caractéristiques de l'aménagement du restaurant du Park Hyatt. Le gracile escalier qui se déroule vers le deuxième niveau est le point de mire de cette architecture spatiale ouverte. Là, dans le bar à vin un romantique baldaquin tout illuminé, qui plonge complètement l'espace dans un bain de lumière rose, exerce son attrait. En dessous, dans le restaurant au style concis, on trouve des formes futuristes de bon ton.

Eleganza e modernità contraddistinguono gli interni del Park Hyatt Restaurant. L'elemento che focalizza l'attenzione nella struttura architettonica aperta è la scala che si snoda esilmente salendo al secondo piano. È qui che si trova il winebar, sormontato da un suggestivo baldacchino illuminato che diffonde tutt'attorno una tonalità rosa. Al piano inferiore il ristorante è caratterizzato da linee ben definite e da forme di vaga reminiscenza futuristica.

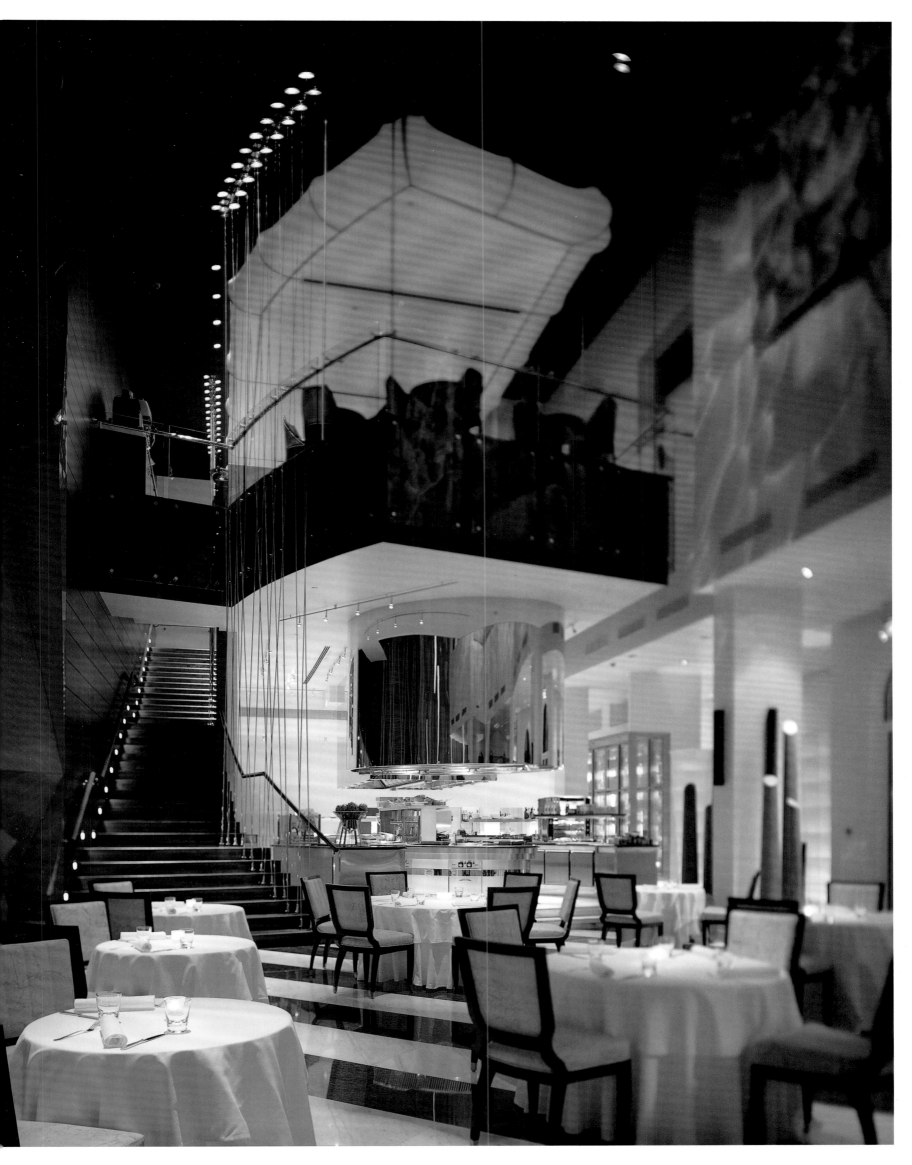

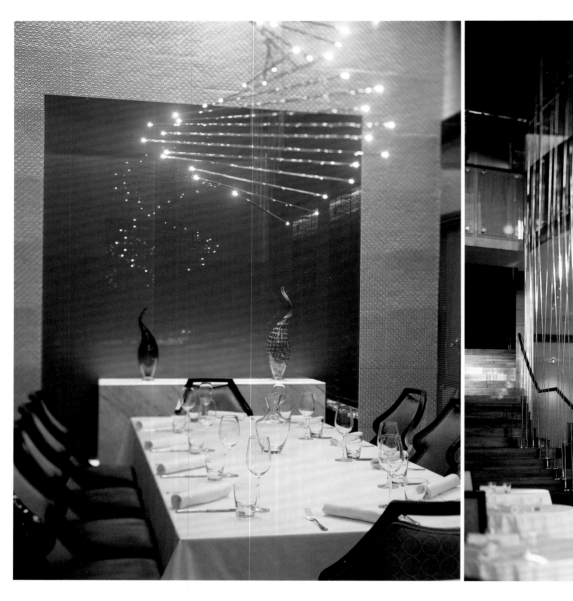
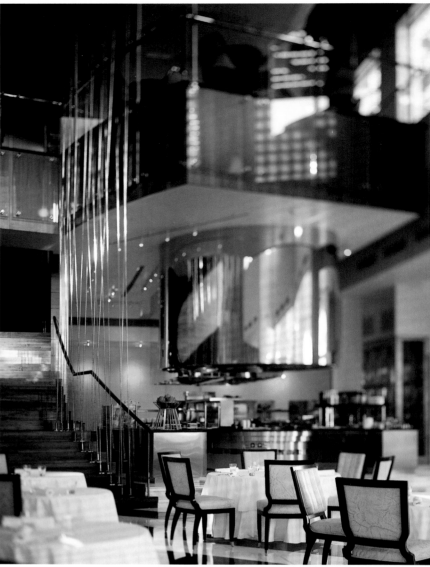

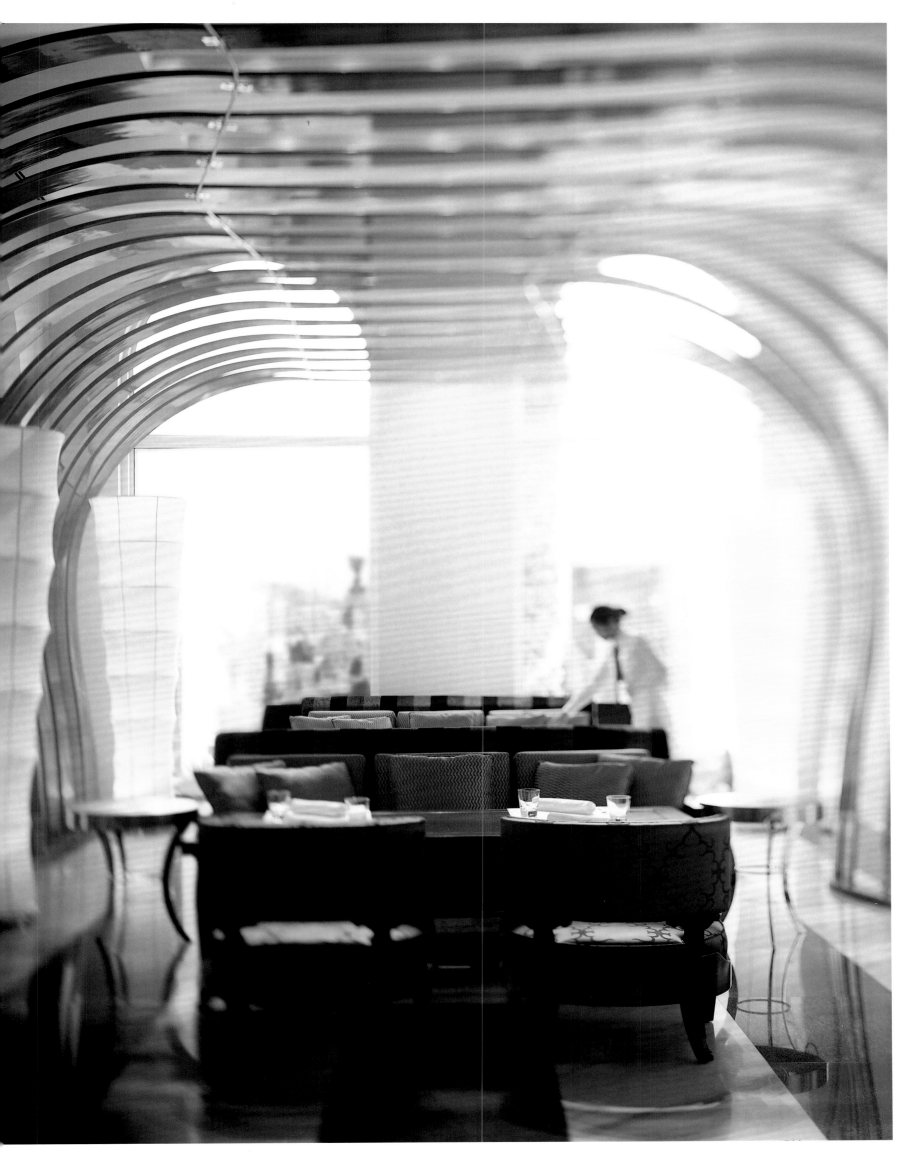

Arkiteknik International & Consulting Engineers
PO Box 7275
Dubai, United Arab Emirates
P +971 4 3375701
F +971 4 3369899
ark123@emirates.net.ae

Creative Kingdom
611 West Sixth Street, 28th Floor
Los Angeles, CA 90017, USA
P +1 213 622 8239
F +1 213 622 1965
www.creativekingdom.com

Chapman Taylor
96 Kensington High Street
London, W8 4SG, United Kingdom
P +44 20 7371 3000
F +44 20 7371 1949
www.chapmantaylor.com
ctlondon@chapmantaylor.com

Dewan Architects & Engineers
Al Wasel Rd, PO BOX 60990
Dubai, United Arab Emirates
P +971 4 3956566
F +971 4 3956900
www.dewan-architects.com
info@dewan-architects.com

Folli Follie S.A.
Athens-Lamia
14565 Athens, Greece
P +30 210 6241000
F +30 210 6241100
www.follifollie.com
postmaster@follifollie.gr

Gensler
Roman House, Wood Street
London, EC2Y 5BA, United Kingdom
P +44 20 7330 9600
F +44 20 7330 9630
www.gensler.com

gmp- von Gerkan, Marg und Partner Architects
Elbchaussee 139
22763 Hamburg, Germany
P +49 40 88 151-0
F +49 40 88 151-177
www.gmp-architekten.de

Project development: Joachim Hauser
P +49 89 12 11 11 0
F +49 89 12 11 11 12
www.hydropolis.com
contact@hydropolis.com

Architecture: 3deluxe / system modern GmbH
Schwalbacher Str. 74
65183 Wiesbaden, Germany
P +49 611 9522050
F +49 611 95220522
www.3deluxe.de
info@3deluxe.de

Ho+k Hellmuth, Obata + Kassabaum
211 North Broadway, Suite 700
St. Louis, MO 63102, USA
P +1 314 421 2000
F +1 314 421 6073
www.hok.com

Jung Brannen Associates
34 Farnsworth Street
Boston, Massachusetts 02210, USA
P +1 617 482 2299
F +1 617 482 4886
www.jungbrannen.com
info@jungbrannen.com

KCA International Designers
111 Westminster Business Square, Durham Street
London, SE11 5JH, United Kingdom
P +44 20 7582 8898
F +44 20 7582 8860
www.kca-int.com
london@kca-int.com

Keith Gavin, Godwin Austen Johnson, Karen Wilhelmm, Mirage Mille

Louis Vuitton Malletier
Architecture Department
2, rue du Pont Neuf
75002 Paris, France

McNally Design International
Warrington House
Mount Street Crescent
Dublin 2, Ireland
P +353 1 661 1477
F +353 1 668 4336
www.mcnallydesign.com
info@mcnallydesin.com

Nakheel
PO Box 17777
Dubai, United Arab Emirates
P +971 4 3903333
F +971 4 3903314
www.nakheel.ae

**NORR Group Consultants International Limited
– Dubai Office**
PO Box 53150
Emirates Towers, 3rd floor
Dubai, United Arab Emirates
P +971 4 330 4400
F +971 4 330 4401
www.norrlimited.com
info@dxb.norr.co.ae

Carlos Ott Architect
PO Box 14526
Dubai, United Arab Emirates
P +971 295 7888
F +971 295 6904
www.carlosott.com

RMJM (Robert Matthew Johnson Marshall)
PO Box 6126
Sheikh Zayed Road
Dubai, United Arab Emirates
P +971 4 3314120
F +971 4 3314199
www.rmjm.com
dubai@rmjm.com

Skidmore, Owings & Merrill LLP
224 South Michigan Avenue, Suite 1000
Chicago, Illinois 60604, USA
P + 1 312 554 9090
F + 1 312 360 4545
www.som.com
somchicago@som.com

Wilson & Associates
475 Park Avenue South, 23rd Floor
New York, NY 10016, USA
P + 1 212 213 1181
F + 1 212 213 1501
www.wilsonassoc.com

W S Atkins & Partners Overseas
PO Box 5620
Khalid Bin Waleed Road
Dubai, United Arab Emirates
P +971 4 3522771
F +971 4 3523045
www.atkins-me.com
Atkins Plc
Woodcote Grove, Ashley Road,
Epsom, Surrey KT18 5BW, United Kingdom
P +44 1372 726 140
F +44 1372 740 055
www.atkinsglobal.com

© 2006 daab
cologne london new york

published and distributed worldwide by
daab gmbh
friesenstr. 50
d - 50670 köln

p +49 - 221 - 94 10 740
f +49 - 221 - 94 10 741

mail@daab-online.com
www.daab-online.com

publisher ralf daab
rdaab@daab-online.com

creative director feyyaz
mail@feyyaz.com
DAS F-PRINZIP © 2006 feyyaz

editor sabina marreiros
text heinfried tacke
layout kerstin graf, papierform
imaging jan hausberg

editorial project by fusion publishing gmbh stuttgart . los angeles
editorial direction martin nicholas kunz
© 2006 fusion publishing, www.fusion-publishing.com

english translation dr. suzanne kirkbright
french translation céline verschelde
spanish translation carmen de miguel
italian translation maria-letizia haas

special thanks to marc steinhauer

© front cover photo courtesy jumeirah
© back cover photo courtesy government of dubai,
department of tourism and commerce marketing

printed in czech republic
www.graspo.com

isbn 3 - 937718 - 47 - 8